The Perfect Room

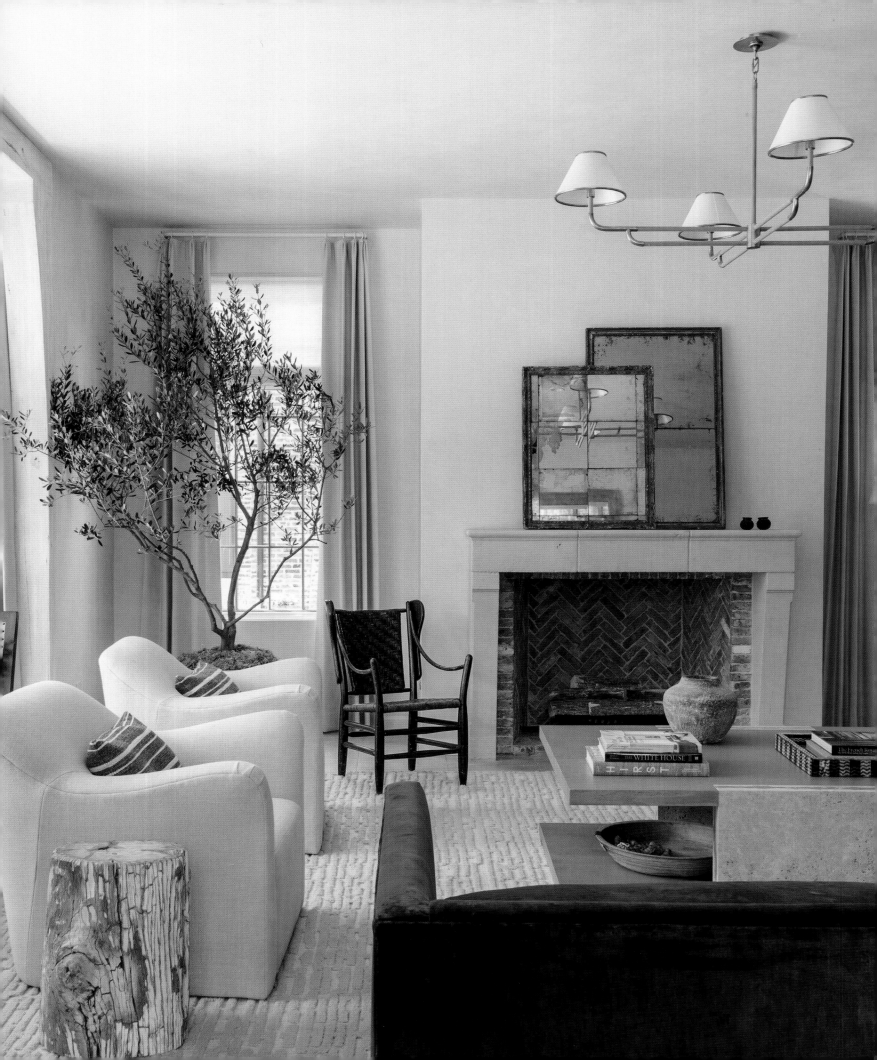

The Perfect Room

TIMELESS DESIGNS FOR INTENTIONAL LIVING

Marie Flanigan

written with Susan Sully

PHOTOGRAPHY BY JULIE SOEFER
FOREWORD BY JEFFREY DUNGAN

RIZZOLI
NEW YORK

New York · Paris · London · Milan

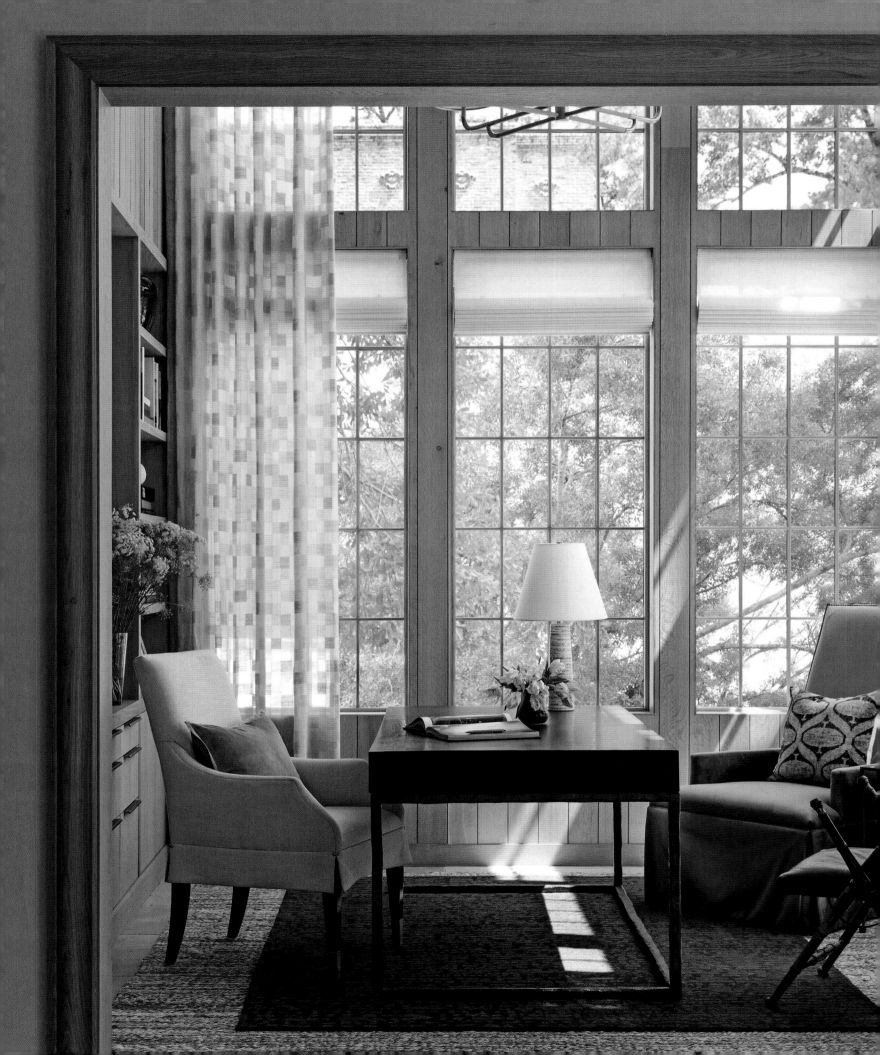

Contents

FOREWORD 6

INTRODUCTION 10

Greet 14
ENTRANCE HALLS

Gather 24
LIVING SPACES

Dine 40
DINING AREAS · BREAKFAST NOOKS

Serve 66
KITCHENS · PANTRIES · BARS

Refresh 100
BATHROOMS · POWDER ROOMS

Dress 132
DRESSING ROOMS

Repose 142
BEDROOMS

Play 166
CHILDREN'S SPACES

Focus 182
HOME OFFICES · STUDIES

Travel 198
STAIRCASES · PASSAGES

Task 212
UTILITY ROOMS · MUDROOMS

Breathe 228
OUTDOOR SPACES

ACKNOWLEDGMENTS 253

PROJECT CREDITS 254

Foreword

BY JEFFREY DUNGAN
JEFFREY DUNGAN ARCHITECTS

I first became aware of Marie Flanigan and her work years ago and was drawn by her clean, edited, and layered interiors. Hers was an approach that seemed to come from a different perspective than most designers. Initially, it was a mystery to me. At the time, I served as a juror for the *PaperCity* Design Awards in Texas. Later, I realized that I had voted to award every project she had entered because of the simplicity and clarity of her vision. Far from the splashy, glitzy, shiny-object kind of "statement" designs strewn across magazine covers and social platforms, hers emanate from a place of quiet and calm. Marie's work is soul-affirming, and my attraction to it was immediate and indelible.

Years removed from those epiphanies, I have had the opportunity to work with Marie and her talented team on projects from Jackson Hole, Wyoming, to Charleston, South Carolina. One of the central things I've enjoyed about collaborating with her is that she approaches each project like an architect—because she was trained as one. She understands the bones of a space and takes many cues from them at the inception of her designs. But the thing I value most is her dedication to creating places of peace, rather than palaces of pomp. She produces authentic environments aimed at how people live or want to live. This can only be achieved by a spirit of understanding the universal emotional and spiritual aspects of what it means to be human. If that sounds hard to do, it is.

I am proud to have played a small part in her elegant and sumptuous second book and am excited to see how her design influence continues to spread far from her native Texas across America. We need more people like Marie creating homes with depth and character that are as real as she is. Thoughtful and beautiful, her spaces are imbued with a deep desire to inspire those rarely occurring sensations of serenity, warmth, and joy.

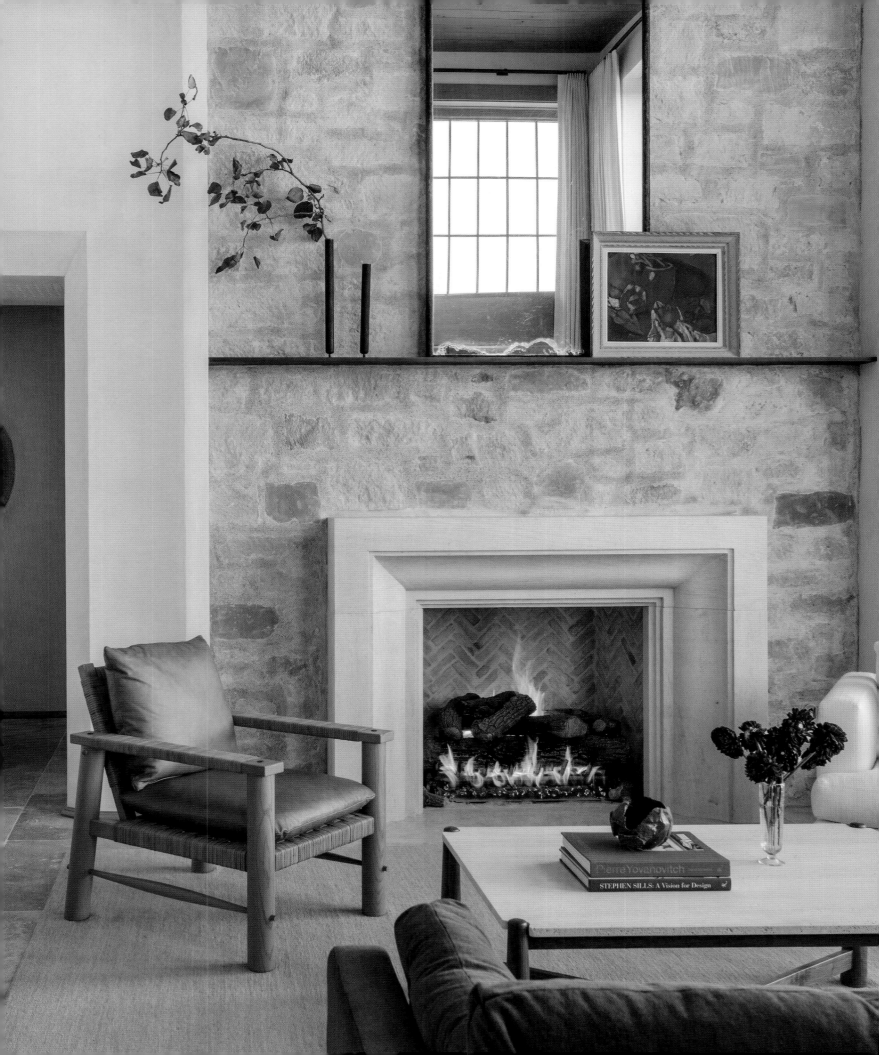

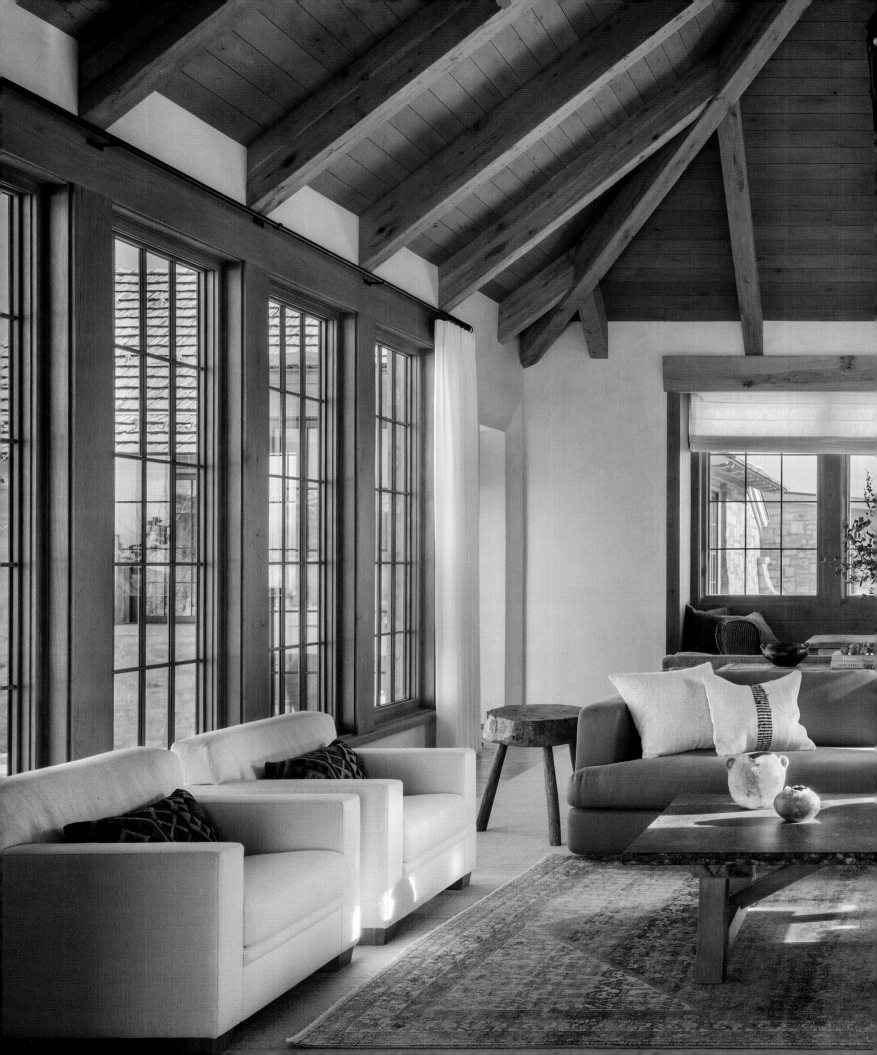

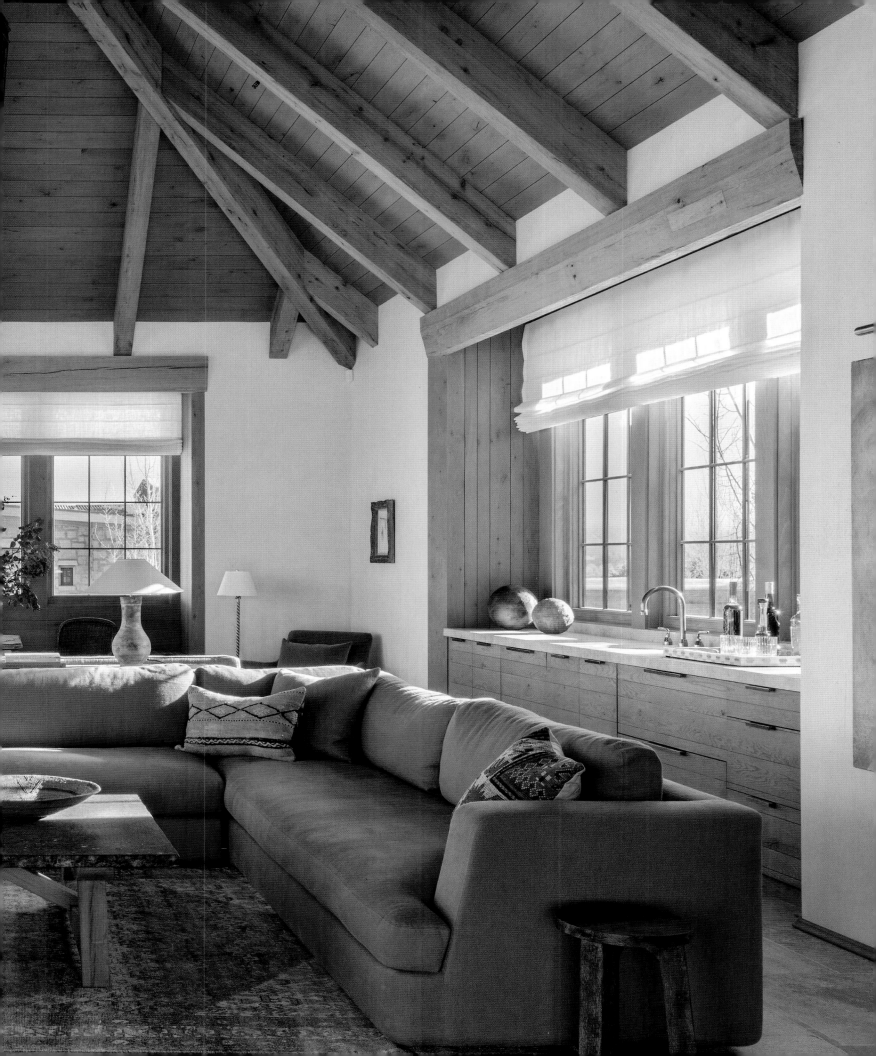

Introduction

We all want our homes to be perfect, but don't always know how to achieve that or even what it means to us. When I use the word *perfect*, I mean what's perfect for you—a personal haven where you can find peace, spend time with those you love, follow your dreams, and create memories that speak to your heart. My work as an interior designer has always been about the pursuit of a beauty that transcends style to inspire what's best in us and support what we know to be meaningful. Over the years, I've helped countless people define their vision of home and have translated that into surroundings ideally suited to their wants and needs. I've worked through challenges both big and small, in traditional, contemporary, and rustic settings, to arrive at solutions as beautiful as they are practical. With this book, I share these lessons in an approachable resource guide that marries timeless design theory with specific ideas about how to implement it, room by room.

My approach is holistic, which is why I always consider geographic and architectural context as well as how each room relates to the next before making any design decisions. There needs to be a common thread that weaves throughout the house and its surroundings in a seamless series of transitions. Otherwise, the experience of moving through them feels disjointed and chaotic. I seek to articulate a consistent language versatile enough to carry from space to space—using the same wood for paneling but modifying the details or carrying a color throughout while varying the materials in which it is expressed. This promotes unity and a feeling of tranquility, making the home a serene retreat.

A house must honor and forge a deep connection with its setting. When you respect the local vernacular architecture and landscape in choices of materials and forms, the home feels as though it was meant to be there and promotes a sense of rootedness and belonging. The design and location of outdoor spaces like porches, terraces, and courtyards should never be an afterthought. These should be treated with as much care as interior rooms to encourage daily communion with nature. Inside the house, I find many ways to build a connection with what lies outside—employing organic materials that echo the landscape, placing windows to strategically frame views or even filling entire walls, and sourcing colors and textures from the surroundings.

For a home overlooking the Grand Tetons in Wyoming, we combined hand-hewn beams and rough-cut stone with sleek, modern touches that reflect both the rugged geography and cosmopolitan culture of Jackson Hole. Built of split-faced rock with smear mortar that softens its edges, the house almost melts into the hill where it nestles. We used the same stone for the fireplace in the living room where towering windows framed in oak showcase a dramatic mountain vista. A nuanced palette of sage, rust, red, and ivory inspired by western sunsets unites vintage Oushak rug upholstery, Navajo-inspired handwoven textiles, and accent tables that appear almost to have been carved out of a tree trunk.

The local quality of light also informed choices we made for a beach house poised on the shore of the Gulf of Mexico. Glossy white paint applied to walls and ceilings reflects the coastal light and an array of blues, seafoam greens, and whites mirror the expanse of waves visible through the windows. We balanced this luminous palette with pale-colored wood reminiscent of driftwood and dark stained floors and window frames, marrying relaxed coastal style with modern sophistication.

Because I'm trained as an architect, I always approach a project from that perspective first. I look for ways that the interior can continue the conversation that the architecture began. In a house we designed in the Texas town of Round Top, the exterior was clad in vertical cypress planks. This same material extended into the entrance area, but the finish changed from sheer gray to a white wash. Inside the front door, walls of glass produce the impression of being in a breezeway. You can see the exterior from every angle, as if you are wrapped in it as you move through the house. Whether you are dining in the courtyard terrace beneath a giant old oak or relaxing in the great room looking out at the landscape, window frames painted the same shade of red unify the experience.

When making decisions about design, be intentional at every step along the way, remembering the purpose of each part of the house—and perhaps even writing a mission statement for it. What are the ways in which you will use each space? What do you want to feel when you are there? How will you share the space with others and what will they experience? This helps identify the true character of a room and gets at the heart of what makes it beautiful, functional, and inspiring. I aim to create spaces that renew and recharge, and that is different for everybody. For one, it might be reading a book in a corner; for another, cooking for the family or giving a dinner party. Discover what is personally meaningful and create surroundings that nurture that.

When designing the primary bedroom in my house, I envisioned it as a welcoming retreat at the end of the day, as well as a place where my family gathers before bedtime. The room had the potential for a twenty-foot-high ceiling, but I preferred a cozy, cocoon-like feeling, so I lowered the ceiling both physically and visually, with the addition of white oak planks that clad a vaulted ceiling. Voluminous curtains of wool sateen in a deep shade of mossy green and luxurious bedding of linen, matelassé, and antique tapestry produce a luxurious, textural refuge for rest and rejuvenation. We love to read at night, so I also included a seating area with two big chairs perfect for story time with our children as well as for quiet moments of conversation.

We should cultivate a quality of perfection in all our rooms that fosters authenticity in our lives and does the same for everyone who shares them with us. Through my work, I hope to bring a level of beauty that elevates our experience and injects joy into all aspects of our being in a unique and personal way. In these pages, I offer inspiration gleaned from the experience of helping many follow this path and guidance that I hope will help you find what is perfect for you in every part of your house.

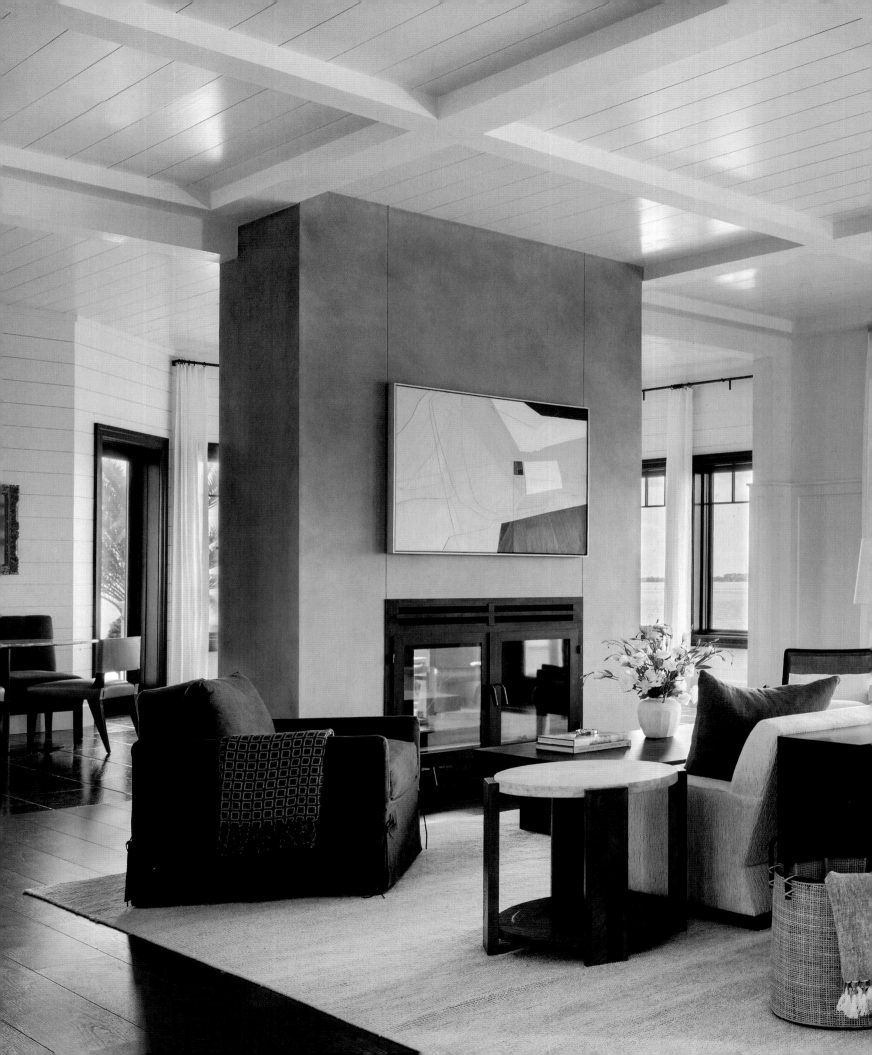

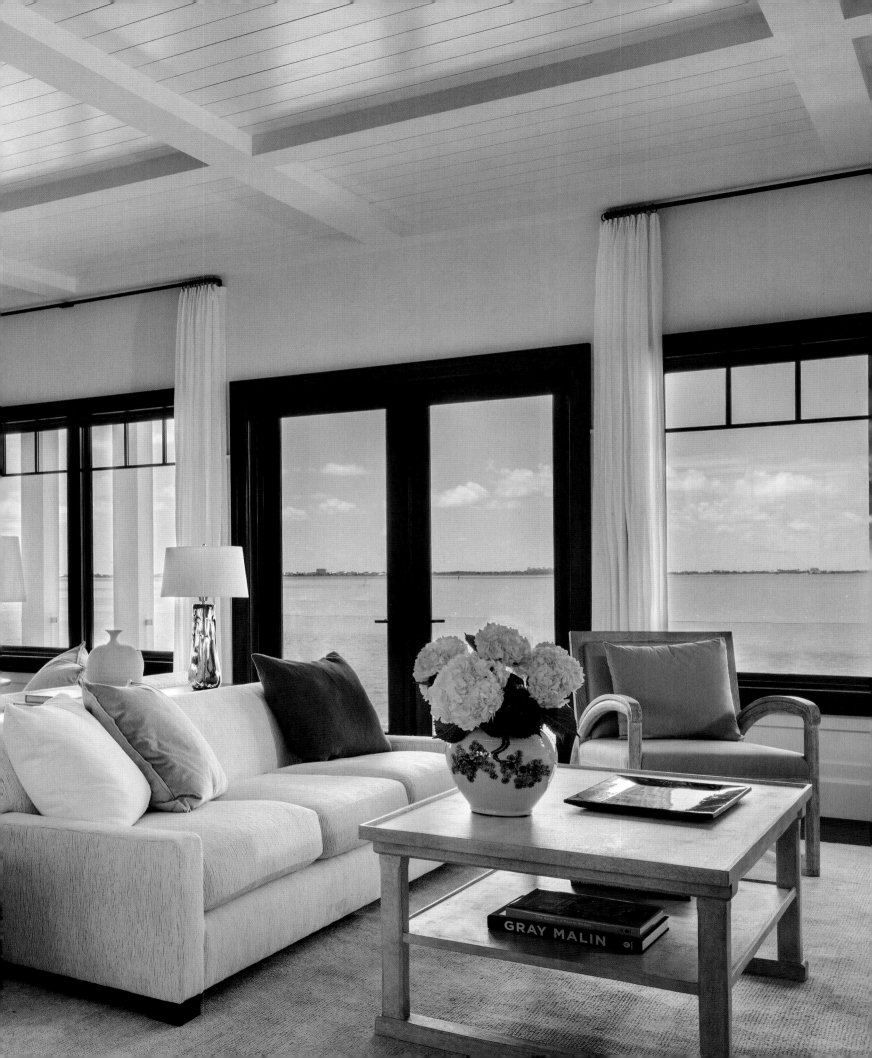

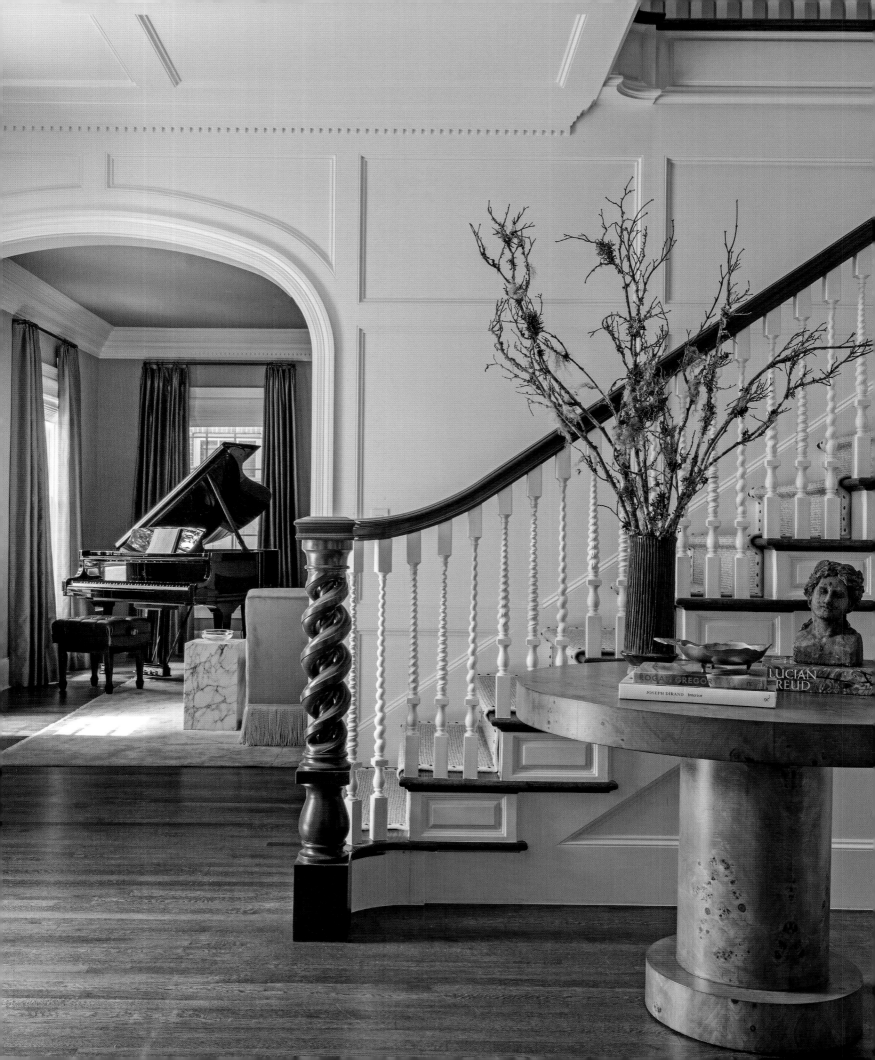

Greet

Entrance halls make a strong statement, introducing
a design language that flows throughout the house.

The entrance to a house begins well before you reach the front door. In the best instances, the journey unfolds in a seamless series of transitions that focus attention on the beauty of the surroundings while building anticipation for what's to come. Every decision we make, from the edge of the property to the entrance hall, forms an impression that signals the character of the home and issues an invitation to join in its life. Because the disciplines of landscape design, architecture, and interior design are so entwined, I try to find ways for them to play by the same rules. In a house built of reclaimed limewashed brick, the same material can be introduced in the welcome gate. A white picket fence perfectly complements a cedar-shake house with crisp white trim. In a rustic retreat we designed in Texas, the red of old barns dotting the landscape inspired the color used to accent the trim of windows both inside and outside the house.

I like to blur the boundaries between the exterior and interior architecture at the front door. In a modern house, large steel-and-glass windows and doors deliver a direct view into the entrance hall. In a more traditional setting, a beautifully detailed front door surrounded by sidelights offers a tantalizing glimpse of what's inside. Because the entrance hall is a transitional space that introduces the design language used throughout the house, it's important to consider it as part of a larger whole. In a home with a minimalist aesthetic, smooth plaster walls, stone flooring laid in a geometric pattern, and a sculptural center table can set the tone. If handsome wood paneling appears throughout the adjoining rooms, I might employ it first in the entrance hall, modifying certain details but maintaining a consistent style. In a house where colorful, modern art is prevalent, a bold painting or piece of sculpture proves the perfect choice for a focal point.

Whatever the entrance hall's style or size, its furnishings should make it feel more like a room than a space through which to rush. Center tables, consoles, benches, ottomans, and chairs, accompanied by gilt-framed mirrors and glittering sconces, introduce the tones and textures of wood, metal, stone, plaster, and upholstery for a richly layered palette. They provide places for guests to put down drinks, perch on a bench, or sneak a quick check in a mirror. When choices of accessories and artwork reveal something about the personality of the residents, guests feel truly welcomed into the heart of the house. These details invite people to linger as they enter or exit, enjoy a conversation with their hosts, and relax into the atmosphere of the home.

Grand foyers call for strong statements like soaring ceilings, statuesque staircases, and overscale chandeliers that make the act of entering a celebratory moment. During the redesign of a magnificent Colonial Revival house in Dallas, we transformed the entry hall's handsome two-story staircase into a dramatic showpiece by adding another flight of steps. To preserve the essence of the historic design, we commissioned intricately hand-carved balusters for the upper level that faithfully replicated the original ones below. A dramatic Venetian glass chandelier suspended from a skylight crowns the room, infusing the space's inviting charm with formal elegance.

First impressions are lasting ones, so it's vital to keep in mind the effect our homes have on all those who come near and enter in. How do you want to welcome friends and family into your home? What do you want people to feel when they arrive—elevated, inspired, stimulated, or relaxed? My foremost priority is to communicate a sense of hospitality and delight. This ensures a harmonious design that immediately puts everyone at ease. It's been said that people don't always recall the details of a place, but they do remember how it felt to be there.

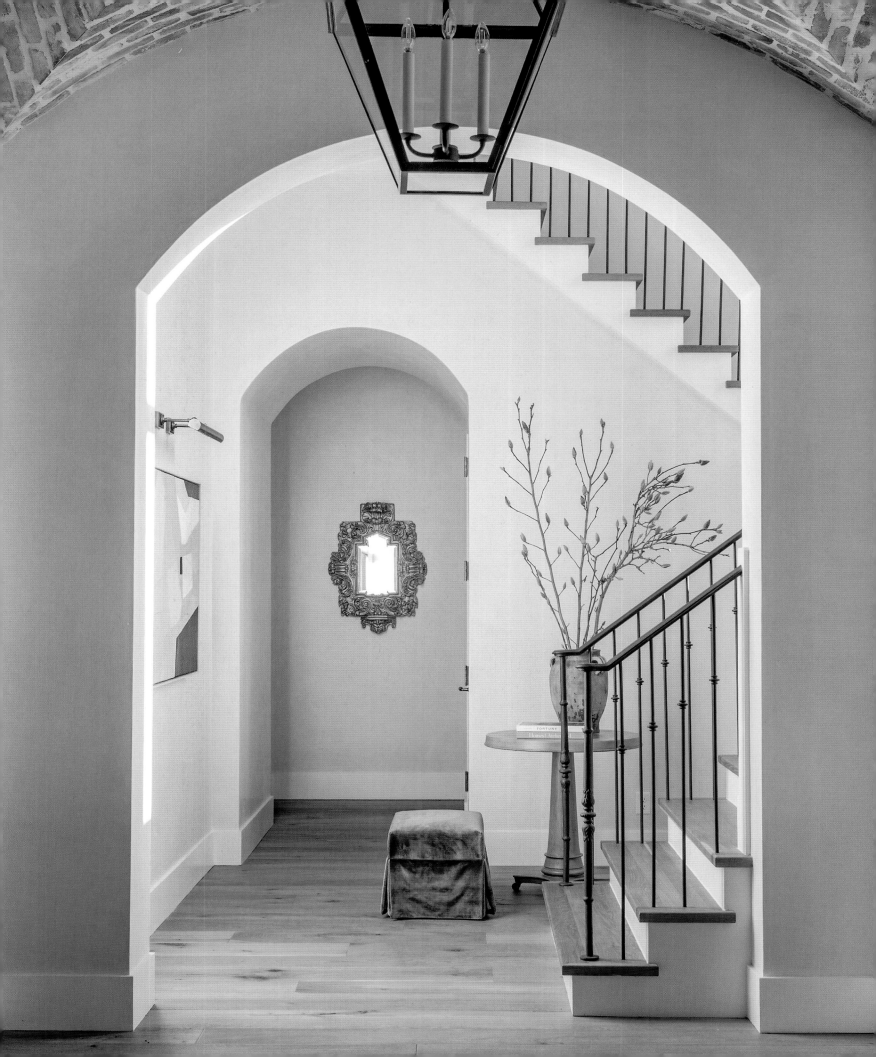

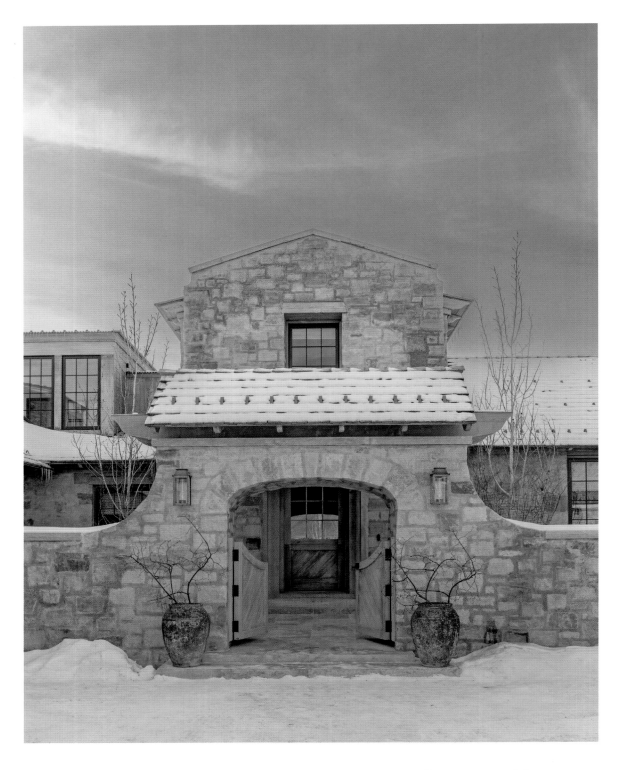

Connect with nature

In the best instances, the exterior architecture of a house forms a bridge connecting what lies within its walls with the surrounding environment. An approach that unfolds gradually, with perimeter walls, gates, paths, and courtyards that slowly introduce colors, textures, and shapes that may reappear inside the rooms, forges a perfect union between the interior, exterior, and natural surroundings.

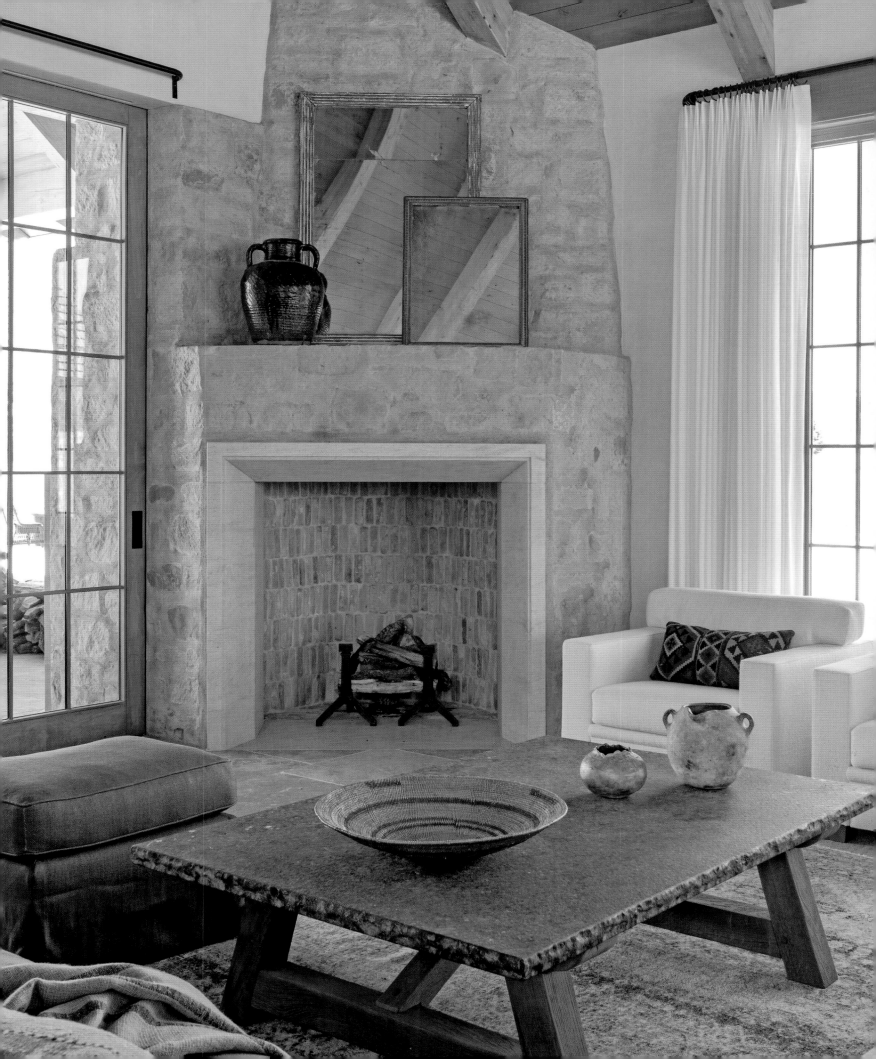

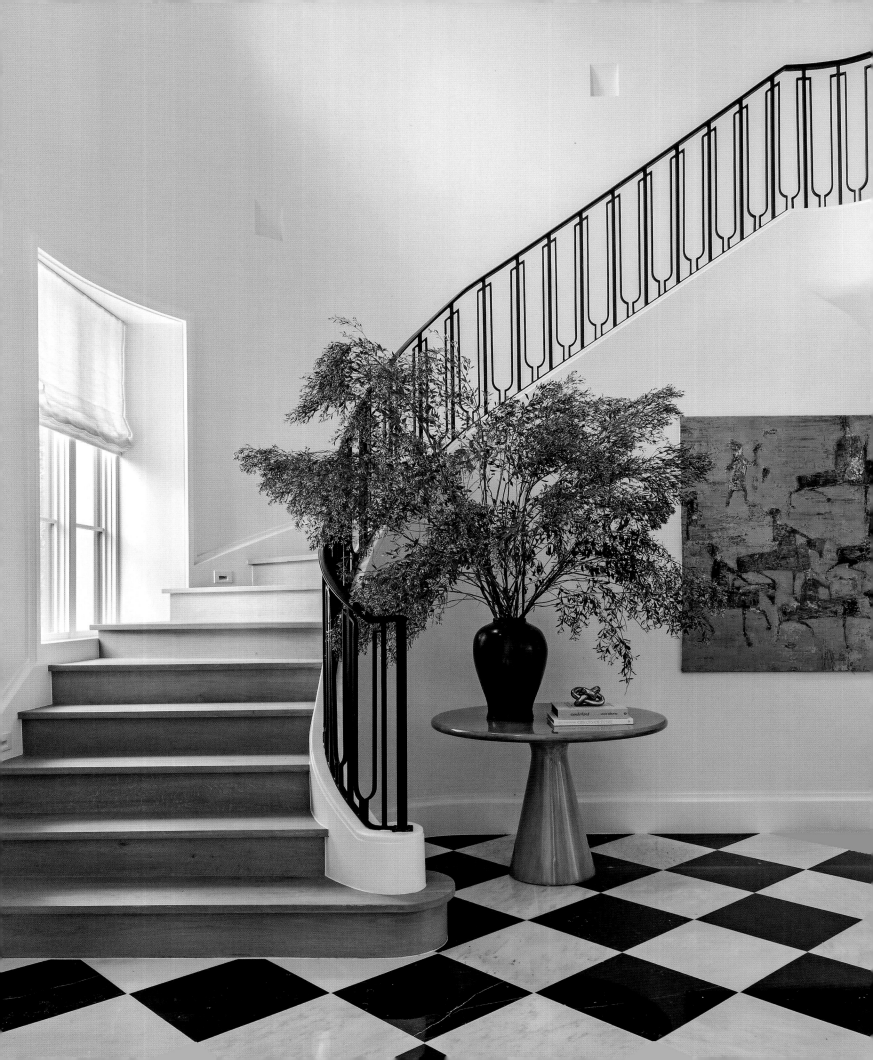

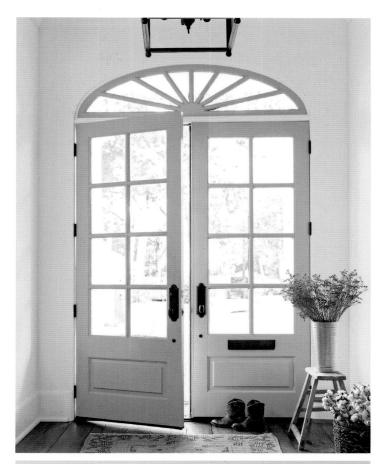

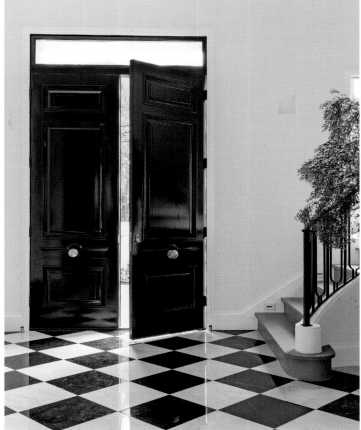

Entrance halls offer instant insight into the personality of the home. A floor of wide reclaimed-wood planks imparts a casually traditional character ideal for a relaxed family home. A gleaming expanse of marble checkerboard makes a sophisticated first impression, setting the stage for glamorous entertainments.

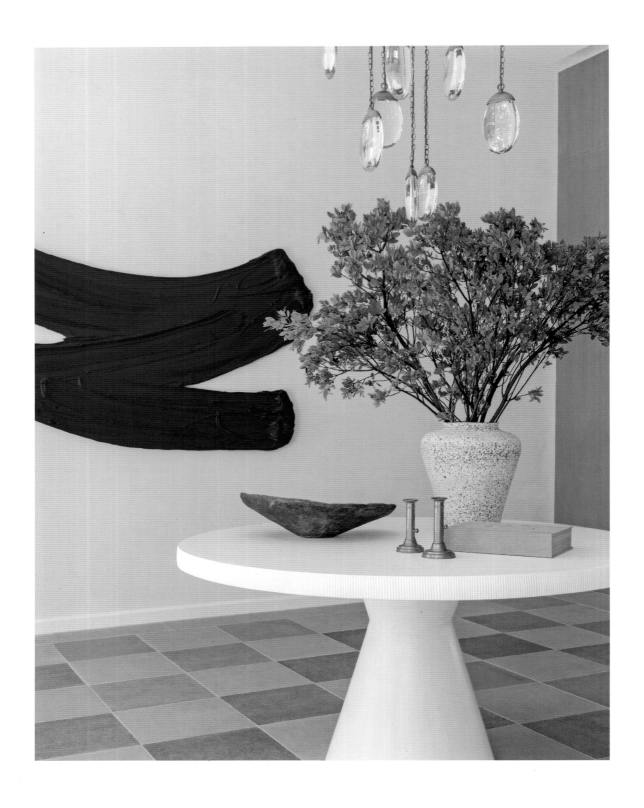

Round tables that are sculptural in form and inviting in texture ground the composition of spacious entrance halls. Tables crafted from polished wood, plaster, glass, or stone bring tactile pleasure into the room and provide a beautiful place for welcoming guests with flowers, candles, and treasured objects.

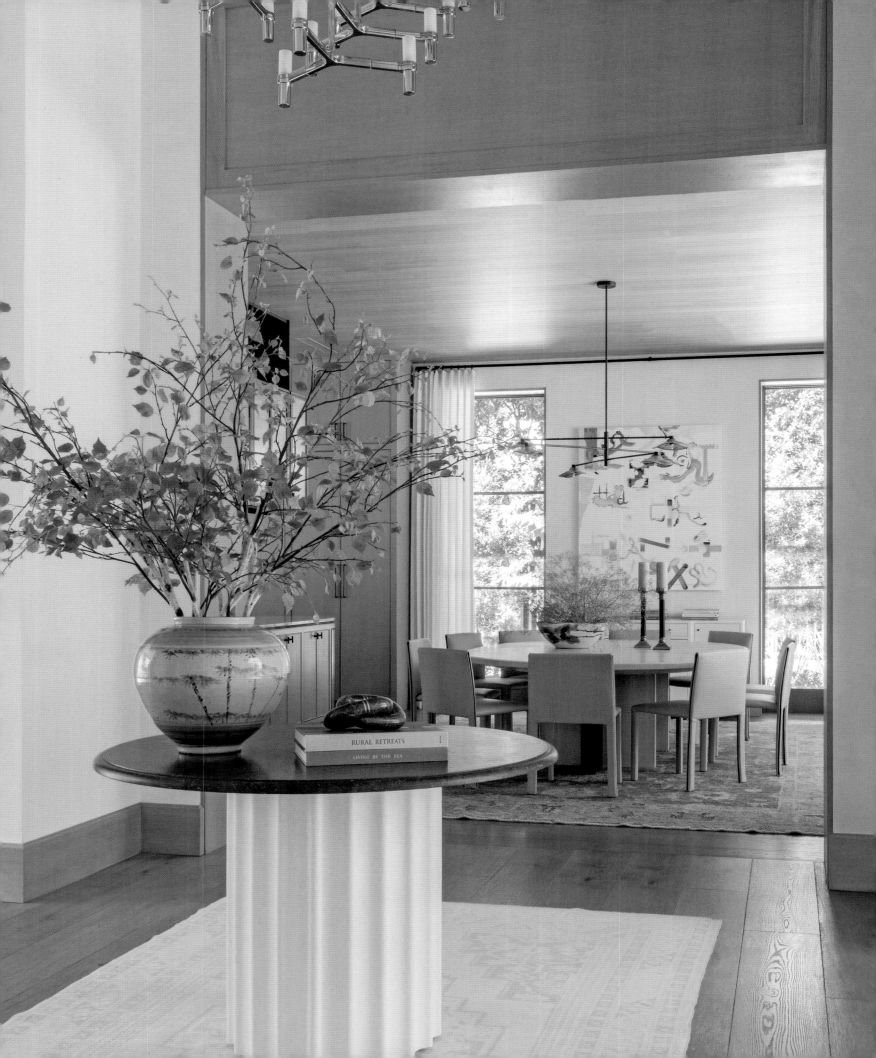

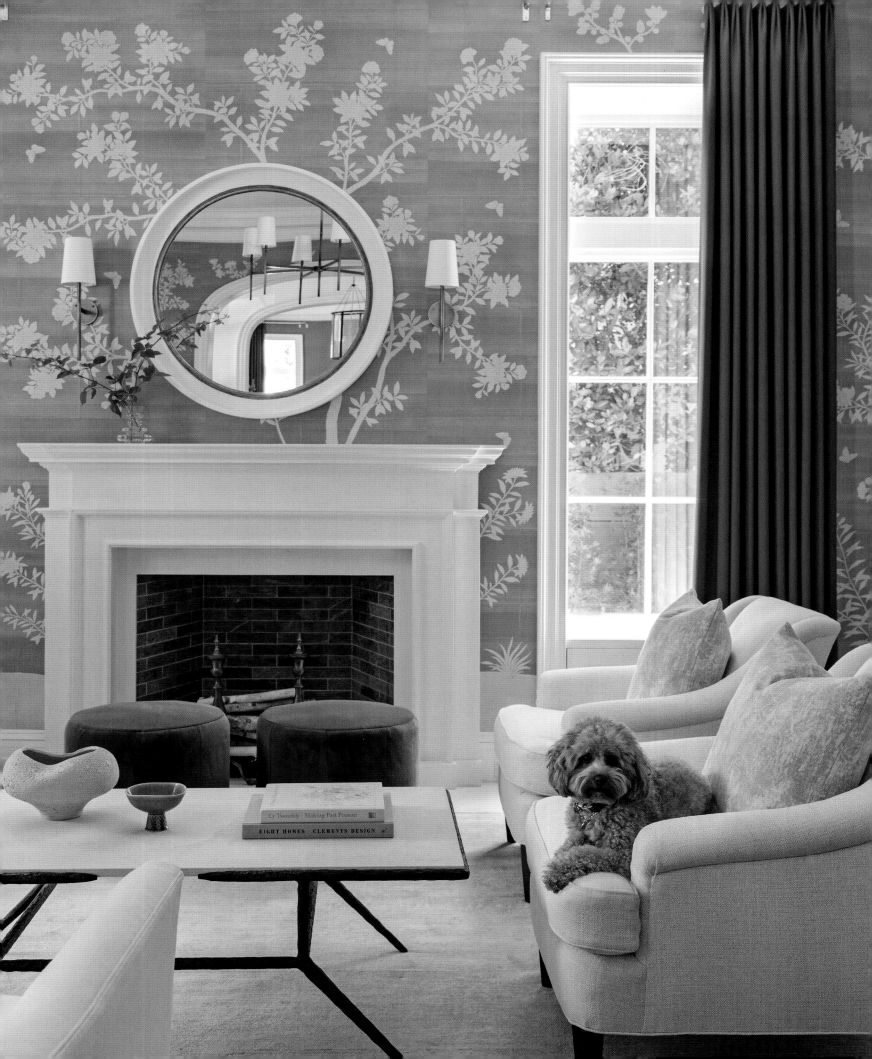

Gather

Layering texture, pattern, and color are key to fostering a warm
and inviting atmosphere in rooms designed for gathering.

The home is a sacred space where people come together to experience the transformative power of love and community. The shared places within it cultivate a sense of belonging and kinship for family and friends. These are the rooms where conversations unfold, ideas are exchanged, relationships are nurtured, and memories are forged. Whether hosting a convivial party or offering a solitary moment of retreat, these spaces invite us to disconnect from the stresses of daily life and reconnect with others and ourselves. If we keep these intentions in mind, then gathering rooms not only become beautiful places but also welcoming ones where we can relax and savor the present.

Because no two gatherings are the same, the composition of living rooms needs to allow for flexibility, adapting to events whether large or intimate, dressed up or dressed down. In sizable rooms I like to create distinct zones intended for different kinds of interaction. I usually anchor the seating plan with large pieces like sofas and coffee tables, with light chairs and cocktail tables that float around them. Sofas arranged back-to-back immediately define two distinct areas where people can cluster and enjoy conversation. Whenever possible, I also include more intimate seating vignettes that invite small groups to enjoy each other's company in a cozier setting. I often tuck a multipurpose seating area with a game table and a few chairs into an unused corner. This is the perfect place for shared or solitary activities, such as sipping Scotch over cards, savoring a cup of tea, or enjoying an intimate dinner for two or three.

The floor plan forms only part of the equation. Beautiful spaces evoke positive emotions and draw people in, increasing their feeling of belonging. A soft rug underfoot, inviting textiles, and a bounty of pillows and throws are luxuries that feed the senses. The effect of color on moods is palpable. Dark shades elicit a completely different experience than bright, stimulating ones. The texture of materials affects us on an even more subconscious level. When we reenvisioned a drab cherrywood-paneled study, we curated a palette inspired by chinoiserie wallpaper hand-painted in deep shades of blue and green. Embracing its hues, we layered in opulent textures of silk, velvet, and wool bouclé enlivened by shimmering metal highlights, transforming this once overlooked study into one of the most frequented rooms in the house.

Family rooms accommodate a wide variety of activities—from members of the household sharing the rhythms of daily life and friends joining in for casual entertainments to children doing homework and adults working from home. To design an environment versatile enough for any occasion, it's useful to envision each individual scenario, consider the flow of traffic, and anticipate needs for seating, tabletop surfaces, and illumination. When considering furniture arrangement, it's helpful to think through a typical day—who needs to be where, doing what, and when. It's also important to think of special events, such as hosting a Super Bowl party or decorating the Christmas tree and deciding in advance where it should go. Sometimes I compose family rooms to complement the overall palette of the home, but I've also made deliberate departures, choosing colors, architectural details, and decorative objects that set the room apart as a special place reserved for family. The decoration of these rooms needs to be practical as well as appealing, keeping durability in mind when it comes to choices of floor and wall finishes and upholstery.

When rooms are designed intentionally to meet the individual and collective needs of family and friends, they become sanctuaries that strengthen attachments with those we care about most. Over time such rooms achieve iconic status, symbolizing the relationships they've witnessed and the milestones experienced within their walls. With this as our goal, living rooms must not only be beautiful places but also purposeful ones that invite us to appreciate the moment and celebrate life's gifts.

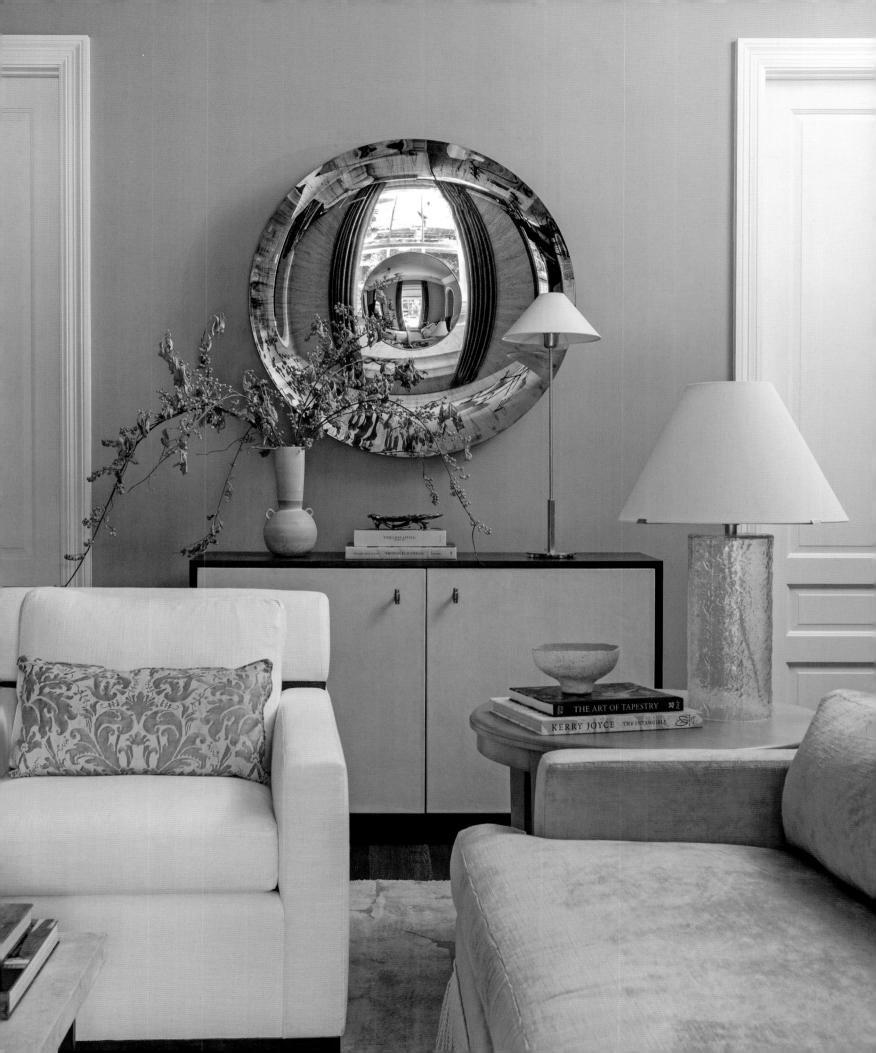

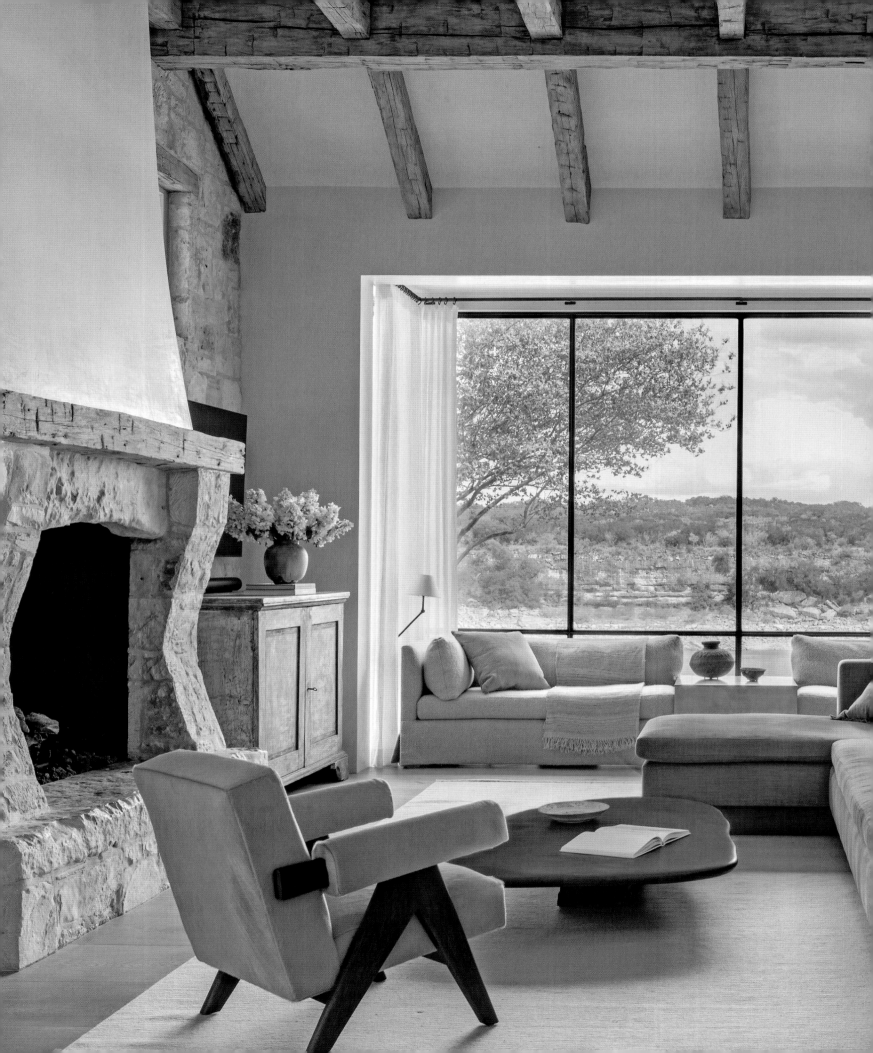

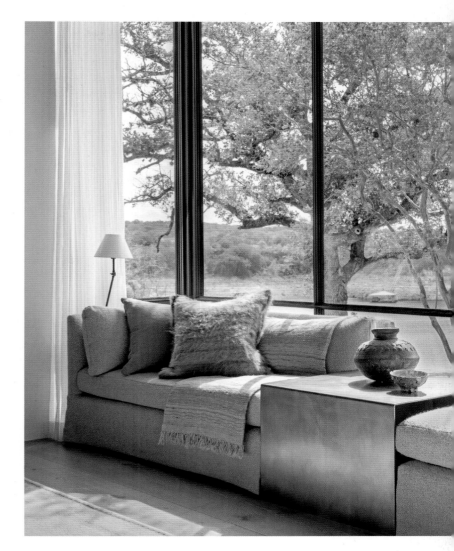

Bay windows and floor-to-ceiling walls of glass and steel frame expansive views and bathe rooms in light. Colors and textures inspired by the surrounding landscape establish a nearly seamless connection with nature that is grounding and reassuring.

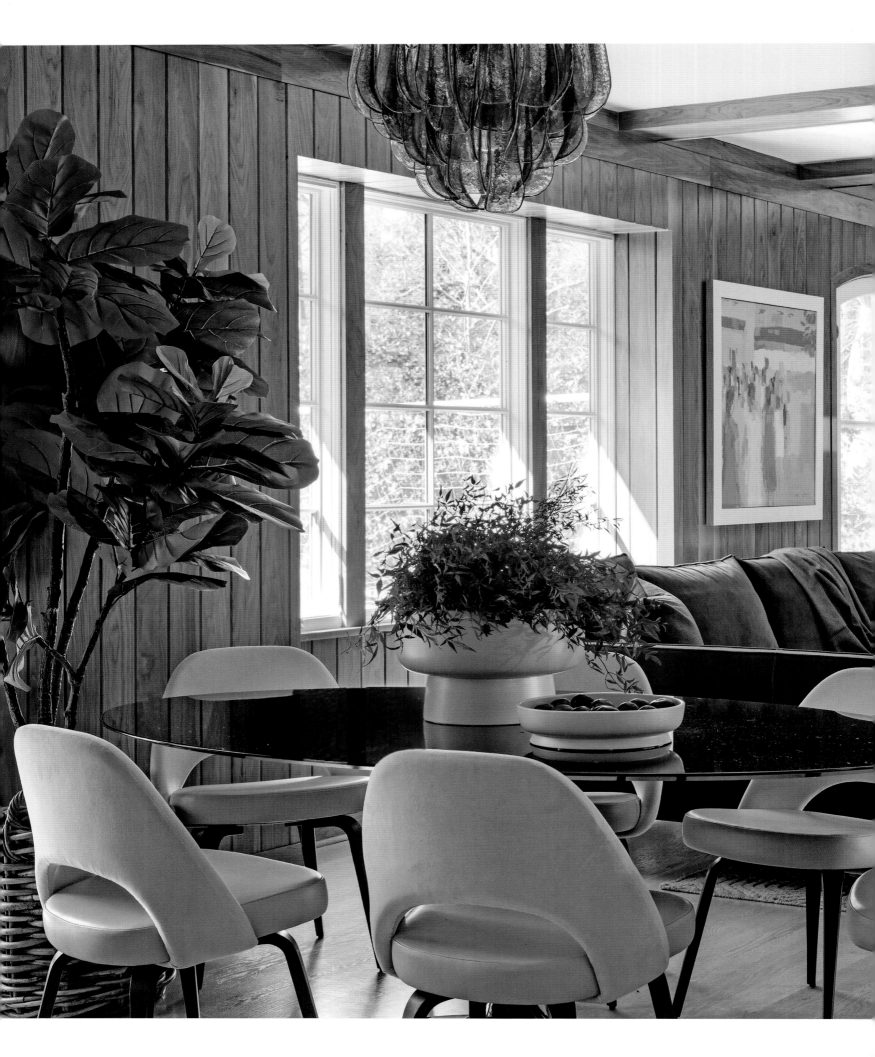

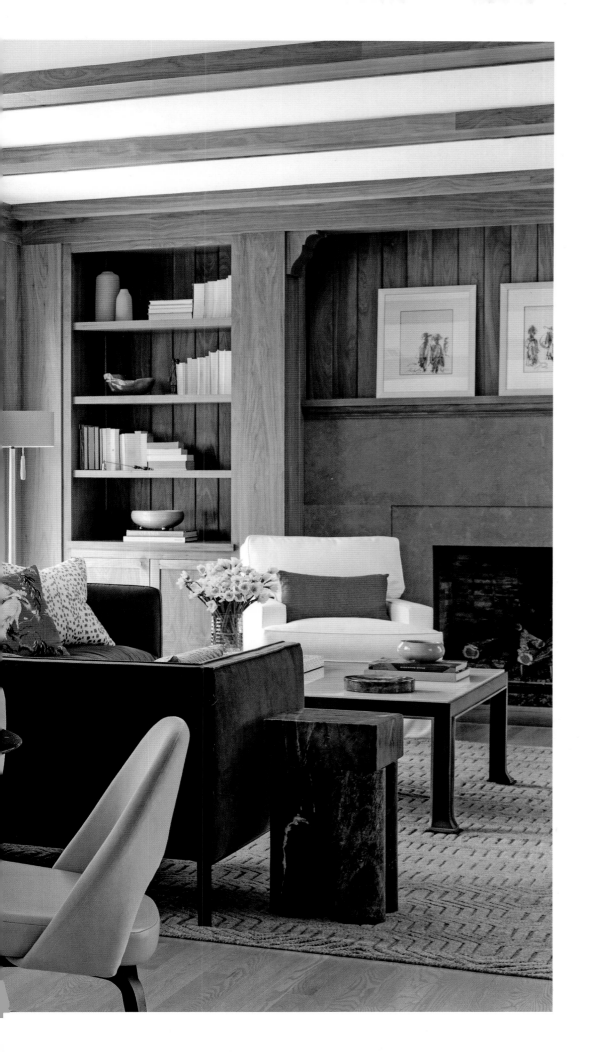

Texture brings rooms to life

Consider every plane—wall, floor, and ceiling—as a chance to celebrate the beauty of natural materials. The architecture of a room offers boundless opportunities to introduce variety through wood, plaster, metal, and stone. Then the soft textures of wool, velvet, silk, and linen can be layered in to deepen the sensory experience.

Fireplaces are symbols of light, warmth, and hospitality

People love to gather around the hearth. Fireplaces provide compelling focal points that anchor a room. They issue an invitation for strong textural statements that bring materials like stone, marble, brick, metal, and tile into the mix.

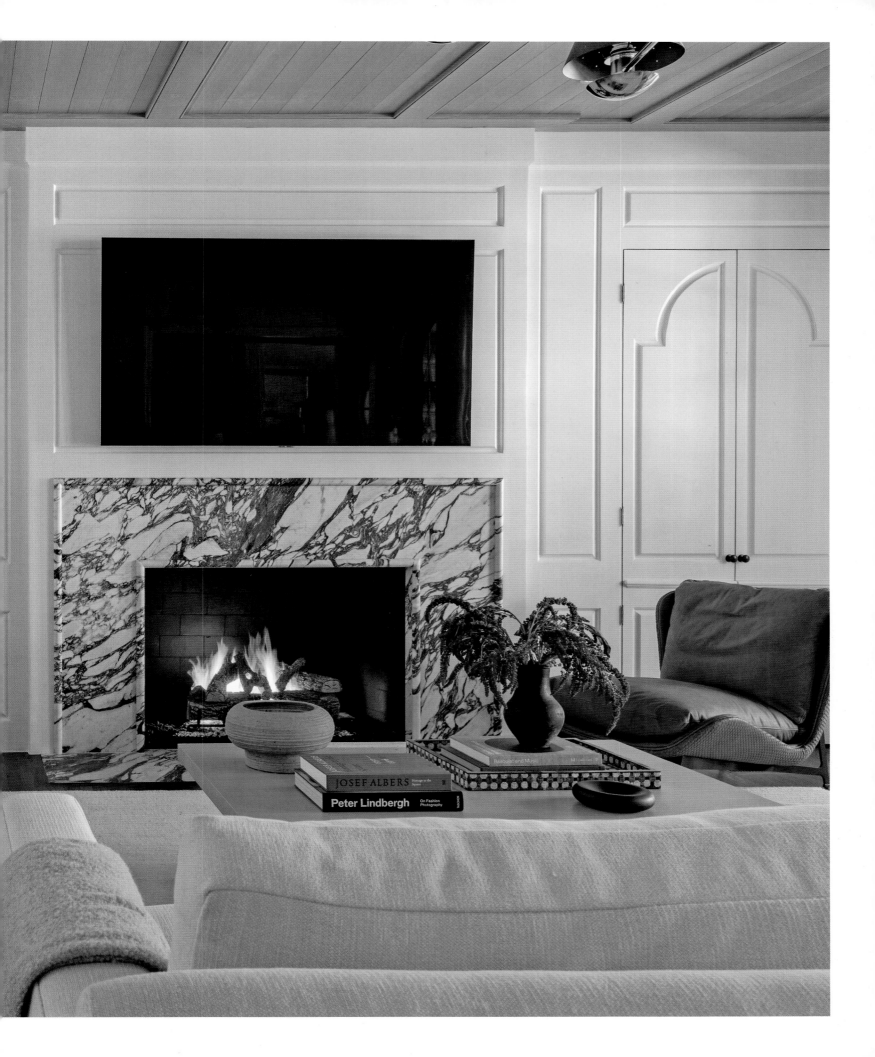

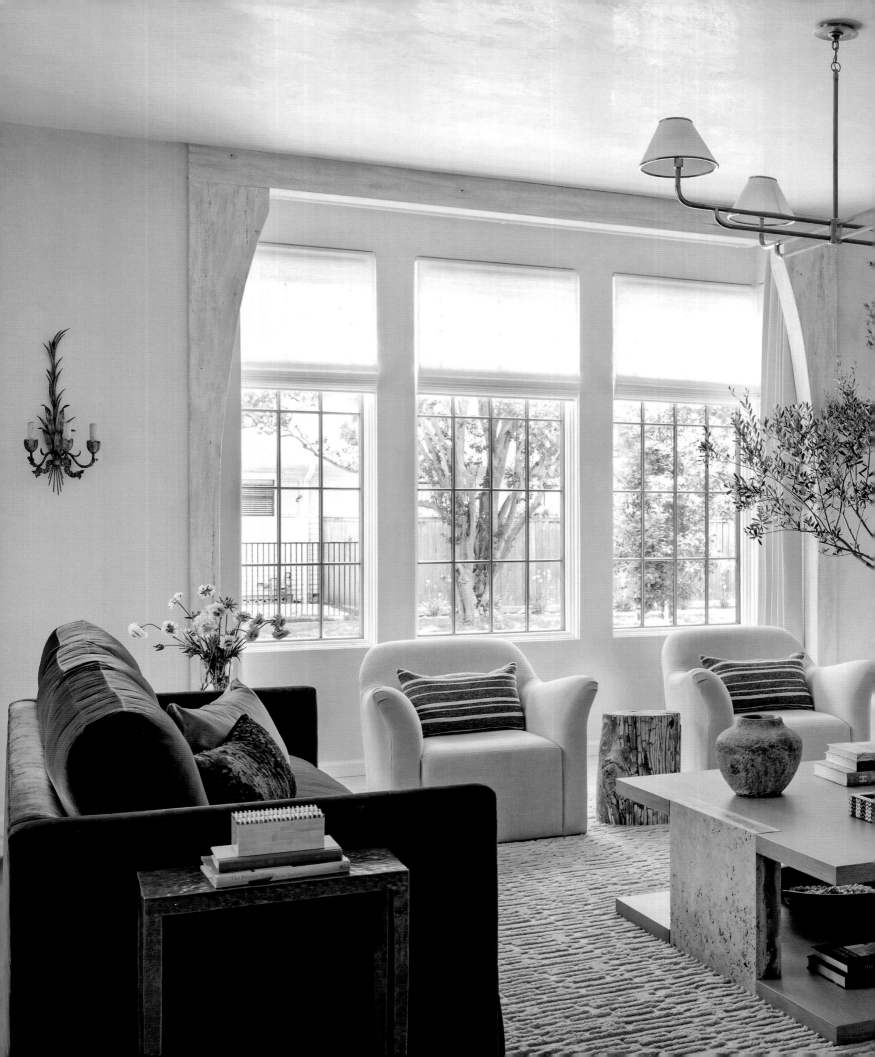

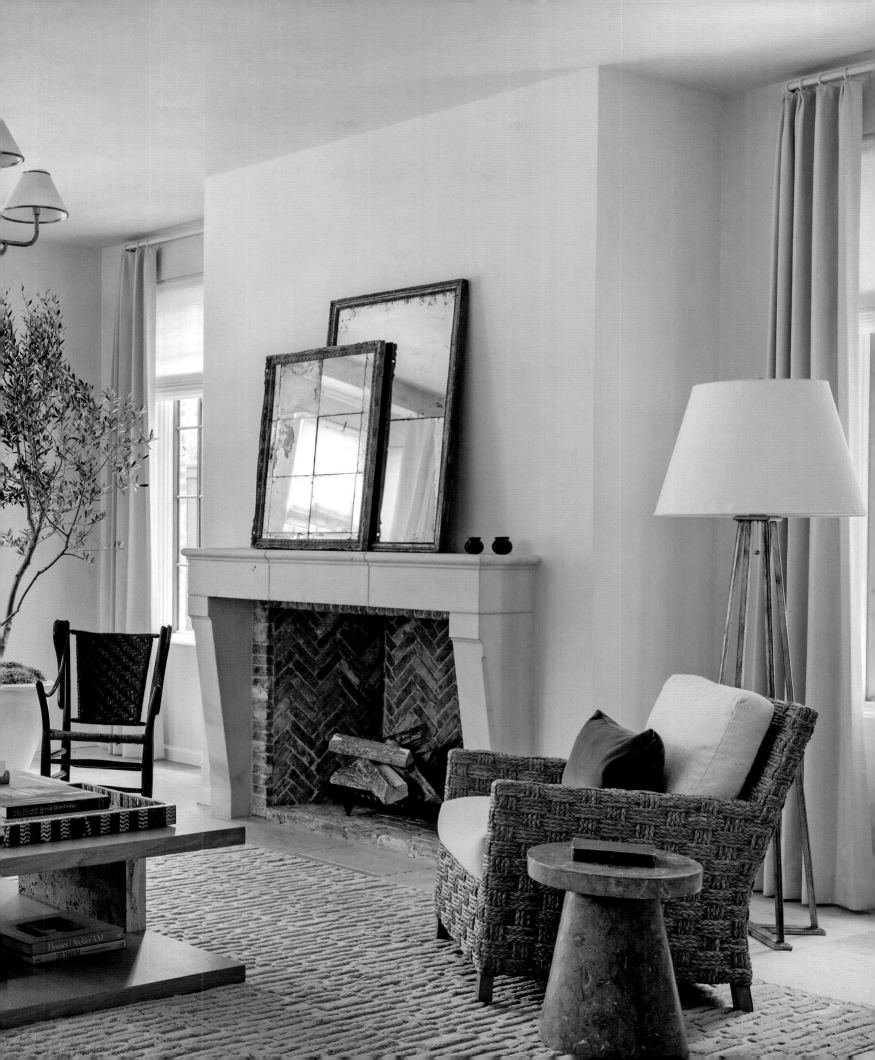

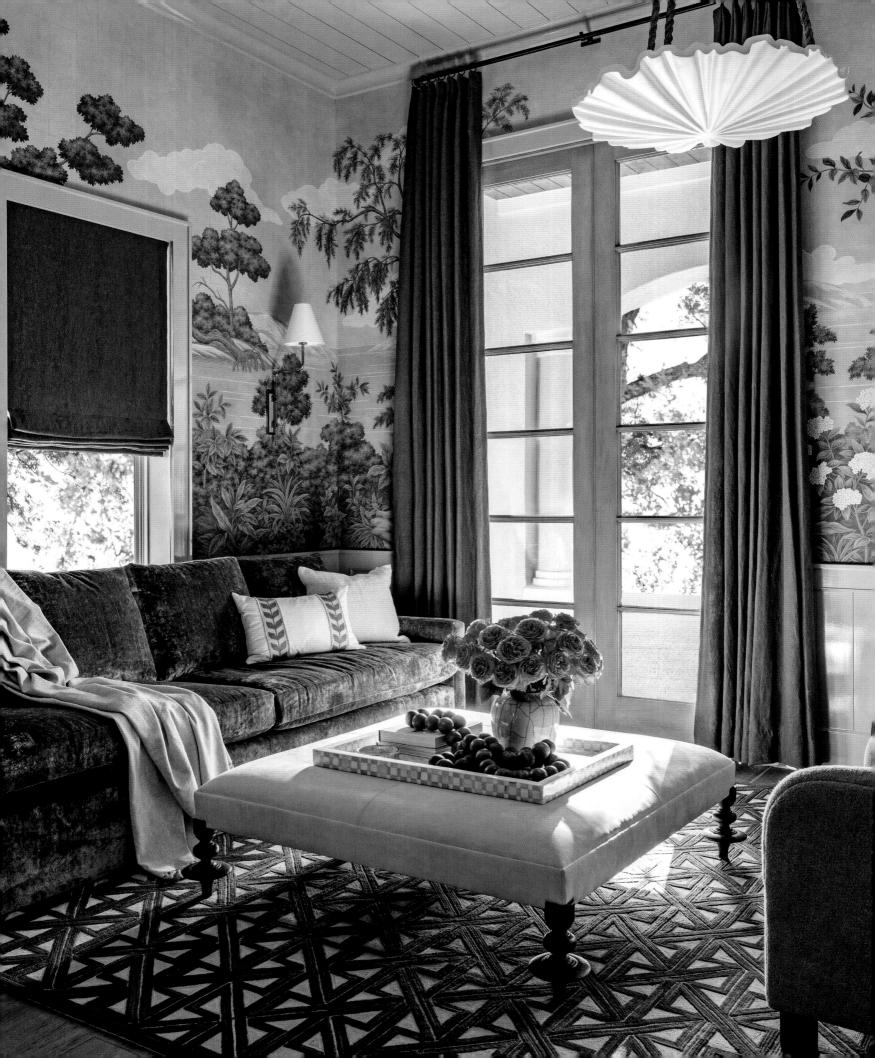

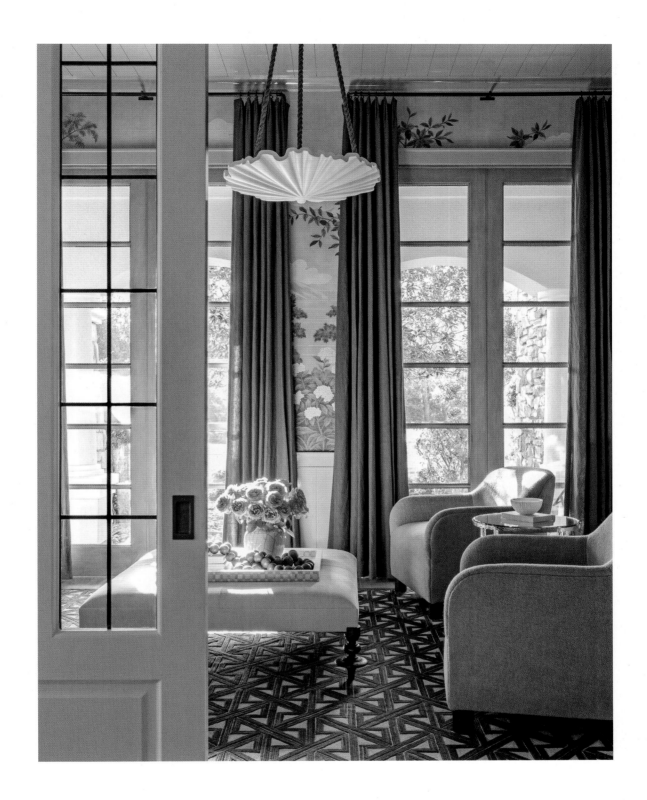

The nuanced tones of Gracie's New World in Color handpainted wallpaper inspired the entire design of this room. If the colors of drapery and upholstery conform to the palette, the result proves restful and inviting. When combined with opulent textures like velvet, silk, and wool sateen, this decorative feature forms the setting for timeless luxury.

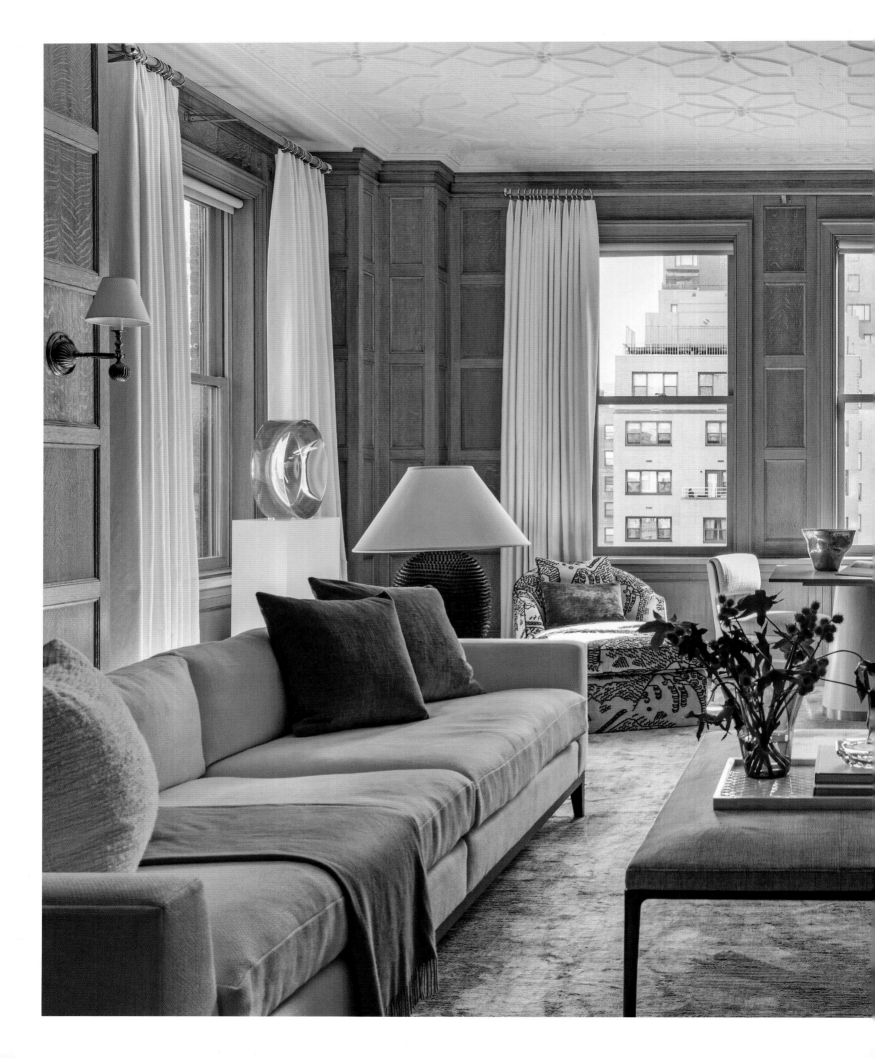

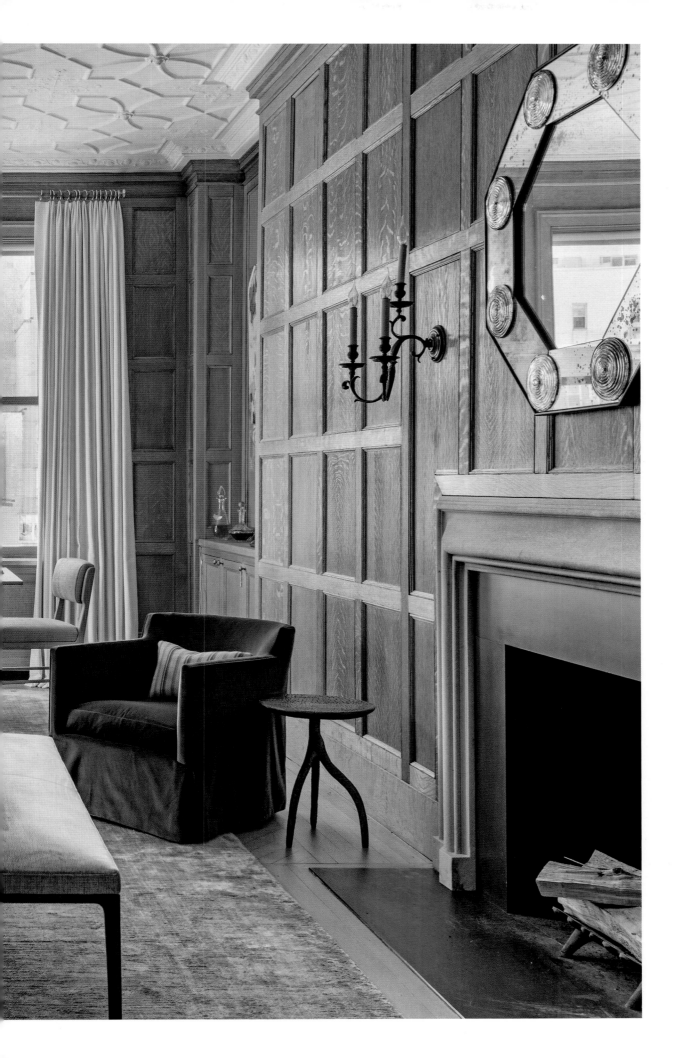

If the architecture of a room is highly articulated with paneling and carved plaster designs, keep the furnishings simple and the palette calm. In long rooms, define different zones with a large seating area designed for gathering and a more intimate space with a small table and chairs perfect for enjoying a cup of tea or conversing with a friend.

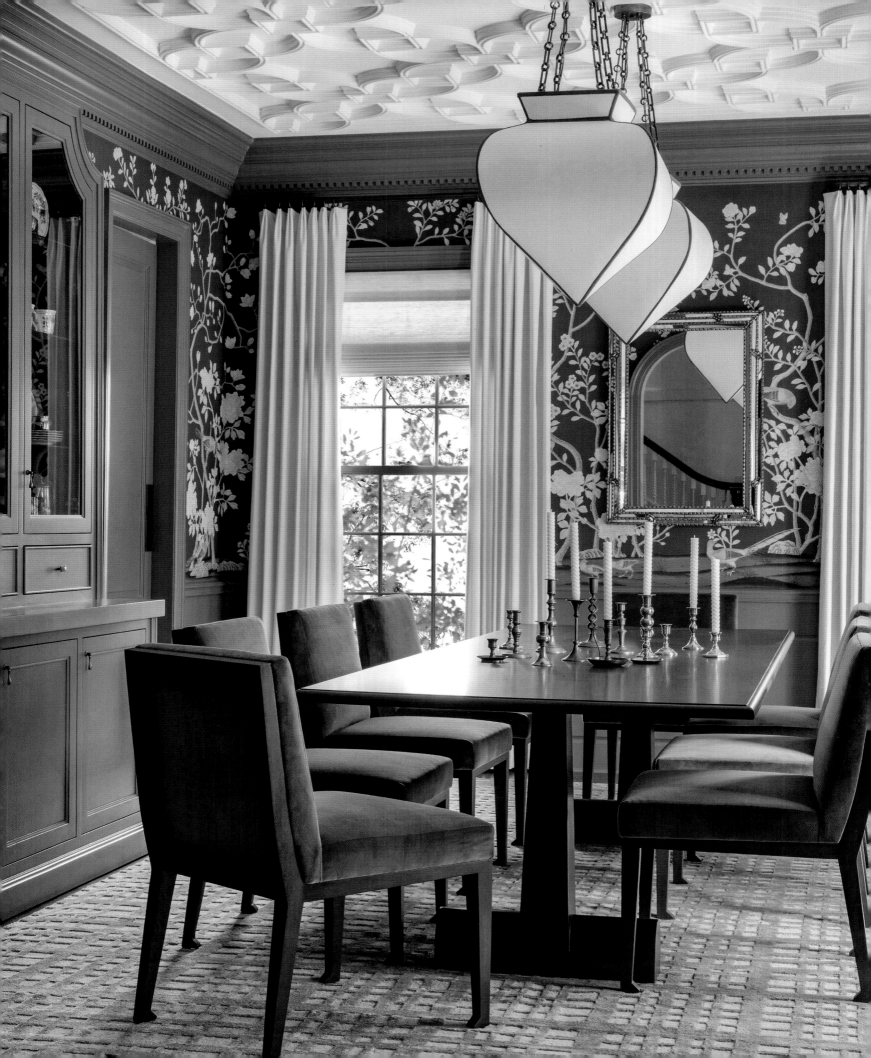

Dine

Rich hues, plush textures, and extravagant gestures
turn dining rooms into places where we want to linger,
savoring the company of those we cherish.

Breaking bread together is one of the most fundamental human experiences. Whether in an exquisitely appointed room or a cozy nook near the kitchen, the place where we gather around the table is not just a space for eating. It's a private retreat where we reserve time to enjoy special moments with family and friends and to engage meaningfully with one another. In my home, dinners are daily rituals when even the youngest child has a spot at the table with a proper place setting. Each night, we take a moment to light a candle to signify the reverence we give to this time together.

When the dining room occupies a space set aside solely for that purpose, opportunities abound to achieve the highest degree of decorative elegance. Dedicated rooms have the potential to become extraordinary jewel boxes with their own palette, character, and ambience. They are my favorite places to take creative risks with custom ceiling treatments, extraordinary chandeliers or pendant lights, and colors, textures, and patterns not found elsewhere in the house. Even when not in use, such a room may be walked past many times a day, which is why I like the entrance to frame an alluring glimpse of an elevated and perhaps unexpected design.

For a room in a home in Dallas, our goal was to orchestrate a space as vibrant as the personalities of the homeowners. By combining wallpaper in an overscale pattern with paint in a saturated shade of blue and introducing sumptuous velvet upholstery, we infused life into the room, creating a symphony of color and texture. A plaster ceiling with an intricate geometric pattern literally elevated the design. Lighting also played a pivotal role in the composition, with two meticulously handcrafted paper lanterns and petite three-inch recessed lights that subtly illuminated the dining surfaces. Antique candlesticks arranged as a centerpiece cast a dreamy glow over the table. Even though the impression is formal, the room accommodates basketball pizza night for teenage boys as easily as a glamorous dinner party.

Casual dining areas are often integrated into multi-purpose living spaces where gathering, dining, and sometimes even cooking take place. In such settings, the ebb and flow among zones enables guests to easily transition from cooking to cocktails and dining to after-dinner drinks. This ease of navigation also encourages families to enjoy time together before and after meals. While I like the design of these dining areas to be consistent with the overall aesthetic of the room, I usually demarcate them by anchoring the table with an area rug or a large-scale light fixture.

Although breakfast nooks typically adjoin the kitchen, they still have potential for beauty and charm. I like to give them their own special moment with distinctive chairs, whimsical light fixtures, or compelling pieces of art. Durable materials like wood, plaster, concrete, and stone are key, especially for table-tops, as well as fabrics resistant to stains and daily wear. The breakfast room in my house features a banquette with an abundance of comfortable pillows that bring color and pattern into the space. The banquette also multitasks as storage, with drawers hidden beneath for tableware and linens. For ease of cleaning, I covered the chairs in faux leather and chose heathered upholstery for the banquette to hide the inevitable spills.

Correct, controlled illumination is essential for producing an inviting atmosphere for dining. It's best to layer ambient, accent, and task-oriented light sources with recessed spots, pendants, sconces, and lamps. I love to make a statement with an overhead light that produces a sculptural effect. Chandeliers are the obvious choice for formal rooms, but I've also used lanterns or several small pendants over tables. When I think back to particularly special meals and gatherings, I always recall the flicker of candlelight and the warm embrace of subtle lighting that turns everyday occasions into celebrations.

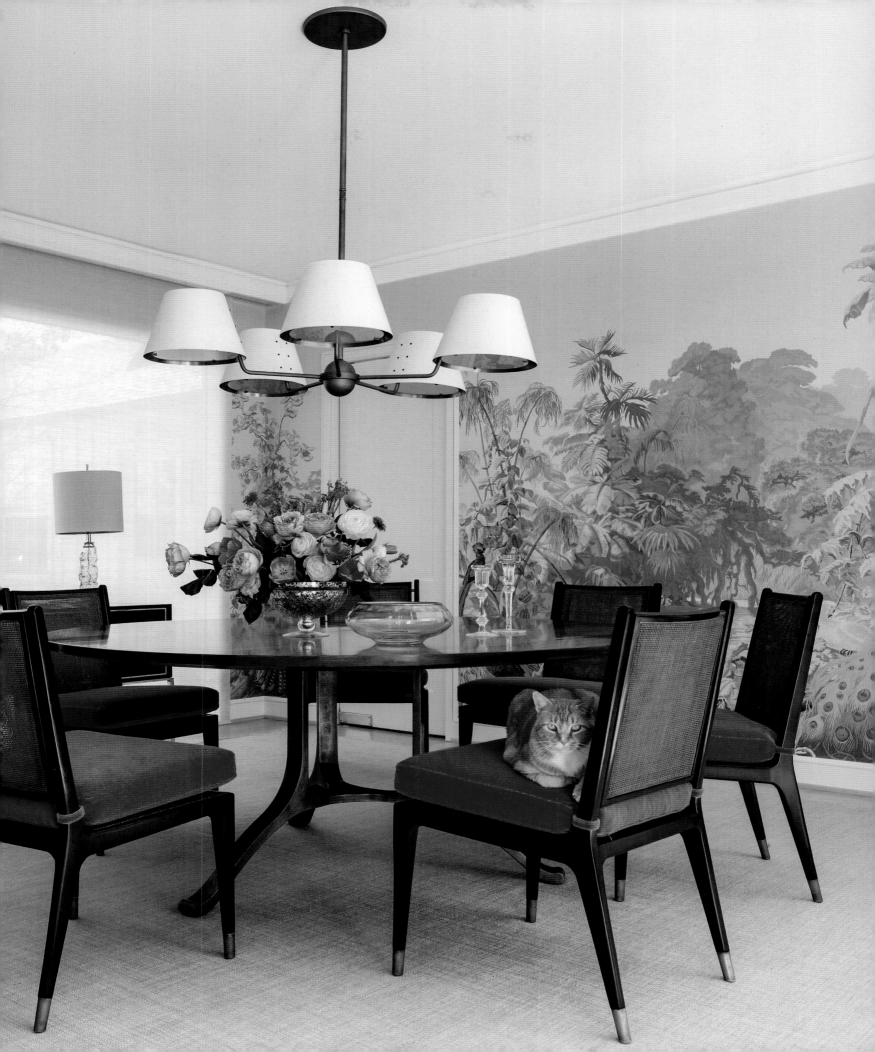

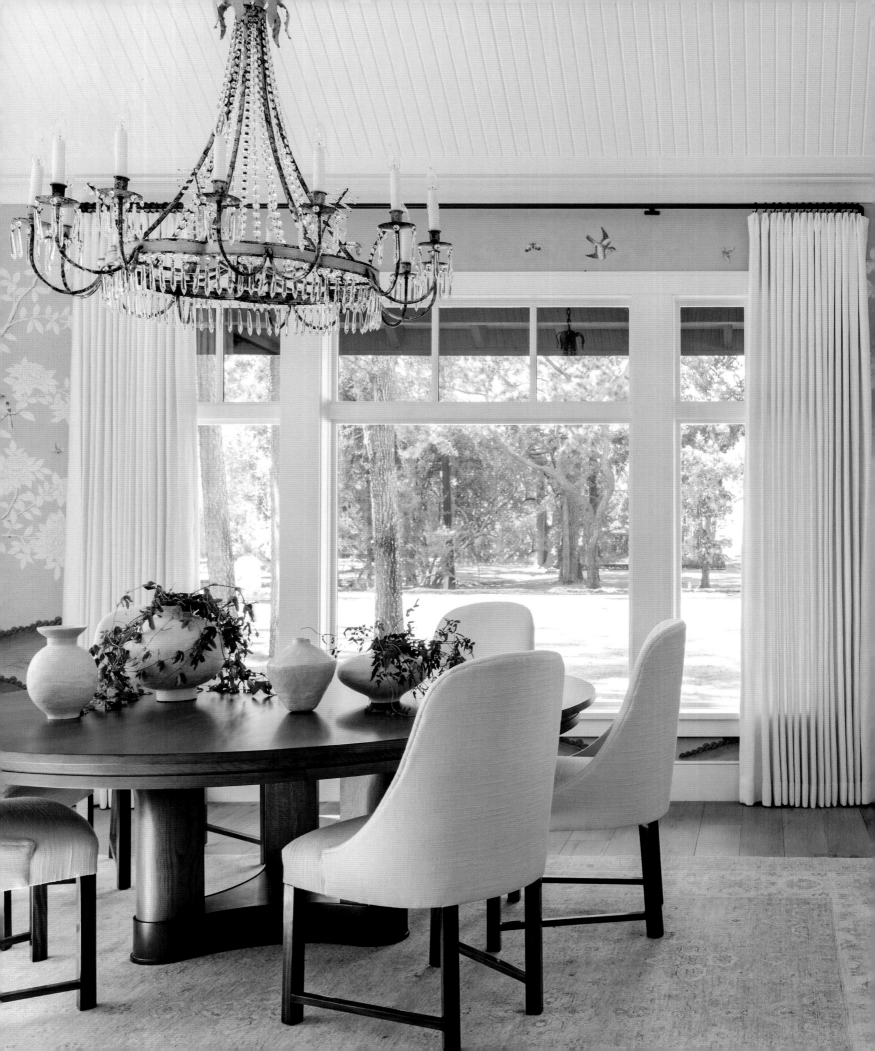

Symmetry lies at the heart of the dining room's composition

Axes that correspond to sight lines, such as windows, doorways, and fireplaces, establish order and direct the placement of furniture. Typically, the table should be arranged in the center of the dining room, leaving plenty of space for circulation. A minimum of four feet between the table and walls allows diners to sit back comfortably while providing space for others to walk behind them. If the room's decor includes a rug, it should extend at least three feet beyond the edge of the table to avoid tripping up chair legs.

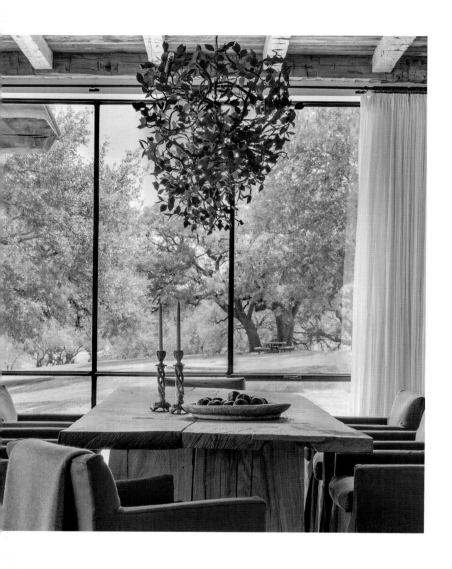

Full glazing equals full impact, so when there is an opportunity to turn a wall into a window, seize it

Tall windows make you feel as though you are outside, especially when the dividers are made of thin steel bands. In a more traditional home, a similar effect can be achieved by tall windows with divided lites. Translucent linen drapery filters light and produces a gentle feeling of enclosure at night.

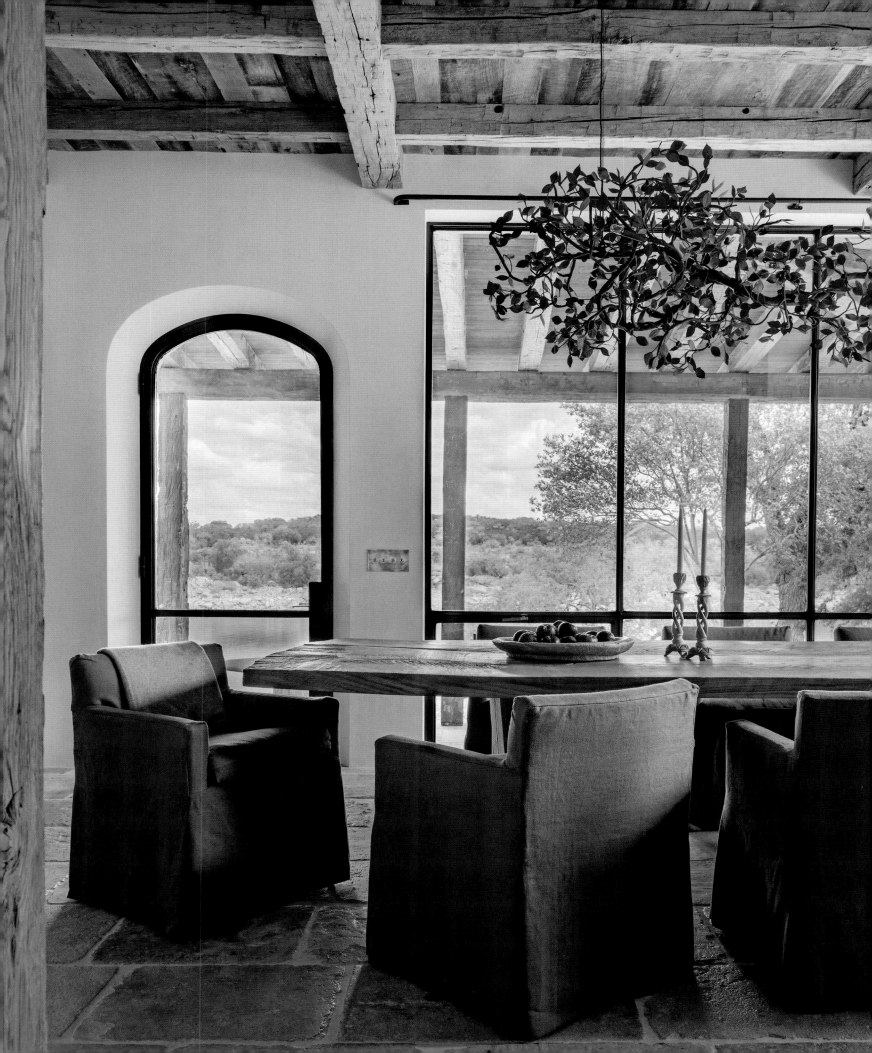

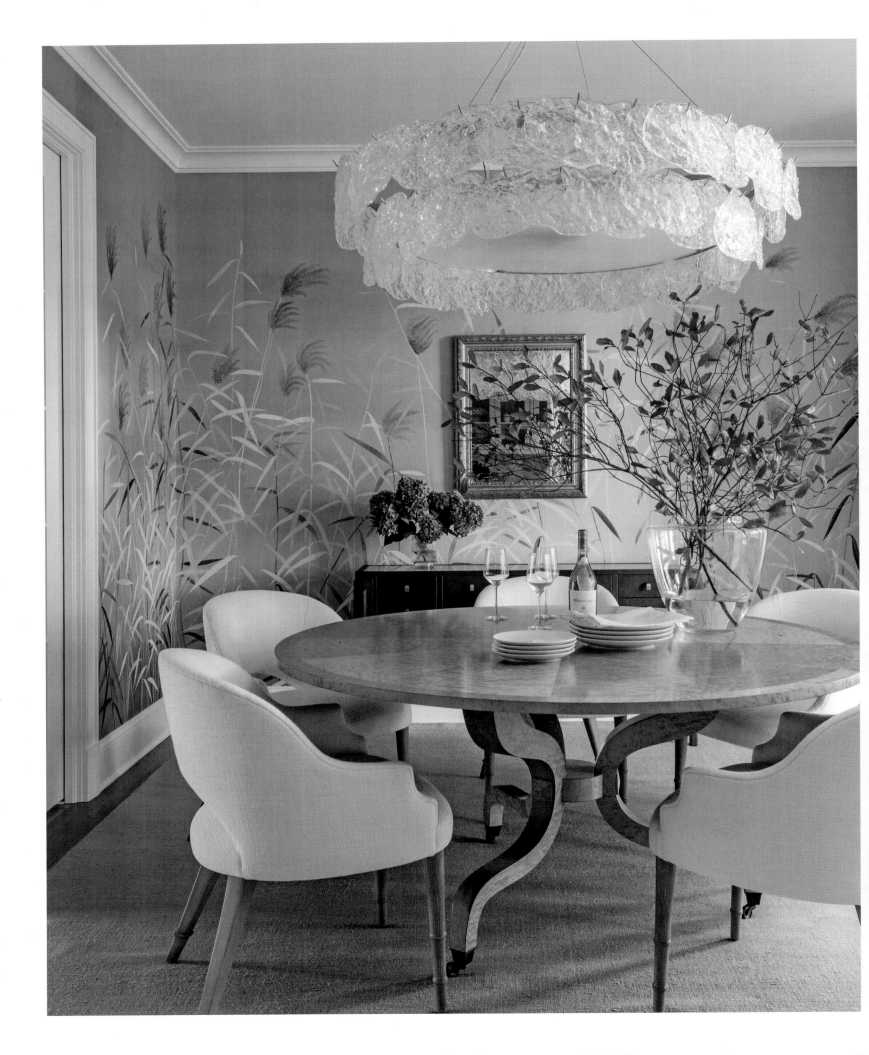

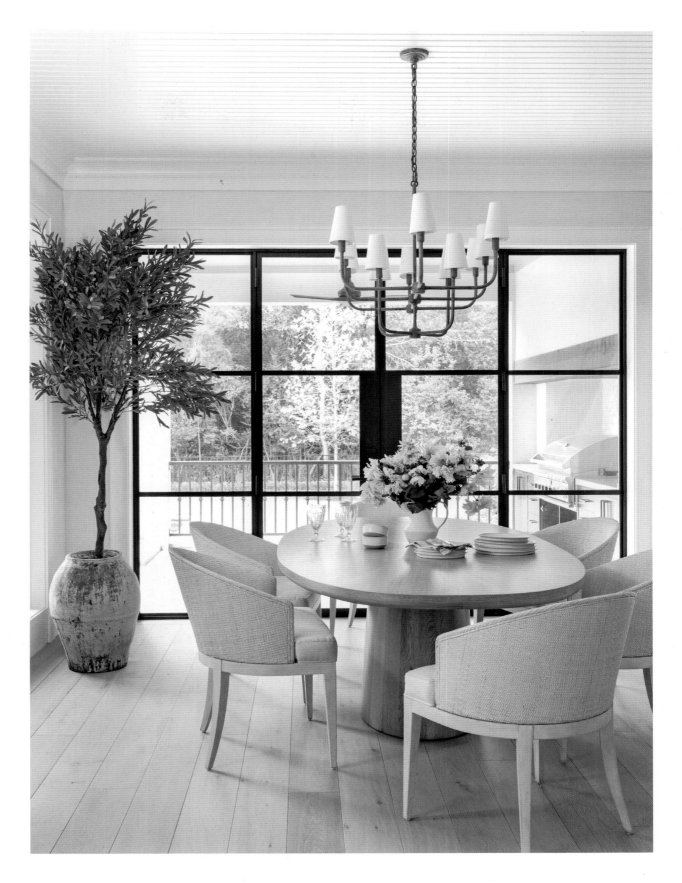

Dining rooms present the perfect invitation for statement lighting

An elegant crystal chandelier is a favorite choice, but unexpected designs can energize a space. To select the right diameter for an overhead fixture, add the dimensions of the overall length and width of the room together, then translate feet into inches. This formula works for any dining room but can be adjusted for dramatic effect.

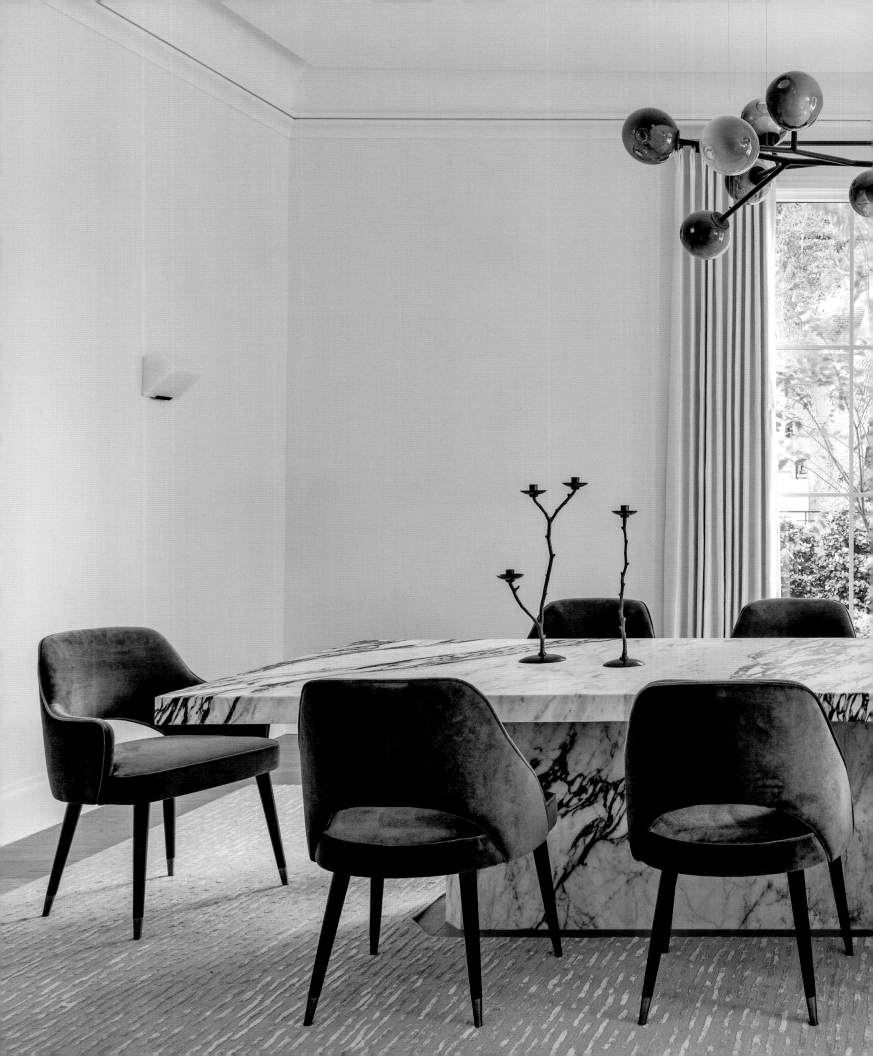

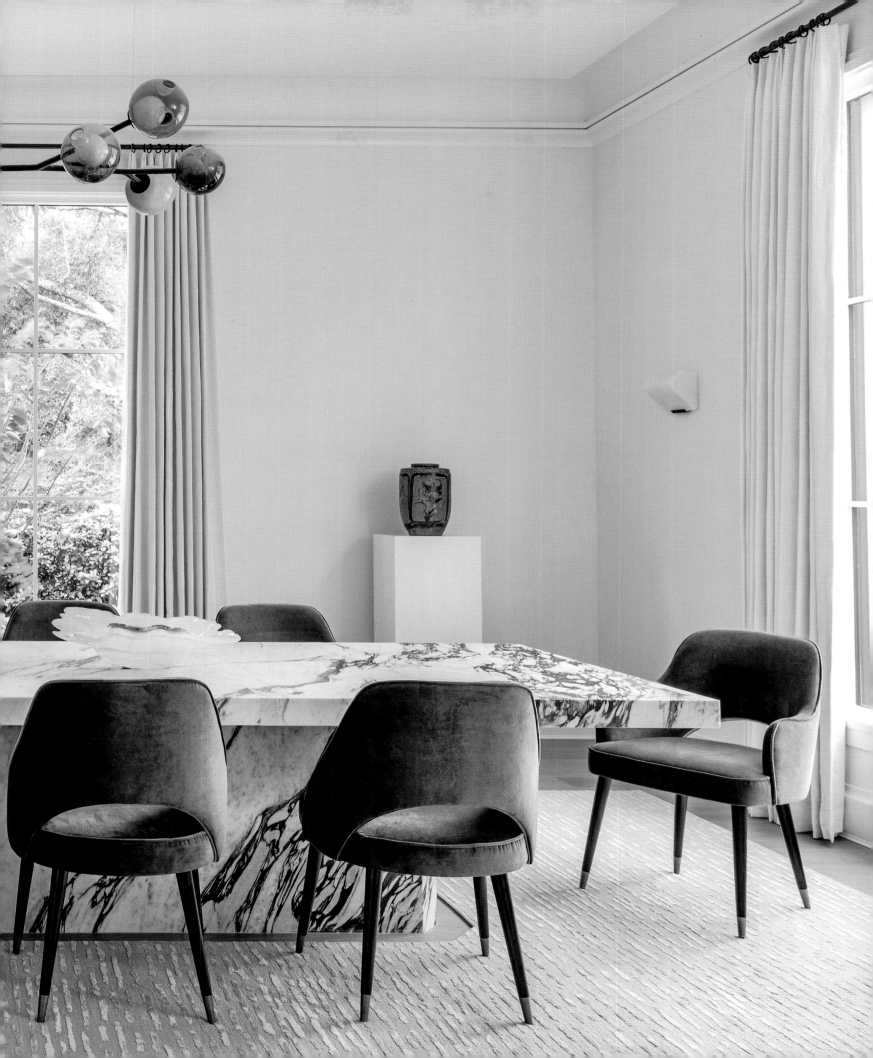

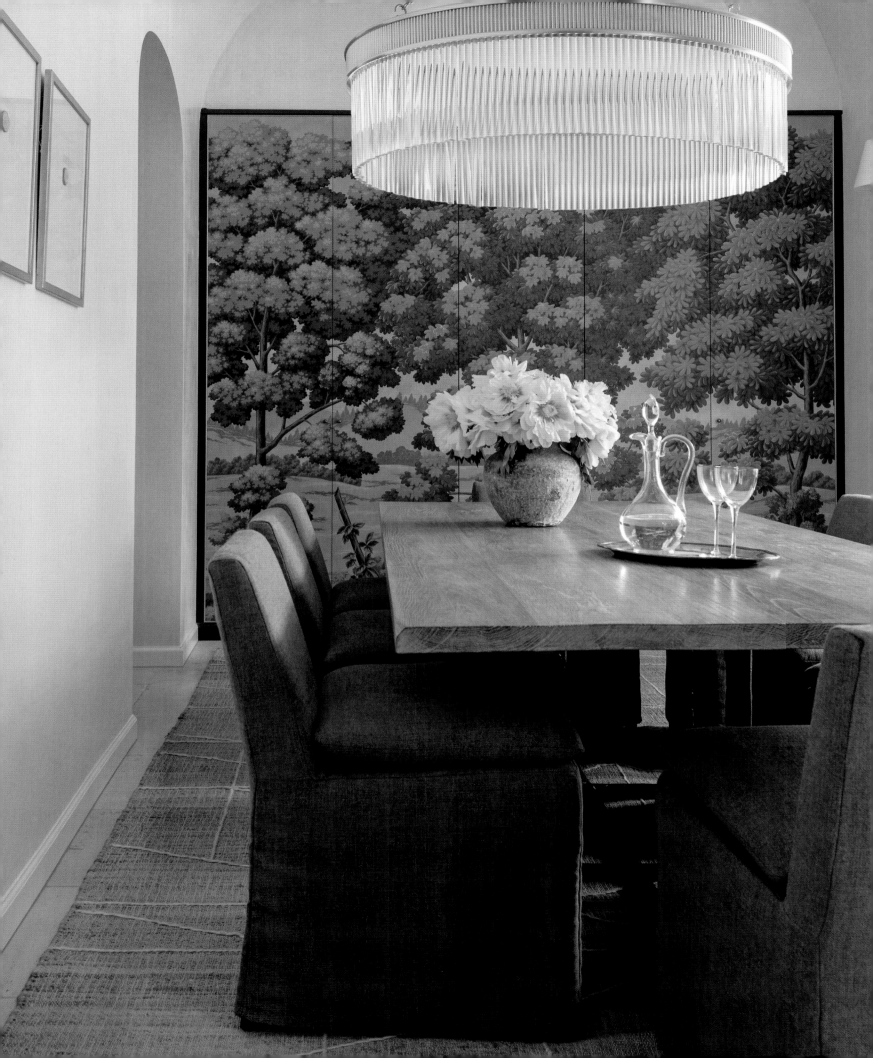

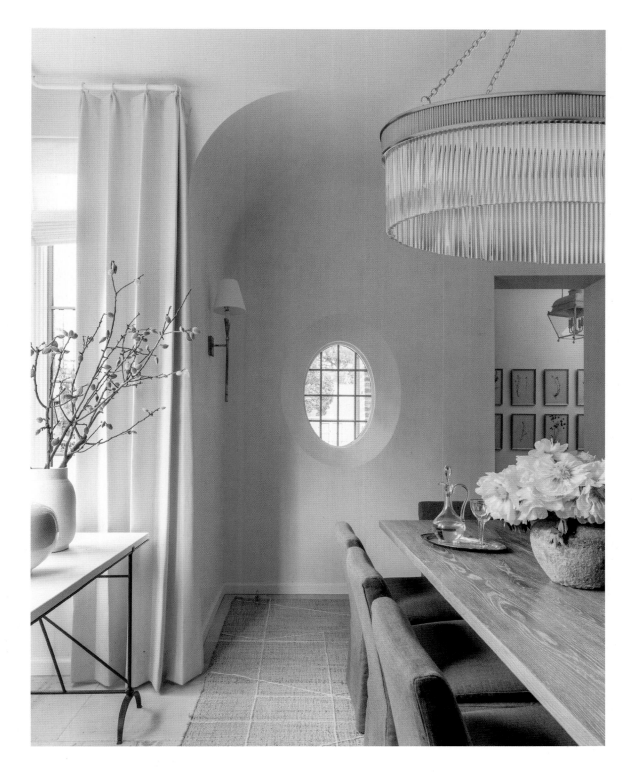

A richly textured environment enhances the dining experience

Don't be afraid to combine refined materials like crystal, gilt, and silver with organic ones. Reflective finishes that sparkle and glow elevate the moment of gathering around the table. The earthy textures of highly grained wood, woven jute rugs, and hand-applied plaster invite us to bend the rules of formality and relax.

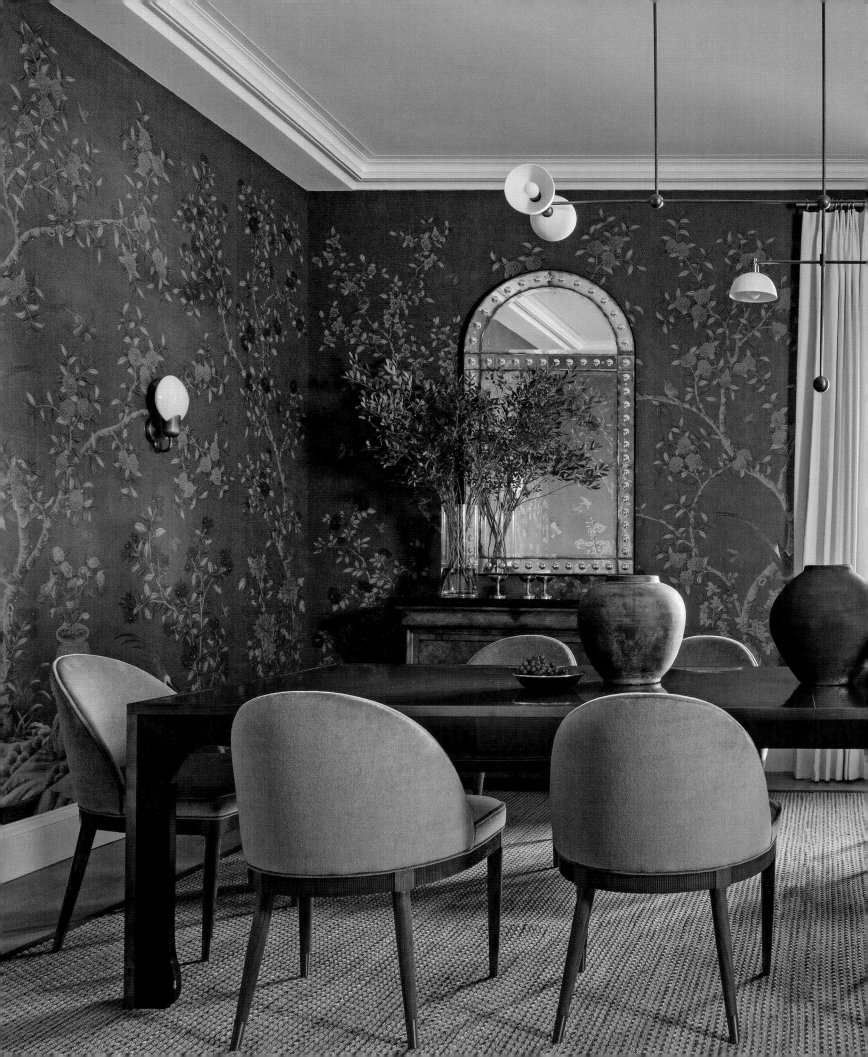

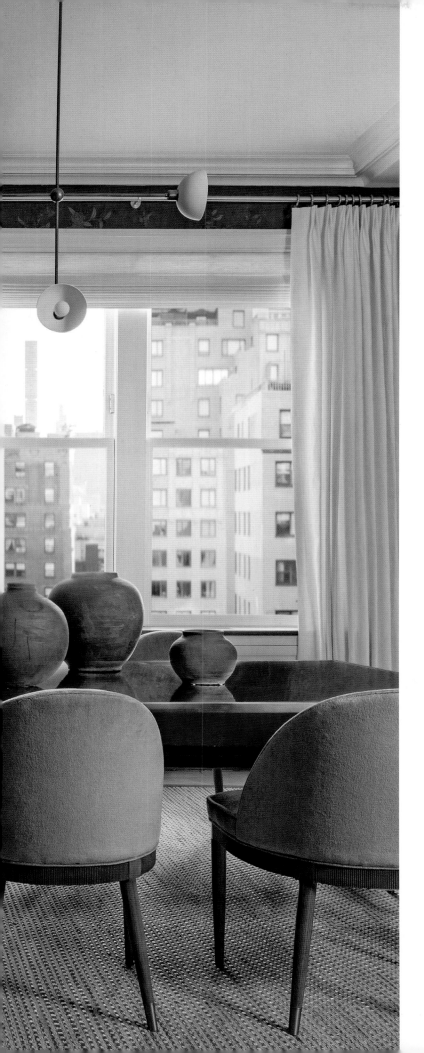

Moody wall colors conjure a magical environment

Instead of highlighting a view outside the window, you can create one indoors with wallpaper featuring overscale patterns or scenes drawn from nature. When the wall coverings and moldings in a room are traditional, I sometimes create intentional contrast with modern furniture and lighting to prevent the room from feeling overly conventional.

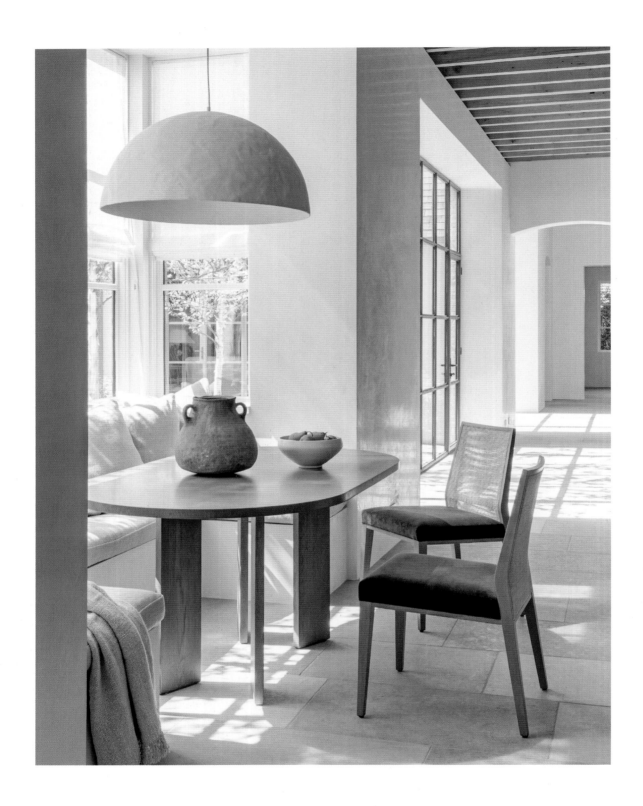

A bay window is the perfect place to tuck an informal dining area within a large room. Just like dedicated dining rooms, these nooks require nuanced illumination, with windows for natural light, curtains or shades for filtering, and sconces or sculptural overhead fixtures that brighten the area and enhance its appeal.

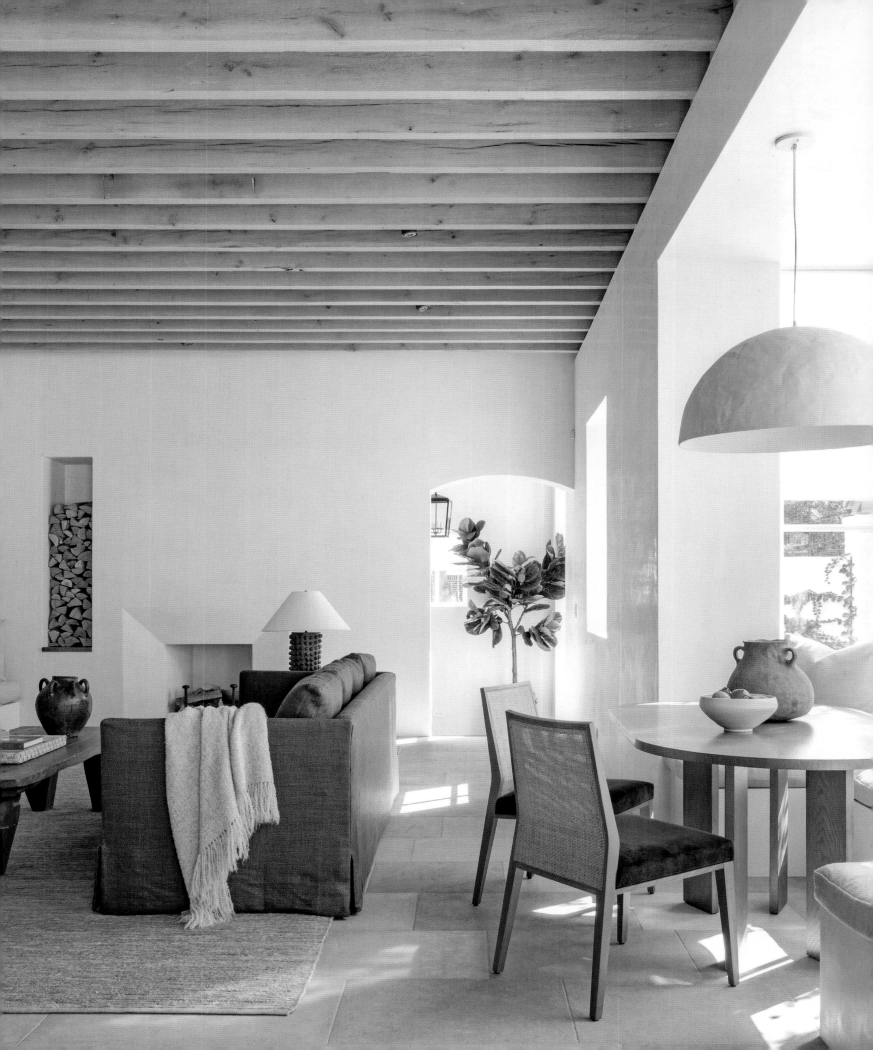

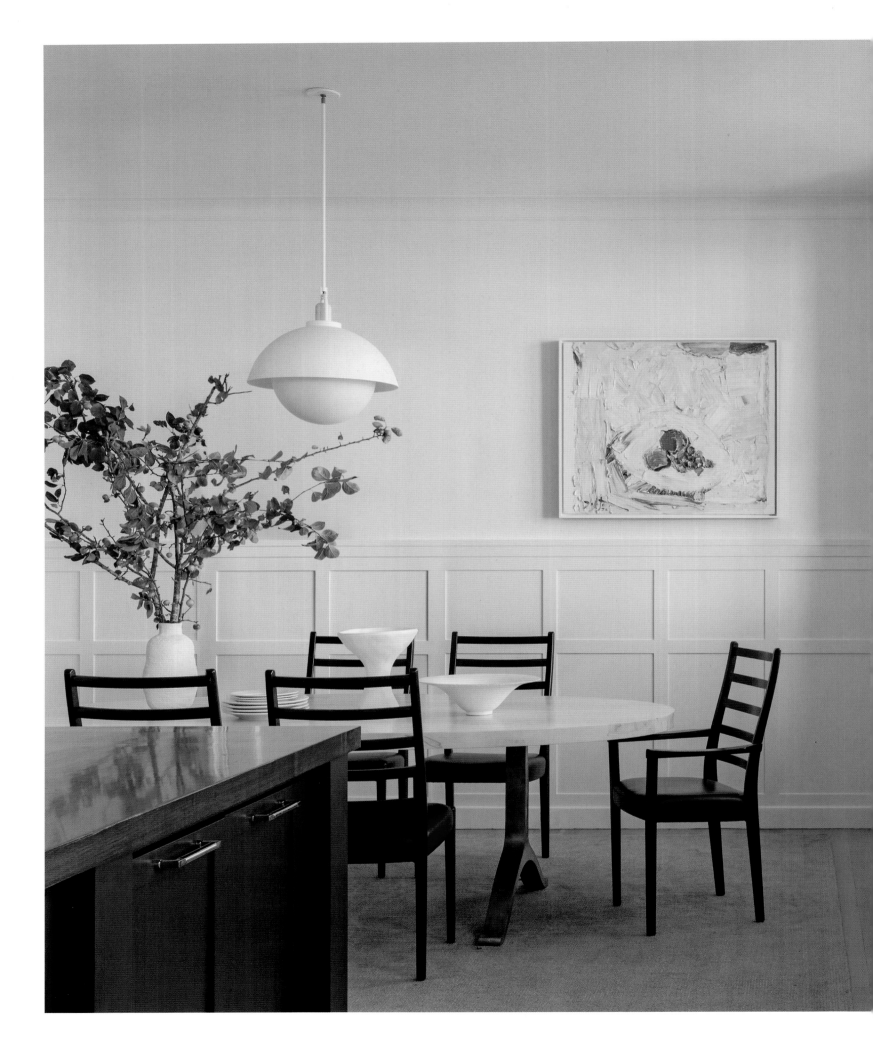

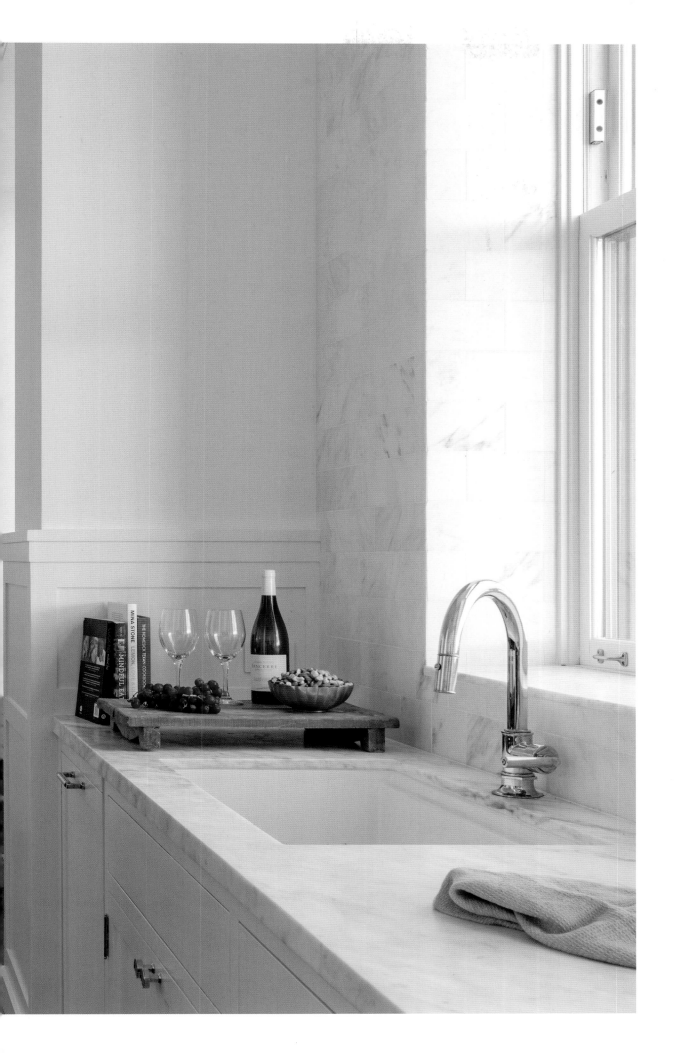

Breakfast nooks are typically adjacent to kitchens, but I like to give them a separate identity with paneling, a distinctive light fixture, or a piece of art. I sometimes omit rugs because of all the traffic, but stain-resistant fibers make them an option to further define the zone as a place apart.

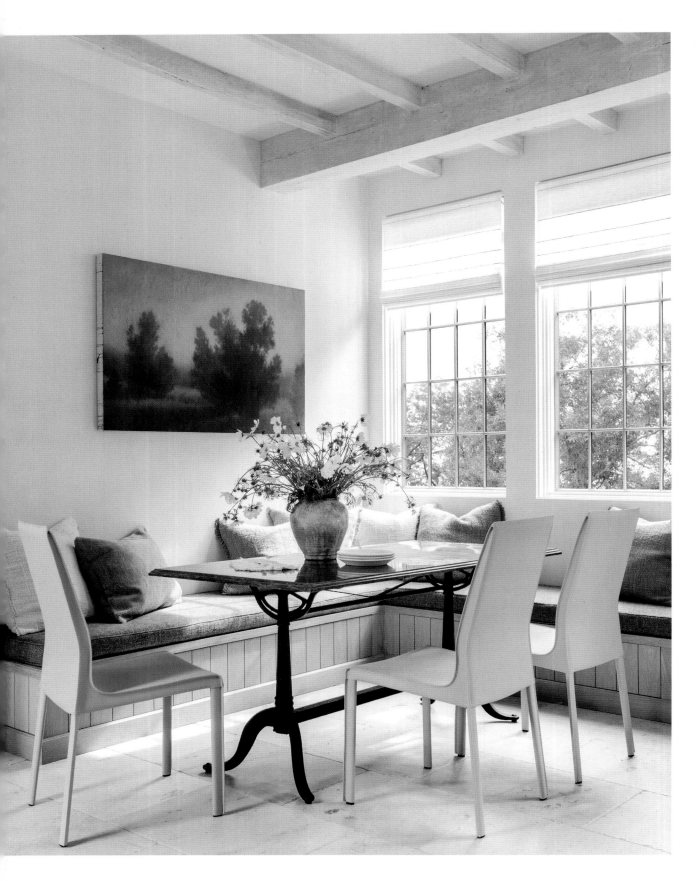

For breakfast nooks tucked into spaces where too many chairs would crowd the table, banquettes prove an excellent choice. Materials that withstand daily wear and tear like bluestone or hand-planed wood for tabletops, stain-resistant upholstery, and leather, both real and faux, combine practicality with style.

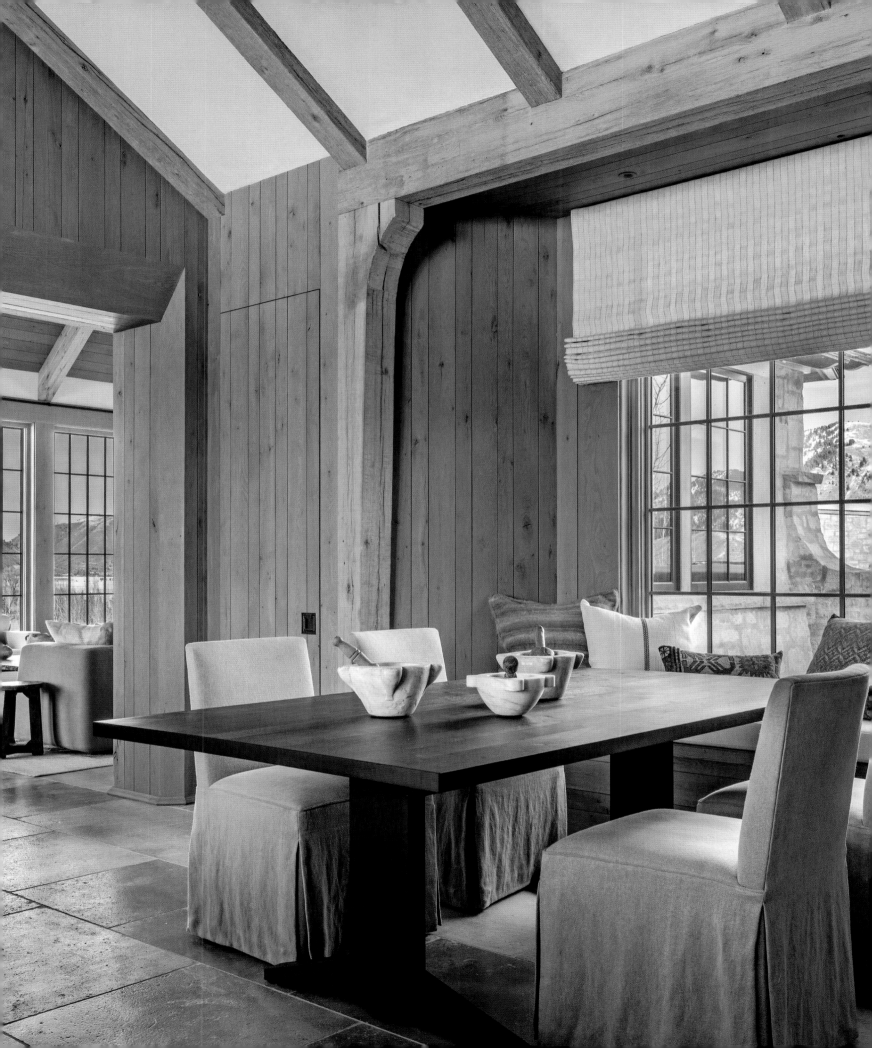

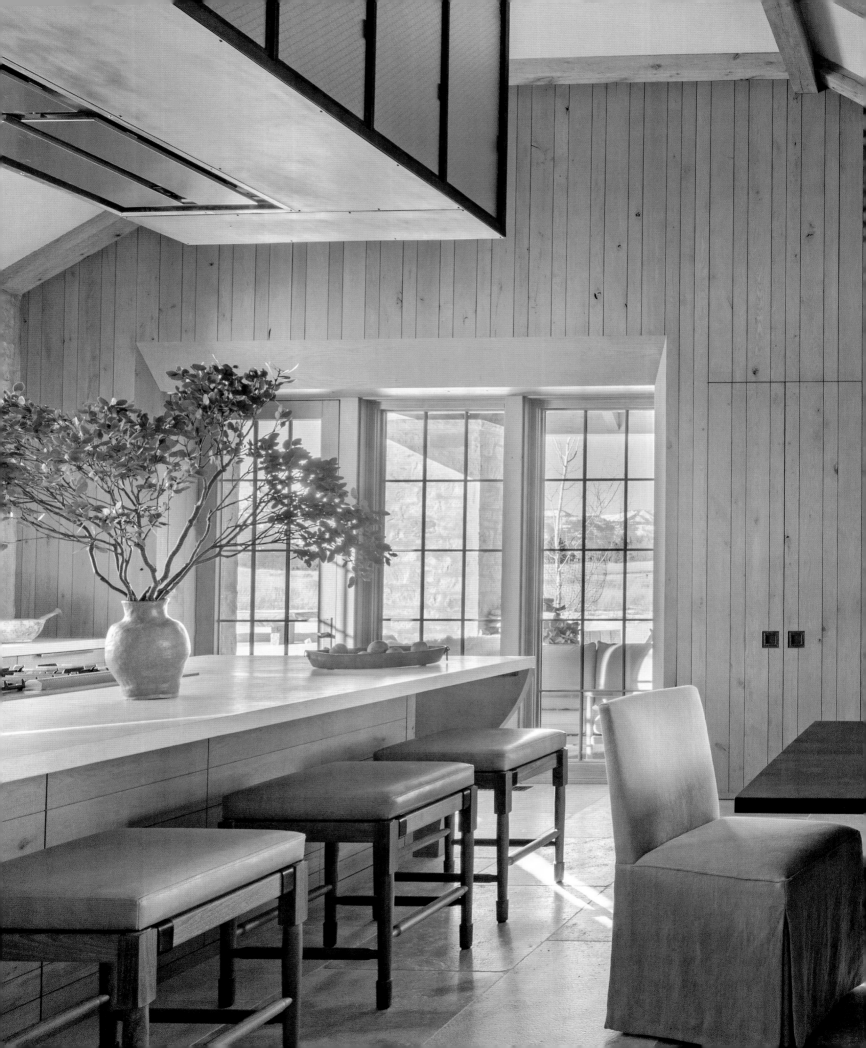

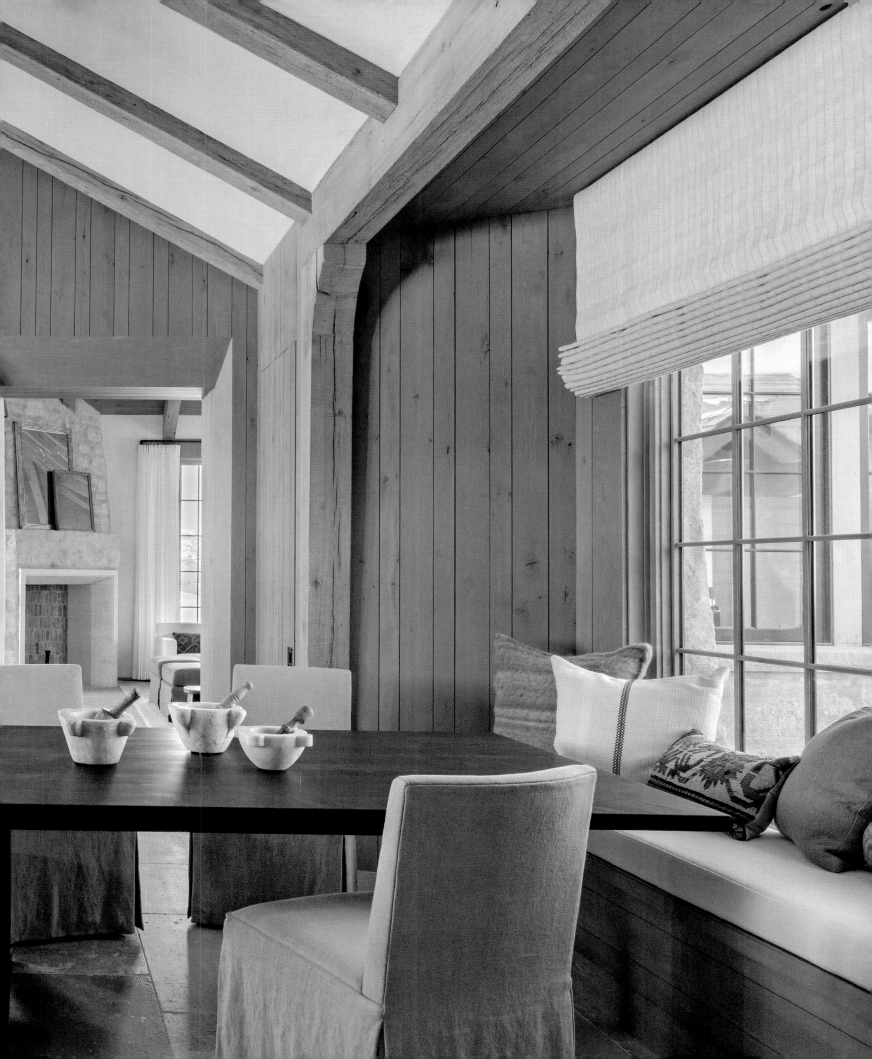

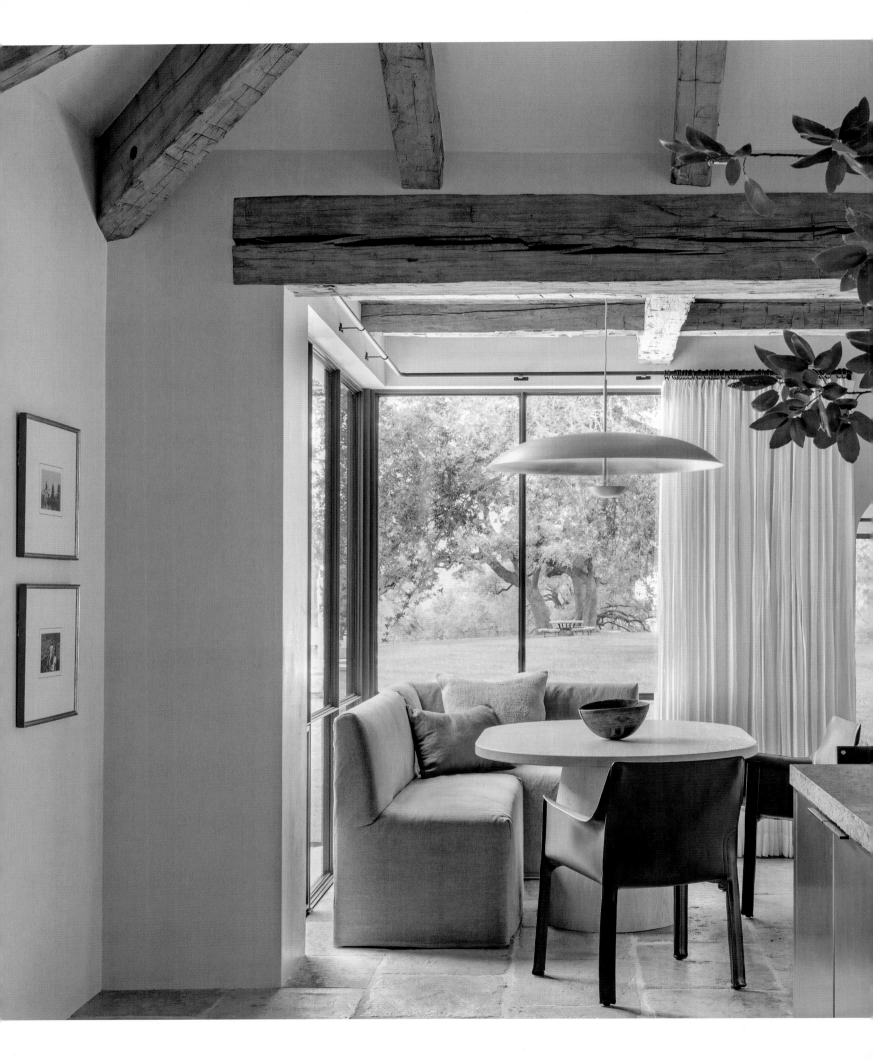

When arranging the elements of a breakfast nook adjoining a kitchen, consider the two spaces as a whole

If the table is not aligned with the central axis of the kitchen, it can be treated as a focal point that complements the overall composition. Hanging a well-proportioned pendant light above the table accentuates it as a destination. I like to position a bench or banquette next to windows if possible. Whoever sits there is wrapped in light and surrounded by nature.

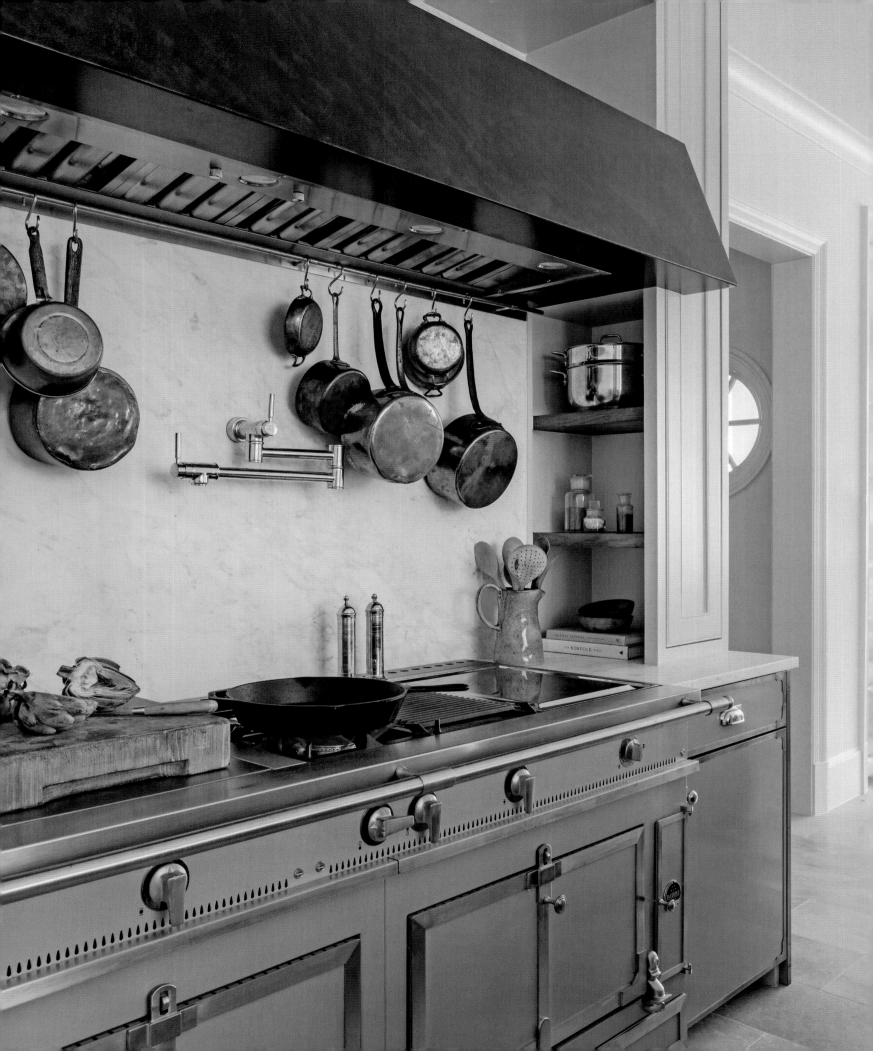

Serve

Kitchens that combine beauty with function elevate
daily chores from tasks to pleasures.

Service is the spirit of the kitchen. This is where humble, everyday tasks are selflessly performed to contribute to the well-being of others. Acts like making dinner together, doing the dishes, or helping a child with homework are gestures of appreciation and affirmation that strengthen bonds between loved ones. Cooking itself can be a therapeutic form of creative expression and a meditative practice that connects us to nature and humanity. The kitchen is a social nexus that fosters meaningful experiences among family and friends in a casual setting. It also holds tremendous potential for aesthetic expression that can transform a utilitarian space into one that elevates daily living and enhances the home overall.

A homeowner renowned for culinary prowess and gracious hosting inspired the design of the kitchen in a house surrounded by the rugged landscape of a Texas horse farm. Rustic wood ceiling beams, a floor of reclaimed limestone, and hand-planed oak cabinets formed a textured mix of organic materials into which we introduced a contemporary steel-clad island. Three-inch-thick countertops of reclaimed bluestone boasting a chiseled edge combined style with resilience. We deliberately crafted dedicated areas to accommodate the chef at work, gatherings of friends, and places to make a cup of coffee or pour a glass of wine.

The composition of kitchens should ease the functions that take place there, with just a few steps required to travel between primary task zones. Clear pathways between the sink, stove, and refrigerator—optimally four feet wide—are essential for access and circulation by more than one person. I usually integrate major appliances into perimeter cabinetry and the island, letting the stove and hood steal the show. The kitchen's identity as a space for casual entertaining has created an appetite for an appearance nearly as decorated and furnished as the rest of the house. Pantries, back kitchens, and sculleries with additional storage and counter space help keep the primary kitchen's countertops clear.

Choice of cabinetry material and profile vastly impacts the expression of a kitchen. I often choose oak because of its versatility and beautiful grain, but I also use walnut, maple, and occasionally burled wood for character. When cabinetry is painted, color is important. While neutrals allow other design elements to take the spotlight, saturated shades of green, blue, and blush uplift the energy of the room. Although it may seem a small detail, cabinetry hardware should never be overlooked, as it helps personalize the space and introduce new finishes. I often select warm tones for hardware and light fixtures in a kitchen where stainless steel abounds to balance the composition.

Countertops and backsplashes make a strong impression. Marble, leathered quartzite, and concrete introduce color, reflection, and movement. I also love limestone, granite, bluestone, and plaster for their durability and natural beauty. Extending countertop material up the walls as a backsplash creates a unified appearance and heightens the drama of elaborately veined stone. However, I also welcome a change in material from the horizontal surface of the counter to the vertical plane of the backsplash—stainless steel for a commercial look, brass for a warm patina, or hand-molded tiles for an infusion of texture and color.

The kitchen doesn't require a lot of furniture, but there are ways to give the room a furnished effect. An island with turned legs resembles an antique apothecary table. A glass-fronted cabinet looks like a freestanding hutch. Cut-out foot details and applied baseboards lend cabinets the appearance of stand-alone pieces. The likeliest place to find mobile furniture in the kitchen is around the island, where chairs and stools can introduce woven, organic material or textiles that mitigate the space's intrinsically hard surfaces. Because the kitchen is the heart of the home where physical nourishment, daily family life, and communion with friends take place, you must consider efficiency, comfort, and beauty equally in every design decision you make.

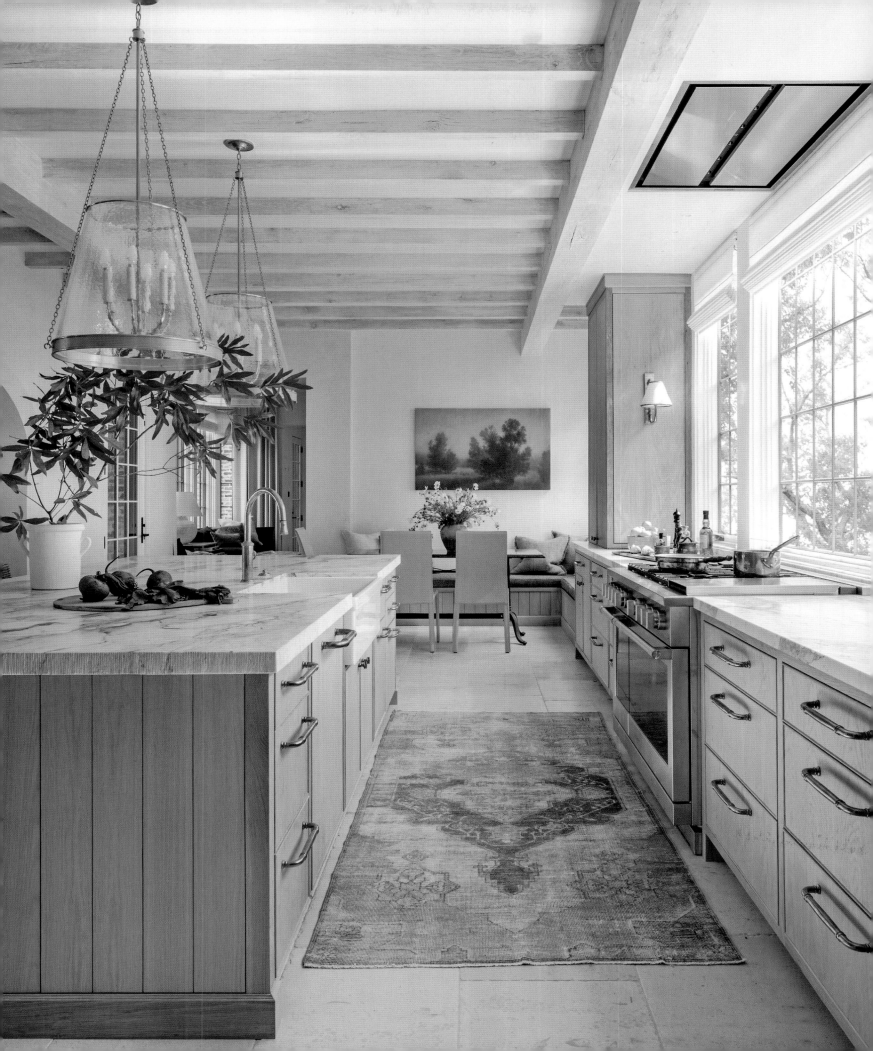

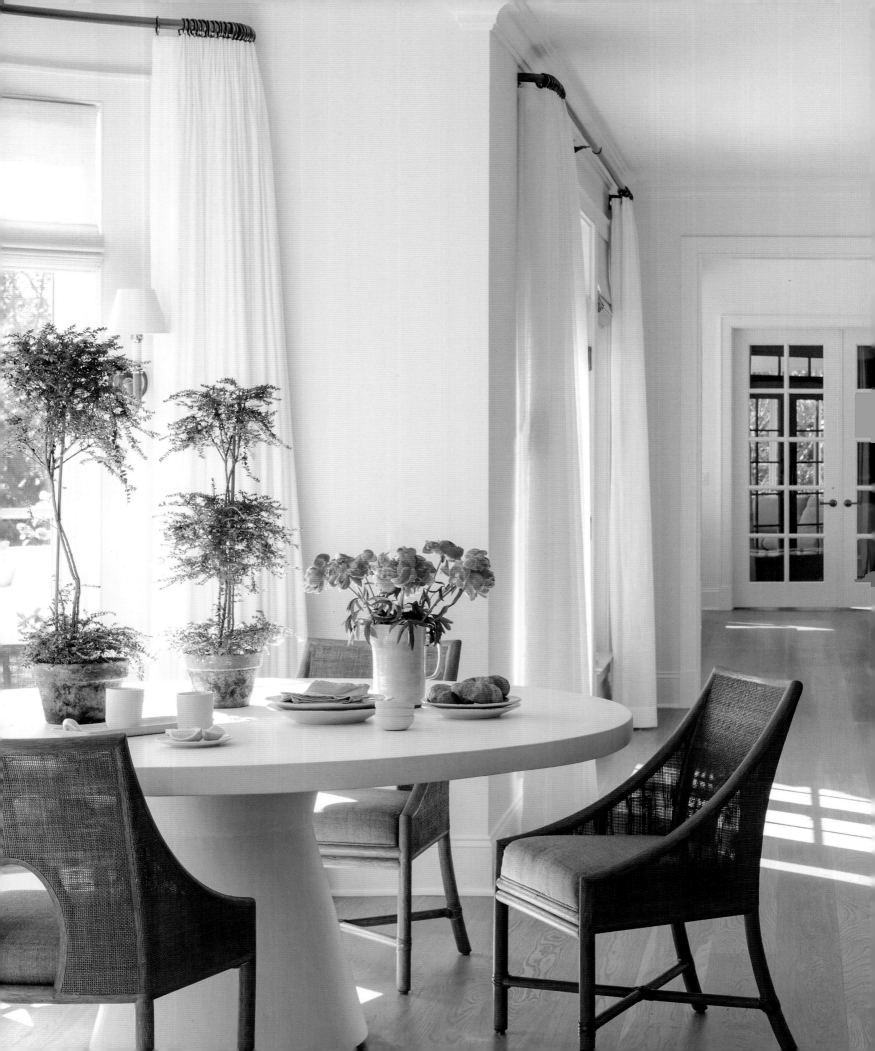

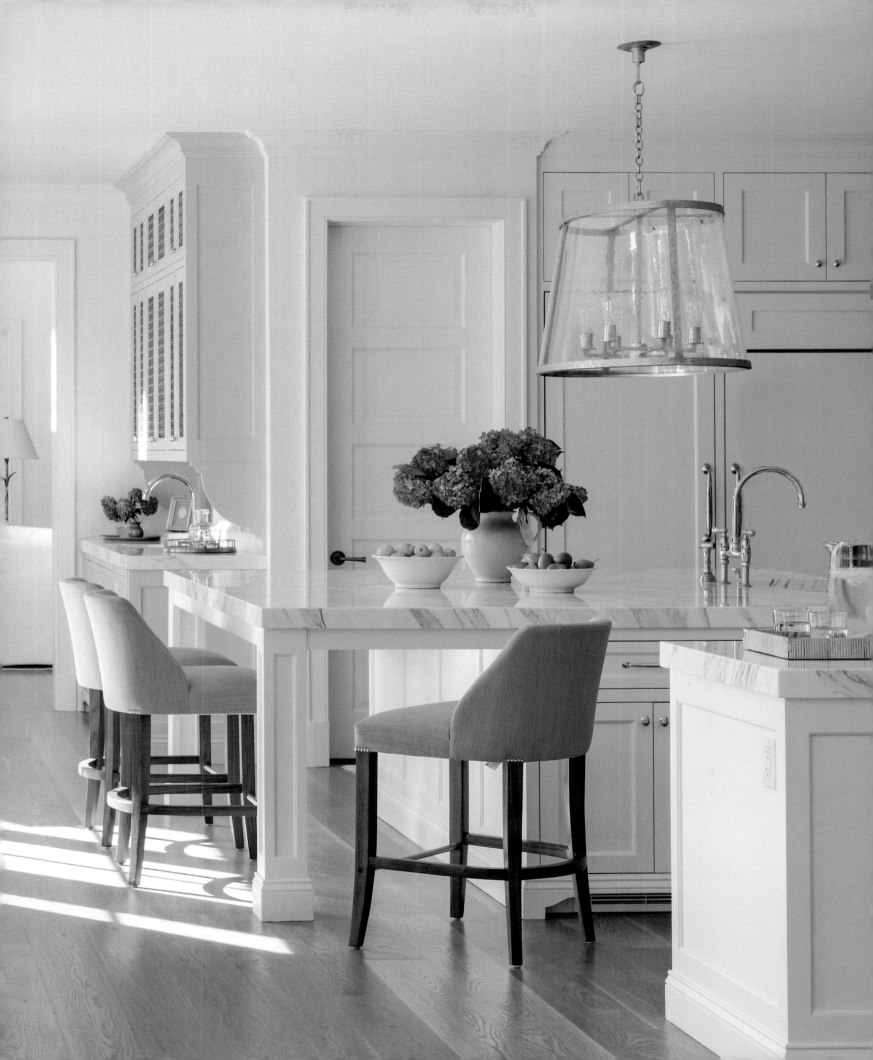

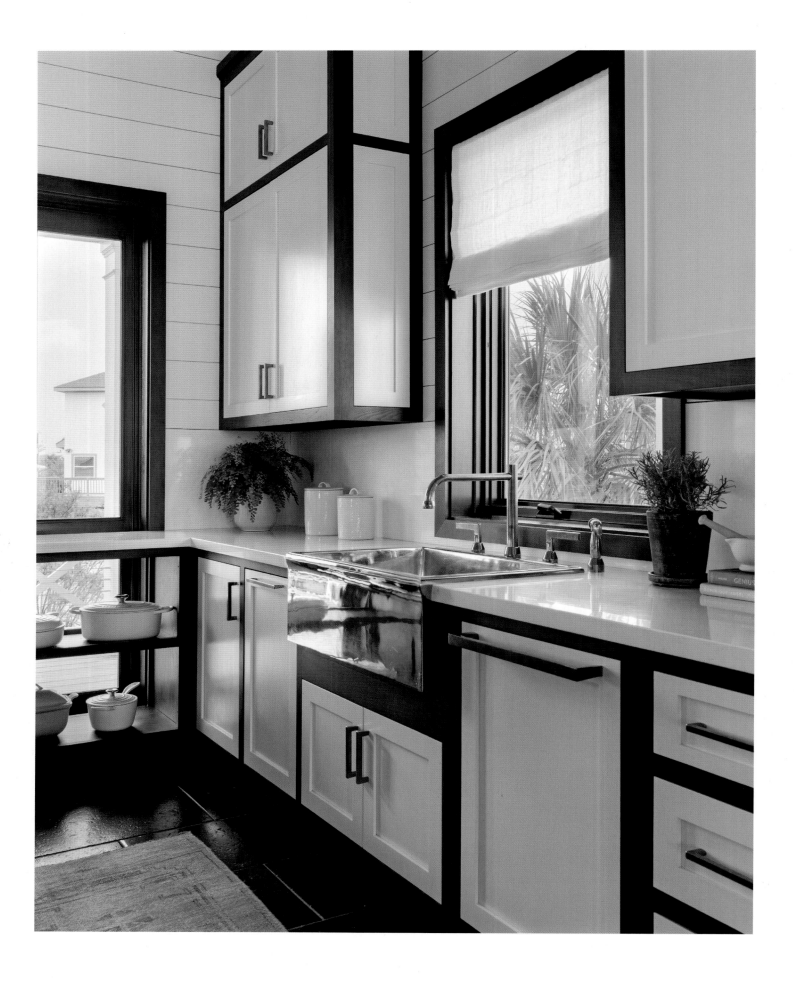

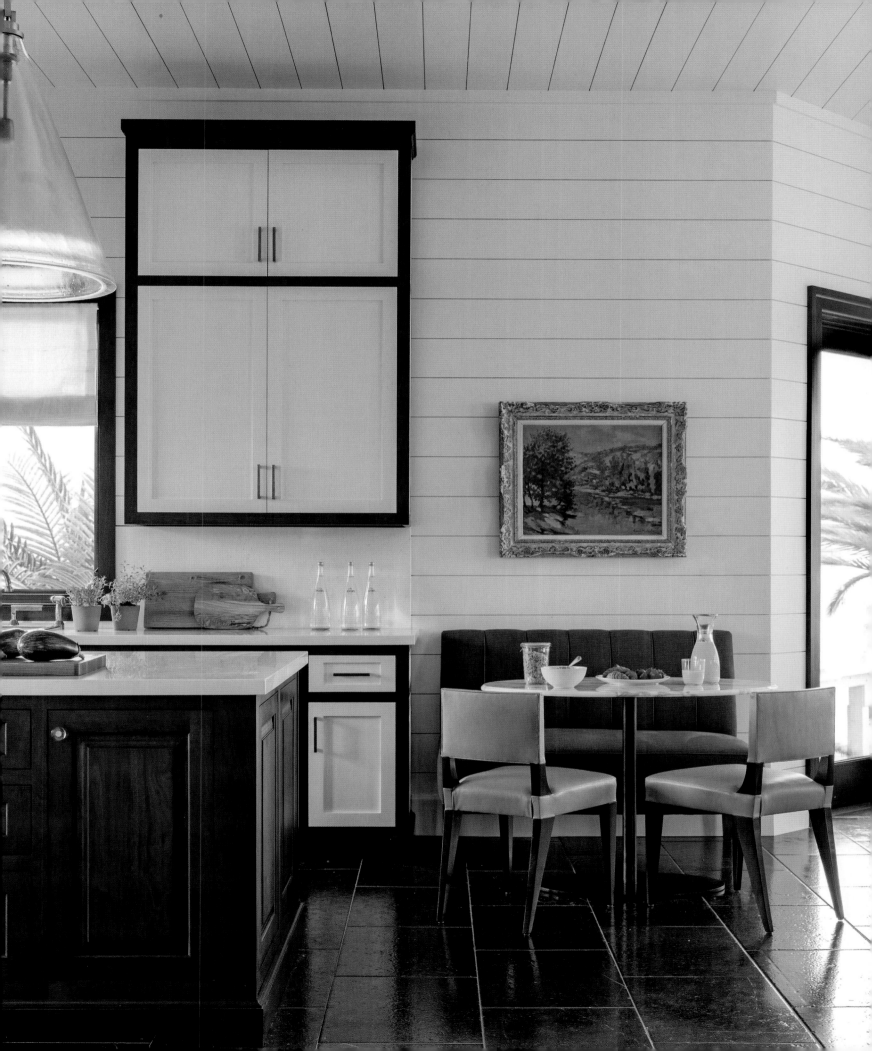

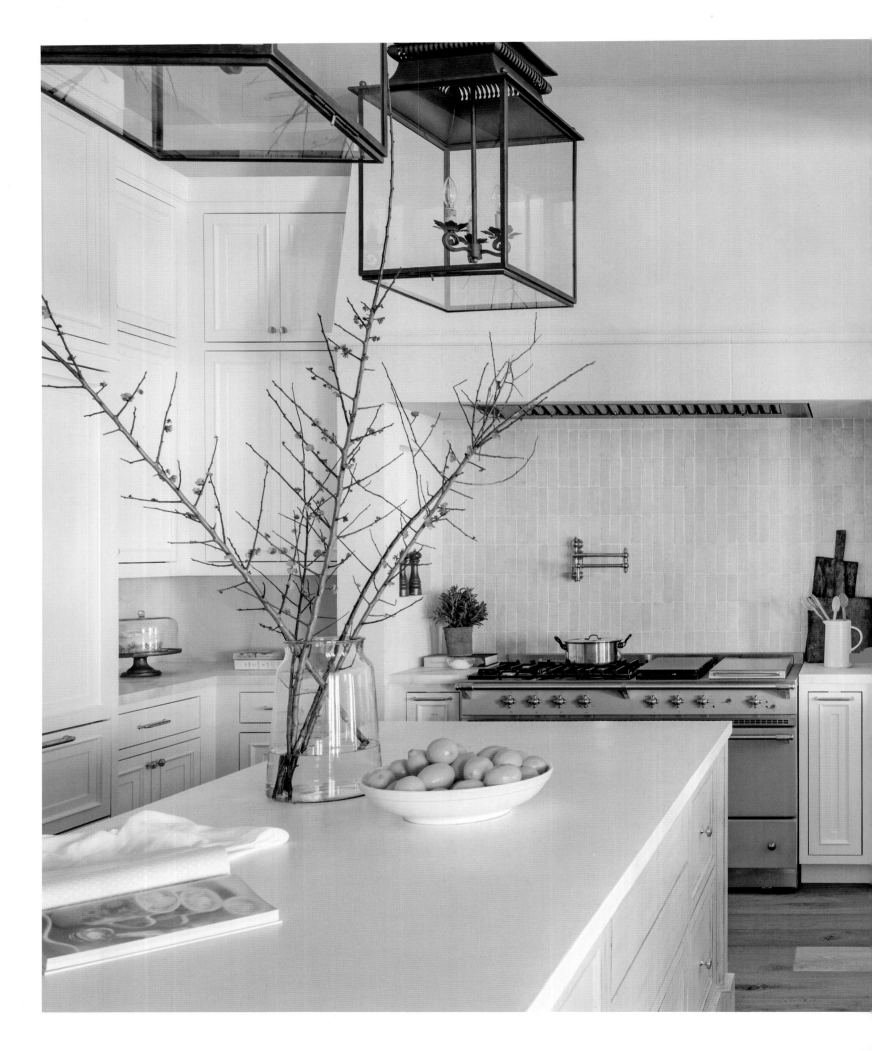

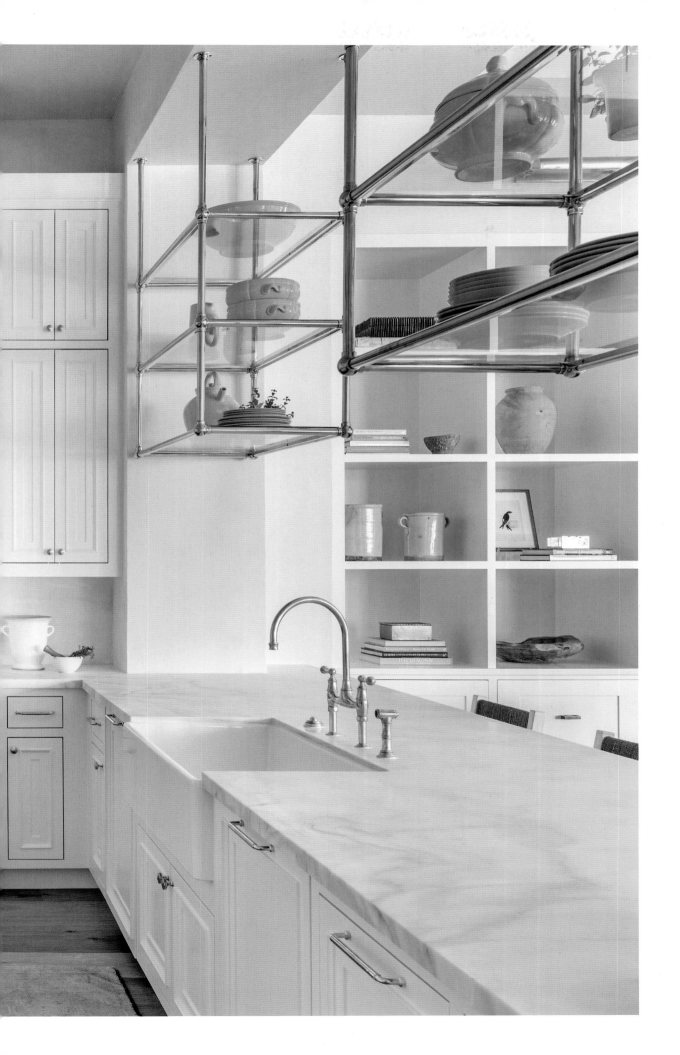

Metallic highlights animate kitchens with a monochrome palette. When white or cool shades of blue and green prevail, I introduce warm tones through metals like brass and bronze in plumbing, hardware, and decorative light fixtures. In one kitchen, I designed hanging shelves of brass and glass to display frequently used plates, serving bowls, and tureens.

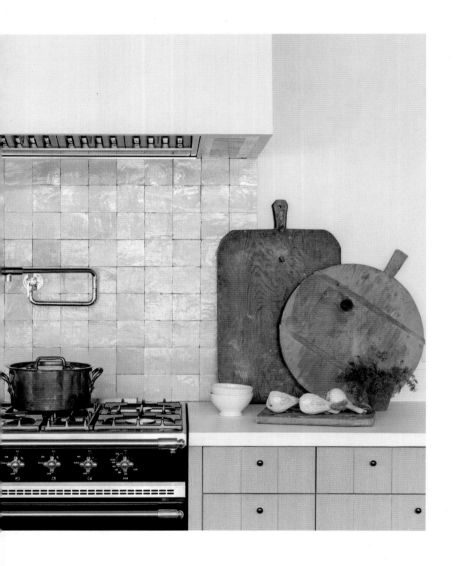

The hood makes a powerful first impression

Consider the placement of the hood first because it is so often the visual focus of the kitchen. A plaster hood forms a strong, yet subtle sculptural impression. For drama, I prefer limestone, marble, or metal accented by contrasting brass trim. For a cohesive, traditional look, I have integrated hoods of stained or painted wood seamlessly into the surrounding paneling.

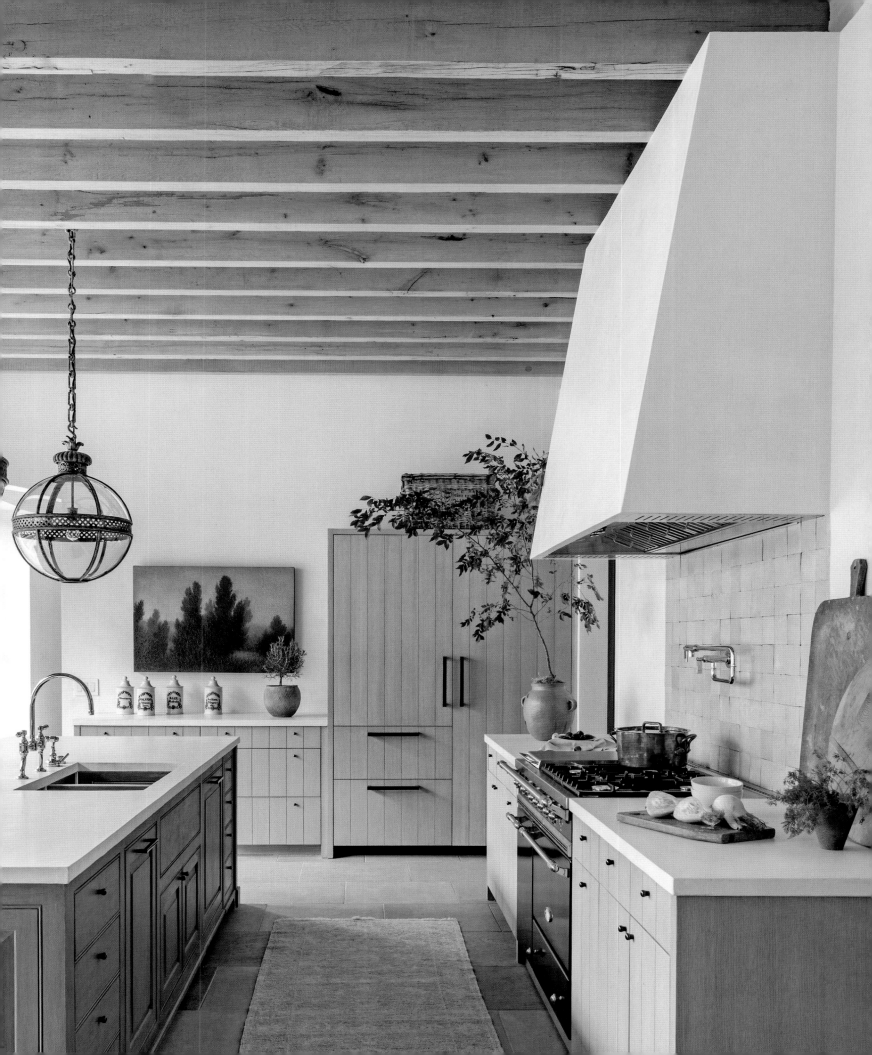

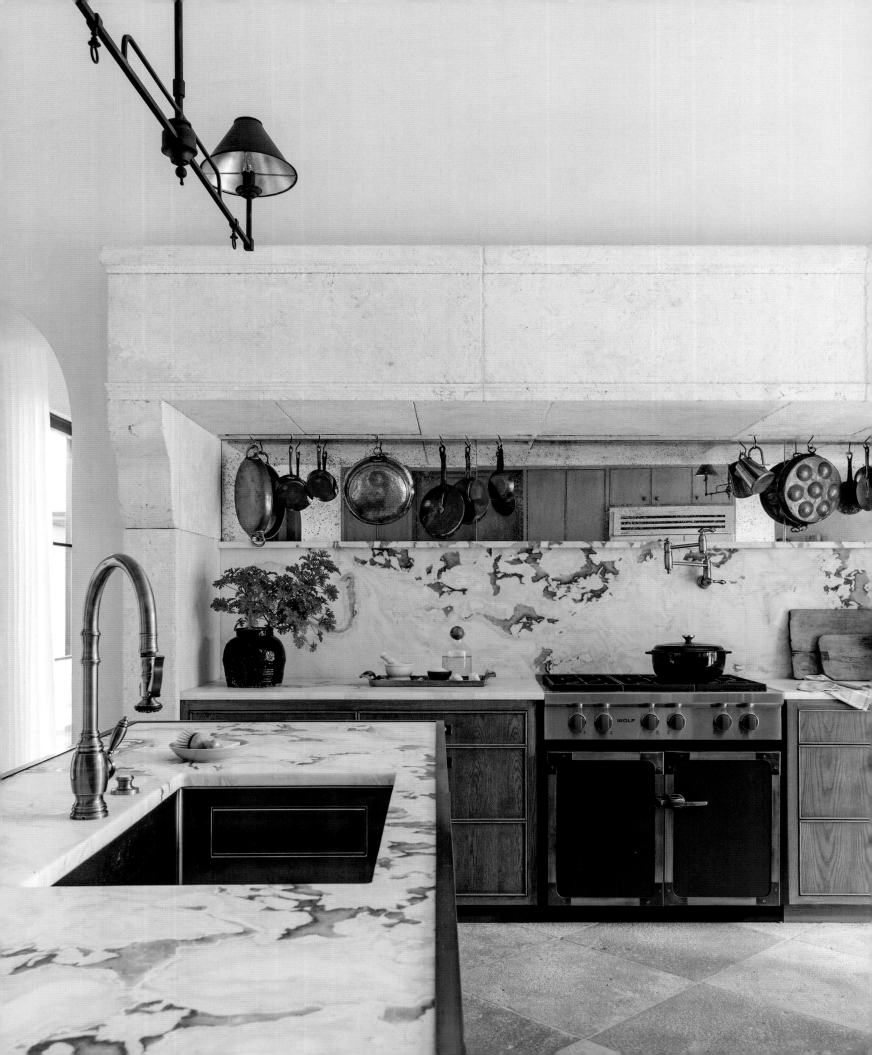

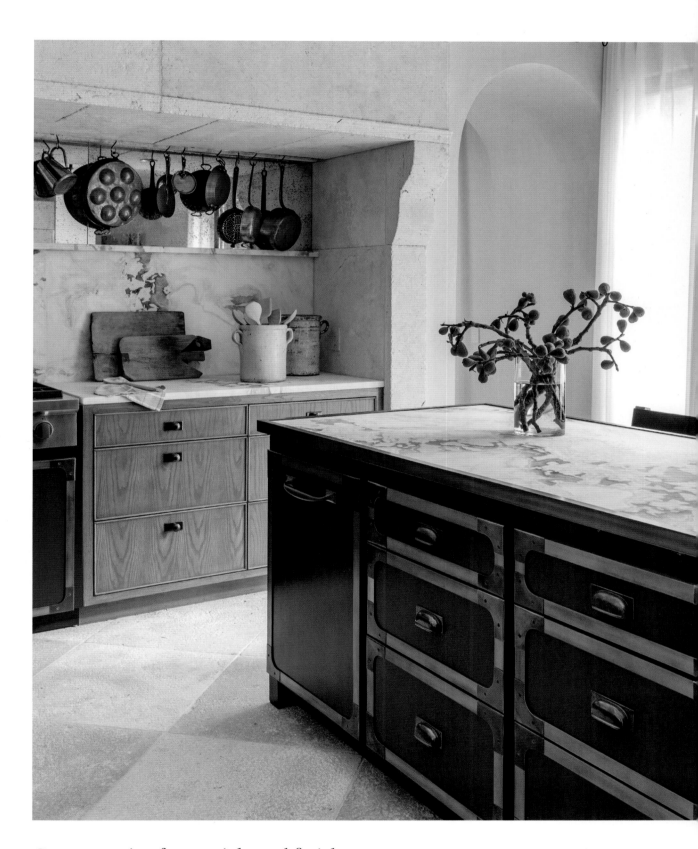

Curate a mix of materials and finishes for a deeply textured environment

Don't hesitate to combine polished marble countertops with tumbled limestone floors or juxtapose bright metal highlights with subtle wood finishes.

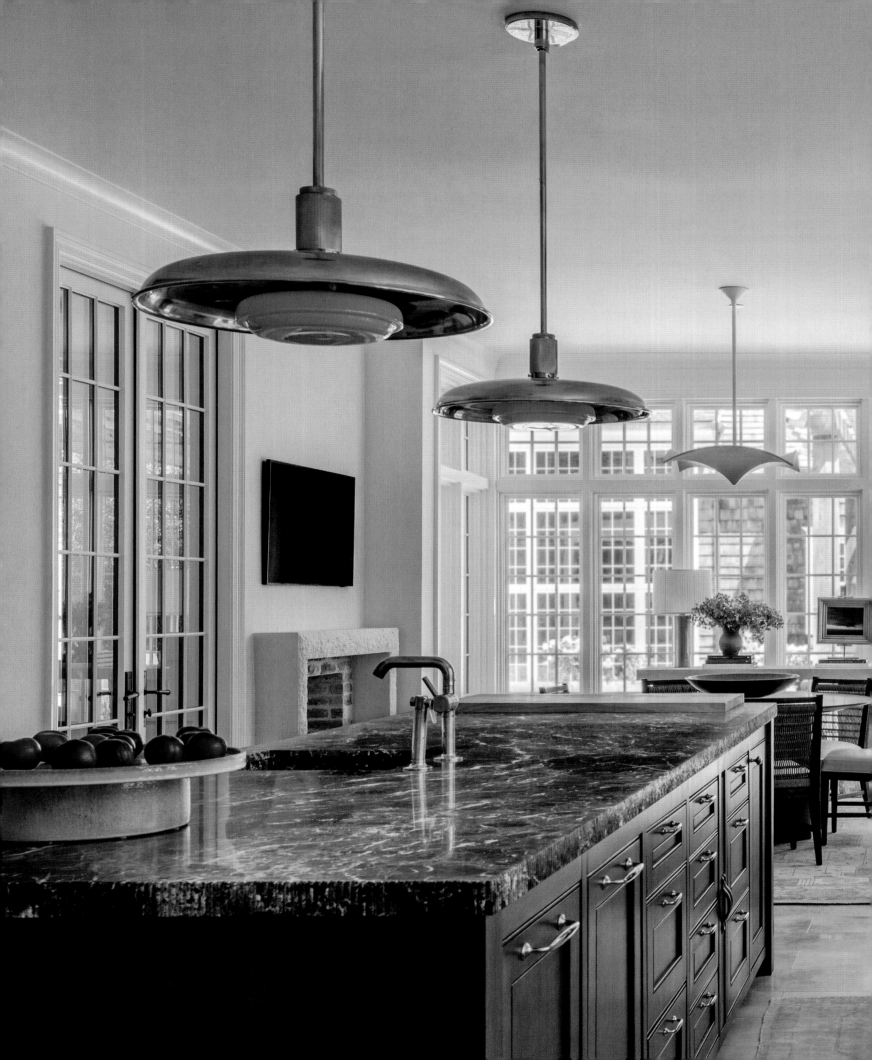

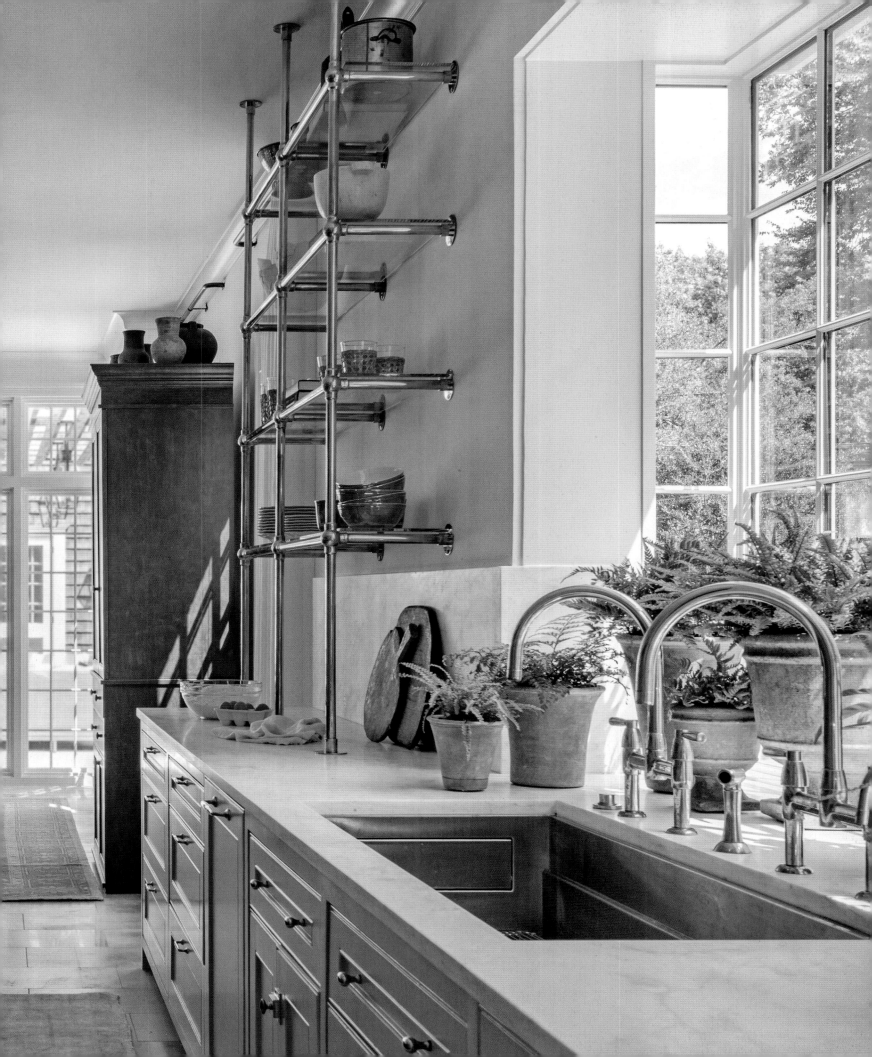

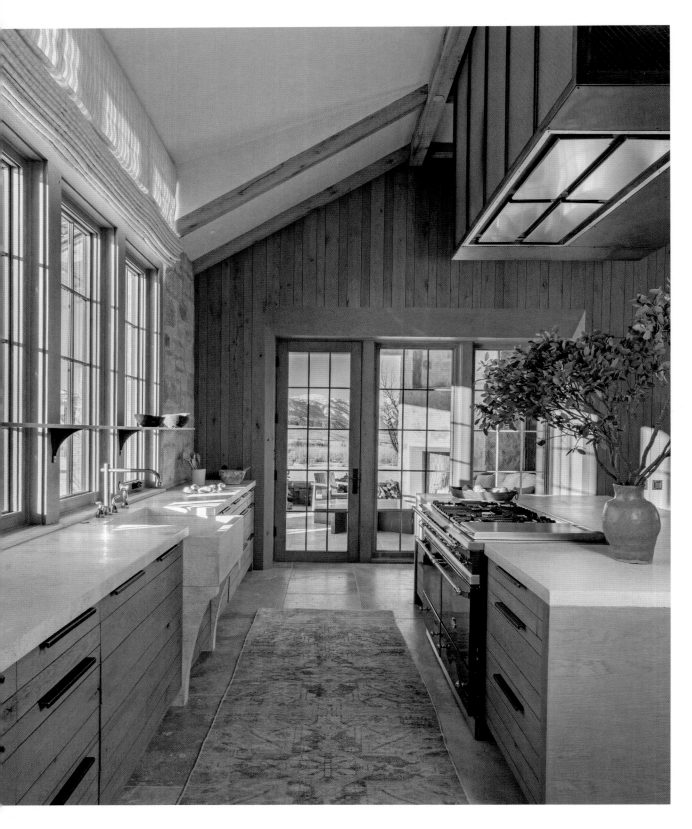

Be bold with materials

Left close to their natural state, materials that come from the earth envelop kitchens in the warmth and beauty of nature. When juxtaposed against the smooth texture of floors, countertops, and a sink of polished stone, the rugged texture and color variations of split-face stone walls stand out. Whether used for cabinetry or paneled walls, quarter-sawn oak brings the grain and texture of wood to kitchen surfaces. For striking contrast, consider adding modern materials like glass with integrated wire mesh and stainless steel on an oversize hood.

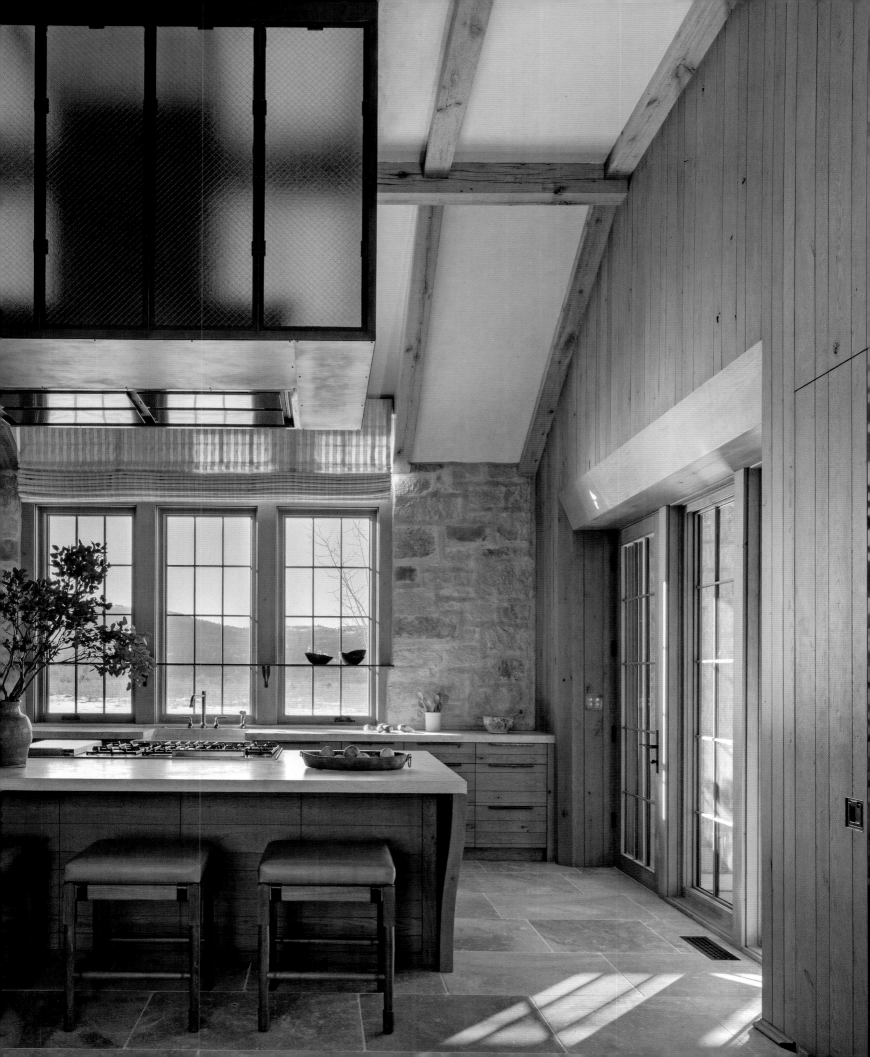

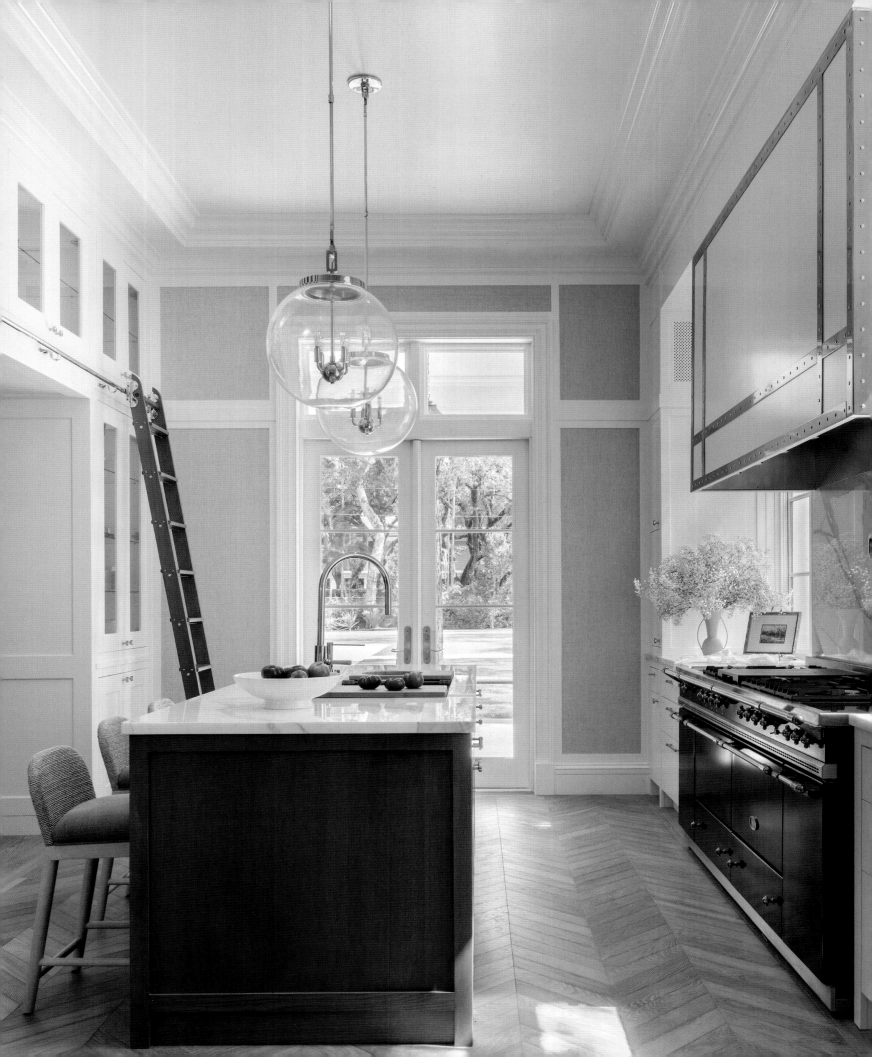

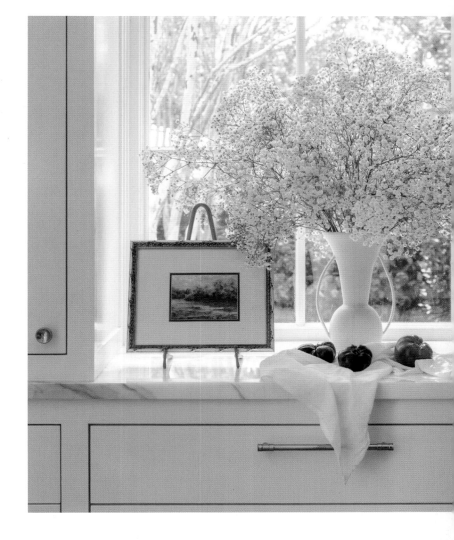

Consider the kitchen's design as an extension of the home's overall aesthetic

Use the same wood for floors in kitchens and adjoining spaces but vary the pattern. If painted millwork is prevalent throughout the house, employ it in the kitchen as well.

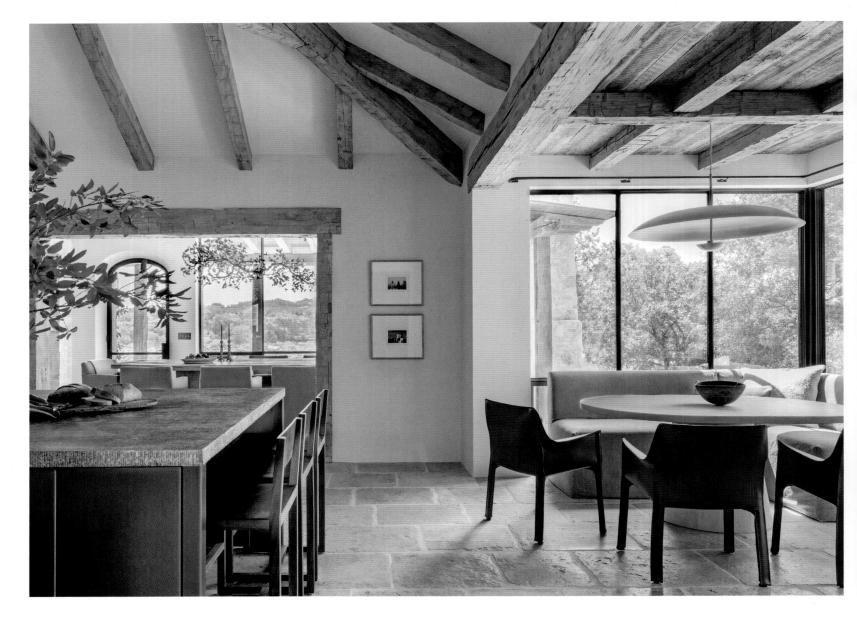

Combine the rough with the smooth

Balance highly textured materials with sleek, reflective surfaces and clean-edged modern features. For a kitchen detailed with weathered ceiling beams, I designed an island clad in silky, oil-rubbed steel topped by bluestone with a chiseled edge. The subtle polish of hand-planed oak cabinetry offers contrast to the rugged texture of reclaimed floor stones from France.

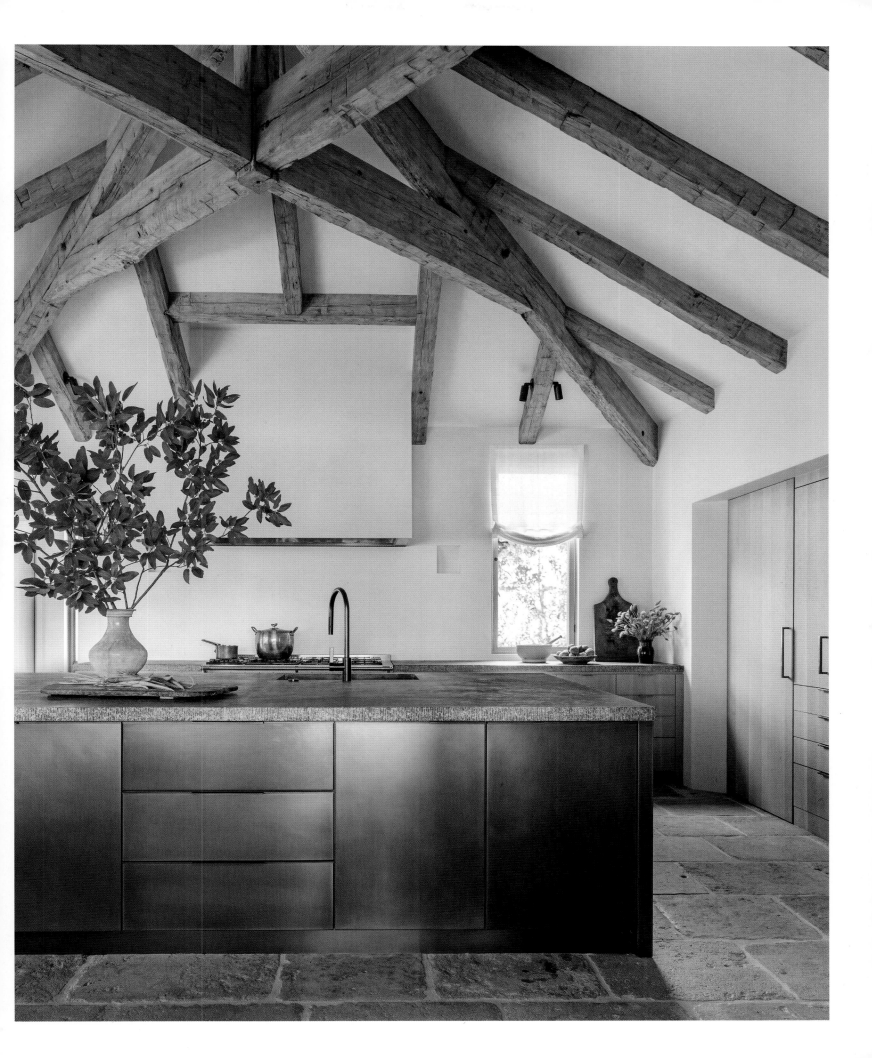

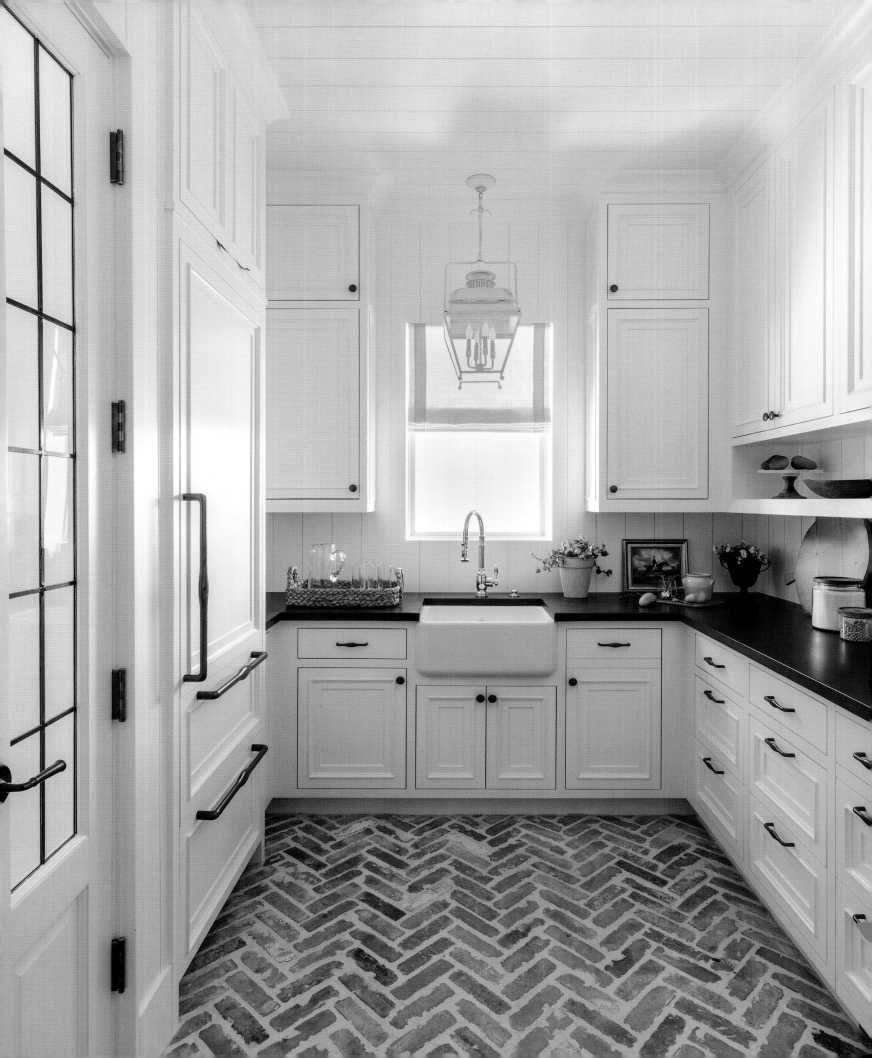

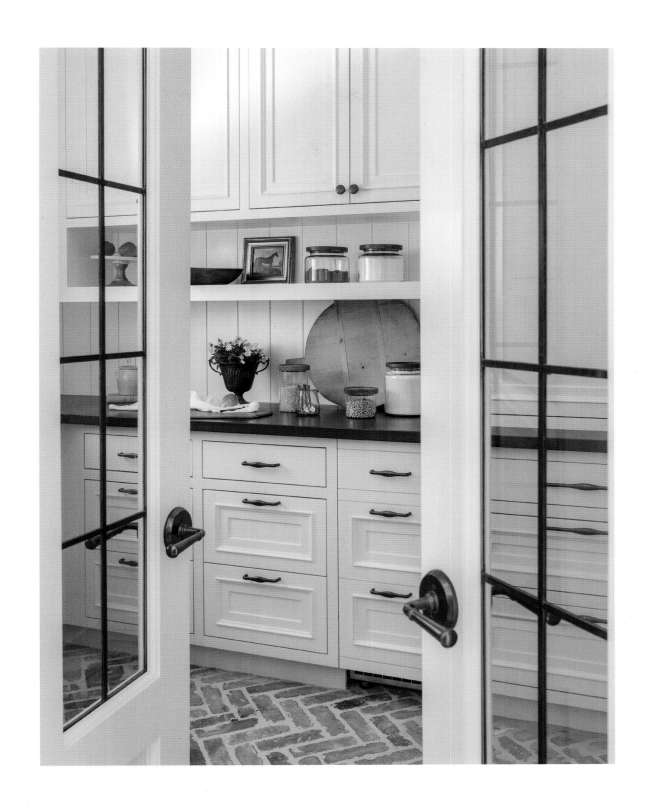

I usually employ the same cabinetry and hardware in kitchens and adjoining butler's pantries but vary details to give each their own personality. Stained wood countertops, unique vintage lanterns, and brick or tile flooring bring character and warmth to small, utilitarian spaces.

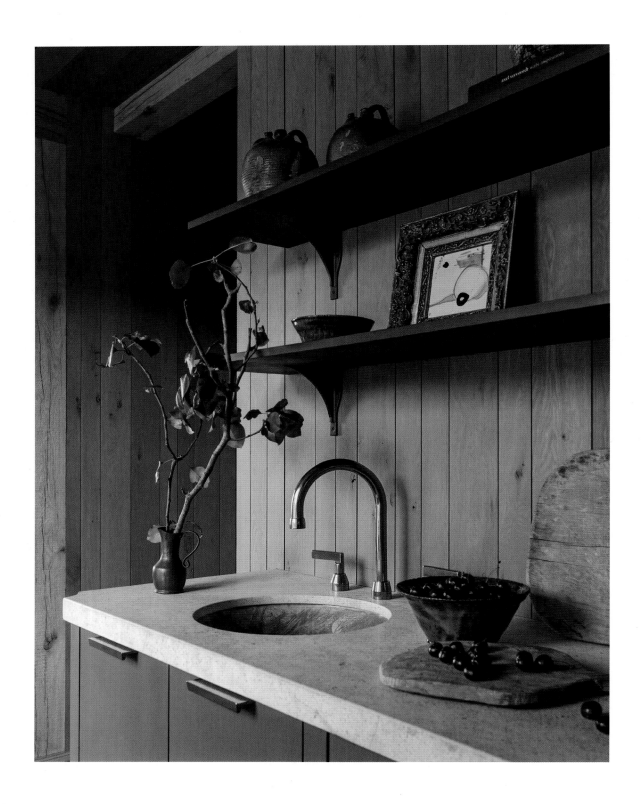

An entire room adjoining the kitchen for dry goods, tableware, and appliances is ideal, but we don't always have that luxury. Sometimes, I find creative ways to tuck pantries and bars into transitional spaces like hallways and pass-throughs. Whether in dedicated or shared areas, these service spaces should complement the design of neighboring rooms, with a few highlights like colored tile or gleaming metallic plumbing to distinguish them.

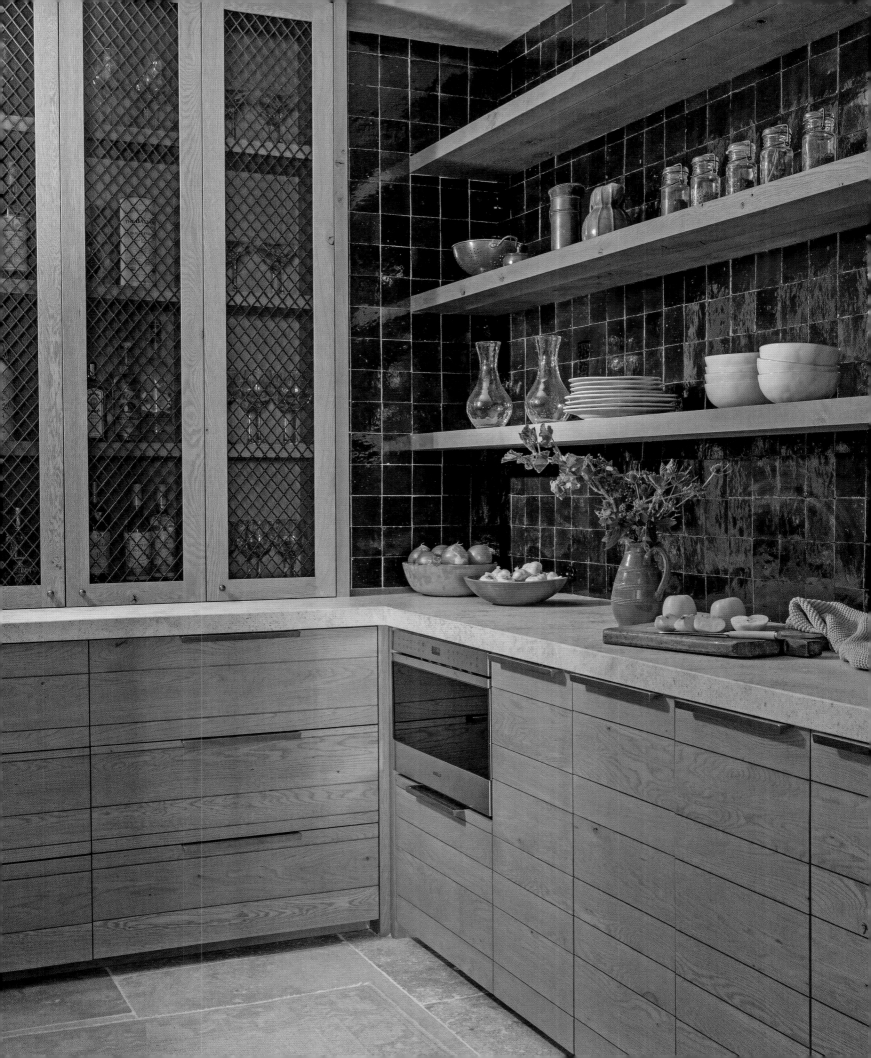

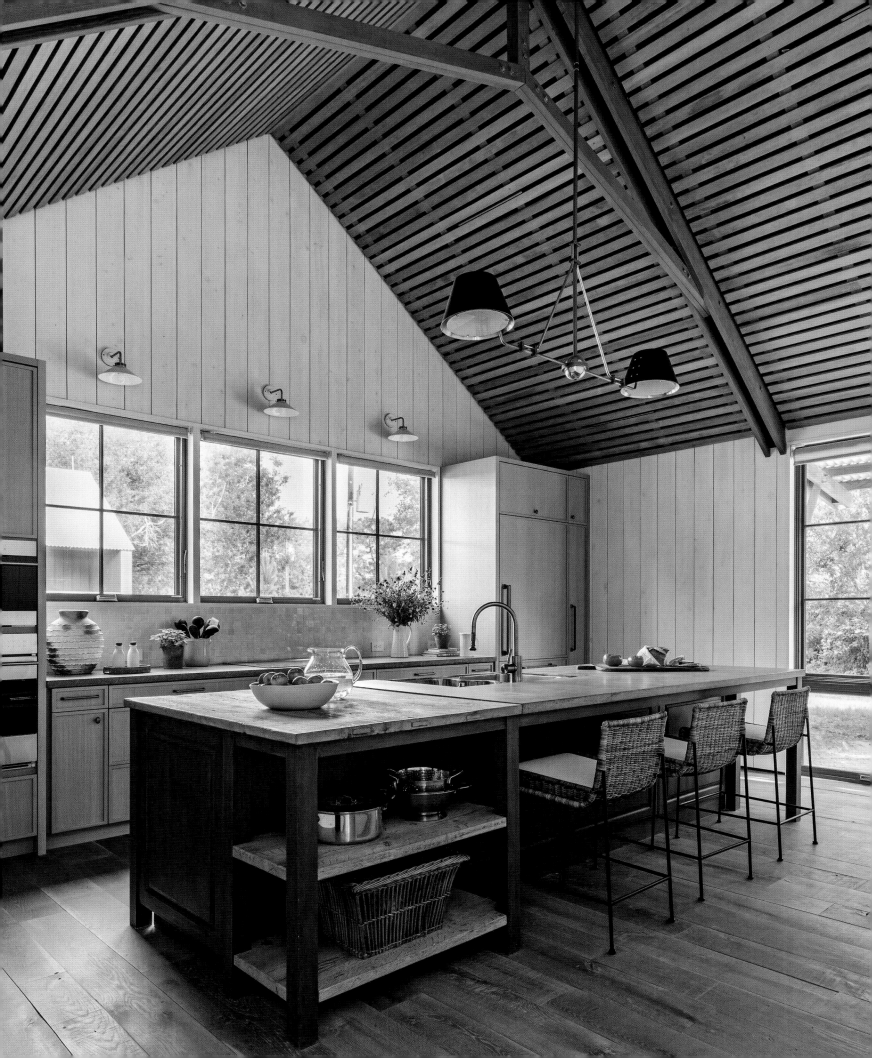

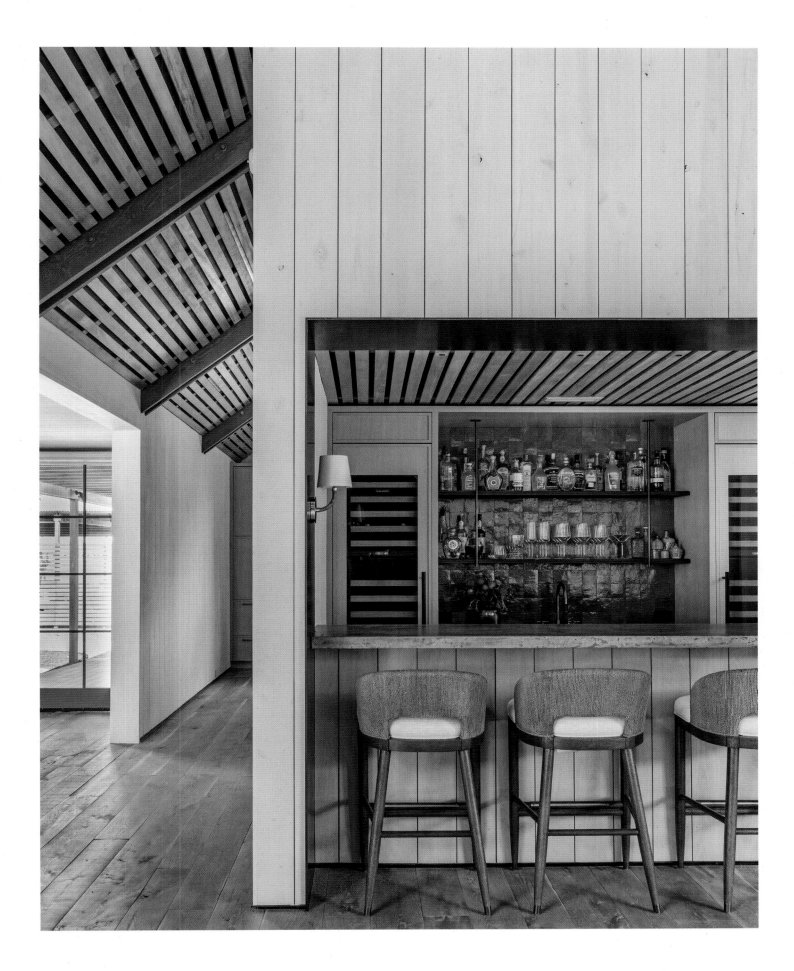

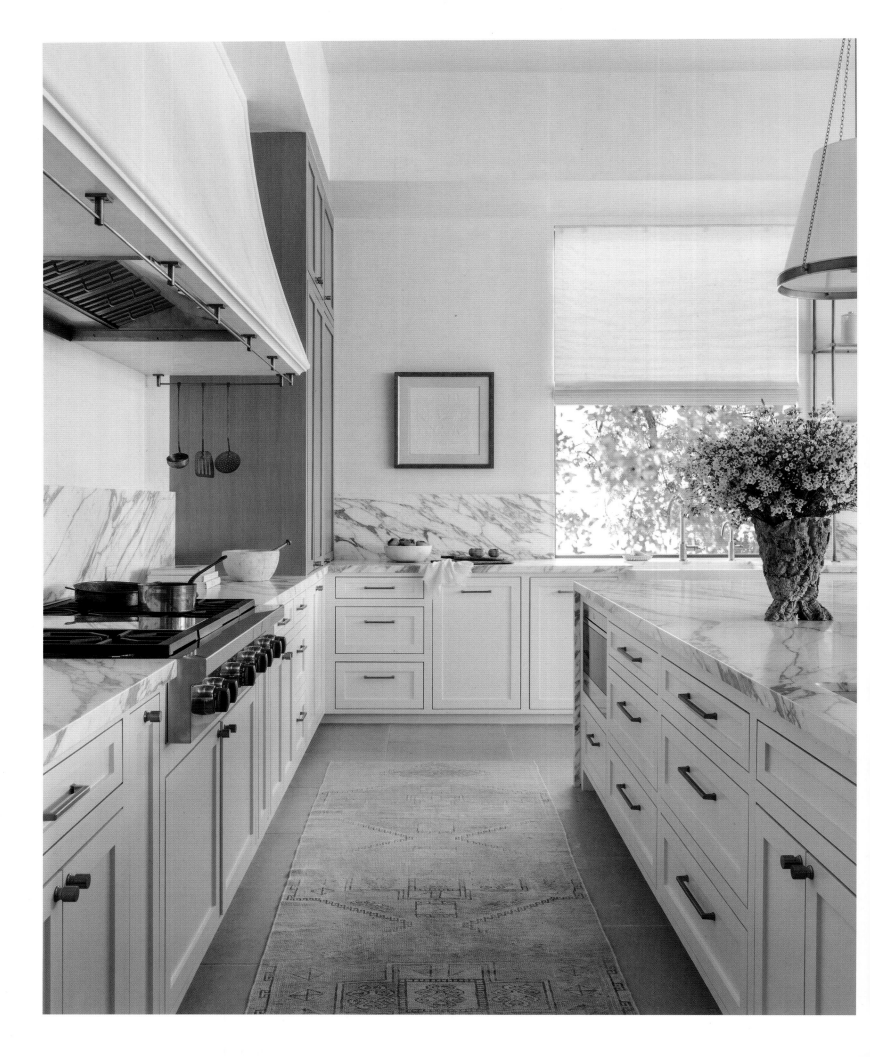

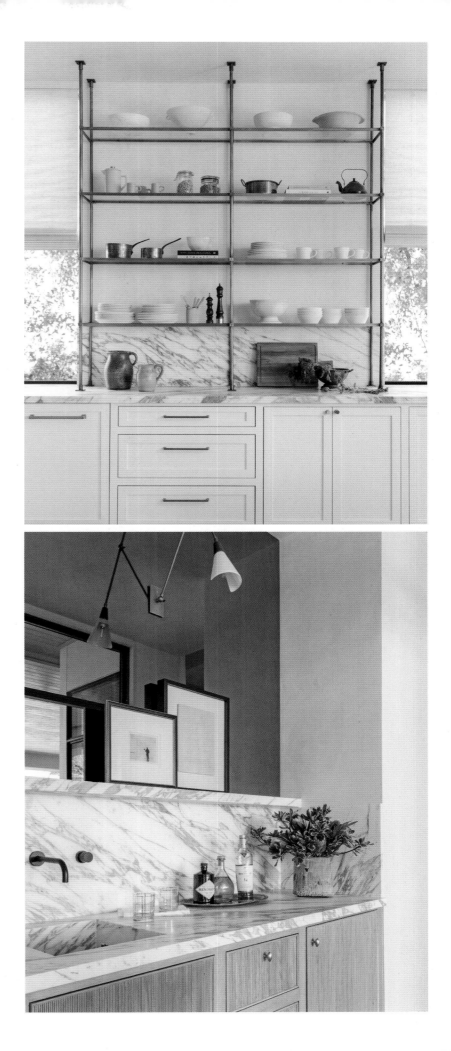

Harness the beauty
and power of stone

Using matching marble slabs on countertops
and backsplashes accentuates the pattern of
the veining and establishes unity throughout
the room. If a wet bar adjoins the kitchen,
find ways to employ the same stone for
countertops, backsplashes, sinks, and shelving.

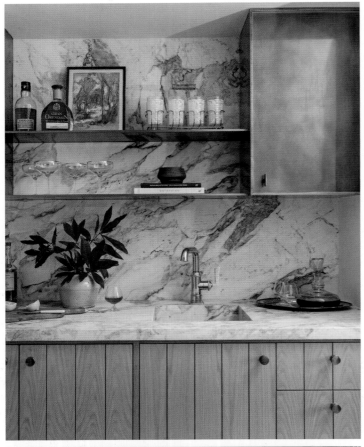

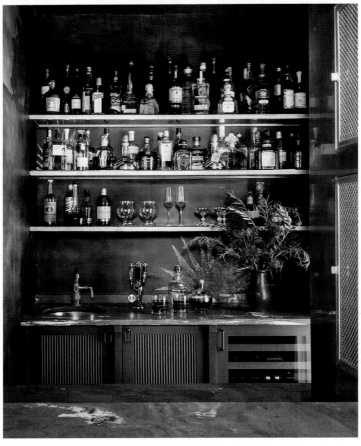

Celebrate the moment in bars and cocktail rooms

Rich wood, sleek marble, unlacquered brass, and polished nickel produce an aura of glamour in bars. Mirrored, metallic, or glass shelves add sparkle to walls and are perfect for displaying curated collections of cocktail shakers, decanters, and trays.

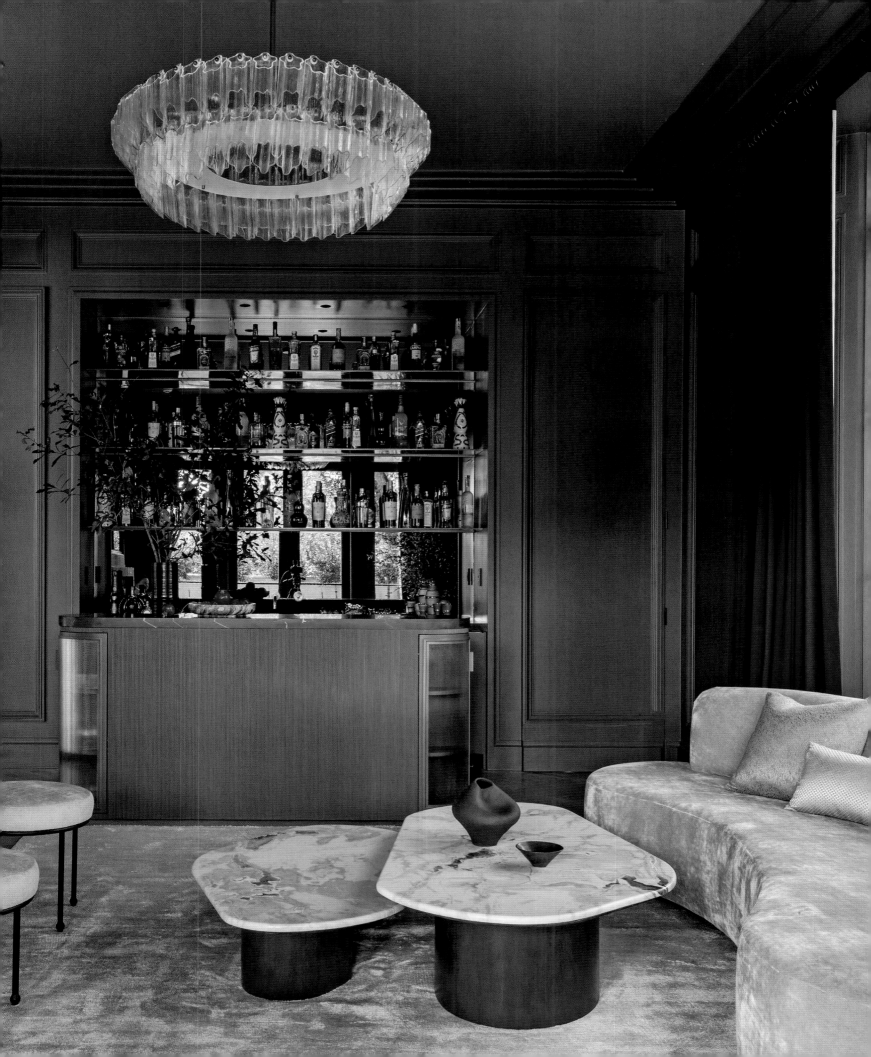

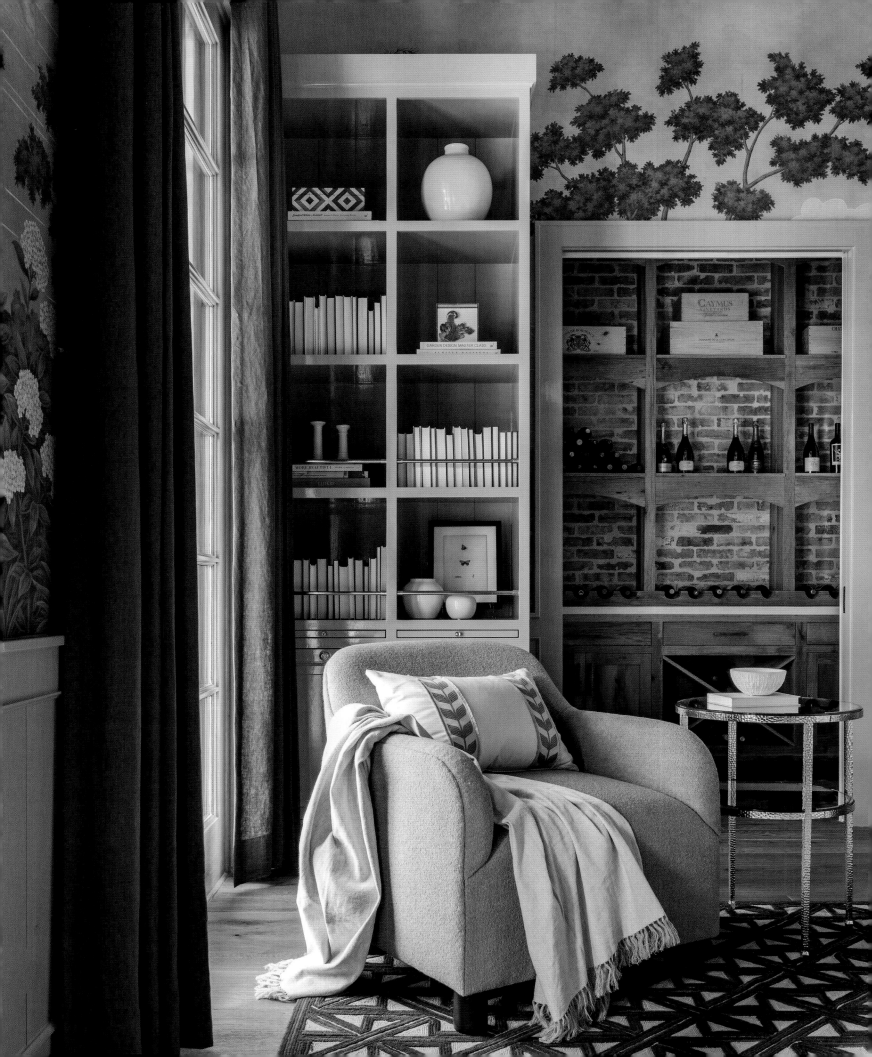

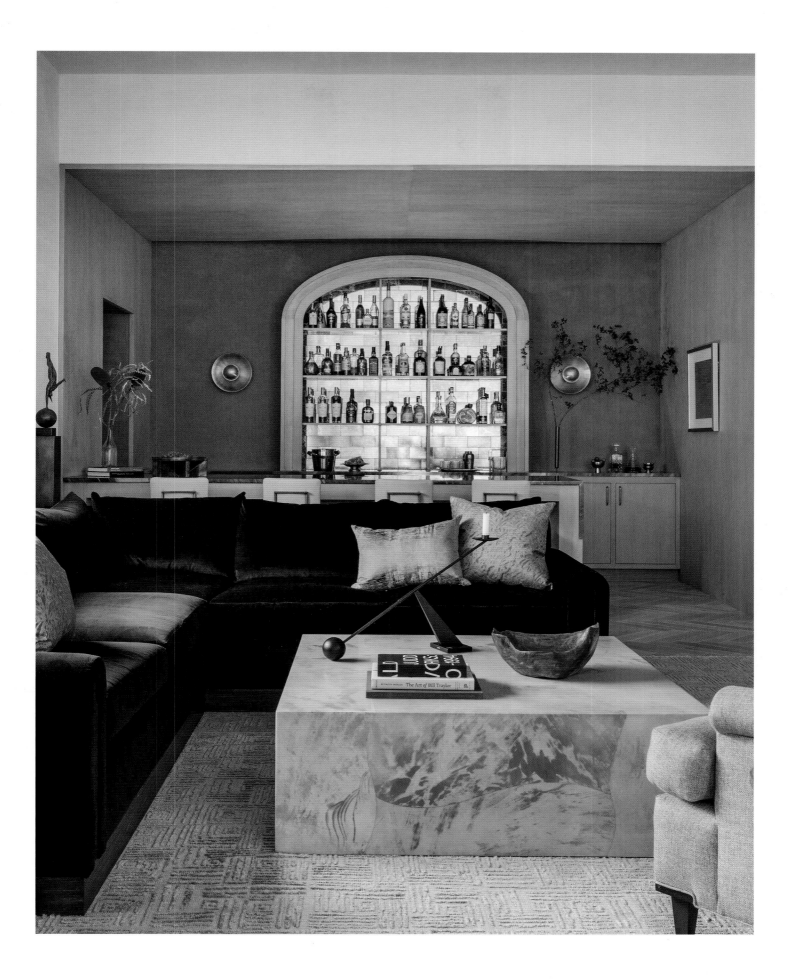

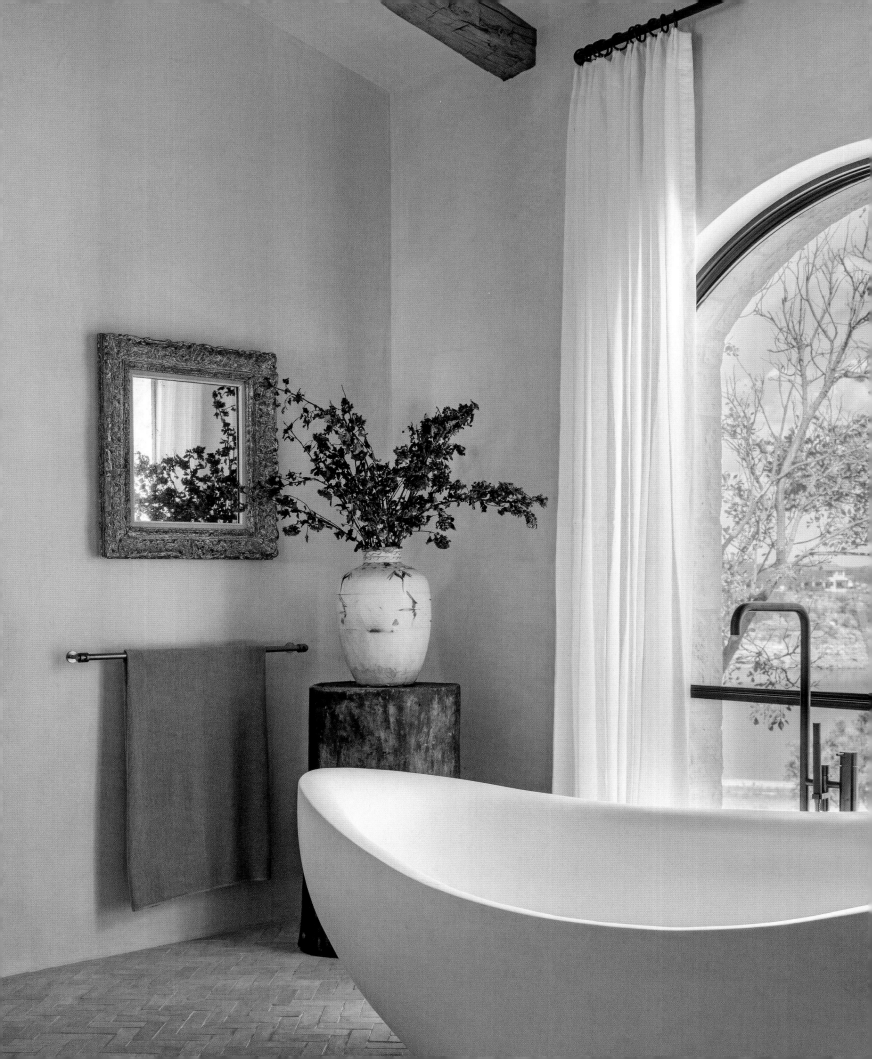

Refresh

Bathrooms enhance the emotional and sensory experience of home. As sanctuaries of serenity, they afford a welcome respite from the outside world.

The design of bathrooms has a profound impact on our physical and emotional well-being. These intimate spaces allow us privacy and cater to our needs as we tend to our daily personal care. They can also deliver interludes of luxury, tranquility, and indulgence that pamper the senses. Careful attention to detail and choice of materials, colors, and fixtures directly affects our mood from morning to night. I believe that each bathroom should have its own distinct personality, making it a destination in its own right. It's fun to introduce an element of surprise, whether extravagantly veined stone or a unique lavatory. But this doesn't mean that bathrooms shouldn't also maintain a consistent voice with the overall aesthetic of the house, echoing its character and style.

For primary bathrooms, I prefer tranquil tones like creamy white or soft gray, but sometimes I introduce a strong color to animate the space. In men's bathrooms, marble in dark tones combined with brass accents and warm wood impart a masculine ambience. For guest suites, I usually meld the aesthetic of the bathroom with the adjoining bedroom for a soothing, enveloping experience. Often, I select a particular feature to inspire the overall palette. In one bathroom, we commissioned a mural painted on blush-toned seagrass that influenced our choices of surrounding paint colors and materials.

Powder rooms invite bold or lavish designs. Contrary to expectation, extravagant gestures like oversize patterned wallpaper, unusual plumbing fixtures, and dramatic pendant lights or sconces work well in these small, self-contained spaces. In a home nestled in the hills of Jackson Hole, Wyoming, we made a statement with a sleek antique brass plumbing fixture that descended from the ceiling over a lavatory fashioned from a rustic split-faced boulder. Layered over walls of richly stained oak planking, the composition seamlessly married modern sophistication with the rugged character of the natural surroundings. As a final touch, we hung an ornate European-style gilt mirror above the sink, injecting unexpected elegance into the room's organic textures.

Marble, onyx, and quartzite are among my favorite materials for countertops, backsplashes, walls, and flooring. Nothing is more timeless and luxurious than their lustrous surfaces and veining. For a powerful effect, consider using extravagantly veined or colored slab marble panels on walls. Sometimes I like to combine tiles of limestone or marble with porcelain or ceramic, allowing the movement and veining of the natural stone to play off the subtler finish of man-made material. I always mix in furniture pieces to temper the bathroom's hard surfaces—an antique dresser or hutch for linen storage, a skirted vanity chair, or an upholstered bench.

Plumbing fixtures tend to be both the workhorses and jewelry of the bathroom, so they must perfectly marry form and function. Exquisitely crafted plumbing and hardware impart an opulent, spa-like experience. Some people prefer a cohesive look with similar tones and finishes, but I often combine metals like polished nickel, oil-rubbed bronze, or unlacquered and antiqued brass to vary the composition. Sconces and chandeliers elevate glamour with the gleam of metal and glitter of crystal pendants. Don't be afraid to incorporate vintage or antique light fixtures with strong character—they literally make a bathroom shine.

When given the chance, I make the bathtub the focal point of primary bathrooms. A hand-carved limestone tub that feels as smooth as butter issues an irresistible invitation. A metal-clad or polished white one set atop marble flooring makes a more elegant impression. In my bathroom, I nestled the bathtub inside a bay window with full-length drapery that provides privacy while also strategically framing a view. Tubs can also be integrated into paneling, set into niches, or centered beneath an arch with ceiling treatments such as coffering, exposed beams, or groin vaults that offer something beautiful to gaze up at. If you pay close attention to every aspect of the design, the result will be an exceptional room that delivers everyday pleasure and sensory delight.

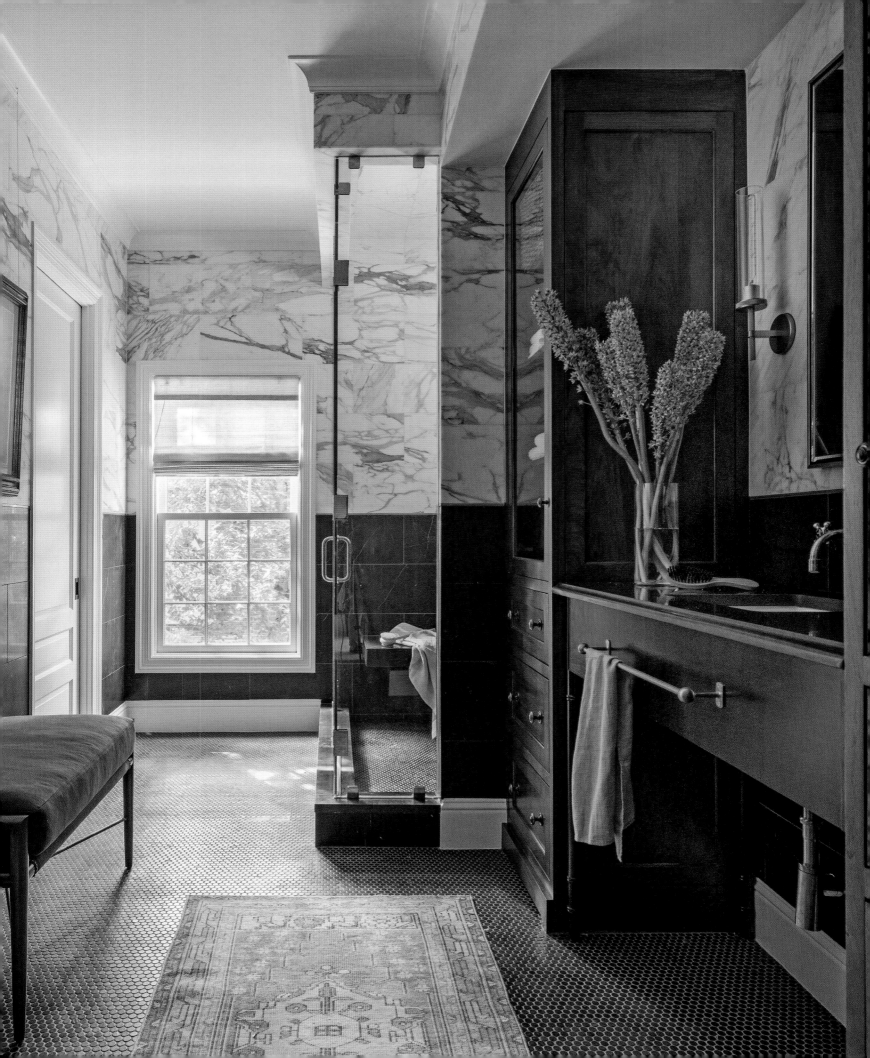

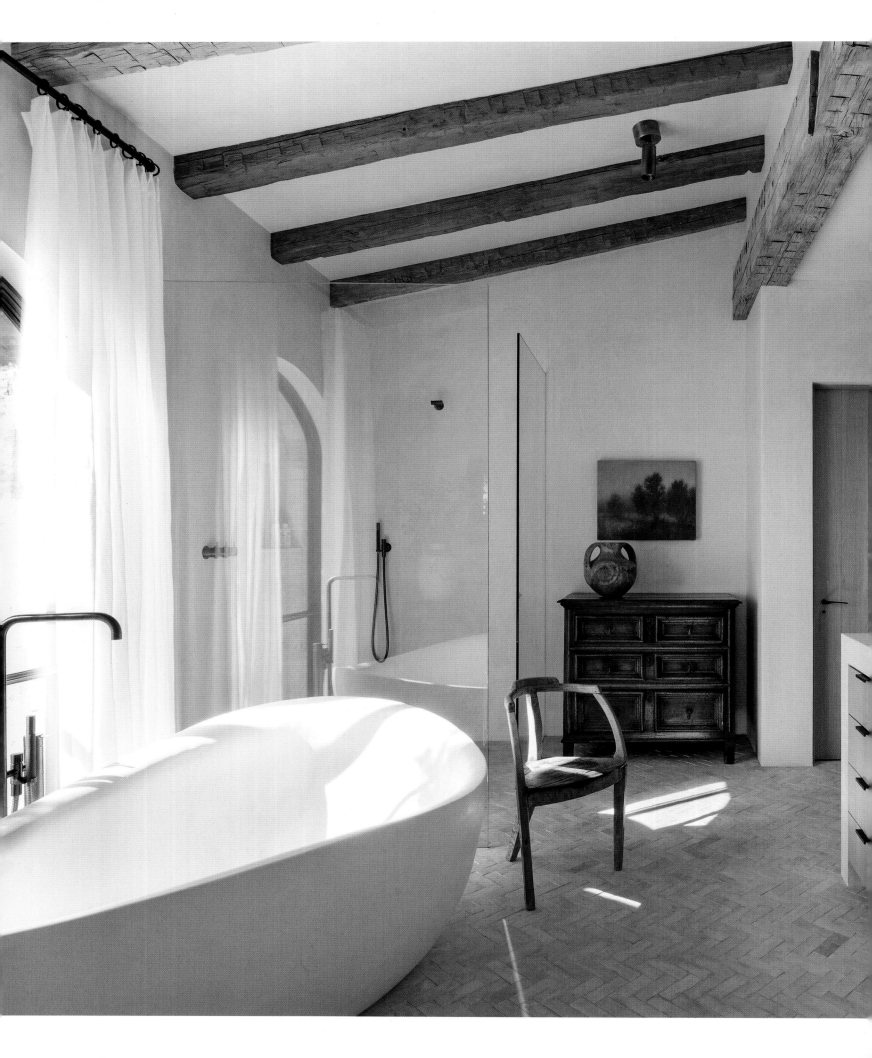

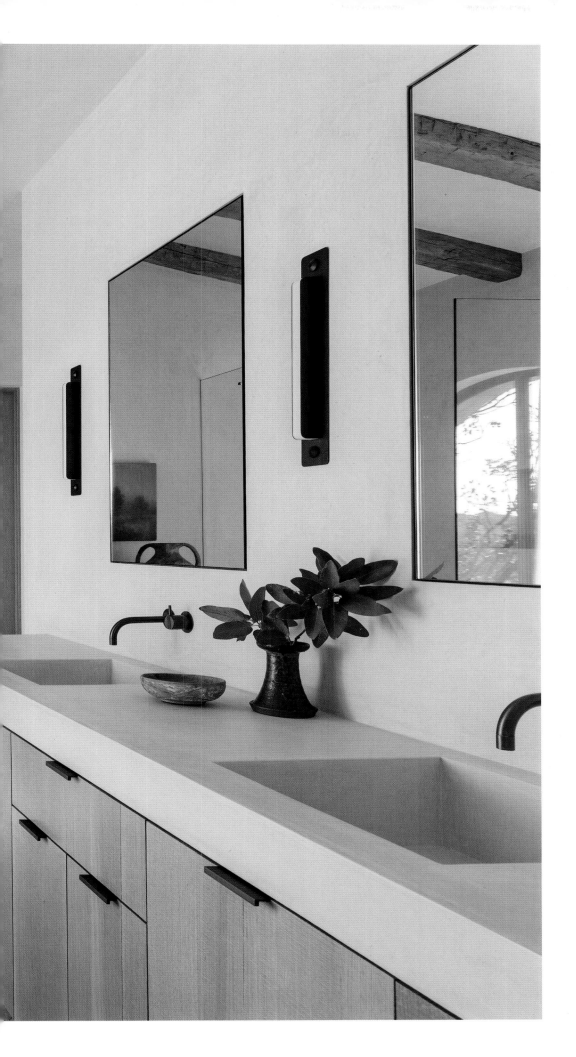

Bathrooms typically feature highly polished, reflective materials, but sometimes I employ organic ones with more artisanal textures. The subtle variations and warm tones of terra-cotta tile and hand-applied plaster impart old-world ambience. Mixing in elements with smooth surfaces and modern lines accentuates their natural beauty.

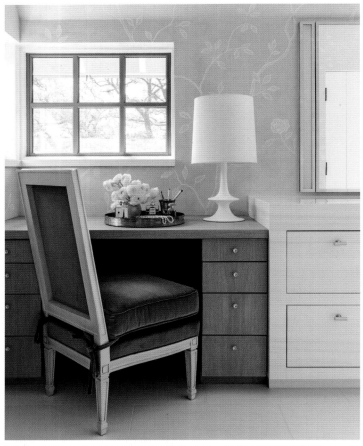

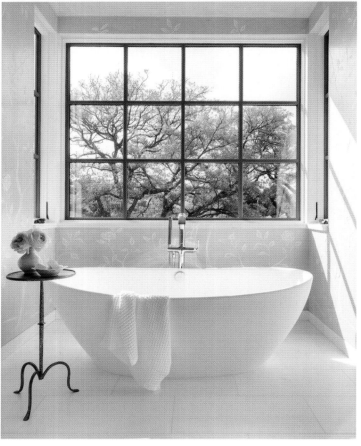

Give bathrooms a furnished look

Vanities can be clad entirely in marble, with countertops, casings, and even drawer fronts displaying its luster and veining. When the bathroom includes a makeup vanity, I often choose a contrasting finish such as stained wood in a room dominated by stone or painted millwork to create the appearance of a stand-alone piece of furniture. Movable furnishings like chairs and stools also offer opportunities to introduce new materials and finishes, both hard and soft.

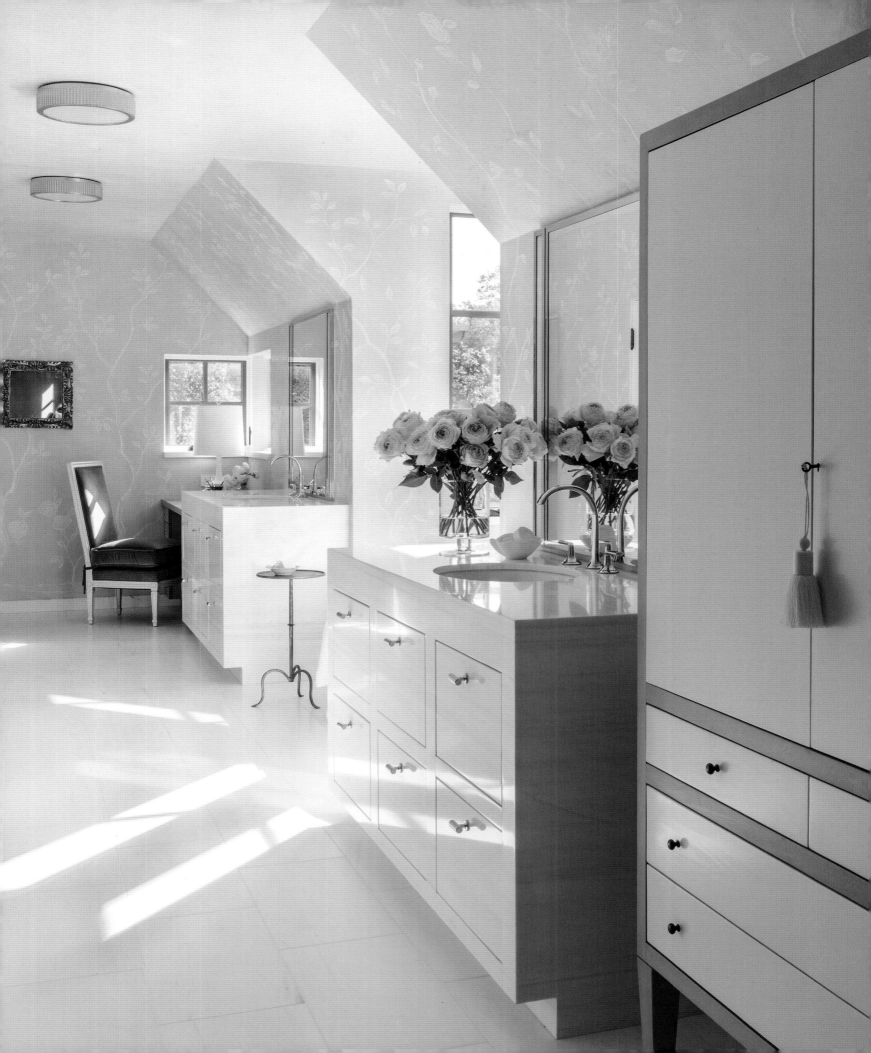

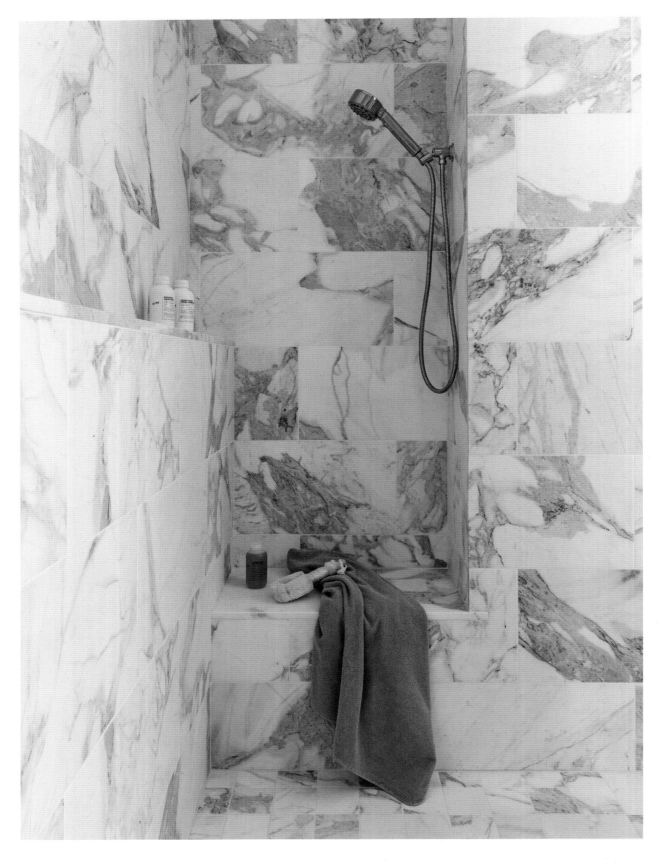

Marble with bold veining patterns makes a dramatic statement

Slabs can be mounted on walls as wainscot, showcased on vanities, or fashioned
into islands. I love using the same stone in multiple formats—slab, large-format tile,
and mosaic—to unify the room while producing compositional variety.

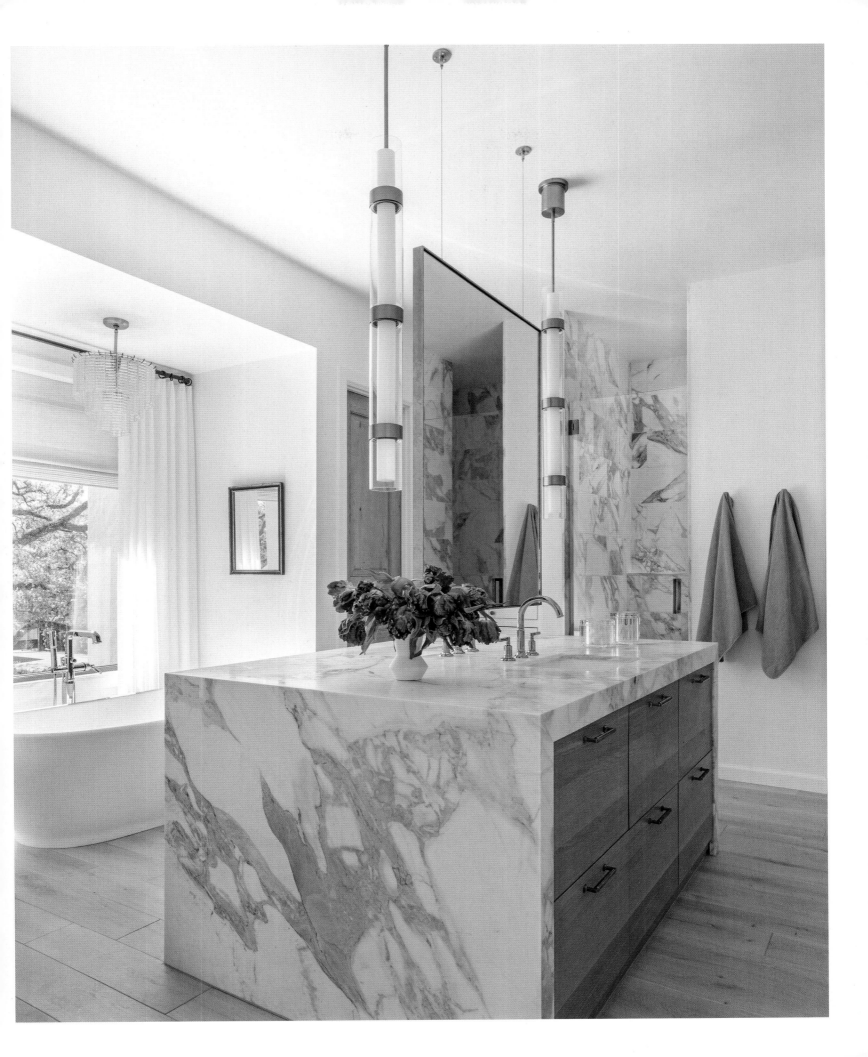

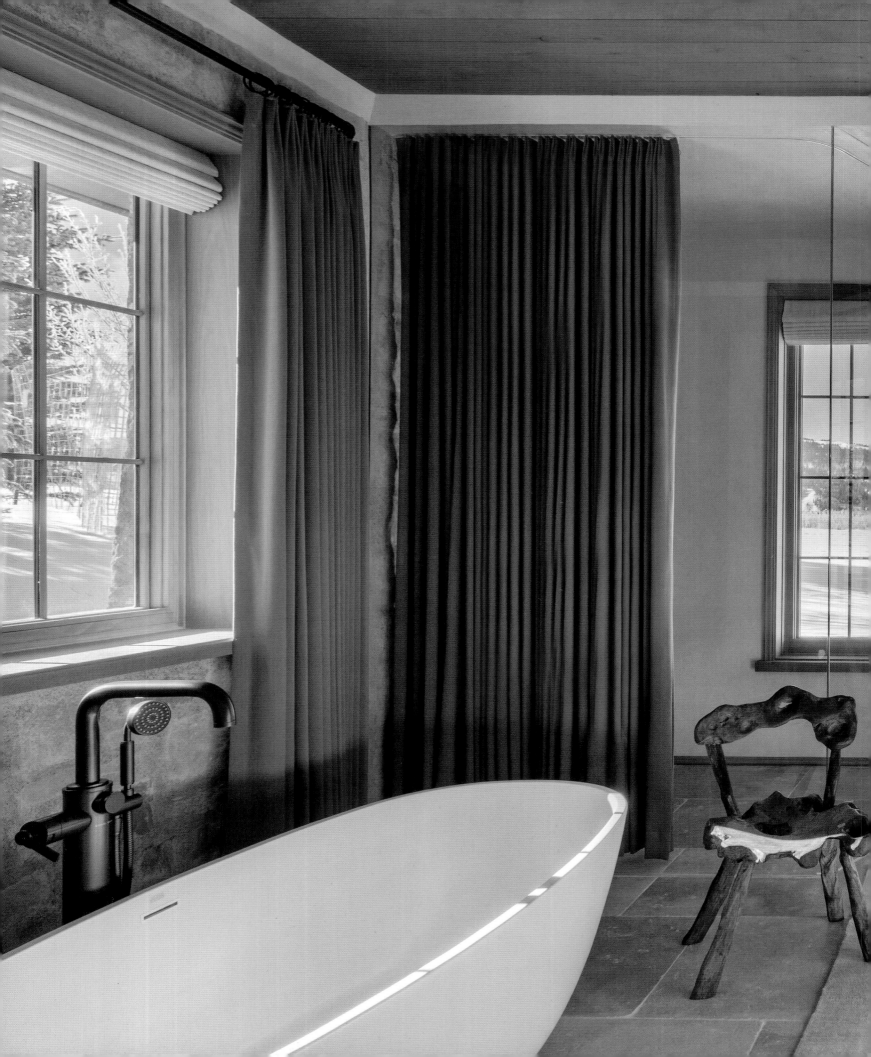

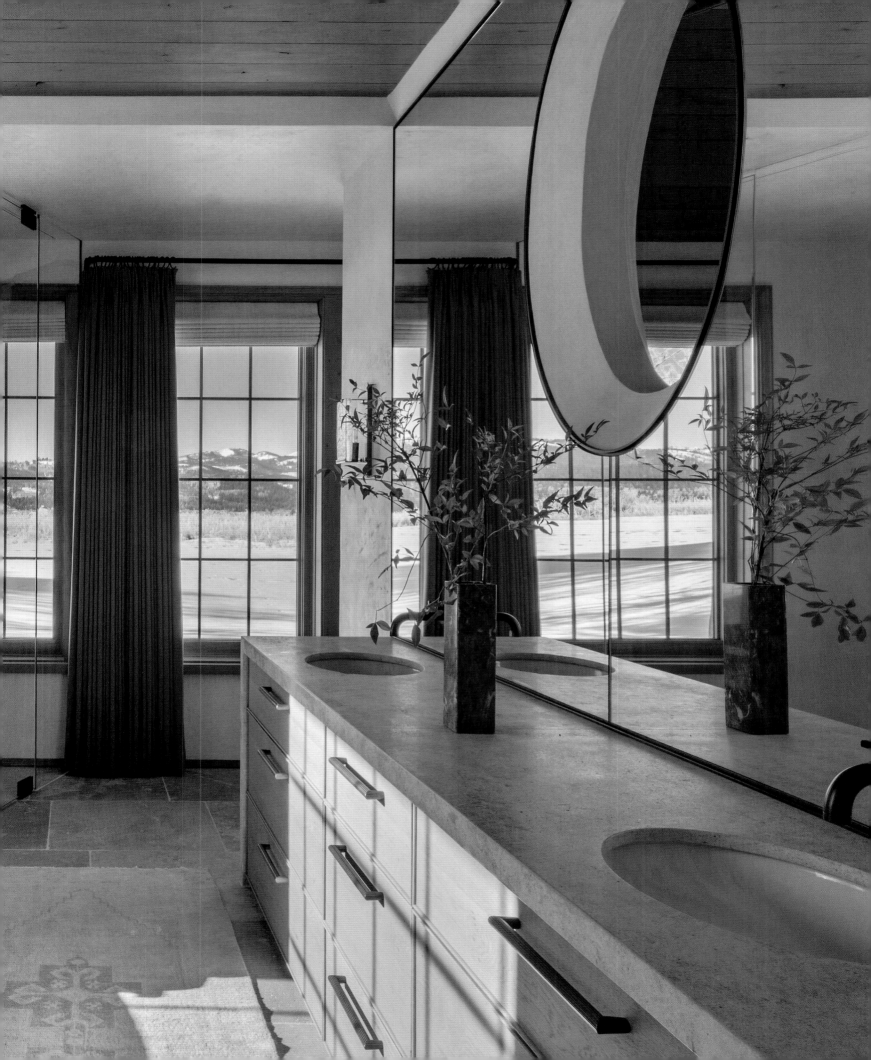

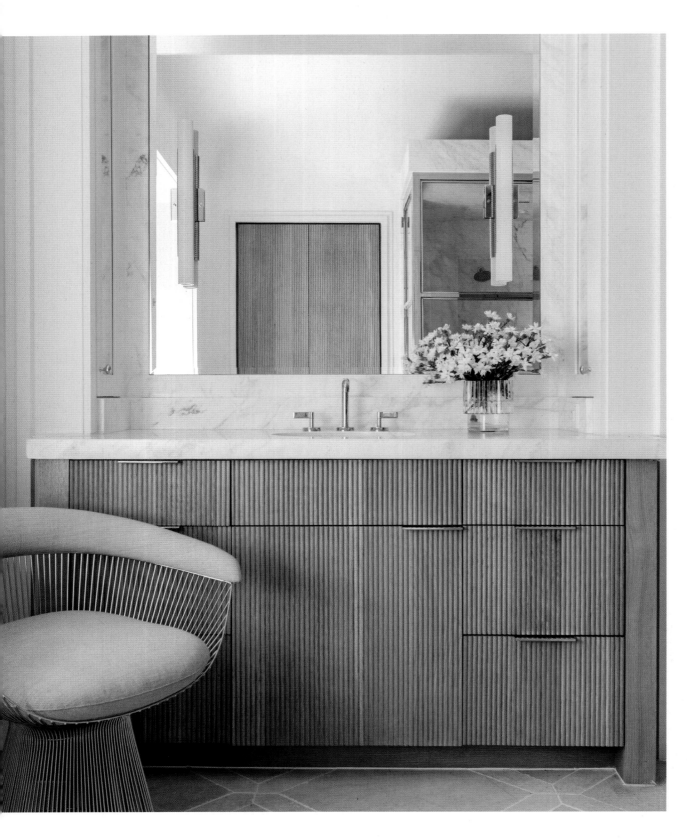

Pattern can be introduced in bathrooms in subtle ways—a floor of tile laid in a geometric design, fluted wood cabinetry, and grids of polished nickel framing glass shower walls. Don't be afraid to juxtapose varied surfaces like smooth plaster with grained wood and glossy porcelain with organic tile for a rich sensory experience.

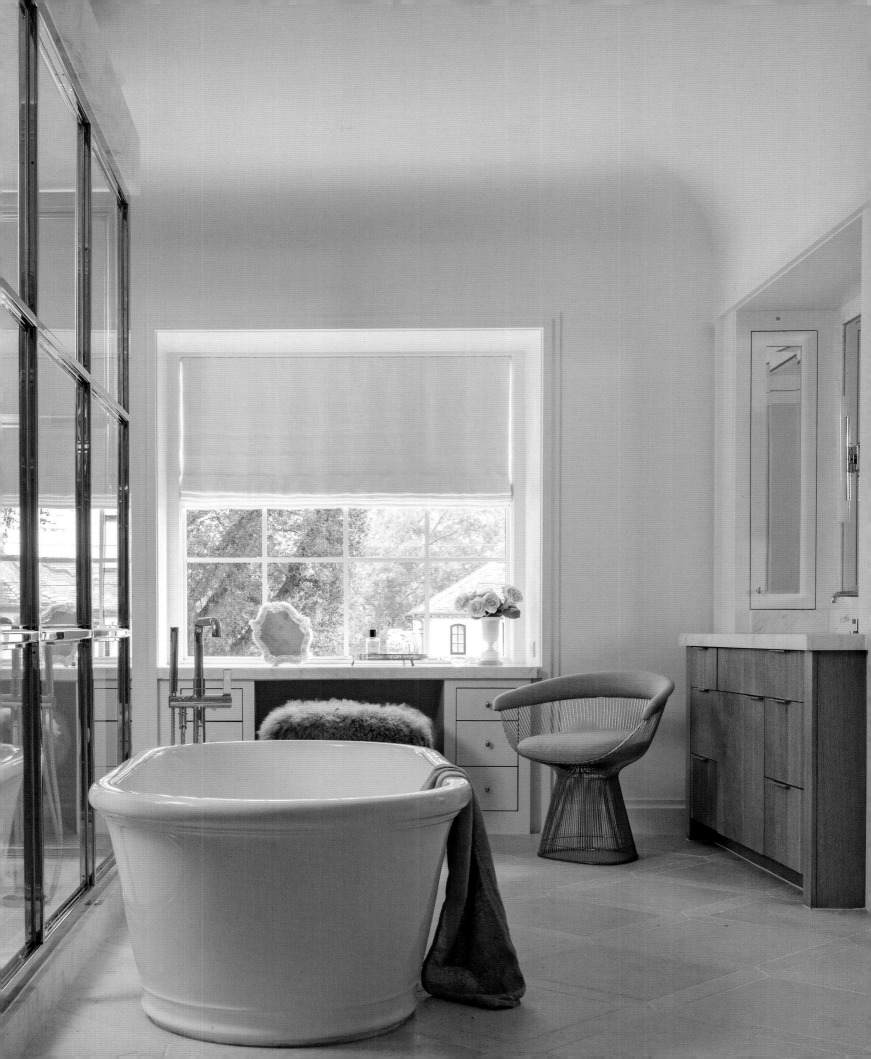

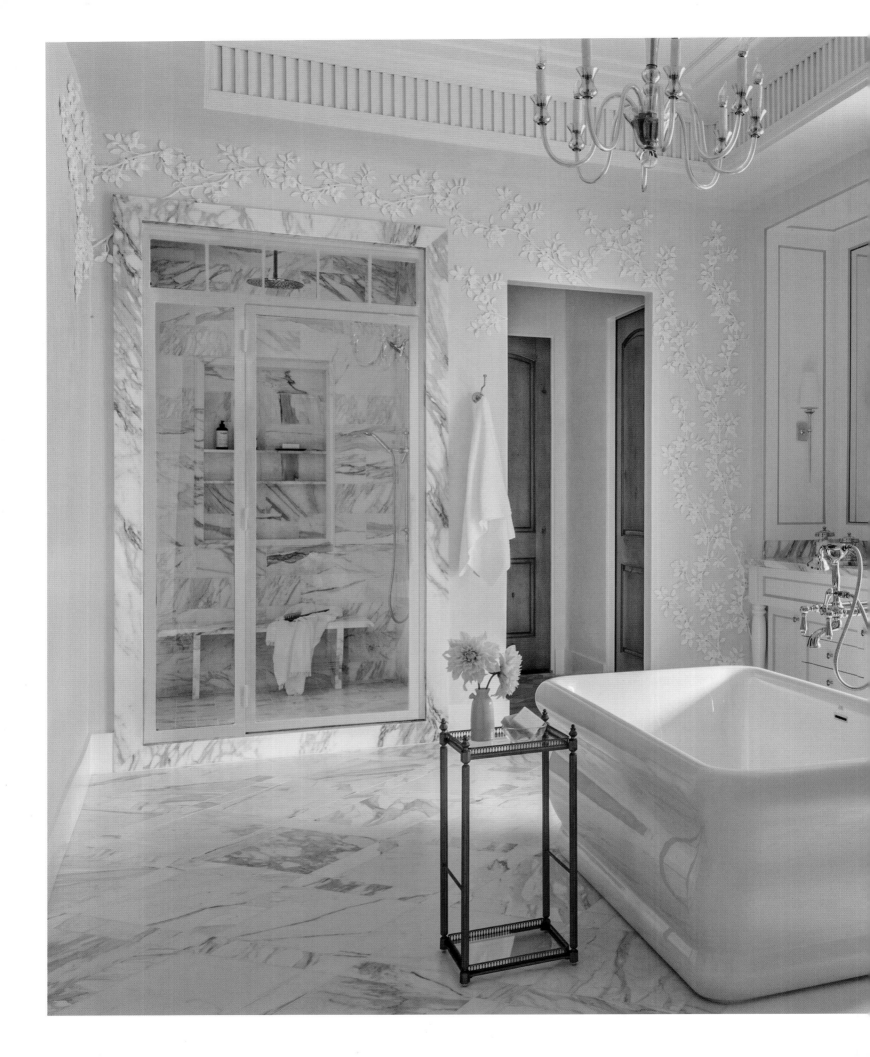

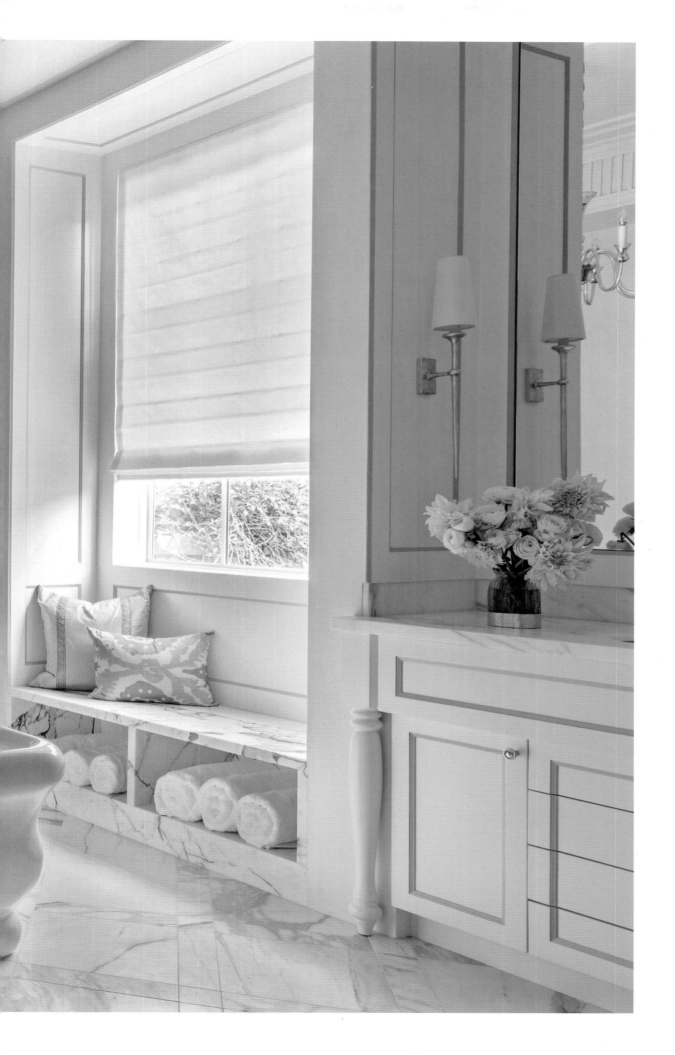

Primary bathrooms can be decorated with the same attention to detail as the most formal rooms in the house, with elegant chandeliers and sconces, handsome crown moldings, and opulent wall treatments like hand-applied plaster appliqué. Nothing is more timeless and luxurious than a marble floor. I often use intricate parquet designs that alternate the direction of veining to create a subtle sense of movement.

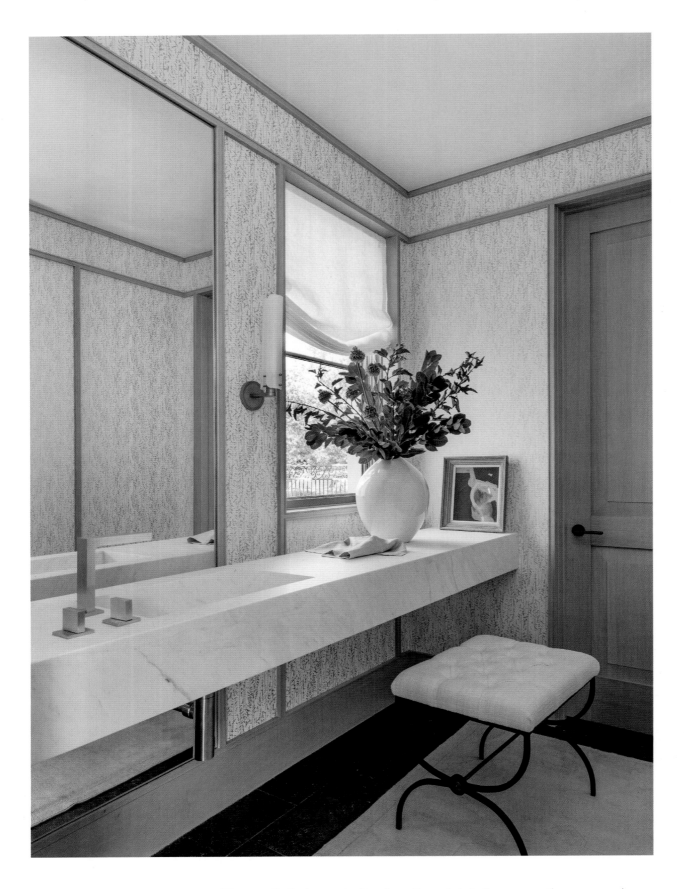

There are limited opportunities for soft goods in bathrooms, so the ones you choose carry weight. Drapery, an upholstered stool or chair, plush towels, and floor mats are ways to increase comfort and to quiet sound in bathrooms. Sometimes, I bring in low-pile, antique rugs. Choices of material, color, and detail like embroidery and piping make each bathroom feel unique and personalized.

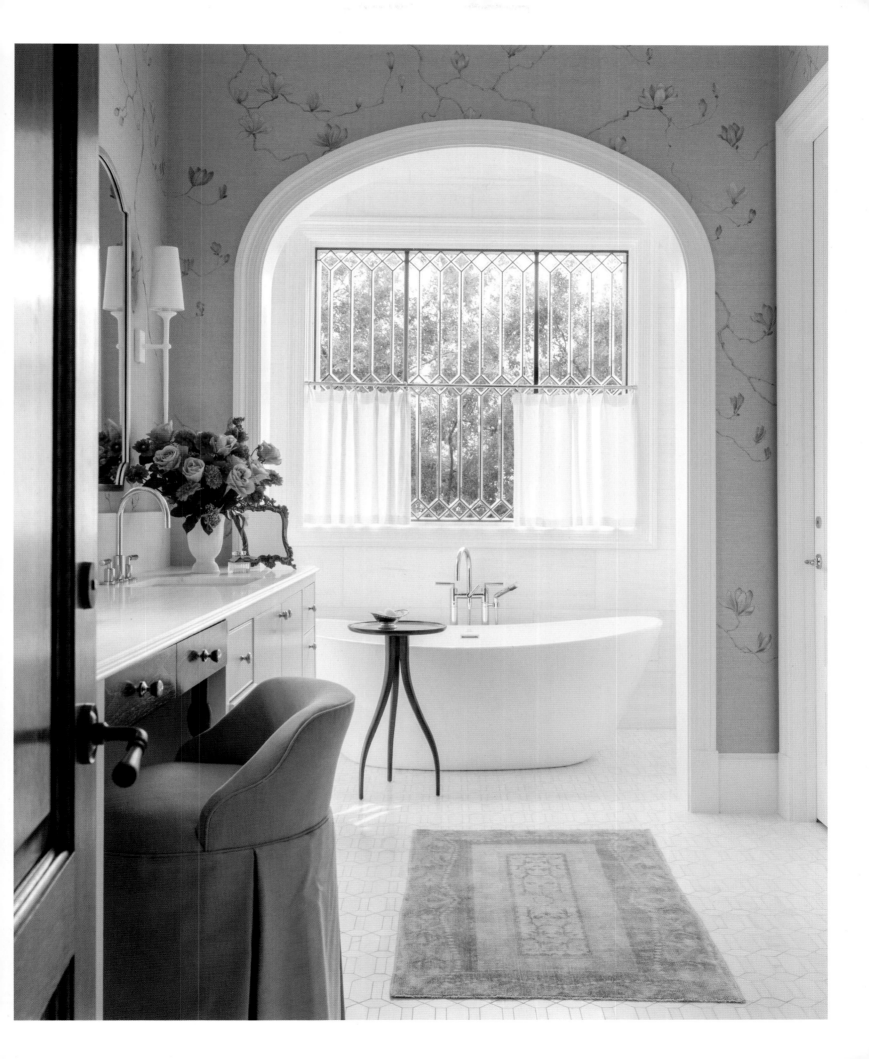

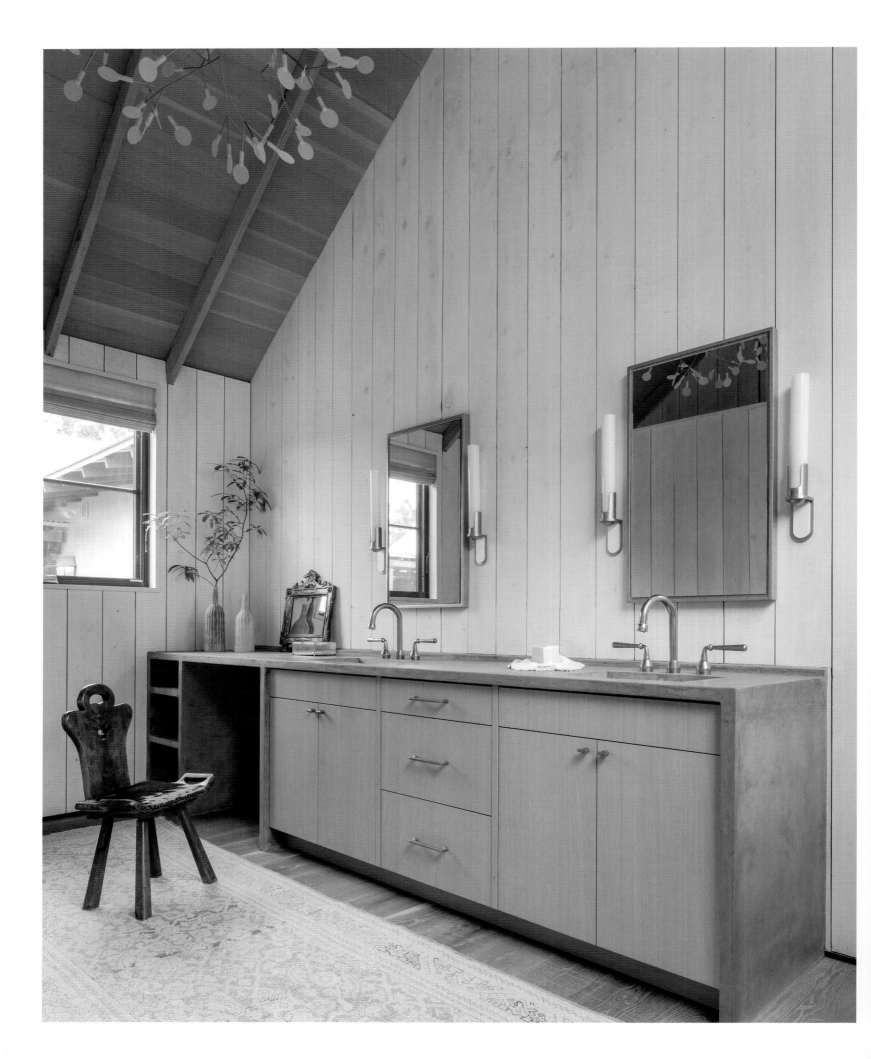

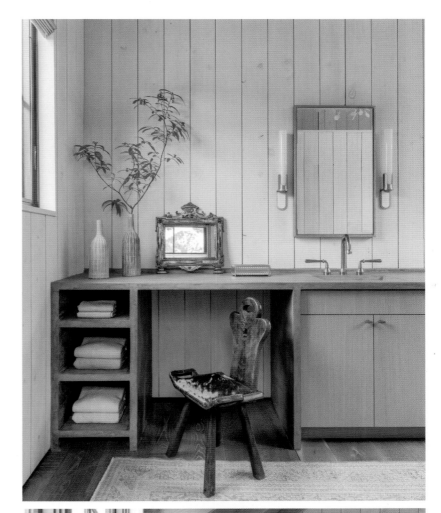

Stay close to nature

In rustic country houses, I often keep details to a minimum, allowing the inherent beauty of organic materials in their natural state to instill depth. When brushed with a sheer wash of paint, the grain and knots of pine planking can wrap a room in a warm, patterned embrace. For smooth surfaces, I am drawn to cast concrete for its stonelike color and variations and rift-cut oak for its understated striations.

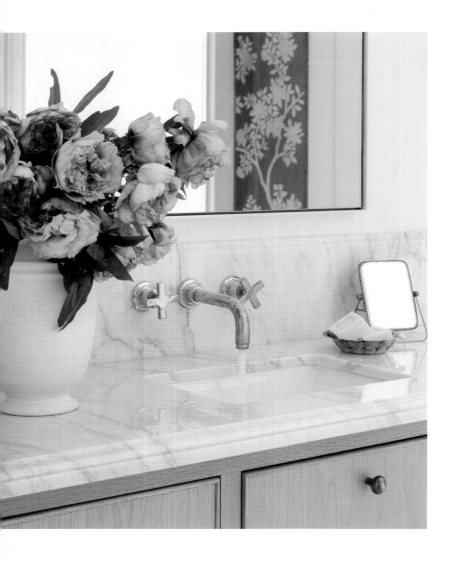

A neutral palette of creamy white, soft gray, or warm beige promotes tranquility. When color is subdued and unified, opportunities abound to enliven the palette with texturally rich materials. I often pair warm and cool tones in floors that combine limestone and marble tile or vanities of stained wood topped with marble. I also enjoy playing with texture, mixing the shiny with the matte, the smooth with the rough.

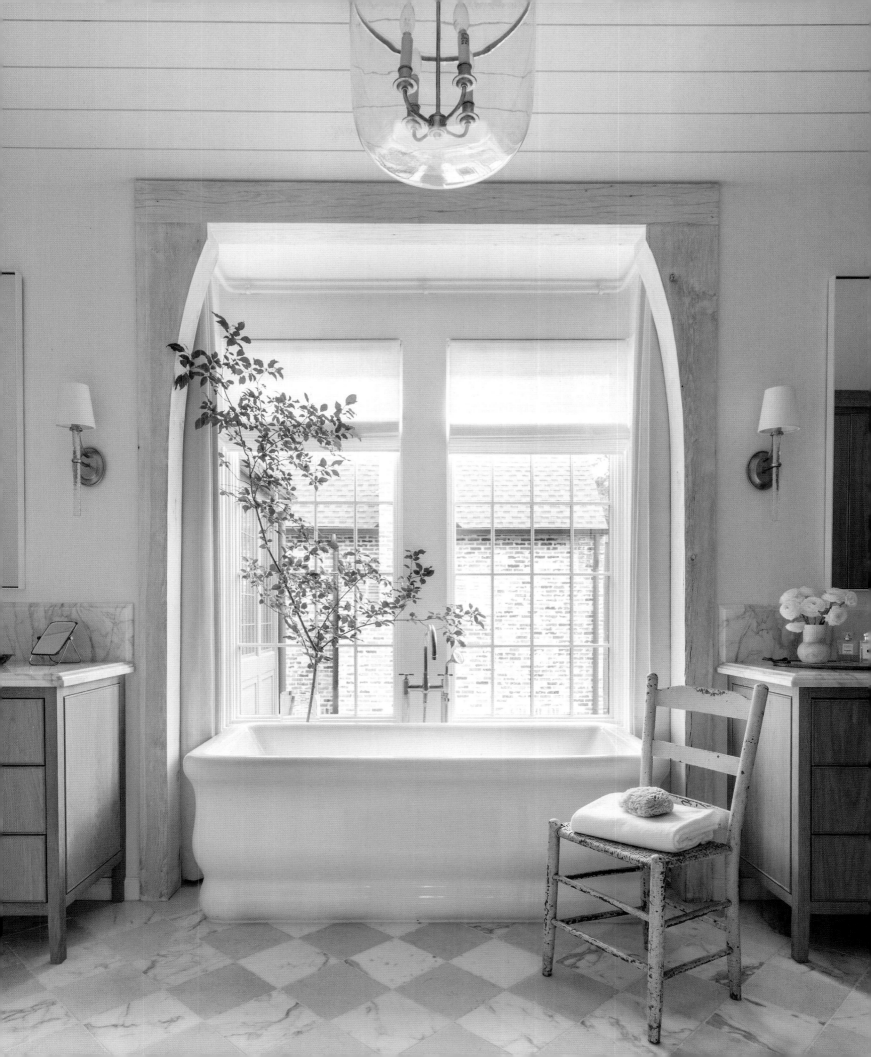

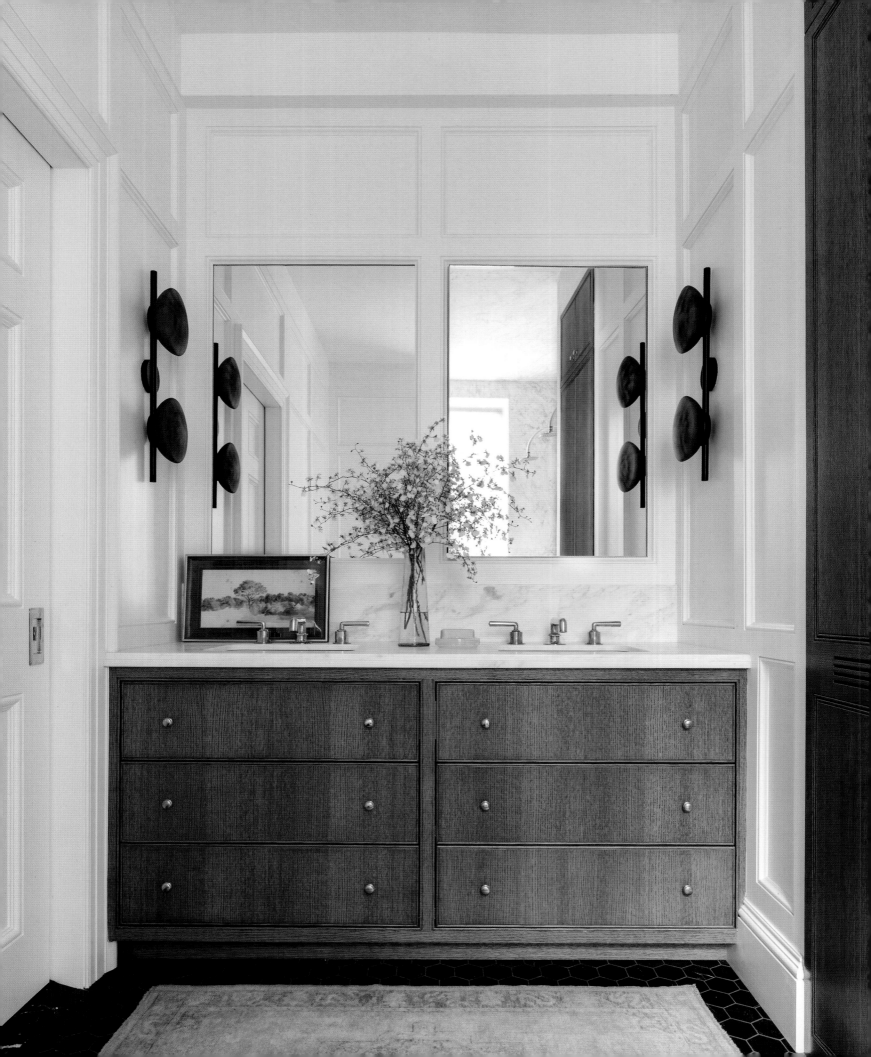

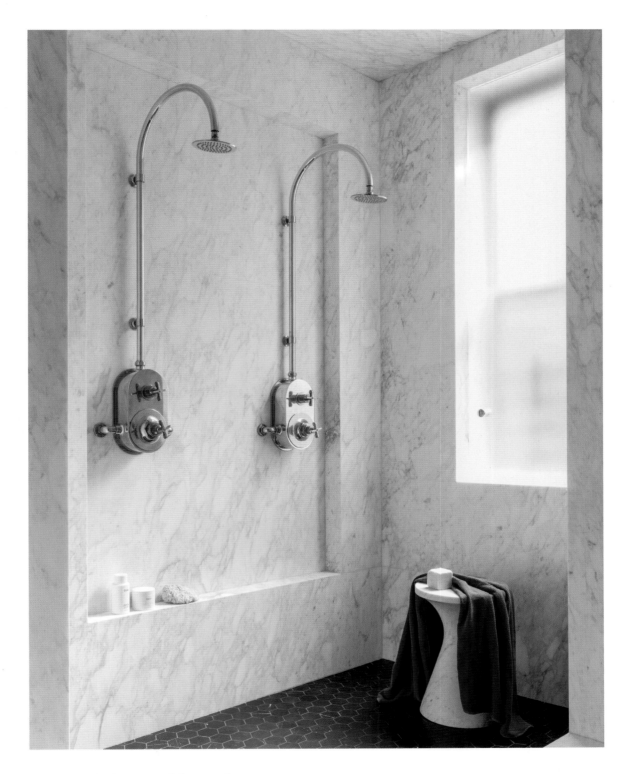

Metal adds sparkle and romance

Exquisitely crafted hardware and plumbing bring brilliance to bathrooms and impart an opulent, spa-like experience. I am particularly drawn to living metals like unlacquered brass, oiled bronze, and unsealed nickel that gain patina over time. These will reward you with a burnished look and feel that can't be compared to man-made finishes.

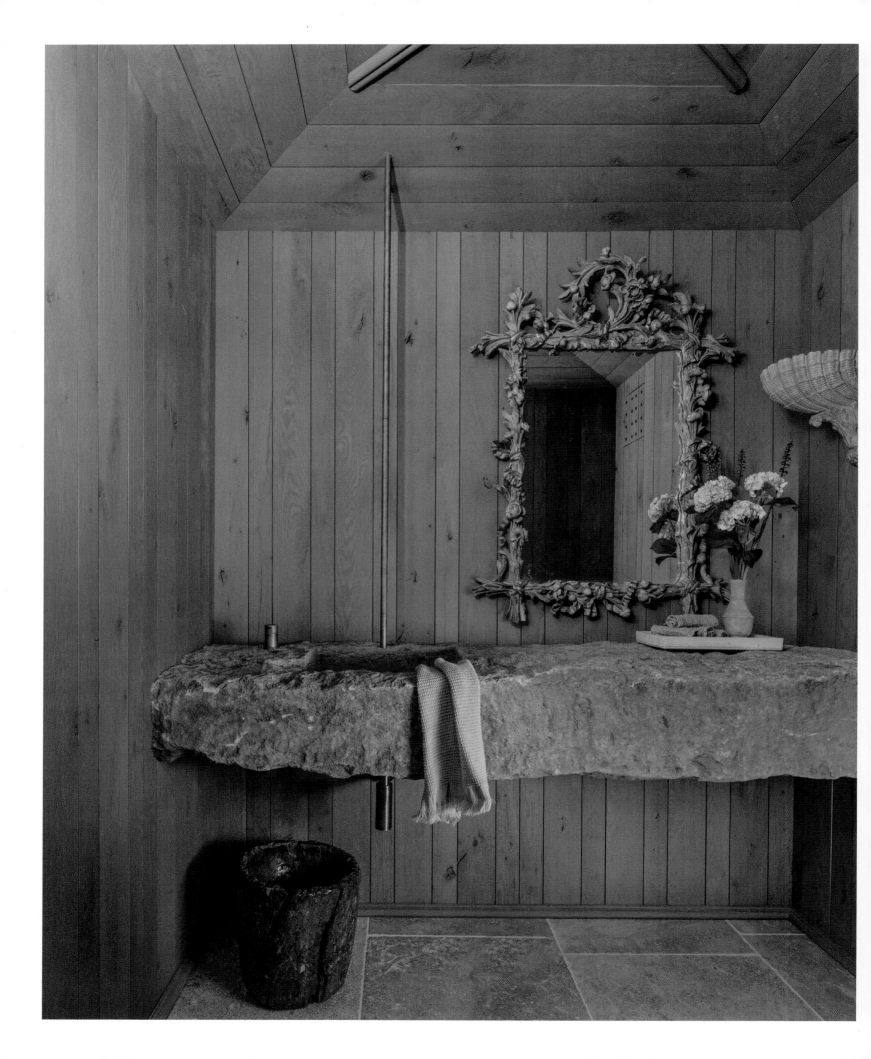

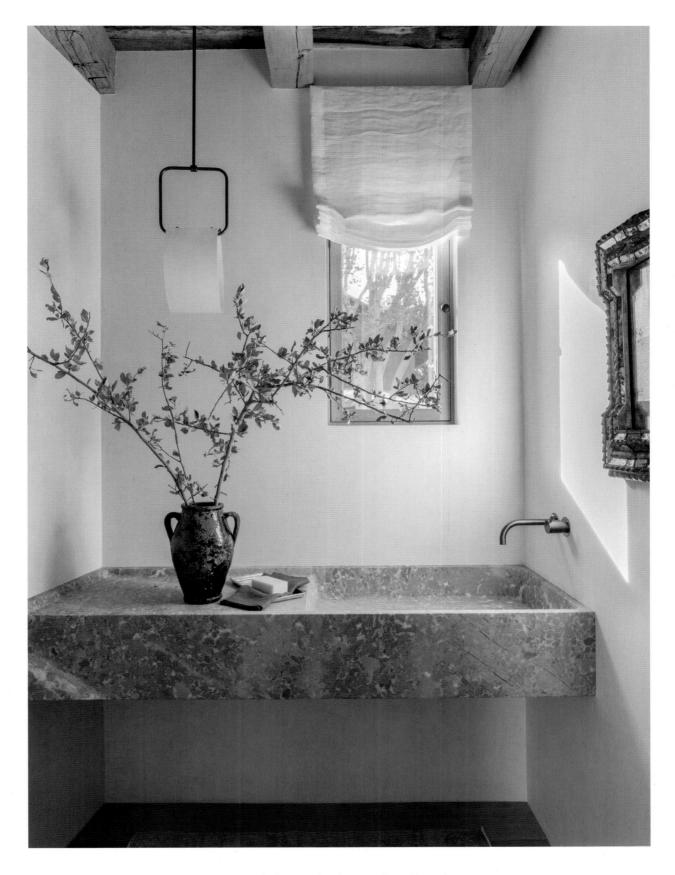

The powder room is a place to experiment with drama in hard materials and have fun doing it. I love inserting an element of surprise like a floating lavatory carved from a single marble slab or split-face boulder. Beautifully aged, gilded mirrors with intricate silhouettes are perfect counterpoints to bold stone features.

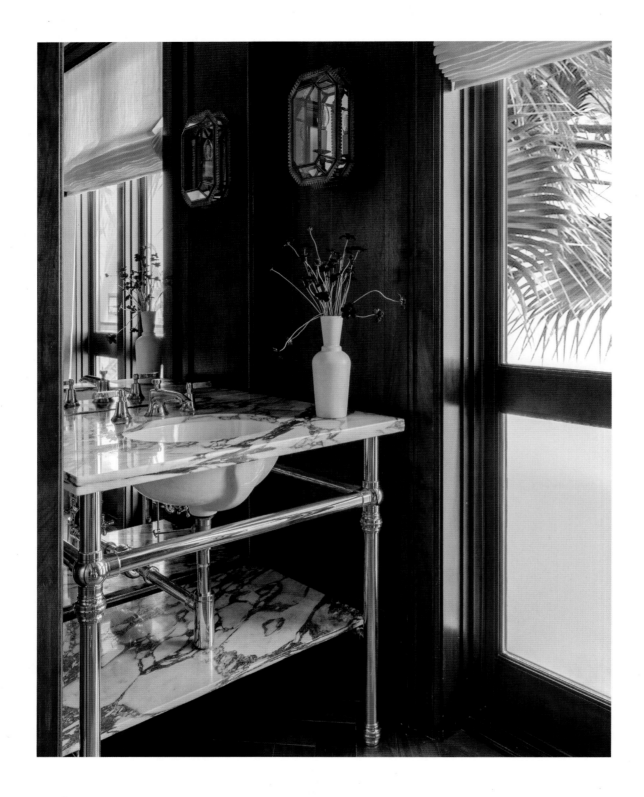

A visually light, stand-alone vanity, whether a converted piece of antique furniture or something custom-designed for the space, is a great choice for powder rooms. Glamorous accents like highly figured marble countertops and gleaming brass legs that frame a glimpse of decorative wall finishes add depth and a large dose of elegance to these small spaces.

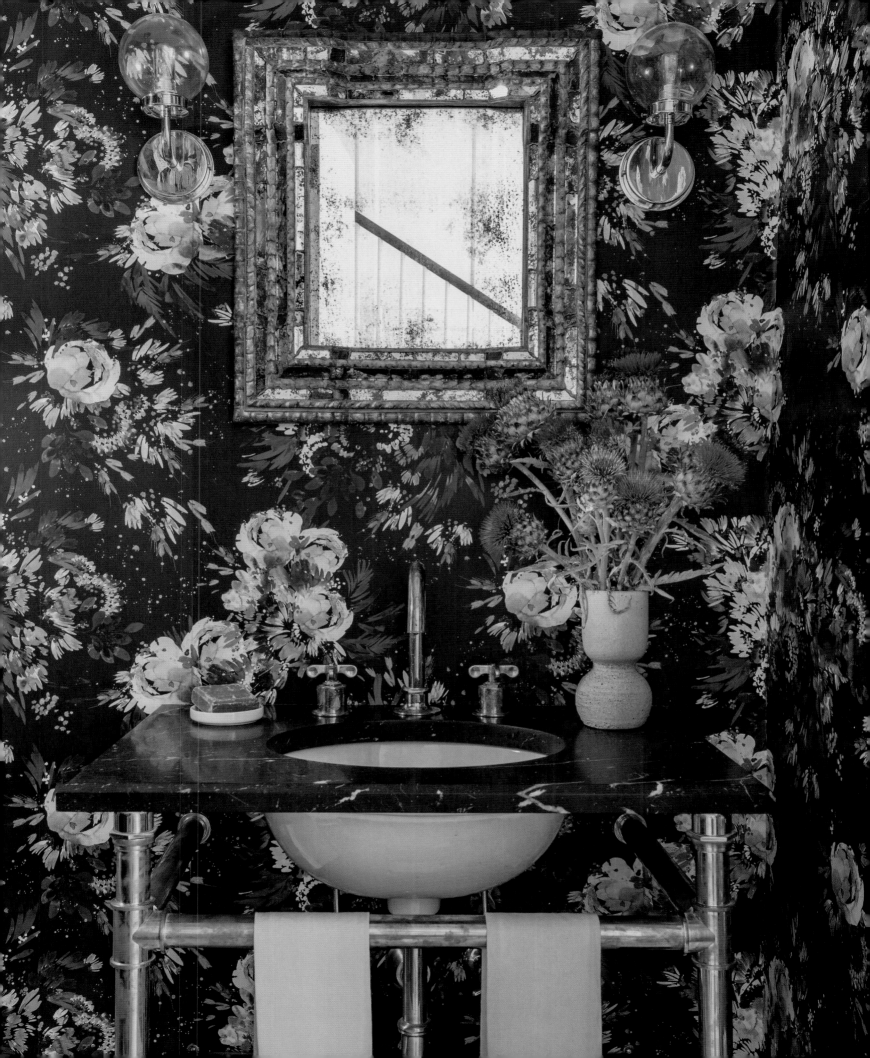

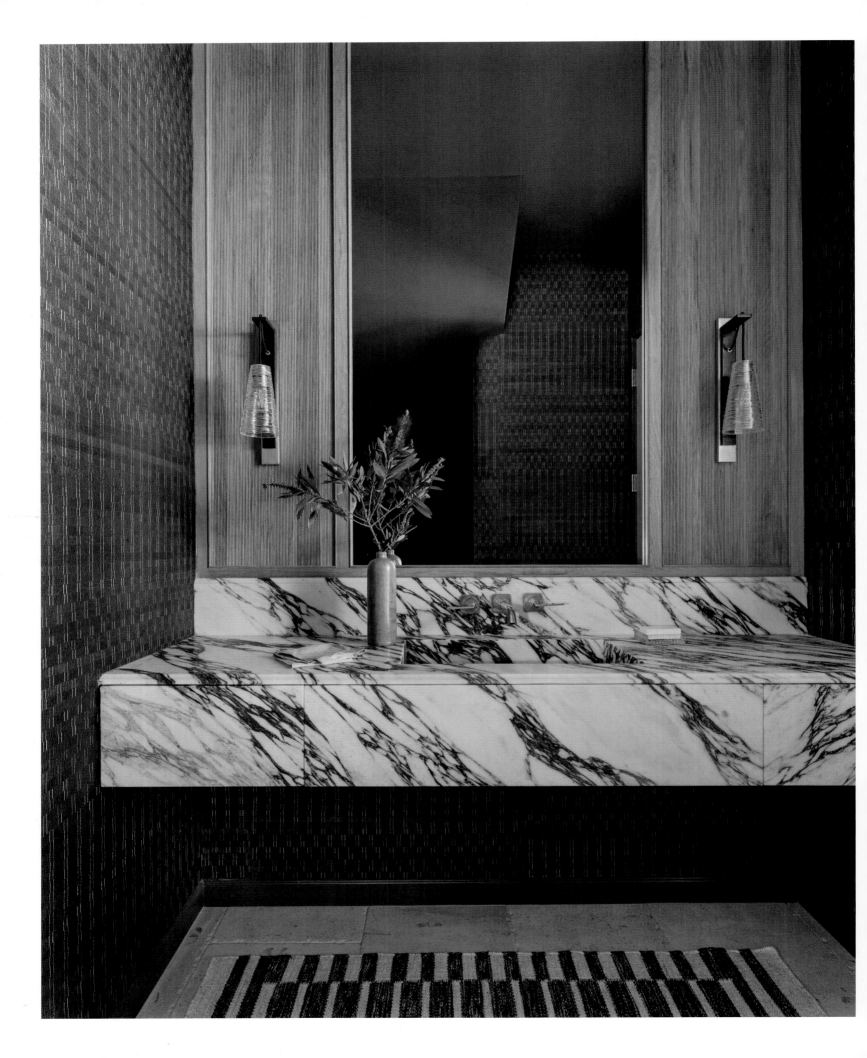

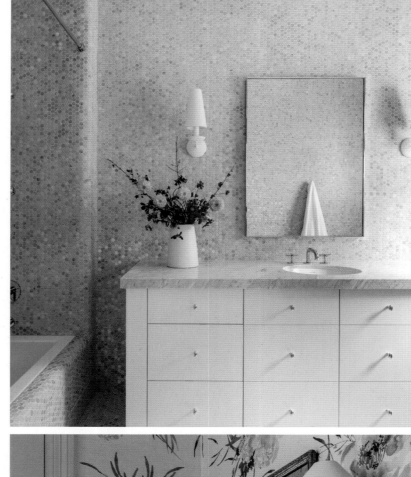

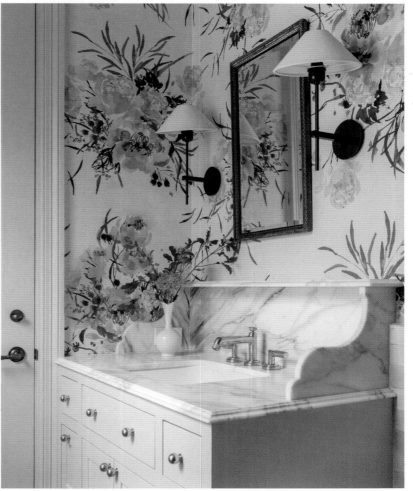

Sconces are essential lighting elements and elegant adornments

Pairing bold contemporary sconces with highly veined marble makes a powerful statement in a small powder room. Those with light-diffusing shades promote a serene mood. Whether mounted on fluted, stained oak, glittering penny-round tile, or wallpaper, properly placed sconces cast balanced lighting on the face while gently illuminating the room.

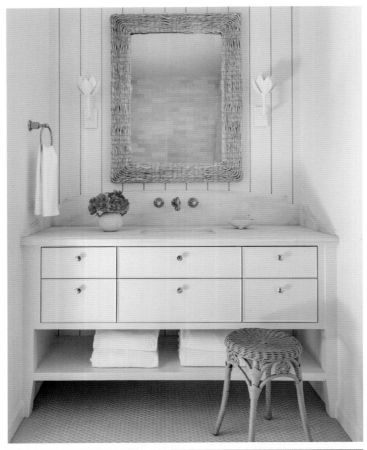

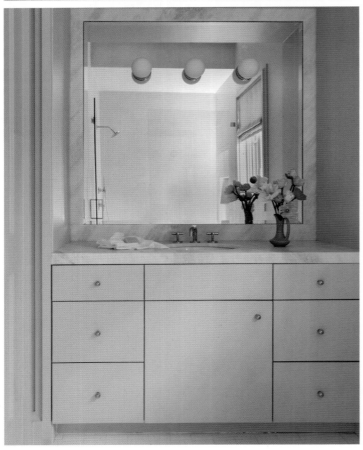

Color is key in children's bathrooms

Adults often want serene, neutral hues in their bathrooms, but children prefer a touch of fun. For girls, a monochromatic palette that pairs marble in a blush hue with pink walls produces a pretty, feminine atmosphere. Creative compositions of tile can bring color, texture, and pattern into the room. In one bathroom, we played with the spacing and color of grout lines surrounding highly textured, hand-glazed terracotta tiles for a whimsical, striped effect.

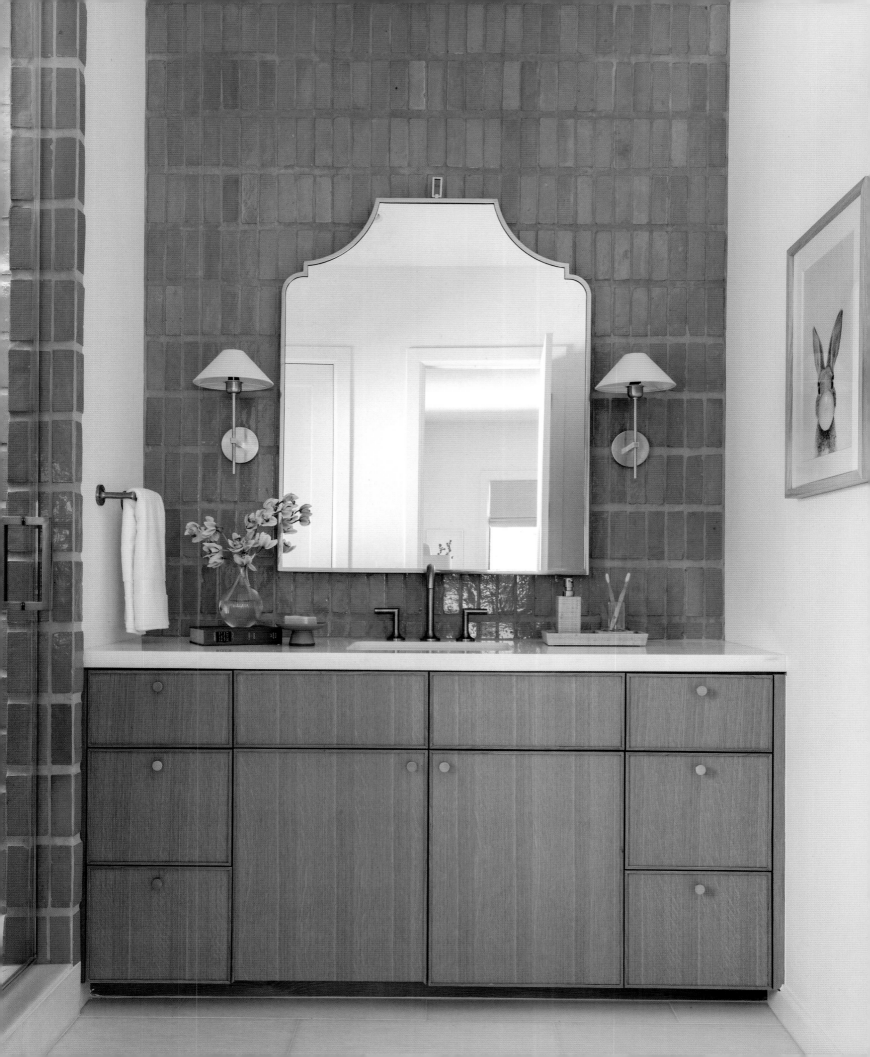

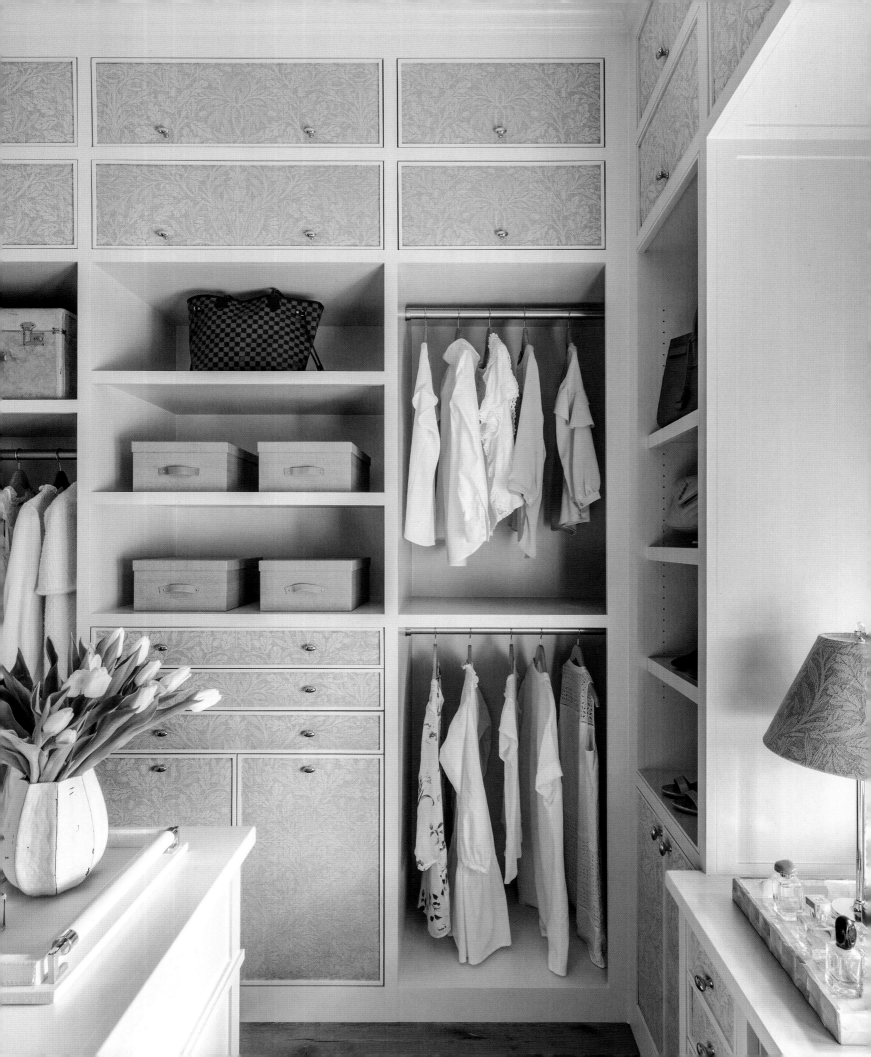

Dress

An impeccably designed dressing room simplifies daily
routines and fosters an atmosphere of tranquility and order.

Dressing rooms are among the most personal spaces in the house. While serving an important practical purpose, they can also be sanctuaries for self-care and quiet moments of solitude. The best ones provide a beguiling, boutique-like experience that accentuates clothing and accessories in ways that make them seem special and new again. I usually begin my design by assessing collections of clothing, handbags, shoes, and smaller items like sunglasses and jewelry to devise custom storage solutions for each. I prefer to combine closed storage with glass-fronted compartments and open shelves to balance efficiency with visual appeal. Typically, I plan for beautifully detailed closed-front cabinets or a dramatic display of shoes or purses to face the entrance, so the first impression is one of beauty and order. Practical wardrobe staples can be arranged next to the entrance where they will be hidden from direct sight most of the time.

Even though dressing rooms are usually small, I like to create multiple focal points such as an antique dresser under a window or a favorite piece of art. When possible, I include dramatically illuminated wall displays of colorful and ornamental accessories. Full-length mirrors also make striking visual statements. I love the way they reflect light, creating the illusion of a large room and amplifying its overall elegance. If space permits, an inviting seating vignette with an upholstered bench, a window seat, or lounge chairs with an ottoman further enhances the decor while also offering a place to perch during dressing and undressing and in moments of relaxation. In an apartment on Manhattan's Upper East Side, we found space for an elegant private office with a custom-made table of burled oak with tapered brass feet. Tucked into one of the quietest corners of the home, it offered a secluded escape for a busy mother of four children.

I gravitate to serene shades like soft white, blush, or gray to present a blank canvas for accurately judging the colors of clothing. In my dressing room, I covered the walls, ceiling, doors, and drawer fronts with textured wallpaper in shades of gray and white, enveloping the room in subtle pattern. Wallpaper, two-tone paint treatments, upholstered drawer and cabinet fronts, and antique wood furniture pieces rank among my favorite ways to enliven a neutral palette. The sheen of metallic drawer and cabinet hardware brightens the room's impression. I prefer unlacquered brass, polished nickel, and patinaed bronze because of their lustrous glow. Sometimes, I integrate leather on drawer fronts, pulls, or handles. I love the way it ages over time, bringing burnished, organic beauty into the composition.

Vanities offer myriad opportunities to enhance the dressing room's character. These can be built into the surrounding cabinetry for unity, but I also like repurposing an antique desk or writing table for counterpoint. An ornately framed mirror imparts a feeling of luxury. I often flank the vanity's mirror with decorative sconces strategically placed to illuminate the face without harsh light or shadows. A chandelier, preferably centered above an island, adds another opulent touch. Other components of a layered lighting scheme include natural light controlled by drapery or roman shades, recessed overhead and task lighting, and LED strips that highlight items displayed in open cabinets and make things easier to find in closed ones.

I always look for ways to integrate meaningful treasures that reflect individual style and history—heirloom furniture, family portraits, or a favorite string of pearls in a trinket dish. When arranged in customized velvet trays and divided drawers, even everyday items like scarves, sunglasses, and watches assume importance as objects of beauty worthy of careful consideration. Such attention to detail and order transforms the act of dressing and undressing from a routine to be rushed through into a serene, pleasurable moment that encourages you to meet the challenges of the day ahead with calm and purpose and to end it in tranquility.

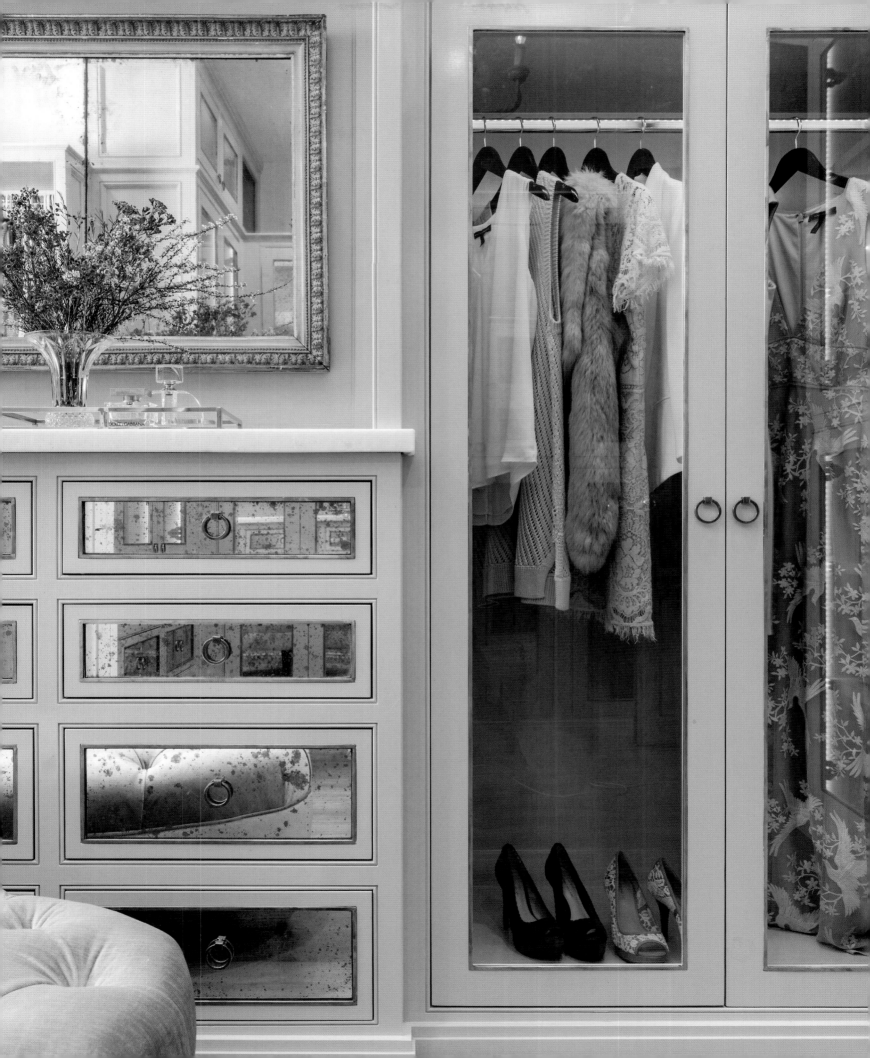

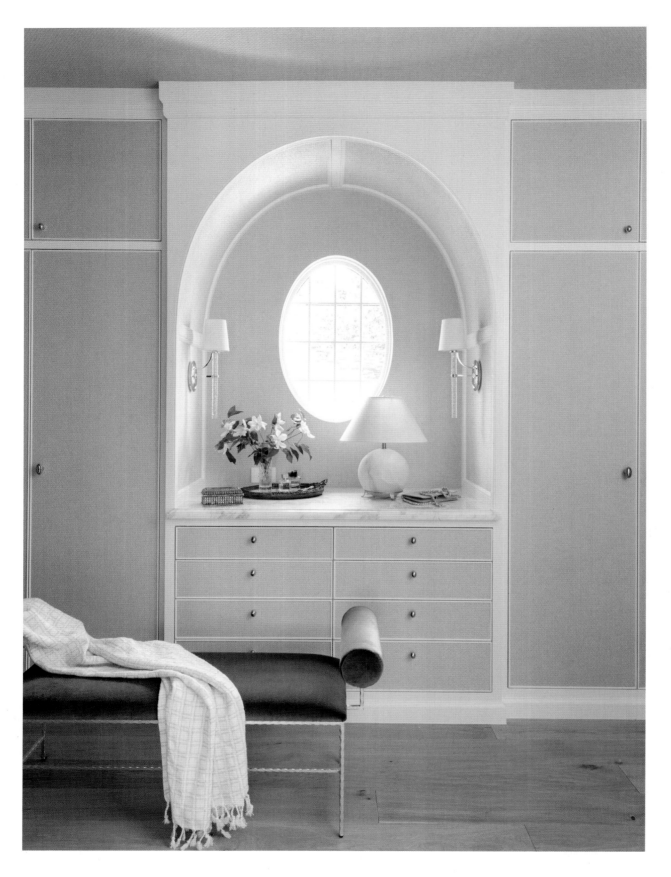

Efficient organization is the hallmark of a well-designed dressing room. Utilizing a combination of open and closed storage solutions balances functionality with visual appeal. Look for ways to create focal points, whether it's a window, a display of shoes and handbags, or a well-appointed packing table. Indirect lighting that illuminates items makes them feel special and new again.

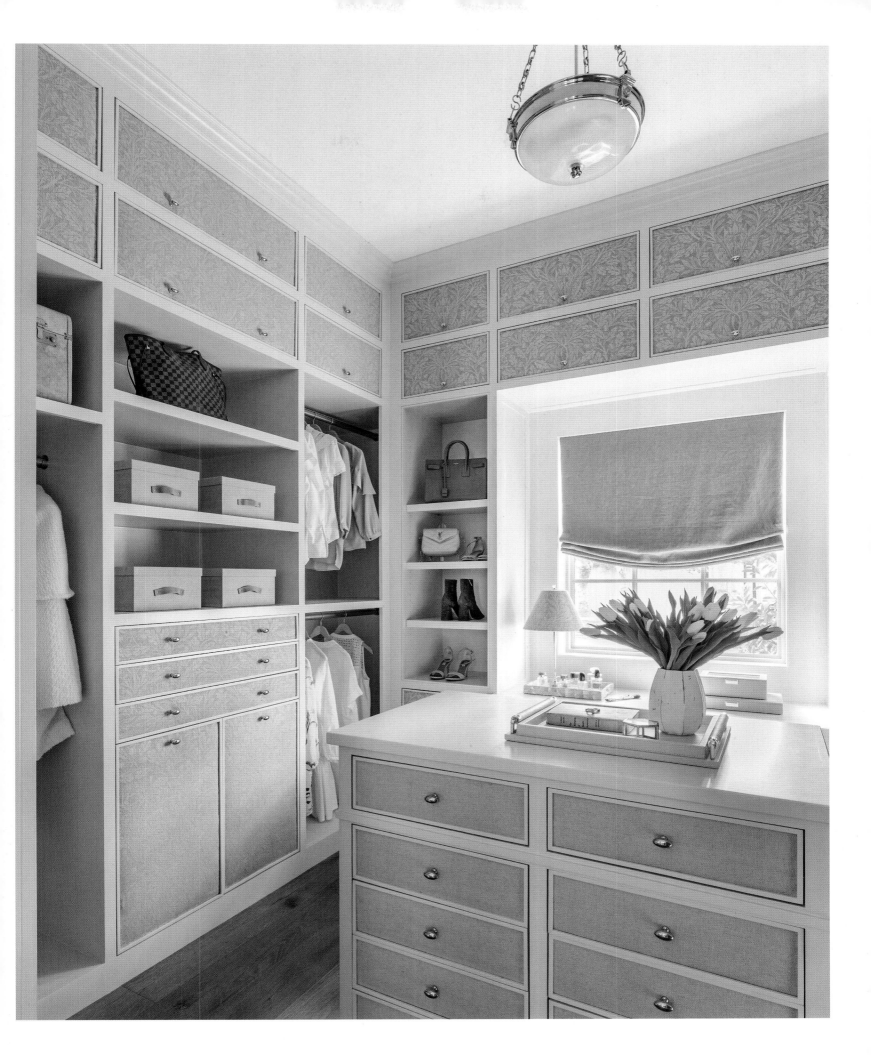

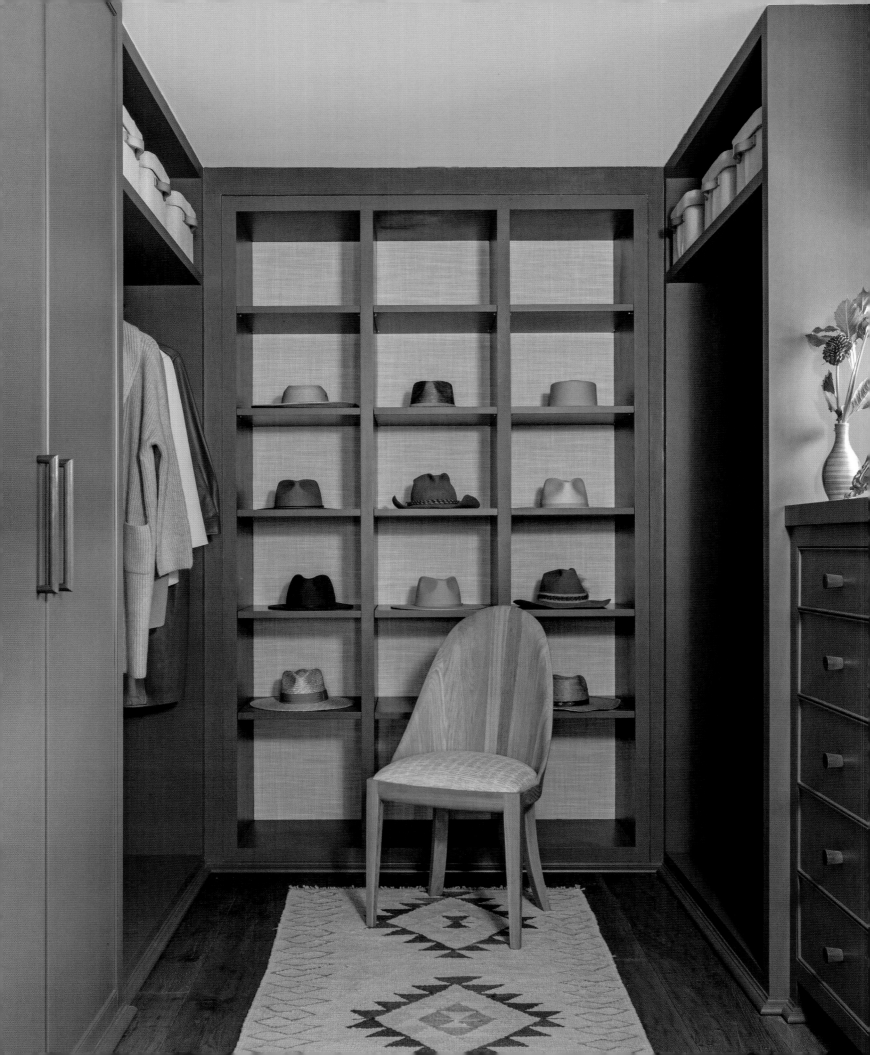

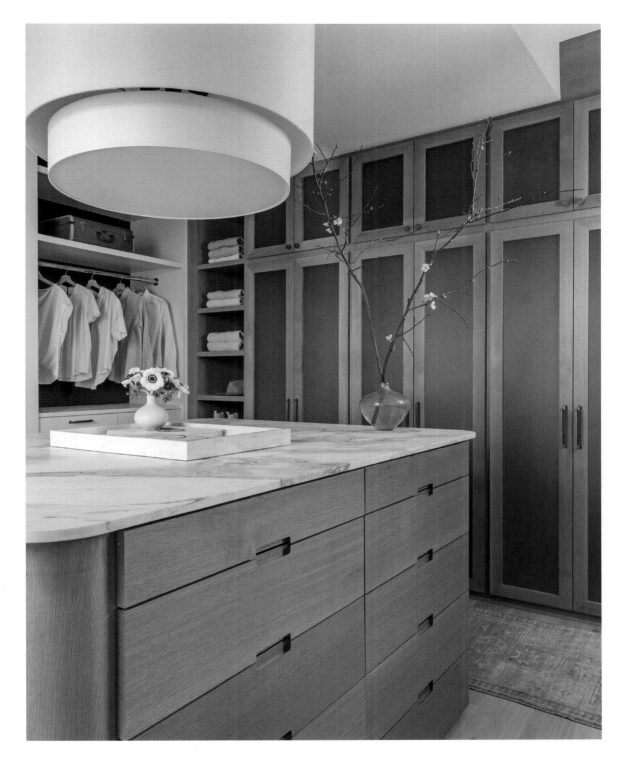

Make a statement in dressing rooms

Dressing rooms tend to be small spaces, but that doesn't mean they shouldn't possess strong features like marble-topped islands, overscale light fixtures, saturated paint colors such as tawny rust or deep blue, and patterned rugs. These lend character and enhance the pleasure of being in these intimate rooms.

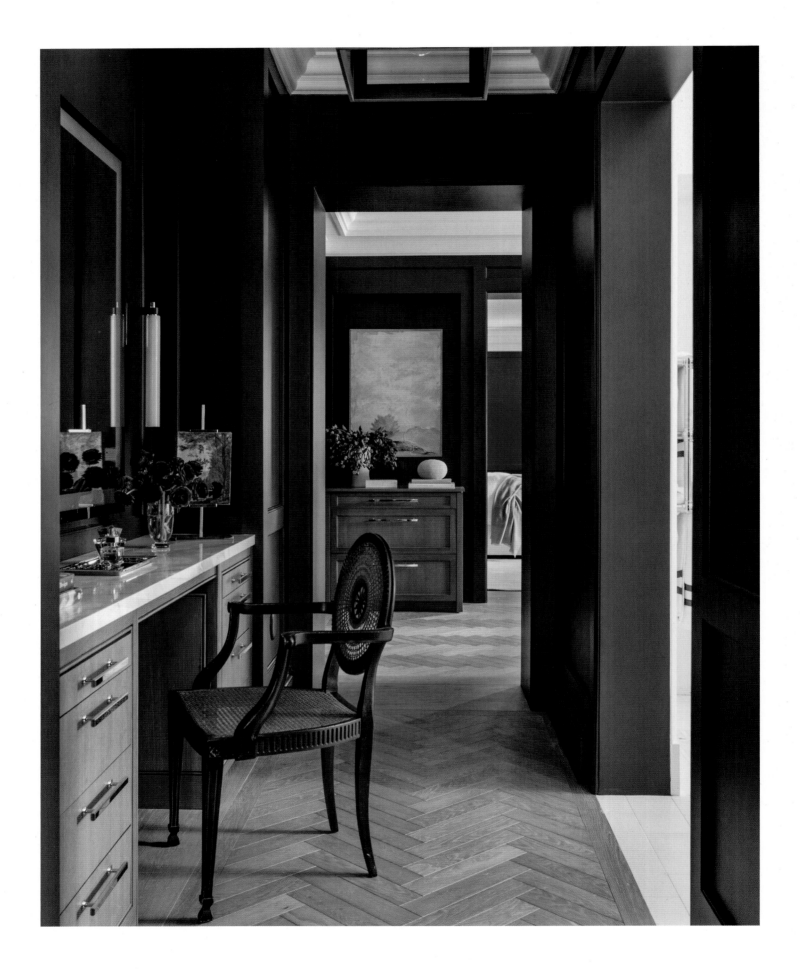

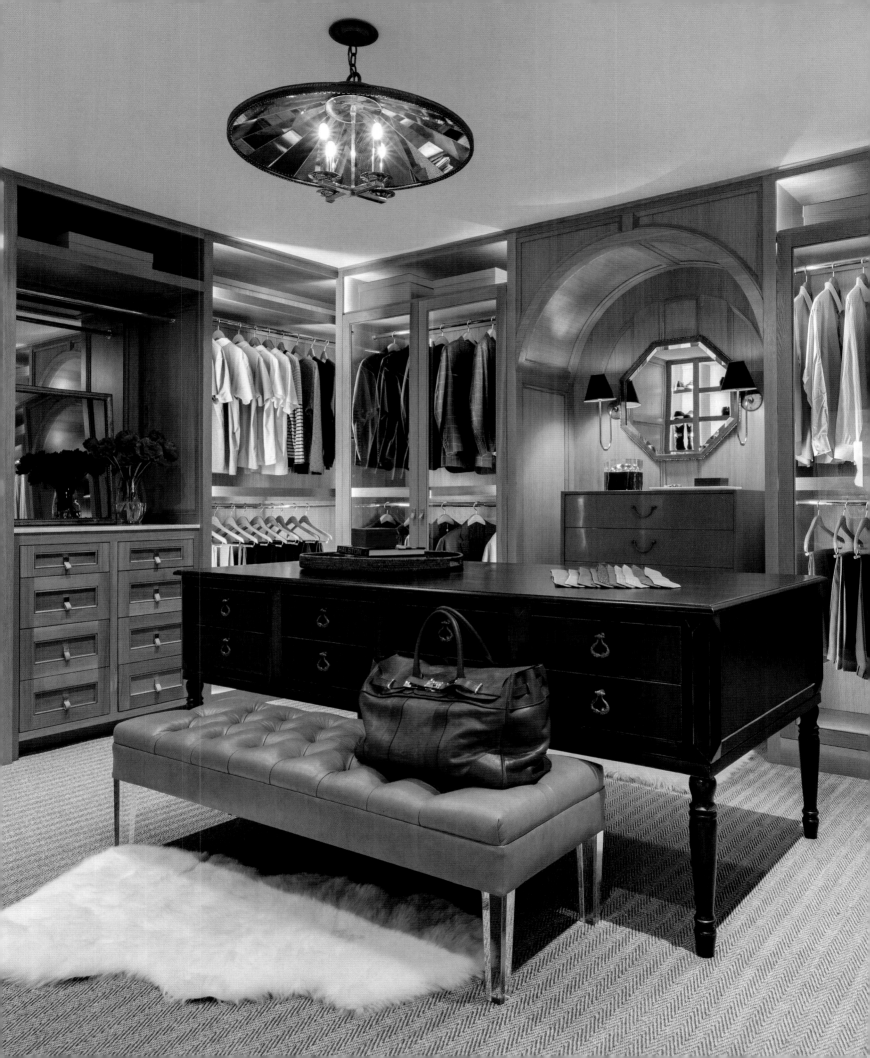

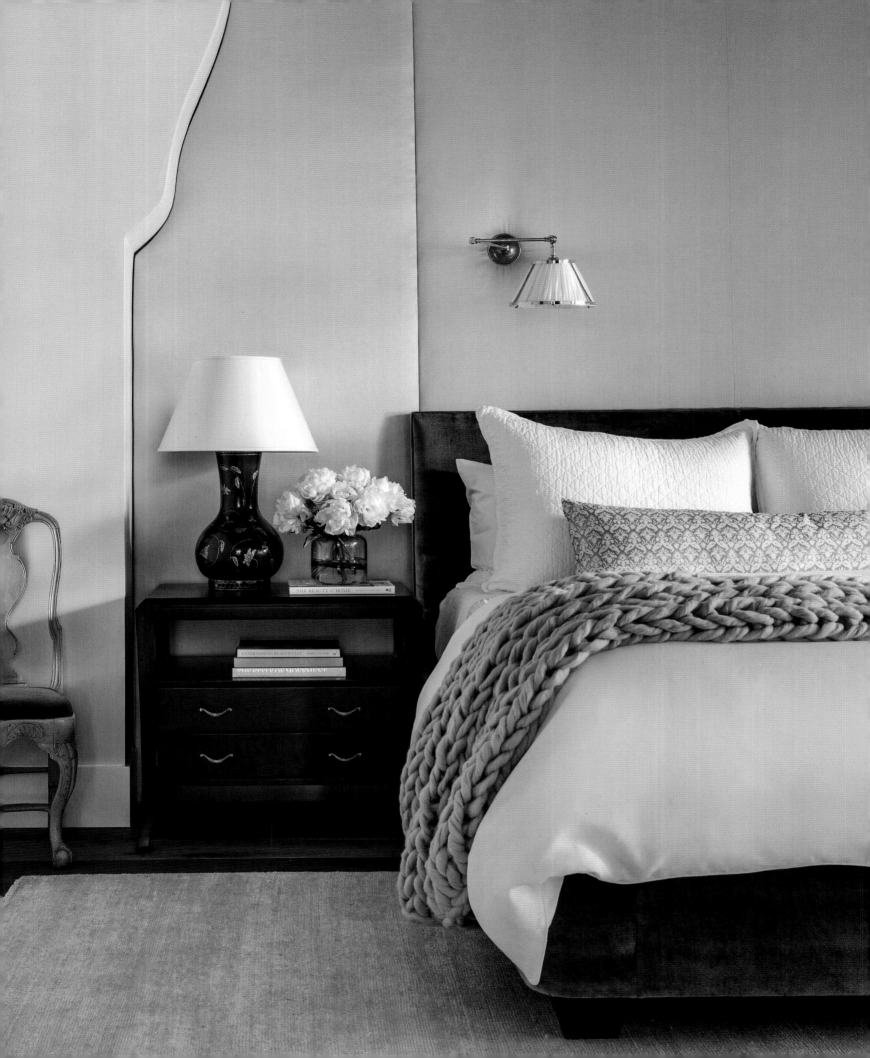

Repose

The bedroom is a private sanctuary and comforting
haven where we find rest, rejuvenation, and retreat
from the demands of everyday life.

The bedroom is a personal retreat where we can let down our guard to rest, recover, and recharge. The ultimate hideaway, it should be exceedingly comfortable and carefully curated to promote relaxation, restorative sleep, and quiet moments with the ones we love. I like to signal the transition into this private realm with a distinctive entry—double doors, antique ones, or doors upholstered with fabric or wrapped in leather. Varied ceiling treatments also distinguish these intimate rooms from the shared spaces of the house. Vaulted plaster, painted planks, tongue-and-groove paneling, reclaimed wood beams, and coffering each shape the mood in a different way. For a bedroom in a casual beach house in Galveston, Texas, we clad the ceiling in planking painted glossy white to reflect the coastal light and create a relaxed impression. On a horse farm in Austin, Texas, we chose highly textured, hand-hewn oak beams that echoed the rustic landscape framed by huge steel-and-glass windows.

The bed is the most important piece of furniture in the room, so it demands careful attention. Whether antique or modern, statement frames with posts or canopies instantly make a strong impression. Lavishly upholstered headboards also draw attention where it is due. Integrating the bed into a niche or paneled wall unites it with the architecture while also creating the appearance of an oversize headboard. In such cases, I often layer in a small, upholstered headboard for comfort and texture. Beds should always be dressed to coordinate with their immediate surroundings. I like layering varied textures like linen, velvet, and silk for an inviting sensory experience. Decorative trim, eyelet stitching, and patterned embroidery demonstrate that every detail has been considered. Fine bed linens of cotton sateen or percale, bamboo, linen, or silk and duvets with sumptuous covers add the final extravagant touch.

The number of furnishings in the bedroom is limited, so what you choose has a major impact. For a comfortable, collected look, I prefer mixing understated upholstered furniture with vintage objects and modern pieces. I often position identical nightstands beside the bed but also love repurposing unmatched antique tables or dressers of similar height. Whatever the bedroom's size, it's essential to include seating that meets practical demands like putting on shoes as well as encouraging leisure activities like reading or meditating. At minimum, one comfortable chair should be provided. A dedicated seating area nestled into a bay window or beside a fireplace complete with lounge chairs or chaises, an ottoman, and a cocktail table is an indulgent luxury. But you can create your own private living room by placing a bench or sofa at the foot of the bed opposite a pair of chairs.

For one family, we created a special room adjacent to the bedroom where the parents and children could begin each day with prayer and contemplation. Walls upholstered in suede, silk rugs, and plush linen chaises encourage complete quiet, focus, and serenity. The room's subdued palette of mossy green and gray, accented by the deeper green of velvet upholstery and golden tones of the walnut mantel and trim produced an environment simultaneously calming and uplifting.

Although guest rooms tend as a rule to be less personal and more understated than primary bedrooms, they should still offer the same degree of comfort, elegance, and functionality. Thoughtful touches that pamper guests such as fine linens, a bedside table that doubles as a writing desk, charging ports, fresh flowers, and a basket with snacks, magazines, and toiletries make them feel at home. So often, people focus most of their attention on entertaining and family gathering spaces, giving less consideration to these private sanctuaries where they spend so much of their time. I suggest a shift in priorities. It's well worth the attention and effort it takes to create exceptional bedrooms that promote bodily and spiritual replenishment. Everyone will leave the better for it, ready for another day.

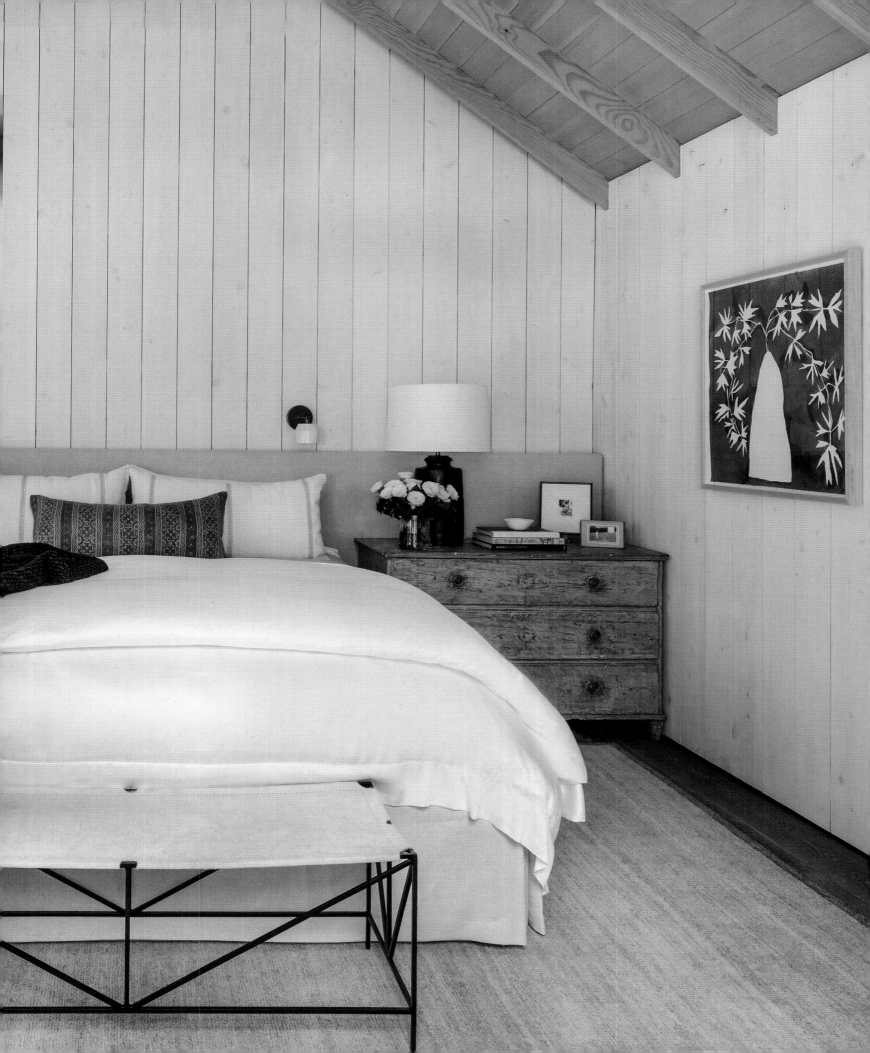

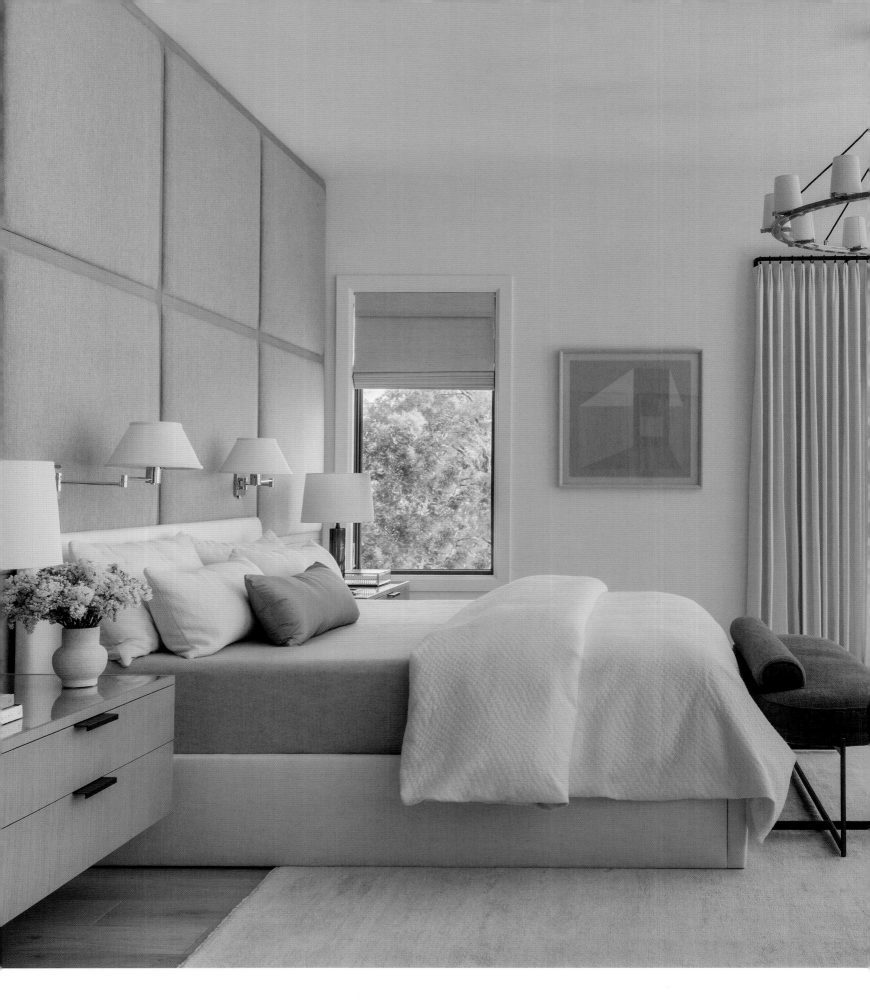

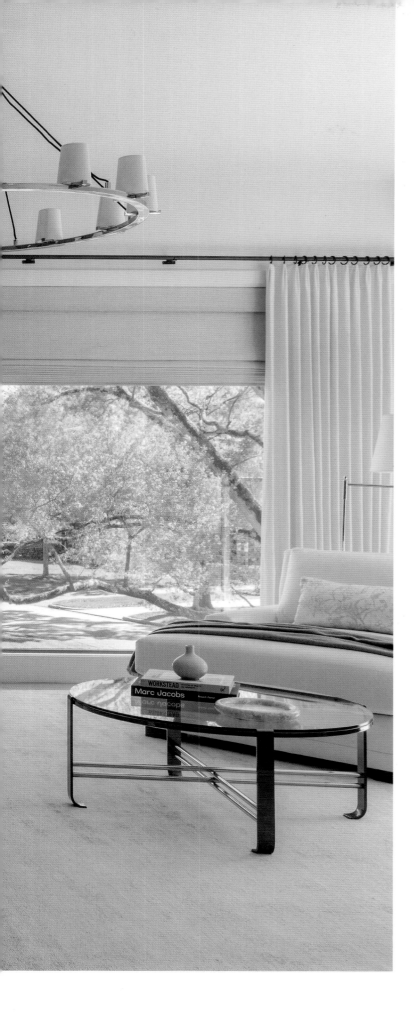

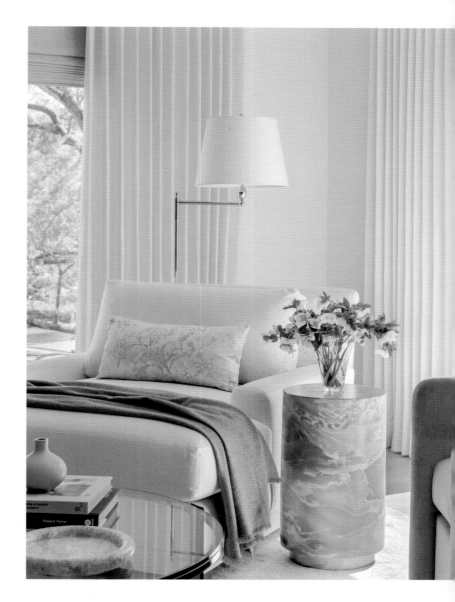

An illumination plan that combines ambient and directional light from multiple sources is essential in bedrooms. In addition to dimmable overhead lighting and lamps on dressers and bedside tables, I like to position adjustable sconces for reading above or next to the headboard. Bedrooms are my favorite place for layered window treatments including textured roman shades, sheer curtains, and opaque, black-out drapery.

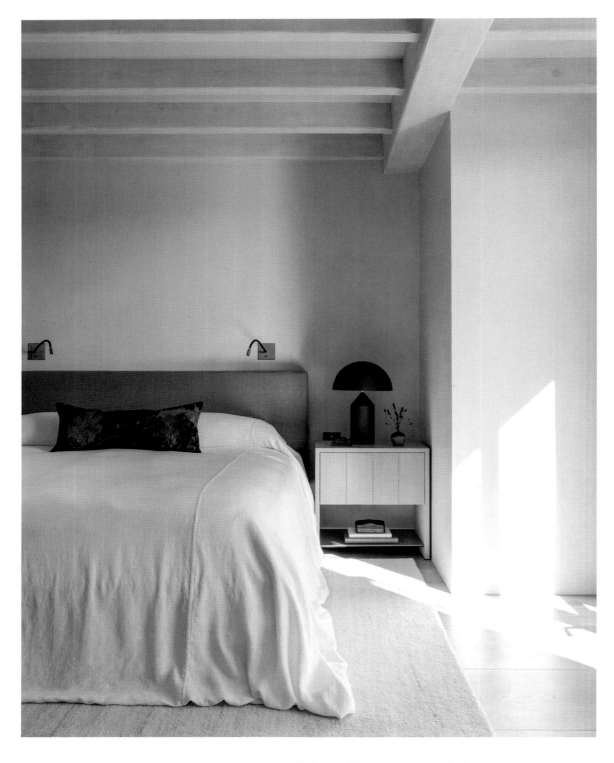

Soft bedding is a delight to the senses

Textiles play a critical role in creating a luxurious and comfortable bedroom experience. Percale, cotton sateen, and linen are some of my favorites for bedding. Often, I layer varied textiles through sheets, duvets, coverlets, and shams to compose a lush bedscape. High-pile rugs of silk and alpaca wool offer a moment of luxury when you first step out of bed.

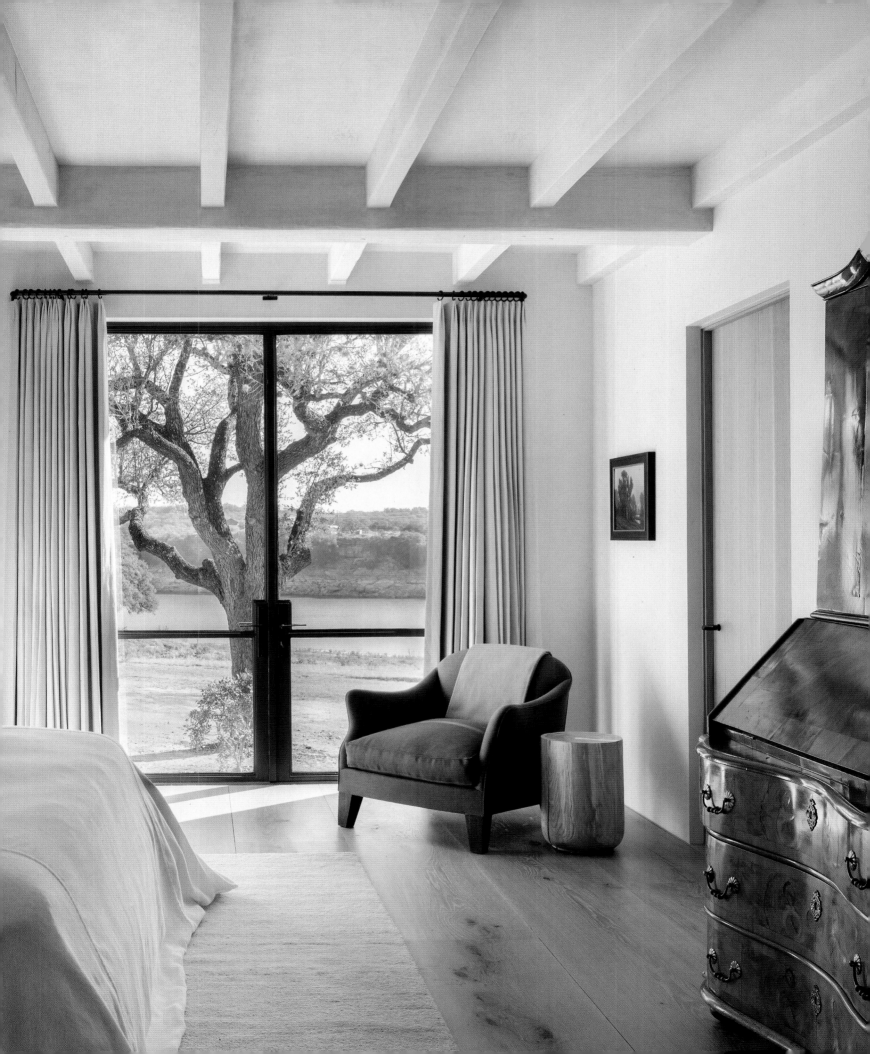

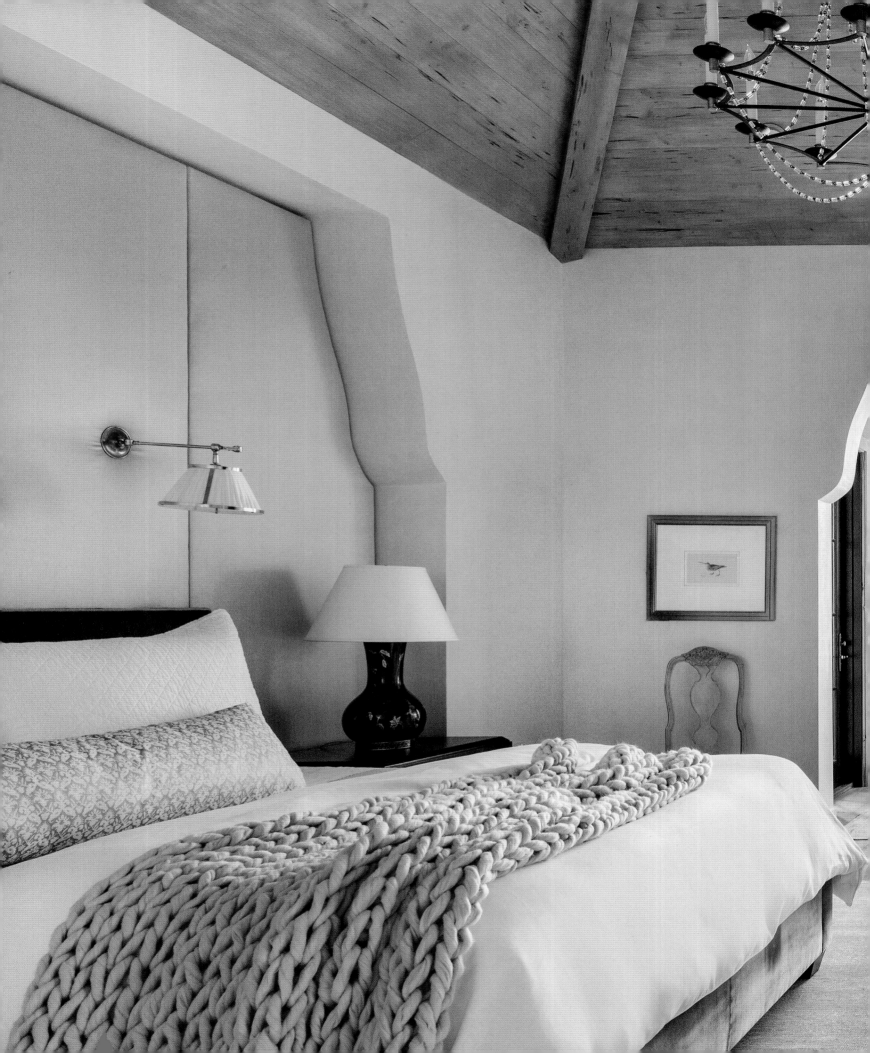

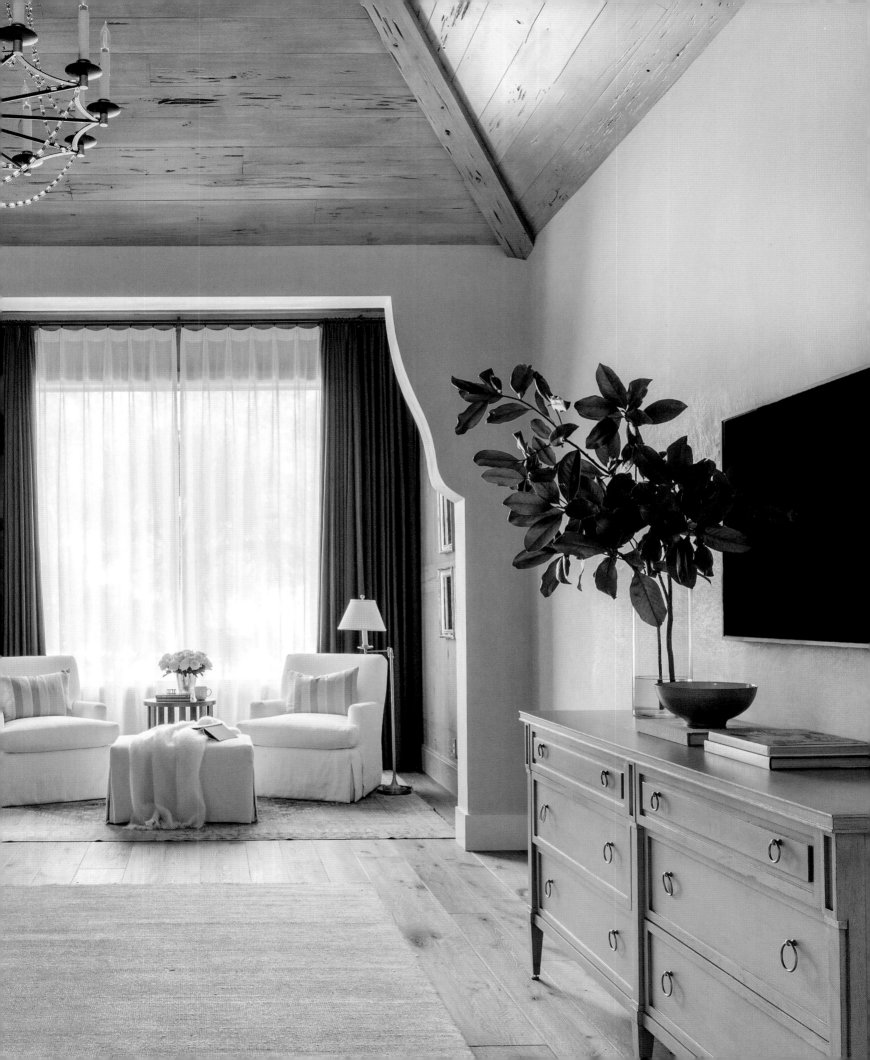

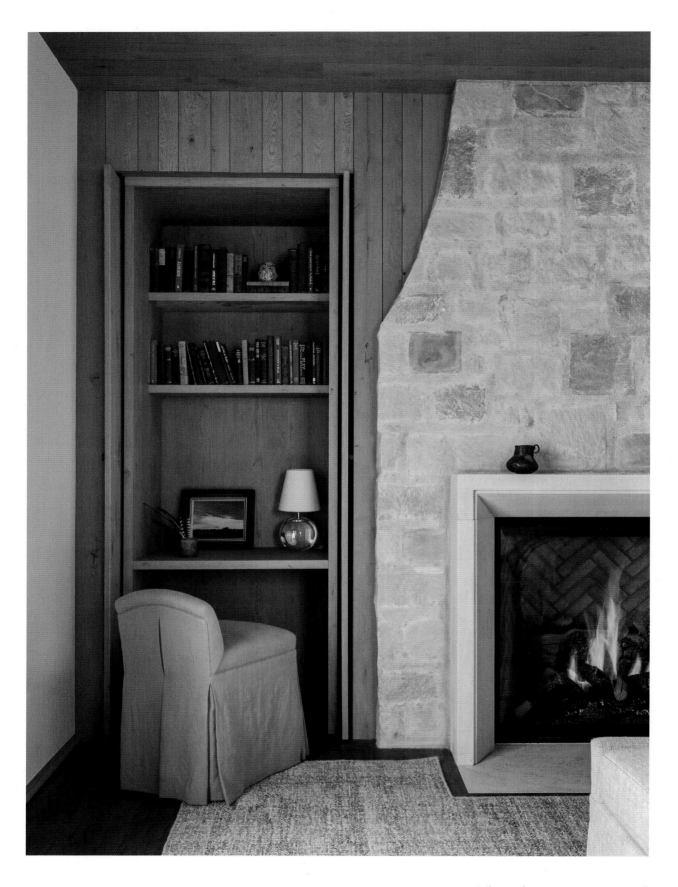

Consider the unexpected

Natural materials like rough-cut or carved stone, quarter-sawn wood, and hand-applied plaster create a cozy atmosphere in bedrooms. Find creative ways to integrate shelving and writing desks into the architecture. When fitted with pocket doors, these can be hidden from sight when not in use.

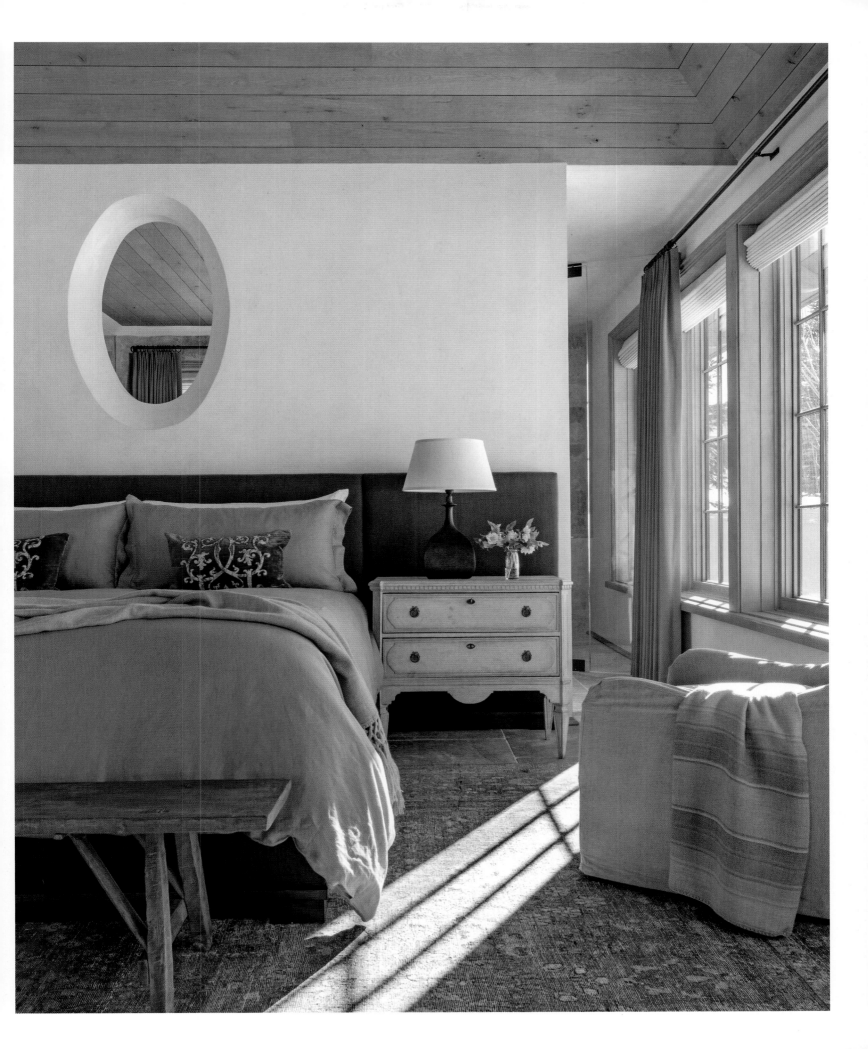

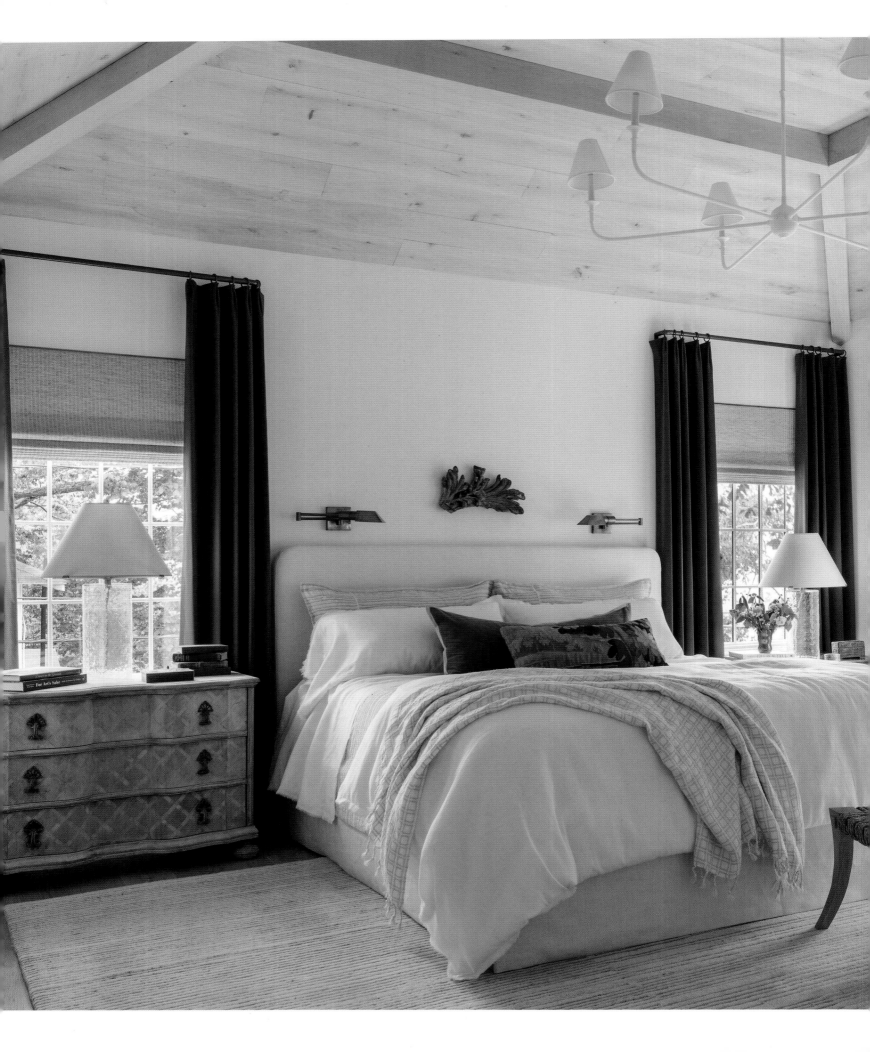

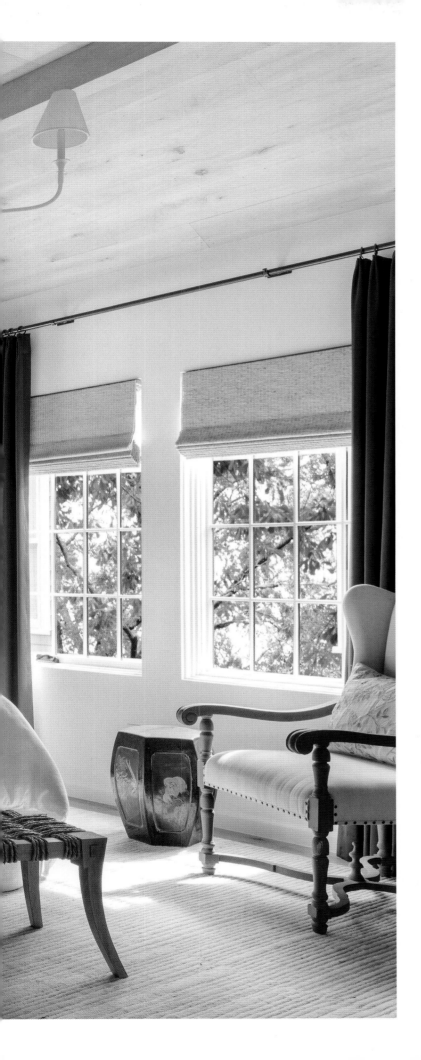

Choose colors that enhance rest and relaxation

Neutrals such as beige, cream, ivory, and soft gray serve as a canvas for layering in saturated tones. While shades of blue, from deep indigo to powdery pale, evoke tranquility, earth tones like brown, taupe, and rust conjure feelings of warmth and comfort. For a dreamy atmosphere, I use pastel tones such as blush, lilac, and mint green. If I want to energize the room, I introduce bold color through accents like artwork, pillows, drapery, and upholstery.

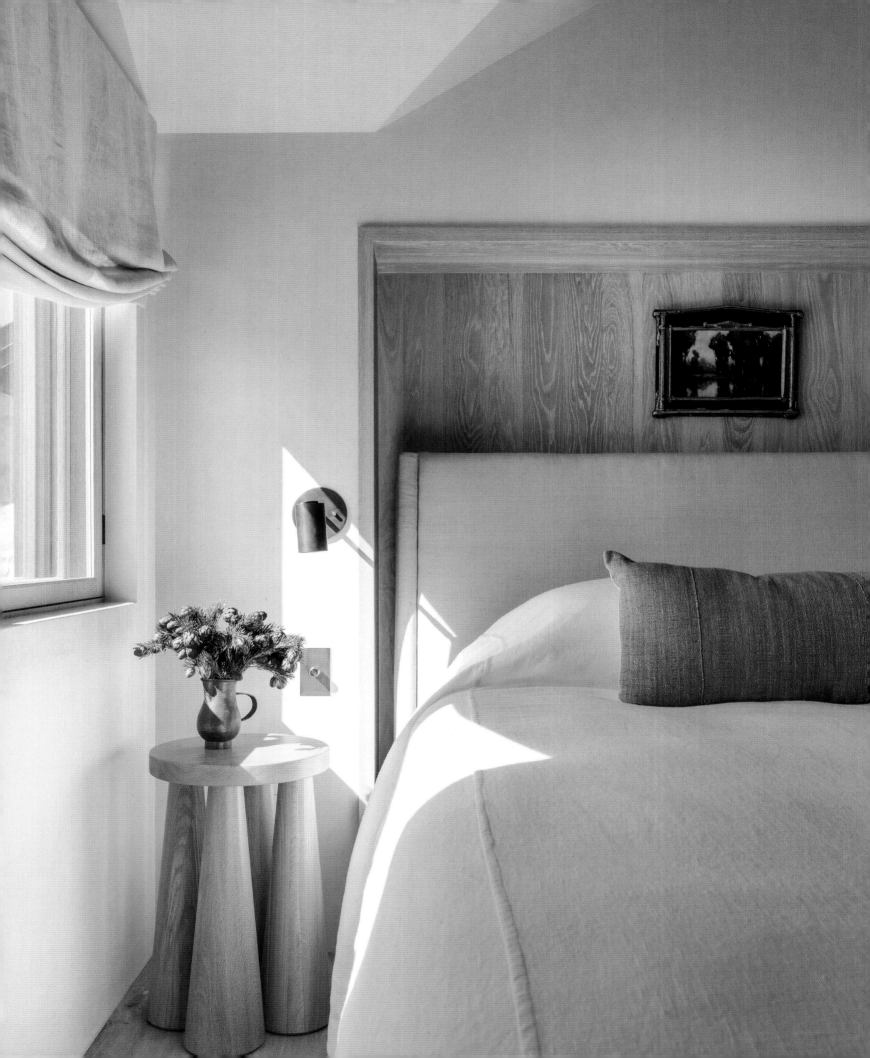

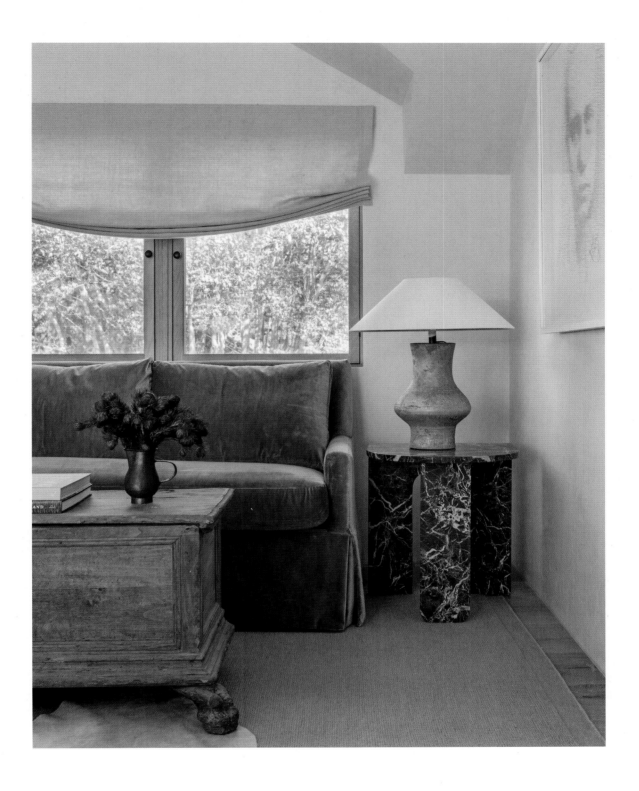

Recessing the headboard into the wall subtly accentuates the bed without the help of elaborate bed frames or canopies. When possible, I tuck a small sitting area into an alcove or beneath a window to accentuate the bedroom's character as a private retreat.

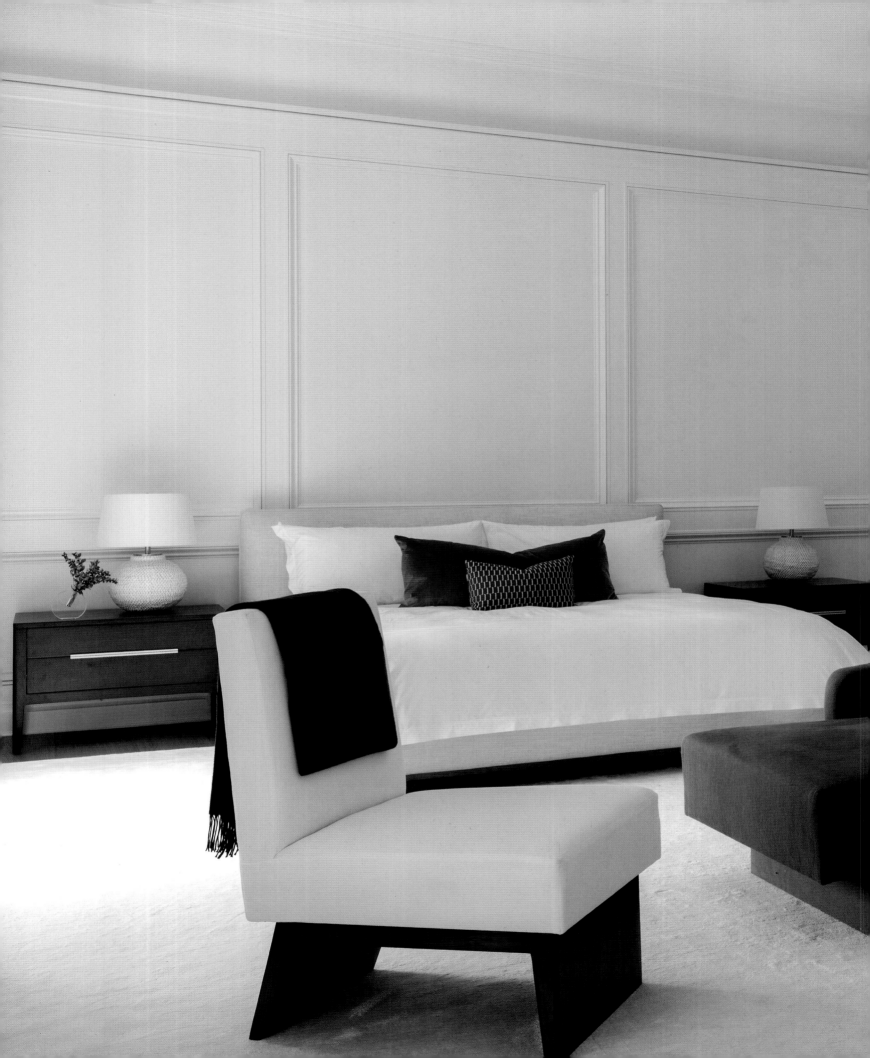

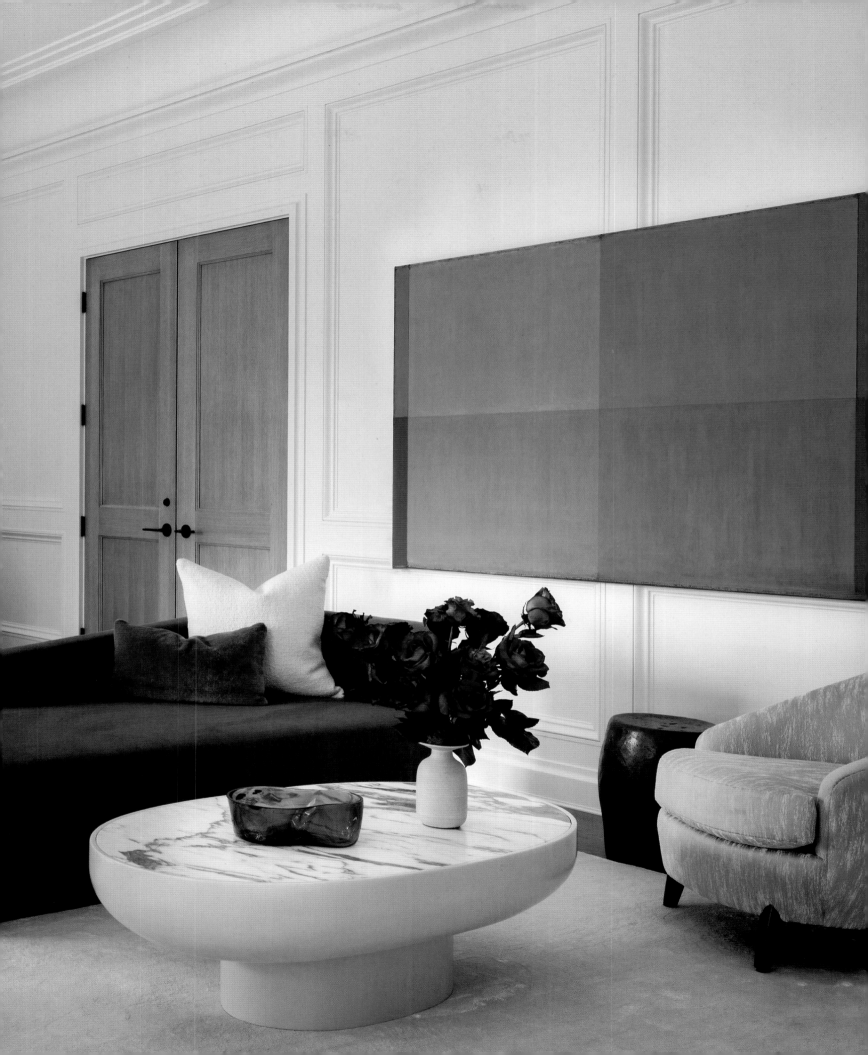

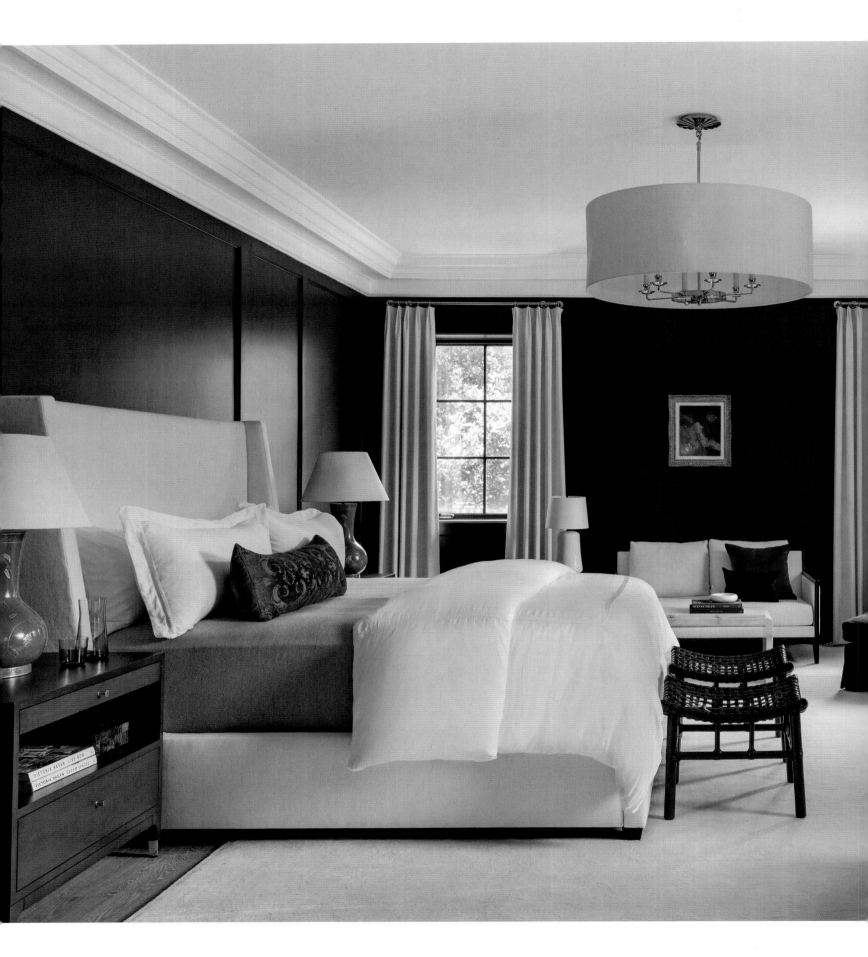

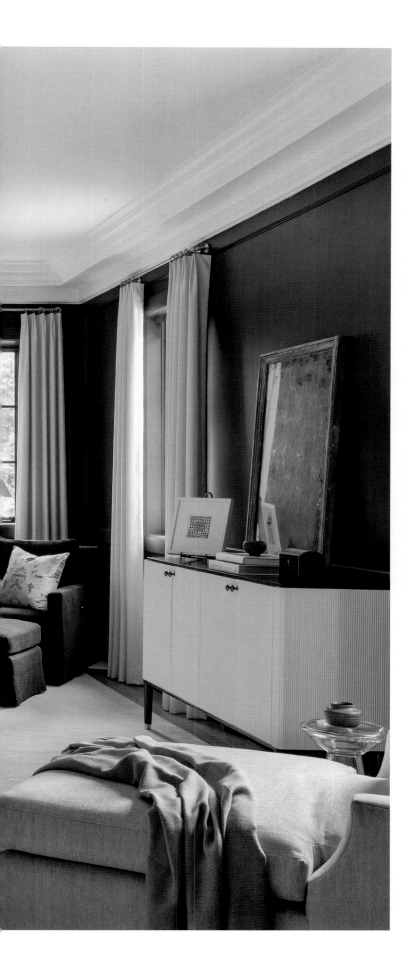

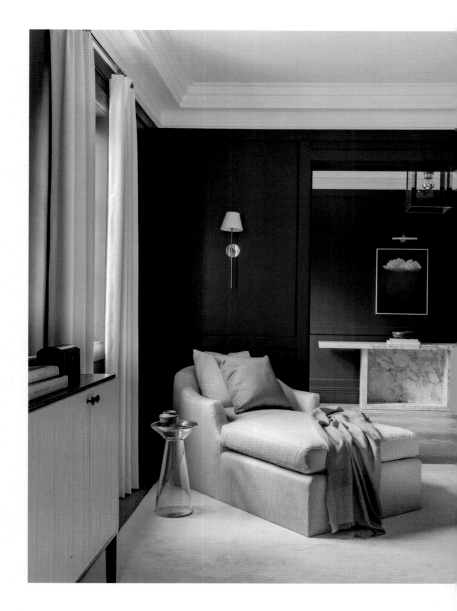

When walls are painted in deep shades of blue or green, the bedroom feels like a cozy cocoon. Frequently, I enhance dark paint colors by framing them with white trim. Then I infuse subtle neutrals into the space through bedding, carpets, and upholstery, creating contrast and imparting a quality of lightness to rich, saturated palettes.

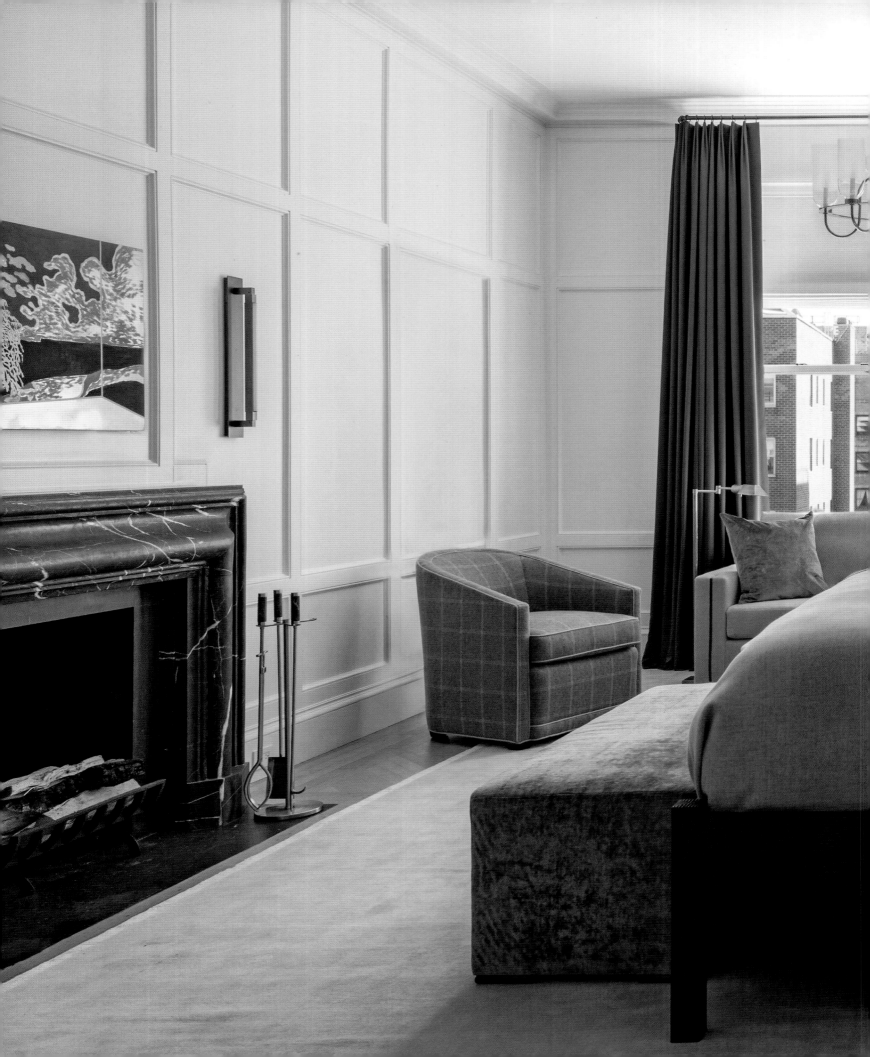

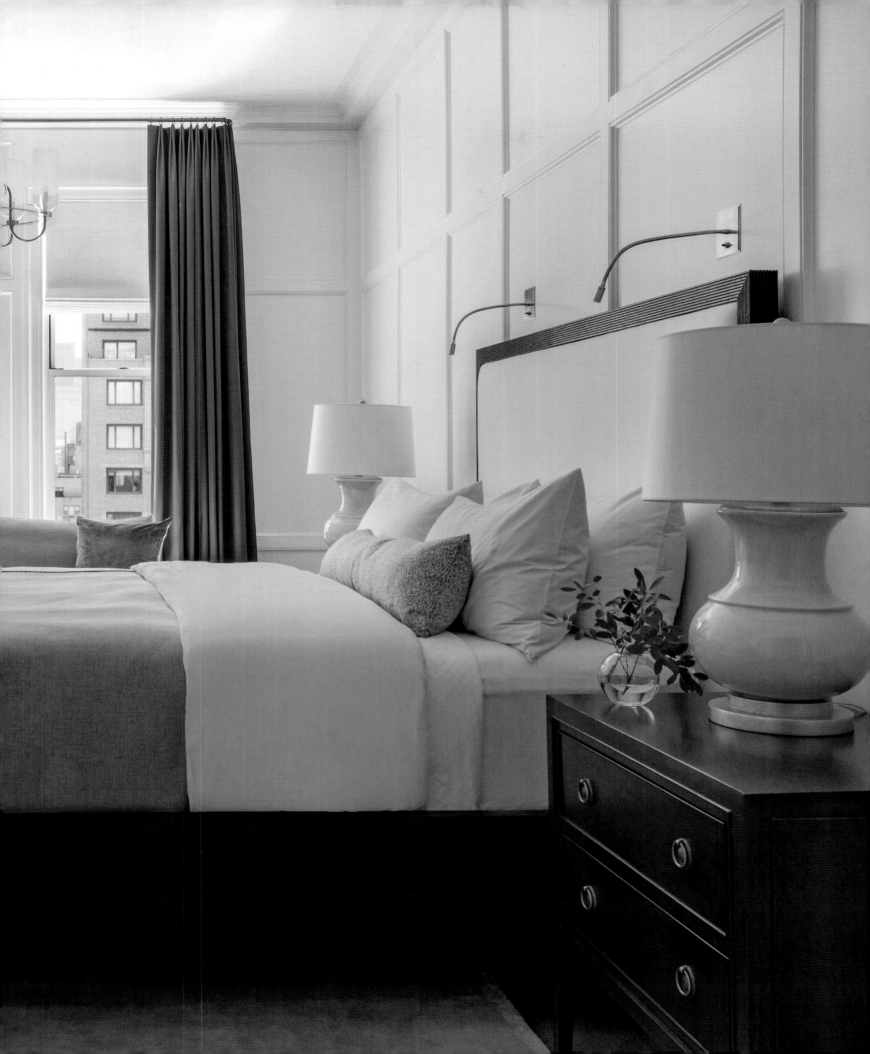

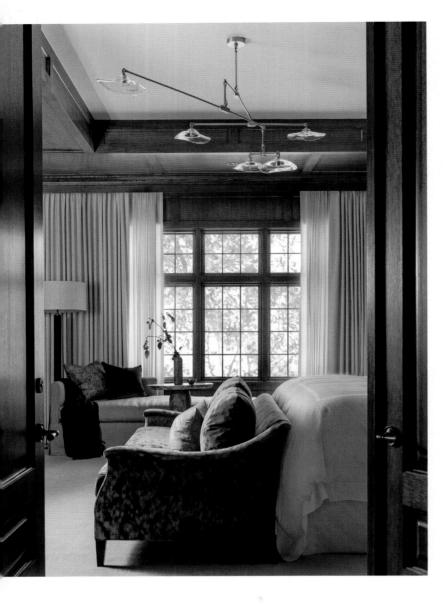

Wrapping a bedroom with paneling cultivates a restful and inviting atmosphere. Daylight accentuates its ambience. At night, the warm, natural beauty of wood envelops you in comfort. Oak and walnut are among my preferred choices for their exquisite grain and depth. Juxtapose dark walls and ceilings with light upholstery, bedding, rugs, and drapery to brighten and soften the palette.

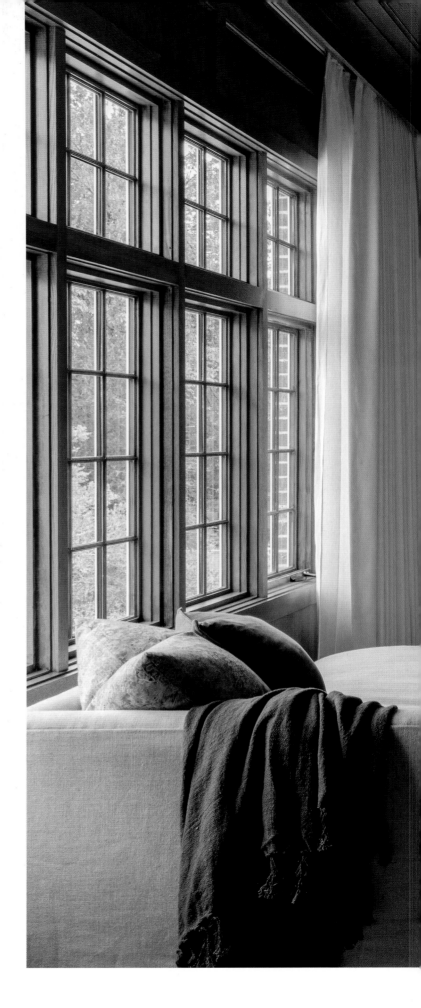

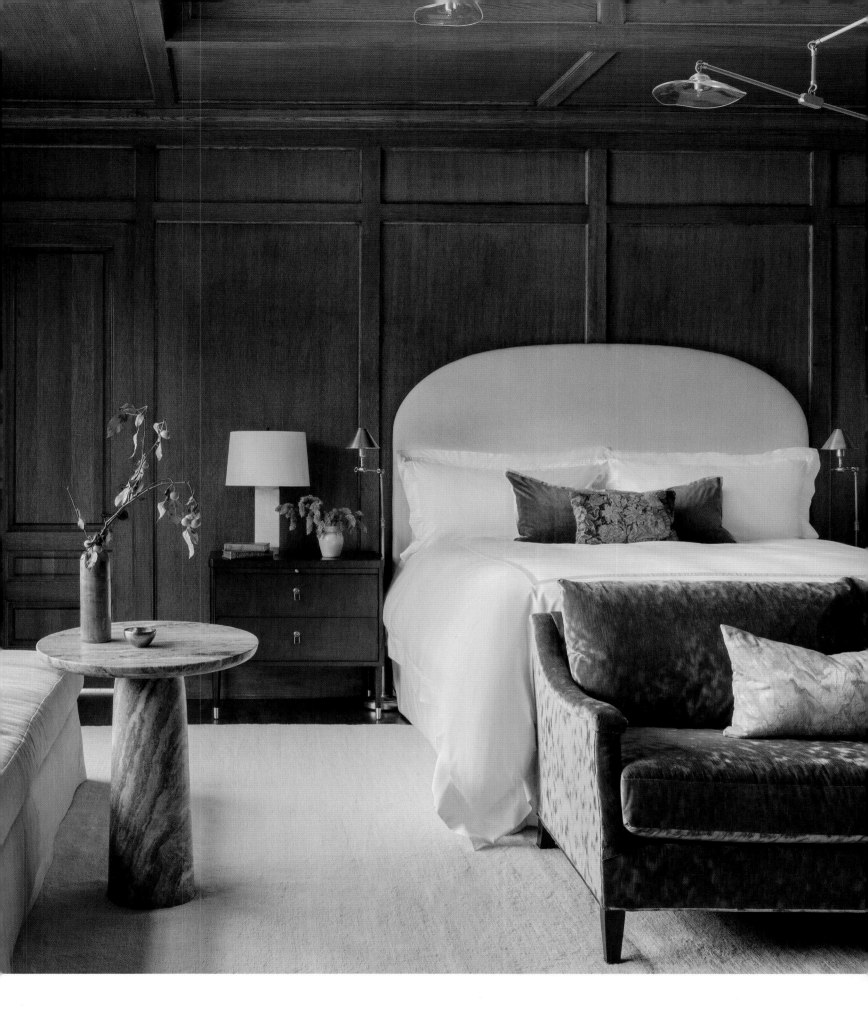

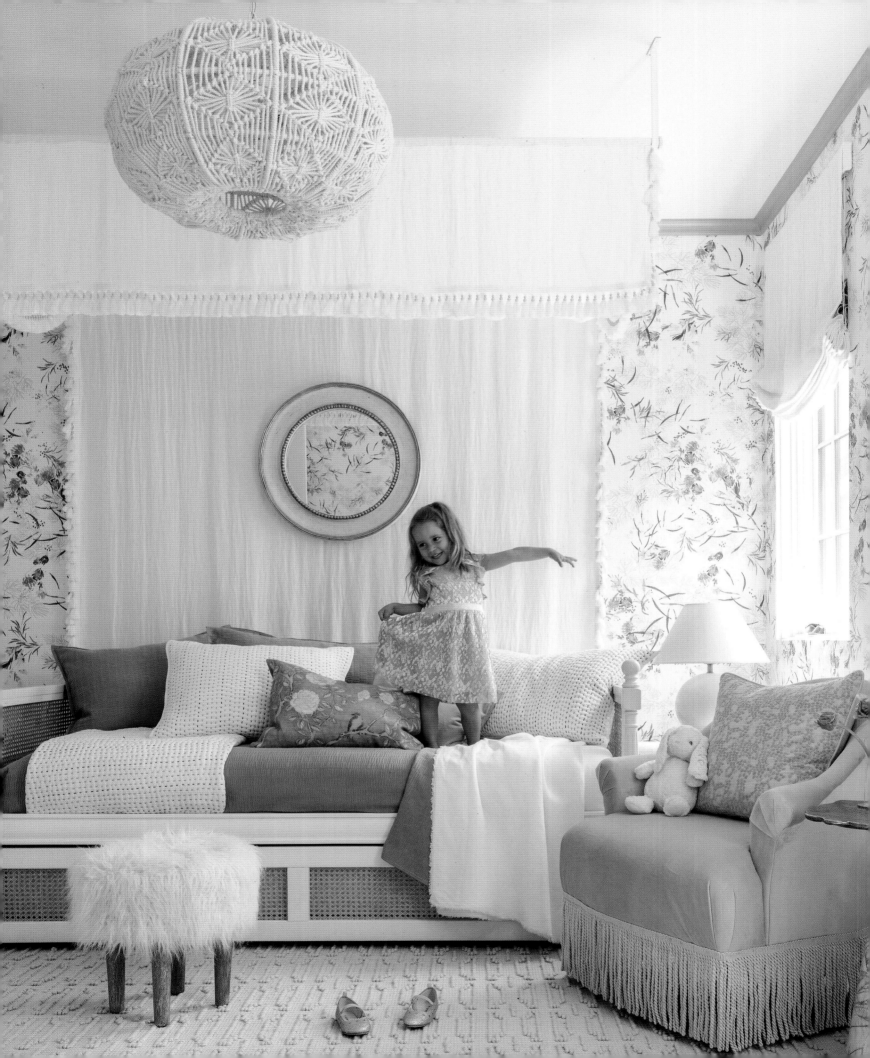

Play

Children's rooms should foster personal growth and self-expression, nurturing curiosity and sparking inspiration.

Children need a space uniquely theirs, where they can enjoy quiet time and express their creativity by themselves or with friends and family. Daily rest and recreation are critical to their emotional and psychological well-being. Providing environments that meet these needs, whether a dedicated playroom or a bedroom with a corner in which to read, make art, or play is one of the most beneficial things we can give our children. Have fun with the design of these spaces and encourage young family members to witness their personal preferences being brought to life. Whimsical murals, imaginative activity areas, or themed decoration set the stage for young people to express their individual personalities. If the room is shared with a sibling, make sure everyone's priorities are met, possessions displayed, and preferences considered.

Children have an affinity for vivid shades that engage the senses and stimulate cognitive processes, but it's best to combine these with serene colors that encourage rest. In my daughter's room, I collaborated with a talented watercolor artist renowned for vibrant floral paintings whose work I have collected and used for others over the years. After careful consideration, I settled on a blue-and-white floral wallpaper that showcased her painting on a grand scale. Simultaneously subtle and lively, the pattern envelops the room in timeless beauty, ensuring that it will be a source of joy for many years to come. To provide an atmosphere that is both animated and serene in children's rooms, balance exuberant features with neutral ones, like the gauzy white linen canopy above my daughter's bed.

Children's beds are often integrated into the architecture—twins tucked beneath a sloping ceiling or bunks built into wall cabinetry or millwork. Stand-alone beds need to be sturdy, stylish, and properly scaled for children. Ideally, beds should incorporate storage areas for pajamas, favorite toys, and books, or trundles with an extra mattress for sleepovers. I like to choose fanciful bedding that combines contrasting materials and textures like lush velvet and whimsical cotton prints, furry pillows with quilted coverlets, or a mix of leather accents with delicate, embroidered ones. These can be coordinated with drapery in playful patterns or textures with black-out lining, layered with shades for maximum light control during naptime. Flexible storage units that accommodate an ever-changing array of games, puzzles, and crafting materials are a must, as is comfortable seating upholstered in inviting fabric, preferably washable.

When the architecture permits, I like to include niches, alcoves, or corner areas where children can feel the safe hug of intimate proportions. Zones intended for specific purposes—a table for board games, crafts, and puzzles; a seating area for watching movies; or a reading nook with cozy pillows—allow bedrooms and play areas to meet various needs. These can be wallpapered or painted a contrasting color to set them apart. In my son's room, I borrowed a small amount of attic storage to create a hidden space behind a bookshelf that swings open like a secret door to reveal a tiny room where he stores personal treasures.

My approach to children's rooms focuses on a marriage of durability, comfort, and stimulation. Soft spaces with scrubbable carpets and rugs encourage children to get on the floor and play. Wall surfaces should be chosen with the expectation of greater than usual wear and tear—painted planking and wainscoting are excellent options for easy cleanup. The shinier the finish, the more wipeable they are likely to be. While frequently used furnishings need to be made from materials that can withstand heavy use, heirloom pieces like a grandmother's rocking chair or a chest from a parent's childhood room have their place, infusing the room with multigenerational memories. The most successful rooms for children cater to the heart, body, and mind, creating a setting for personal growth and joyful self-expression that has a lasting impact.

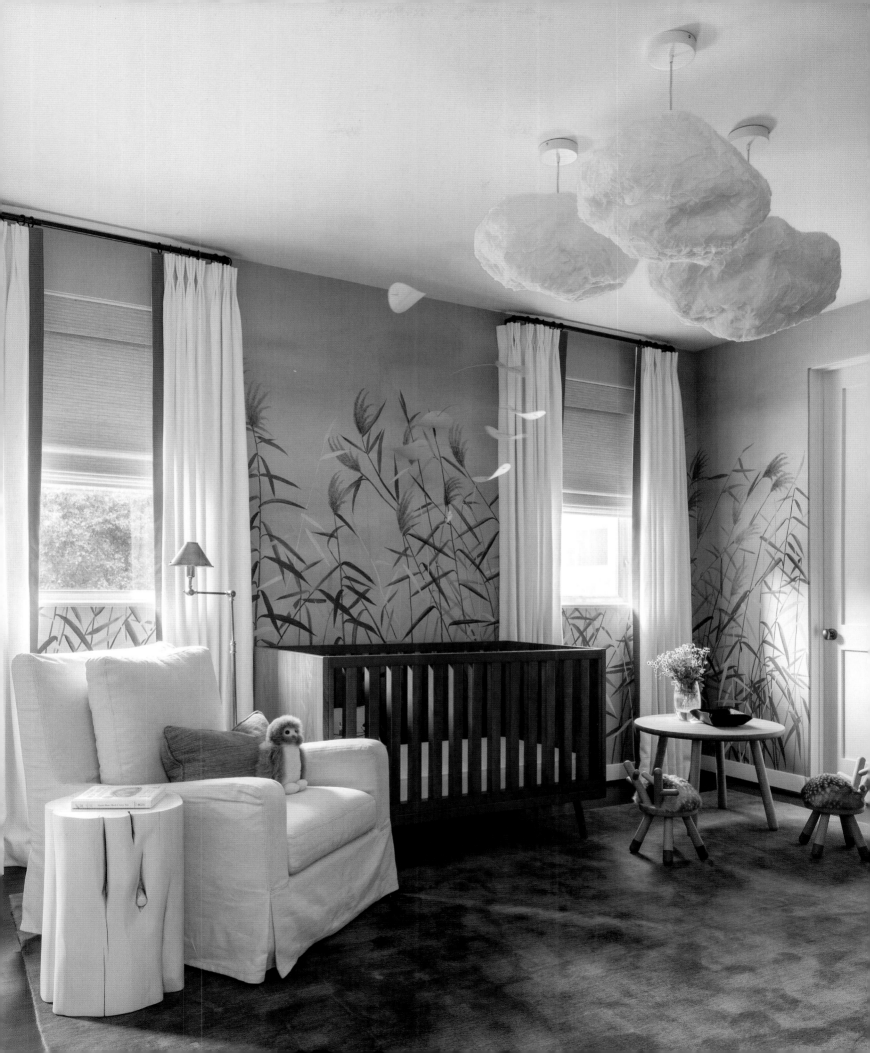

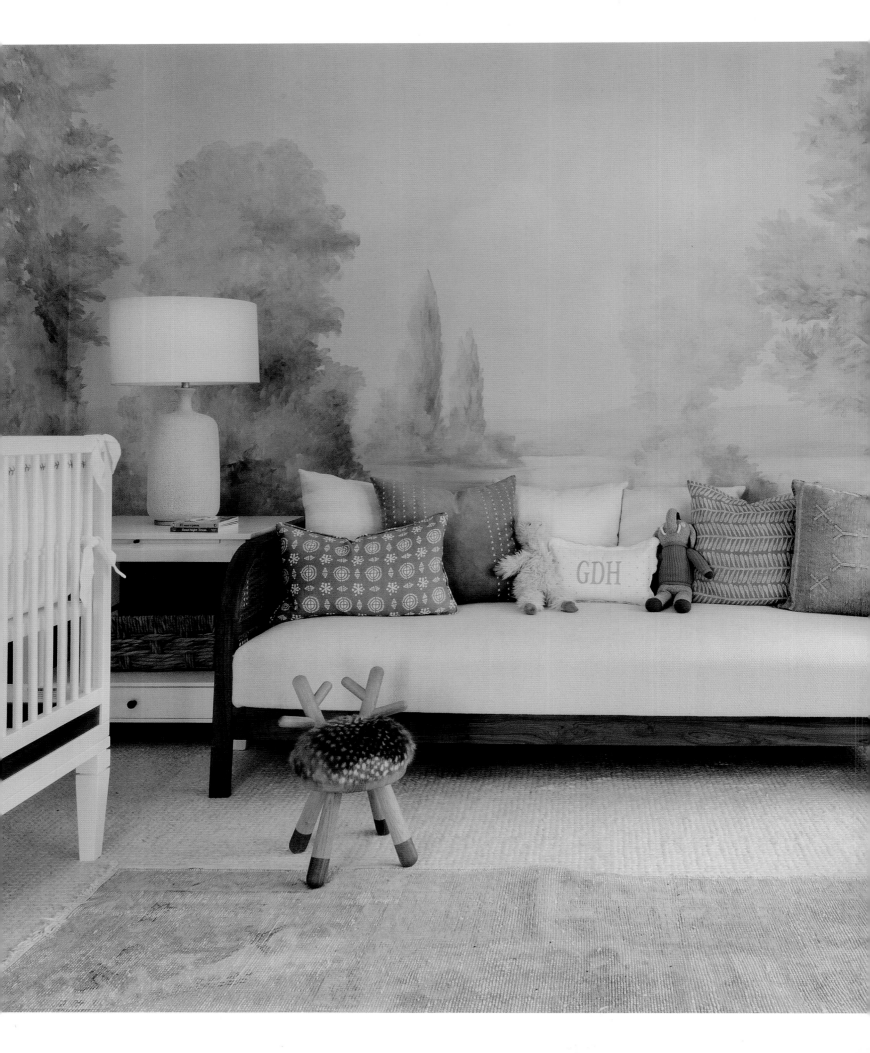

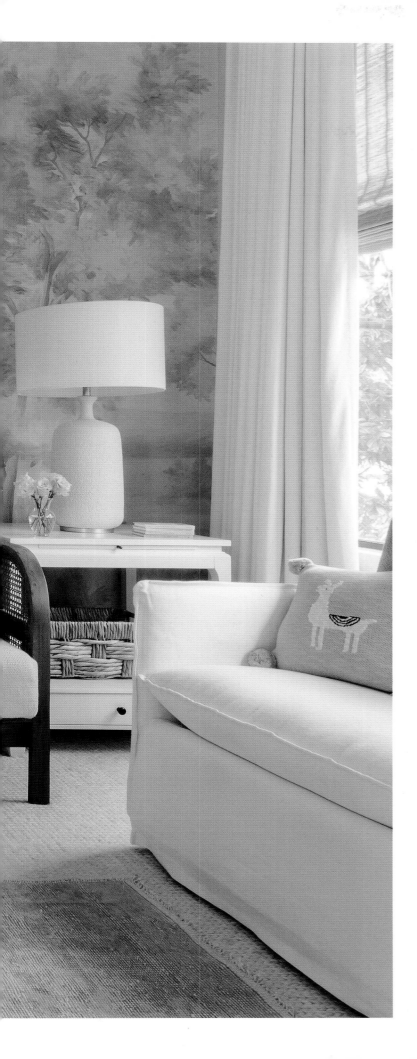

Set the scene for imagination

Landscape murals are often reserved for adult spaces, but they can conjure a magical effect in children's rooms, inviting daydreams and storytelling. Walls papered in whimsical designs or decorated with colorful art installations inspire creativity. A palette of pale neutrals or soft pastels promotes rest between play sessions.

A bedroom for brothers calls for deep, masculine colors and crisp geometric lines. Layering patterns through textiles weaves a captivating interplay of color and design throughout the room. Maximize opportunities for storage with built-ins and dressers that double as nightstands.

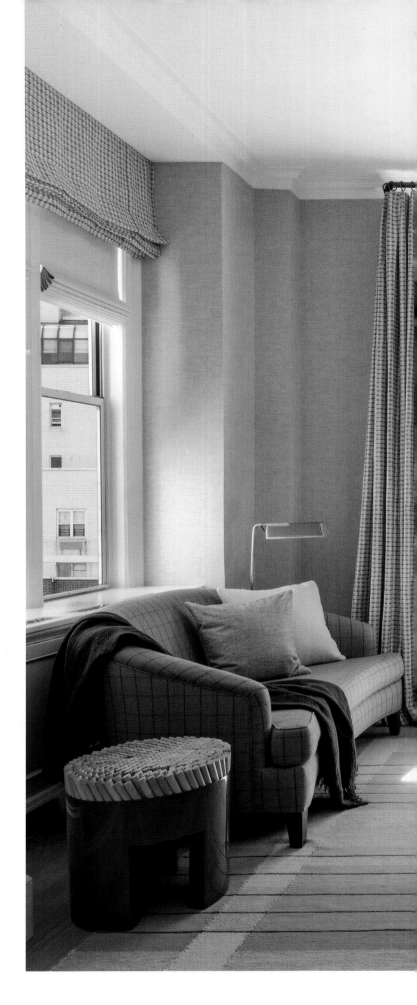

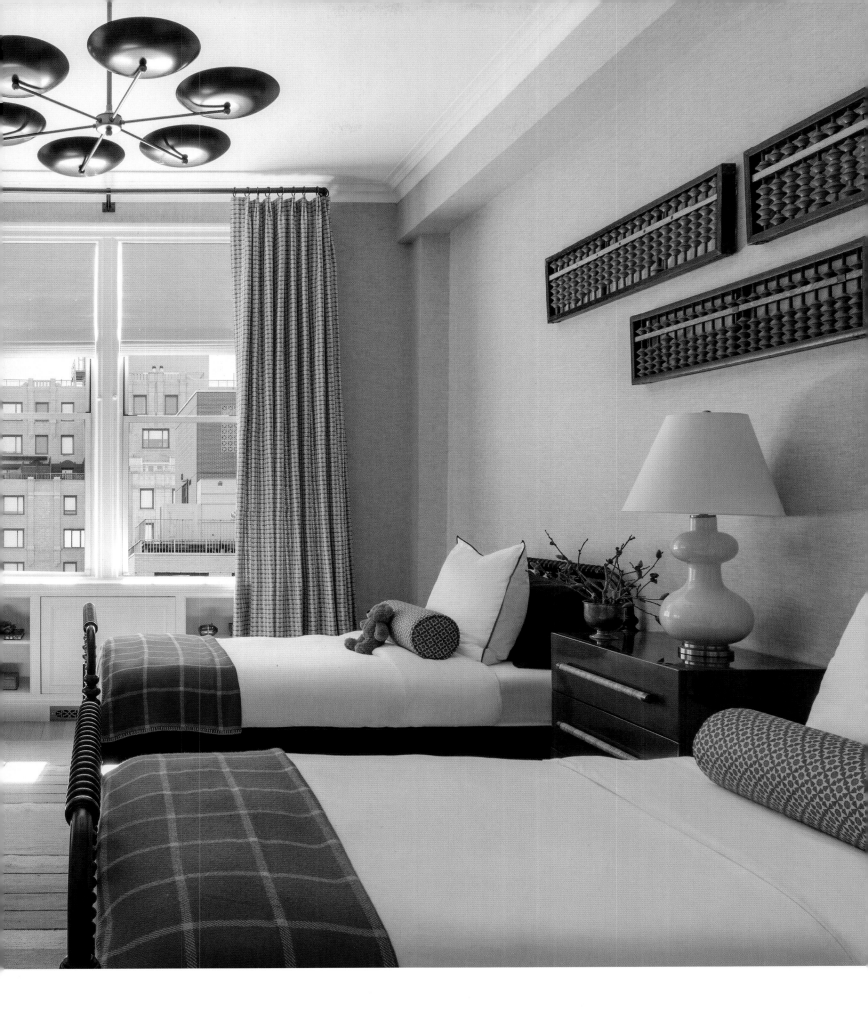

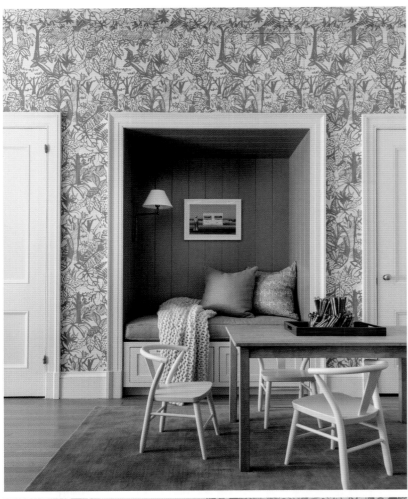

I always look for ways to build nooks and alcoves into the architecture where children can curl up in a cozy place to read or nap. If space allows, define zones within the room for different activities—sleeping, dressing, and playing games or doing crafts. If wall treatments are highly patterned, I complement them with solid colors to calm the space.

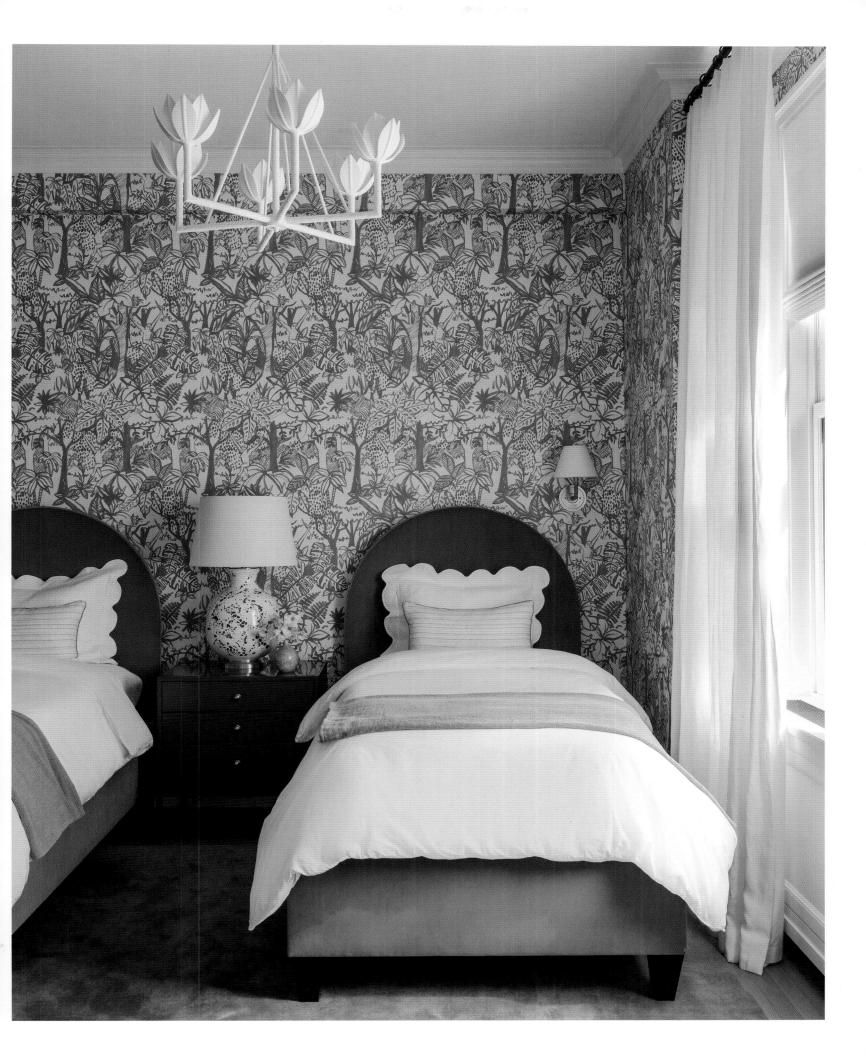

Make it personal

When playful artwork and exuberant hues are balanced by a neutral foundation, children's bedrooms promote both rest and recreation. Choose colors and design elements that reflect aspects of a child's personality. Then the room becomes a personal retreat. Window treatments and decorative pillows can celebrate a child's favorite colors without oversaturating the room. I like pairing patterned textiles with an array of plush accents and inviting textures such as velvet and linen.

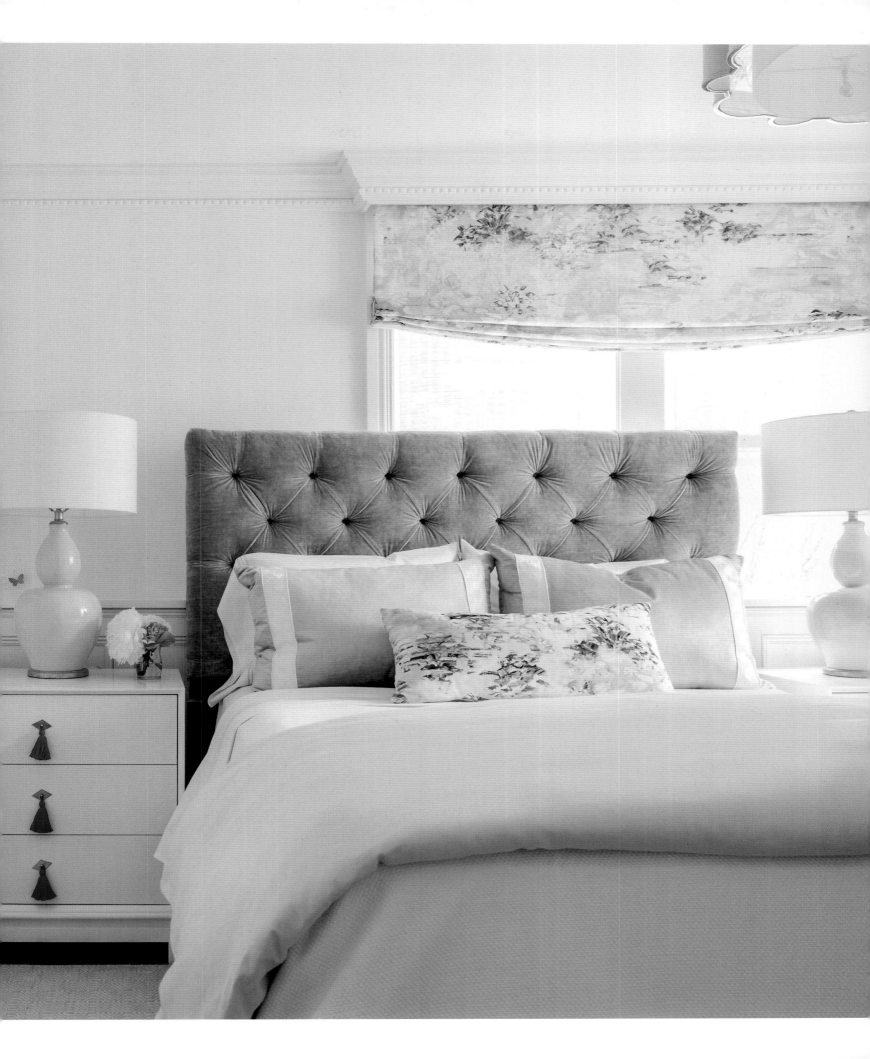

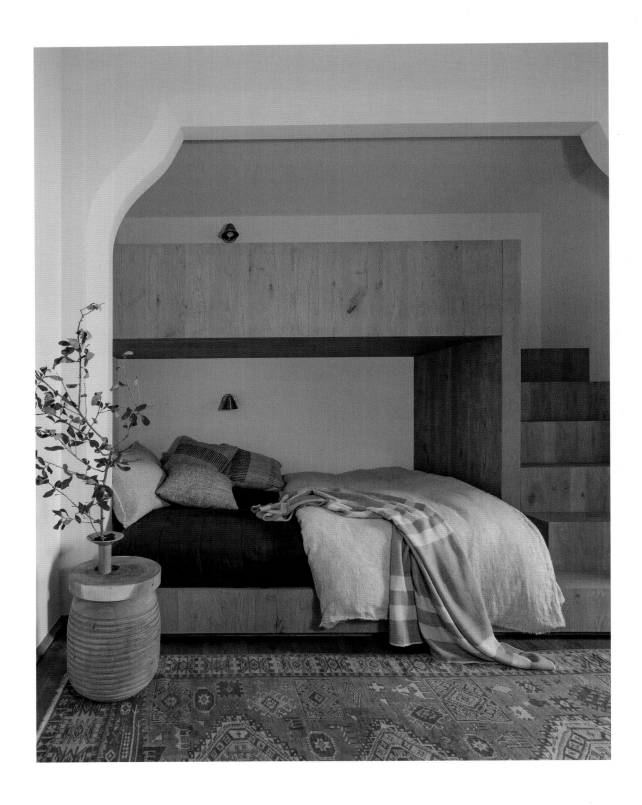

Bunk beds built into the architecture make the most of available space. Incorporating curtains gives each child privacy and allows for light control. Furniture should be appropriately scaled for little bodies with plush fabrics for snuggling up with toys and easily cleanable ones where markers, crayons, and glue might be used.

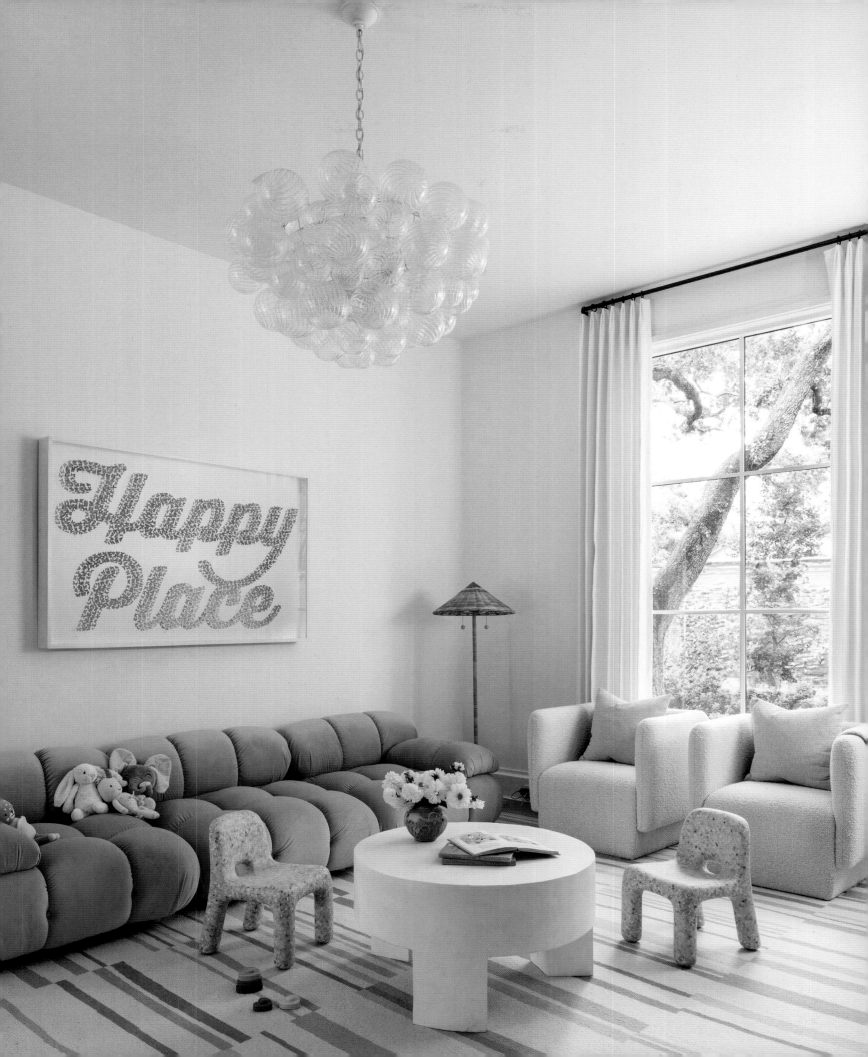

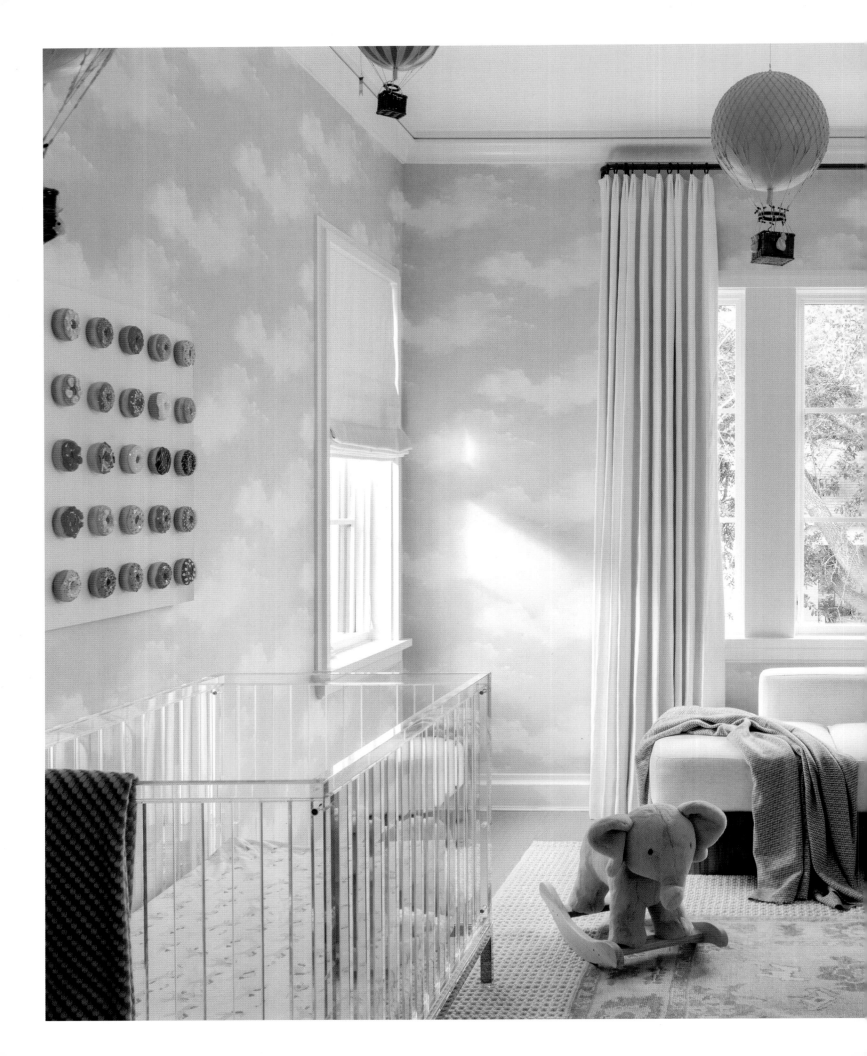

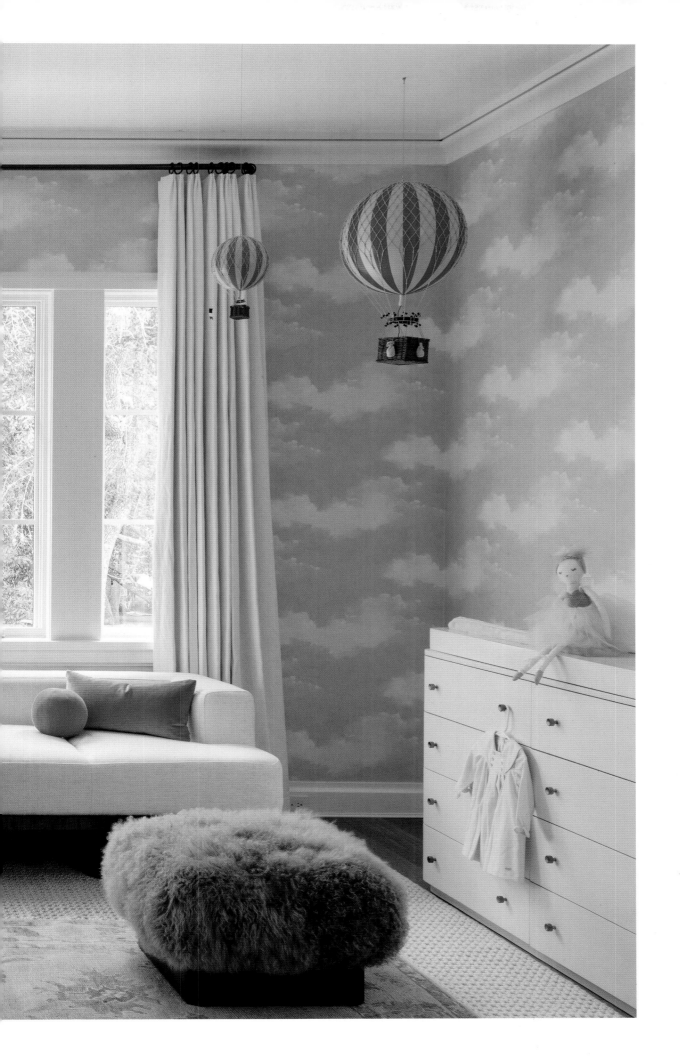

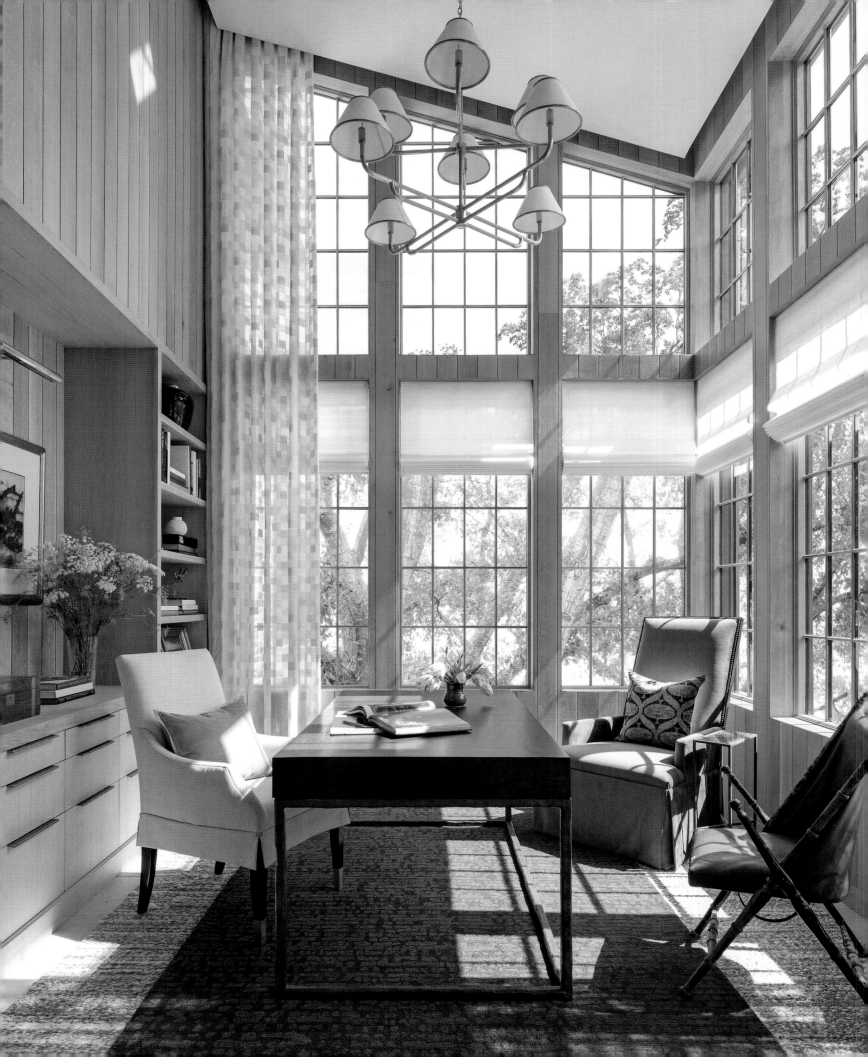

Focus

Spaces intended for concentration call for a spirit of
simplicity that promotes focus and inspires creativity.

We all need time for solitude when we can give undivided attention to what matters most to us. Spaces specifically intended for work, study, creativity, and meditation support us in our most meaningful undertakings, both personal and professional. Large or small, enclosed or adjoining another area, these are places reserved for seclusion and productivity. Even when there's no option for a dedicated room, opportunities can be found in unexpected places. When we walked through a house during construction, we searched for a spot where a stay-at-home mother of three, who is actively involved in philanthropy, could conduct correspondence while also keeping an eye on her children. We discovered unused space beneath a flight of stairs that was amply sized for this purpose, as well as ideally located near the kitchen. By wrapping the wood paneling of the staircase around the corners of the niche and integrating a bookcase, we were able to marry charm with function.

I always strive for a balance of simplicity and sensory abundance that delights without distracting. Orderliness is imperative, with shelves, cabinets, credenzas, and drawers that make sure everything stays in place and, when preferable, out of sight. I often incorporate monitors, computers, and cords into perimeter cabinetry, allowing the desk to be the most important feature of the room. Although wood is the traditional material for desks, I also like alternatives such as stone, glass, leather, and even metal. Desk chairs may be occupied for hours, so they should be upholstered in materials that feel good to the touch like linen, leather, or suede. Introducing a combination of textiles produces a relaxed environment, pairing tweed armchairs with a leather ottoman or silk pillows on a nubby bouclé sofa. I gravitate toward muted colors like gray, beige, blues, or earth tones that promote a serene atmosphere for undistracted contemplation.

In crafting a study for a gentleman in Miami, who dedicated long hours to remote work, we aimed to endow the room with sophistication and subtle energy. For the curtains, we chose plaid linen in rich gem tones. When backlit by the sun, they infused the space with a spectrum of rainbow colors that radiated warmth. Walls and trim painted a saturated shade of blue provided a perfect backdrop for the warm natural tones of a fluted oak desk and woven leather ottoman, achieving a harmonious, masculine aesthetic.

Thoughtfully designed, layered lighting proves crucial to balanced illumination. Task lighting combined with decorative sources such as floor and table lamps, sconces, art lighting, and maybe even a chandelier are ideal. A window that bathes the area with natural light and encourages the visual breaks that enhance cognitive function and well-being is a luxury. For drapery, I prefer heavier textiles like wool sateen or velvet that create a cocoon-like atmosphere. Floor-to-ceiling black-out drapery layered over natural woven shades is best for controlling light, but nothing promotes a meditative atmosphere better than the ethereal glow of sunlight diffused by sheer drapery.

Wood feels timeless, warm, and touchable. I often employ it as the primary material in home offices and studies. Burled or rift-cut oak, cypress, ebony, and walnut are a few of my favorite choices. Floors, ceilings, paneling, and architectural moldings offer opportunities to celebrate its natural beauty. Bookcases detailed with metal-mesh doors, shelves accented with wallpaper or contrasting paint, or brass library stretcher bars offer pleasing accents. For dramatic effect, precise directional lighting can illuminate the colorful spines of books, mementos, and artwork displayed within shelves. Whenever possible, I'll include a fireplace of marble or limestone for textural contrast. It's the perfect place for quiet moments of introspection or conversation. As physical spaces intended for intellectual and spiritual purposes, libraries, home offices, and solitary nooks fulfill basic human needs that often go unmet. There is always room in the house for a sanctuary that promotes personal growth, the quest for knowledge, and the courage to chase dreams.

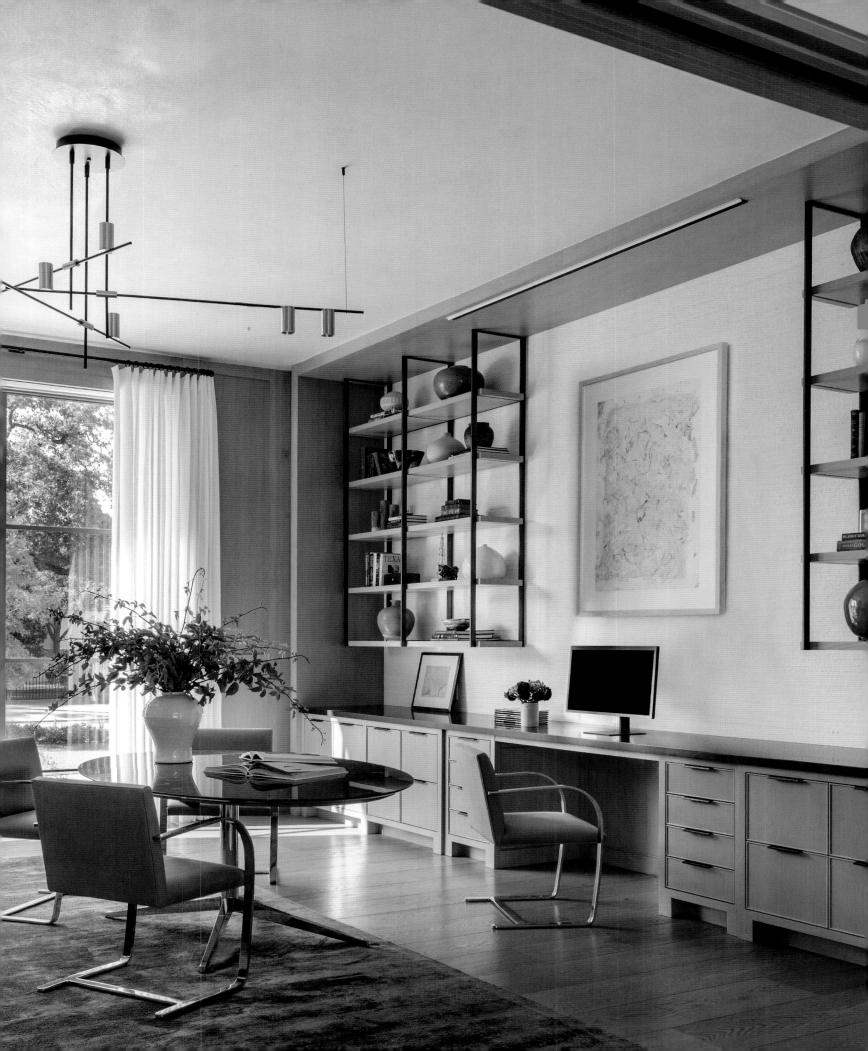

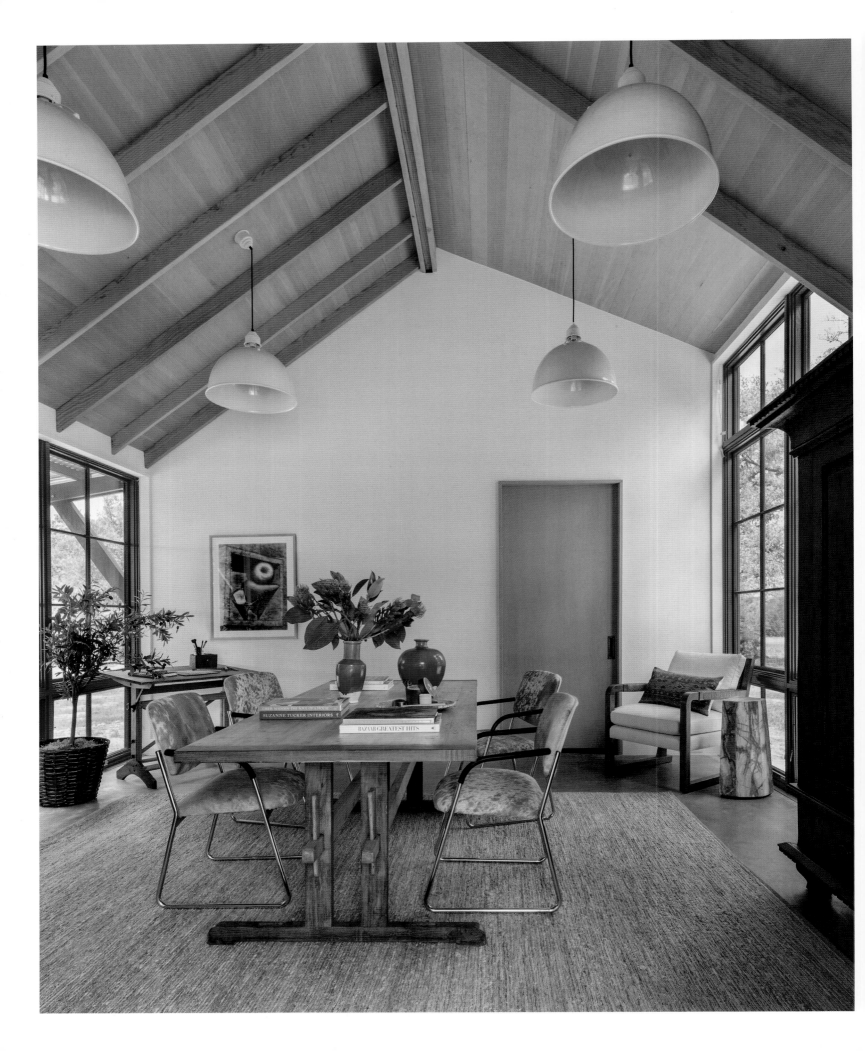

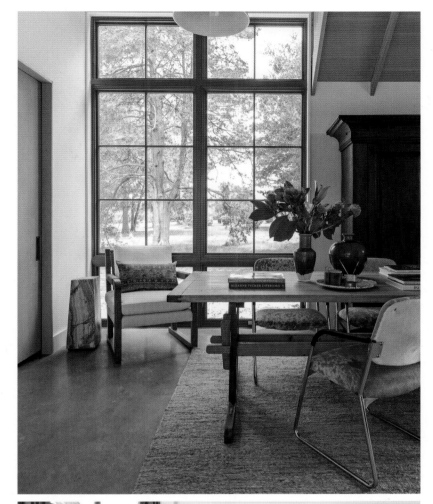

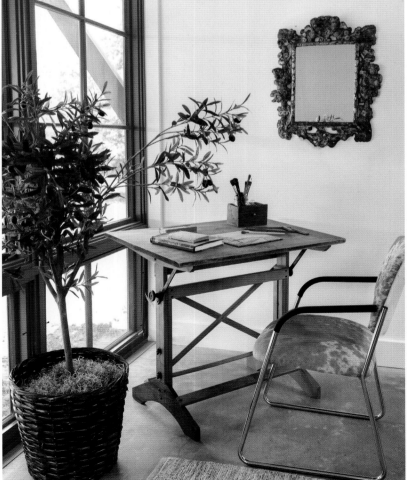

Balanced lighting is essential in places where we spend long hours at work or creative pursuits. Nothing compares with the natural light and restful views afforded by windows. Whenever possible, I maximize opportunities for glazing that infuses the room with light and provides a place for the eye to rest. Well-placed overhead illumination is also essential to ensure that the room promotes productivity as well as moments of leisure, day and night.

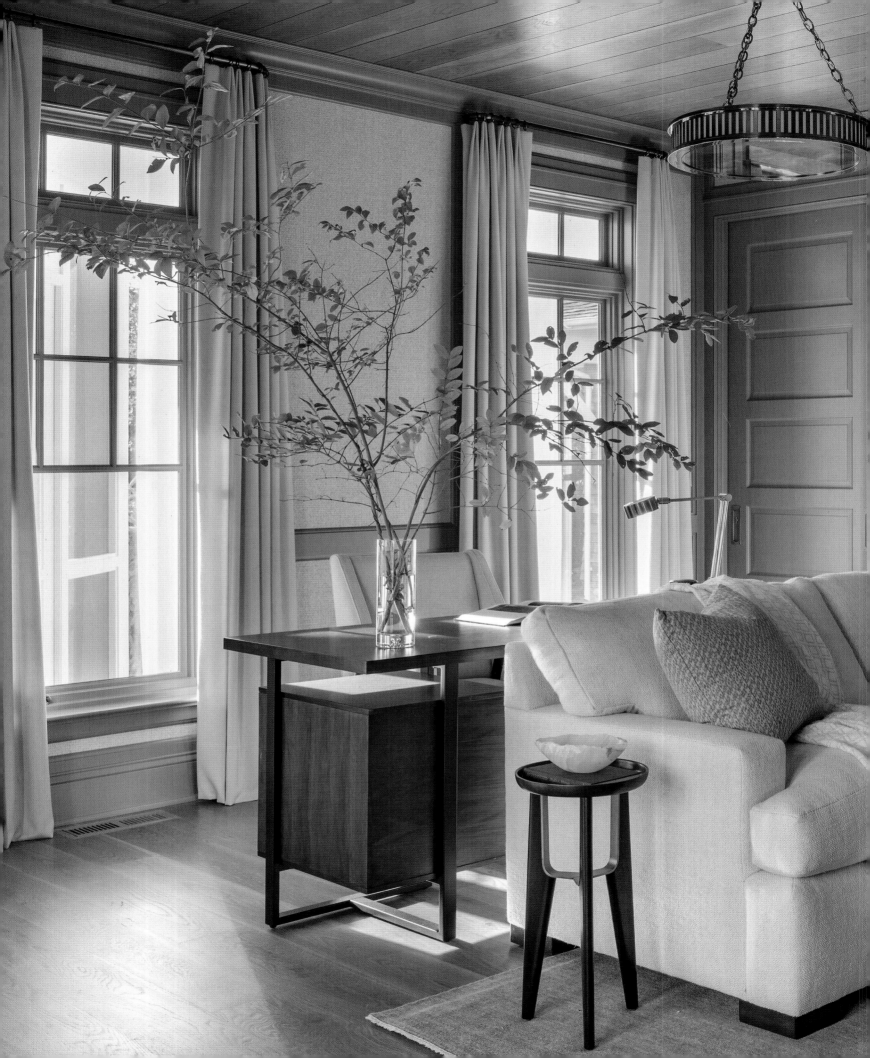

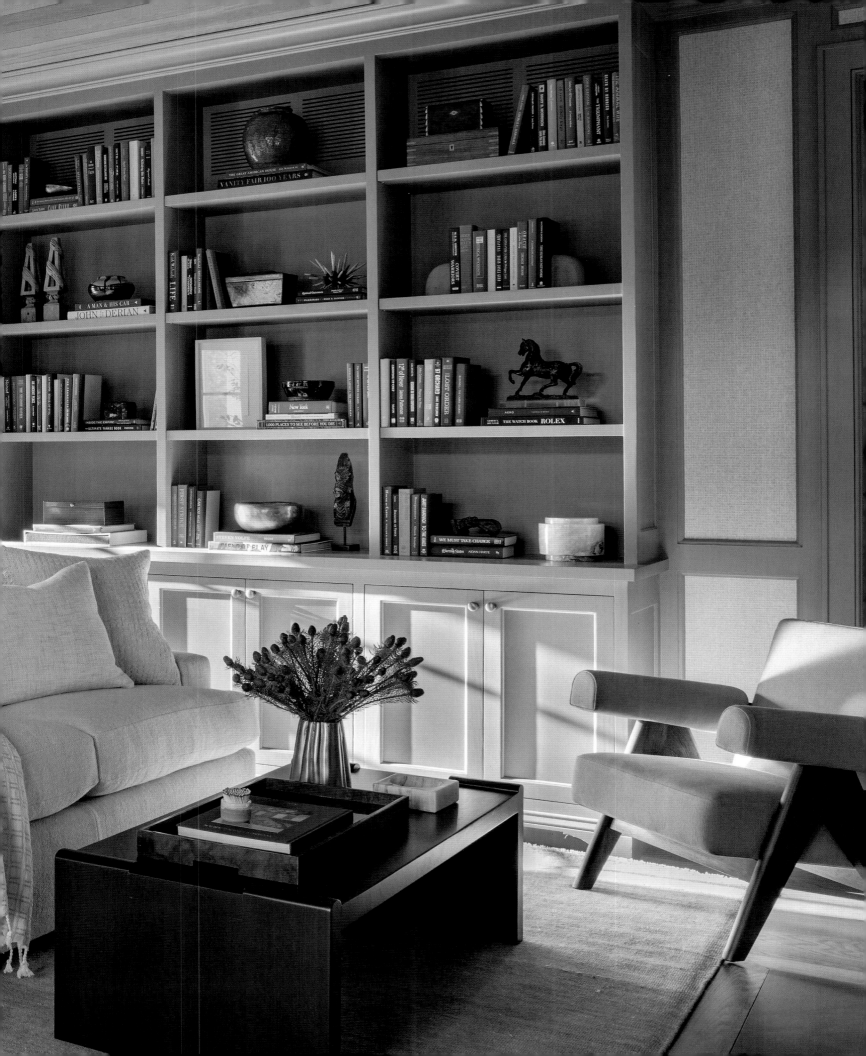

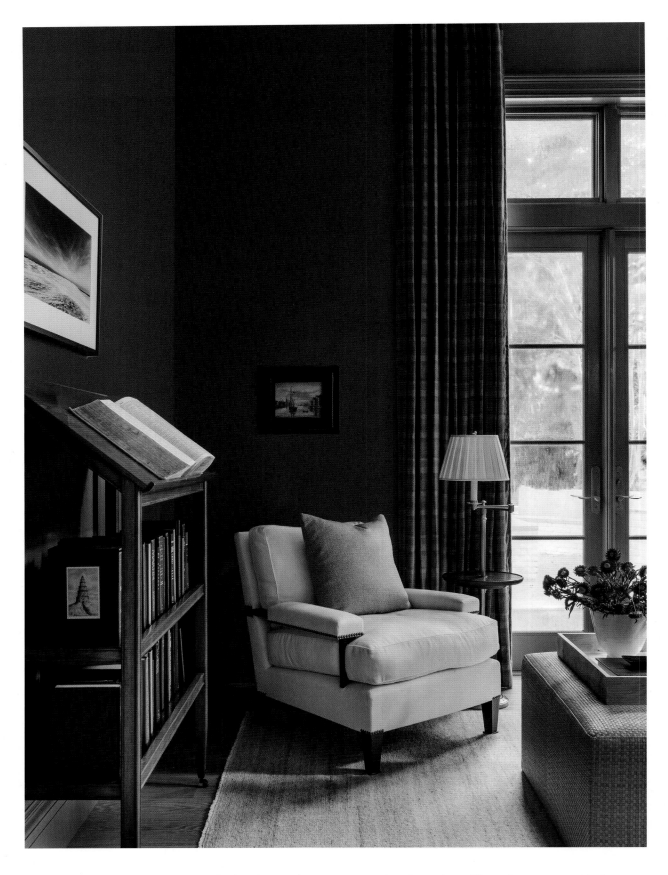

Dark colors promote concentration. Sometimes I'll envelop a room with the same deep shade on walls and ceilings, brightening the composition with gem tones and the burnished glow of leather and wood.

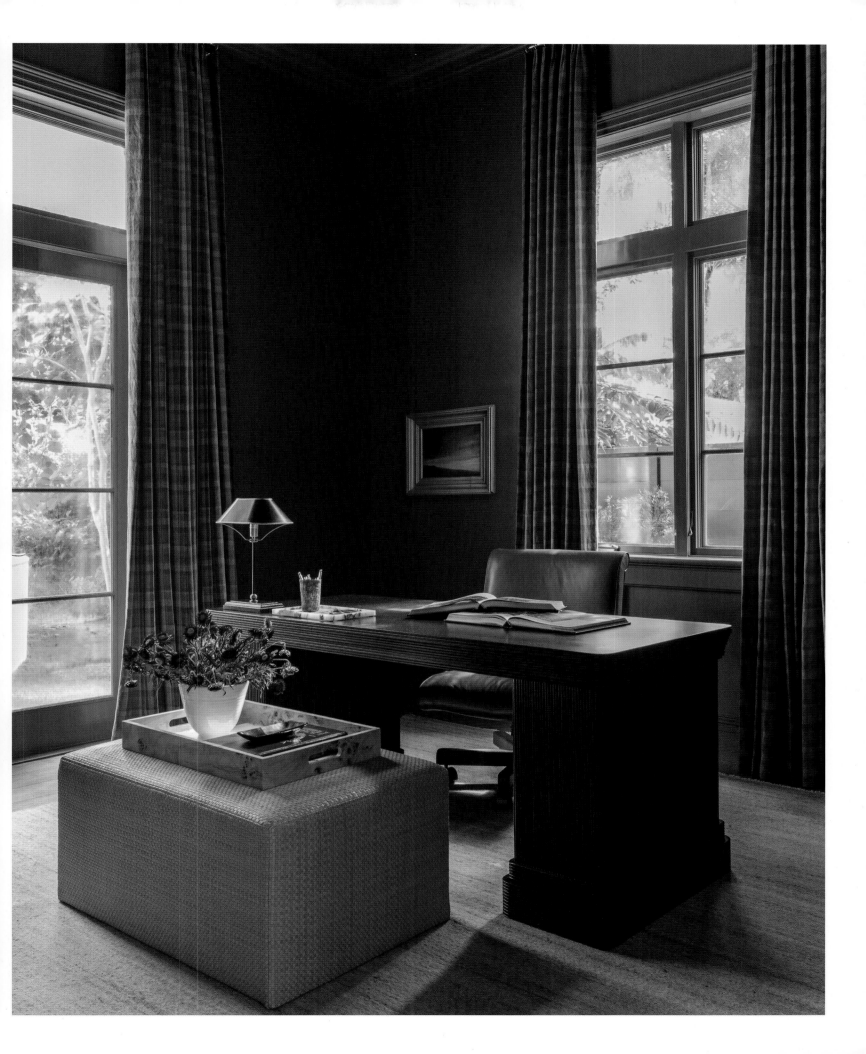

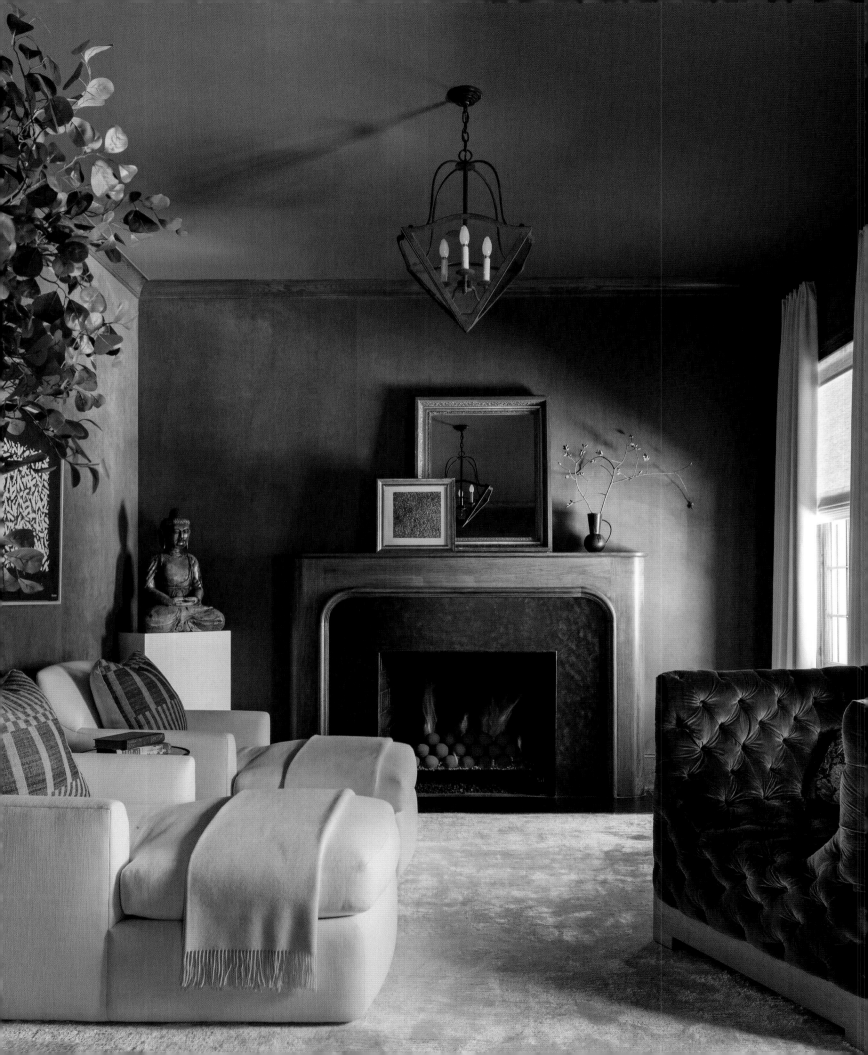

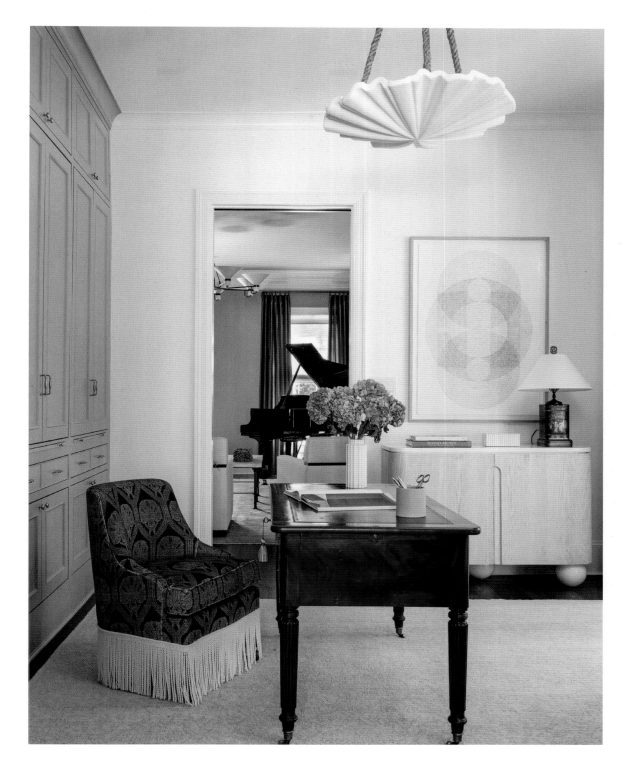

Make a statement with overhead lights

In a deeply hued room intended for quiet contemplation, I might choose a lantern of dark metal like bronze or iron rather than one with a shiny finish. For a room where bright illumination is required, I prefer an overhead light with translucent material that diffuses light and forms a luminous focal point. The velvety texture of suede wallpaper paired with walnut woodwork creates a peaceful environment for reflection.

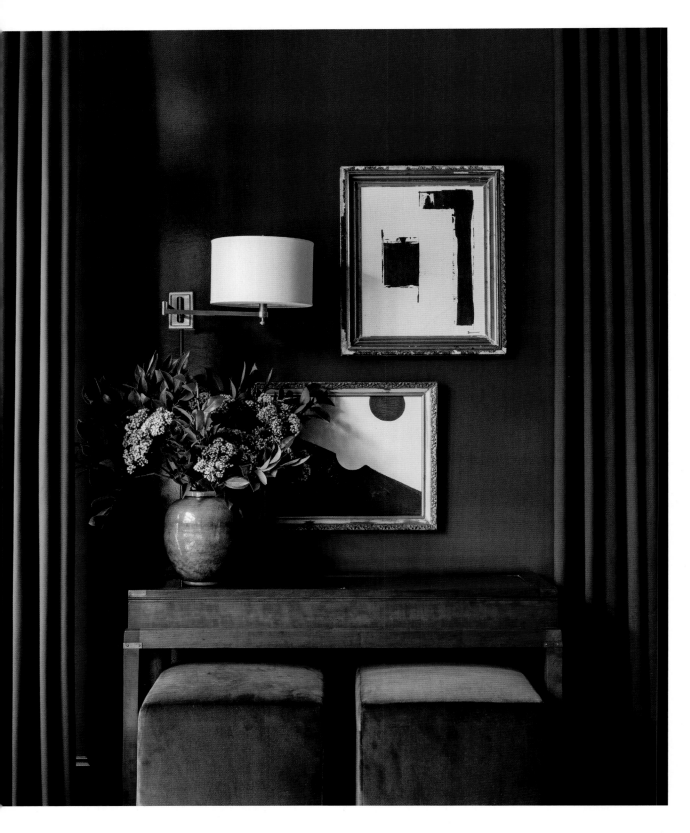

Lacquering dark-painted walls and ceilings accentuates their color and brightens the overall effect. Contrary to expectation, a monochromatic palette embracing paneling and trim draws attention to architectural details. Using the same tone for textiles, but varying texture and introducing pattern, produces a deep, dimensional experience.

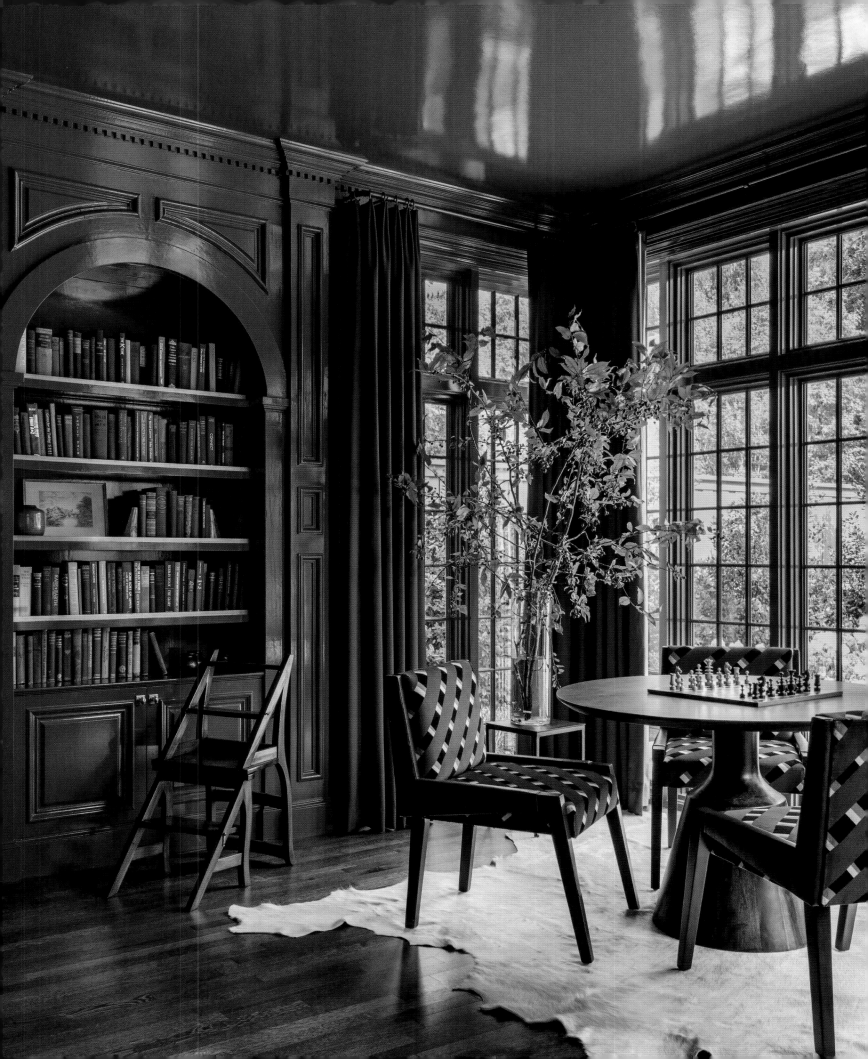

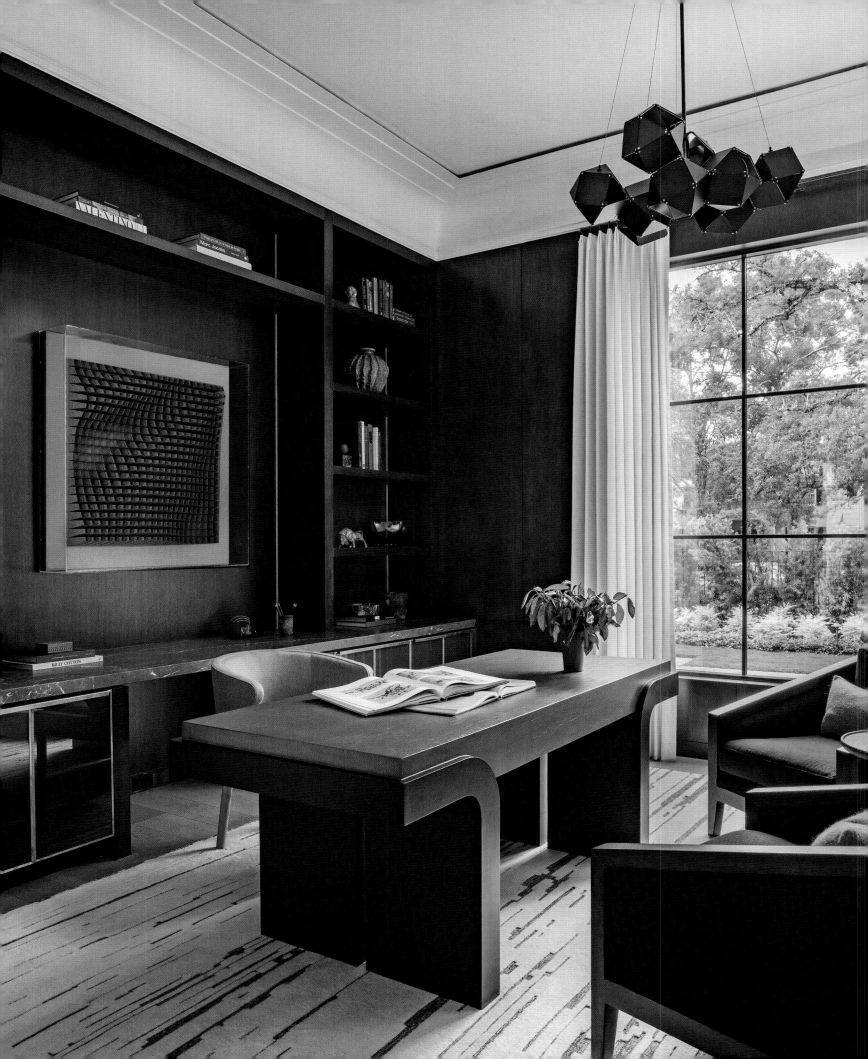

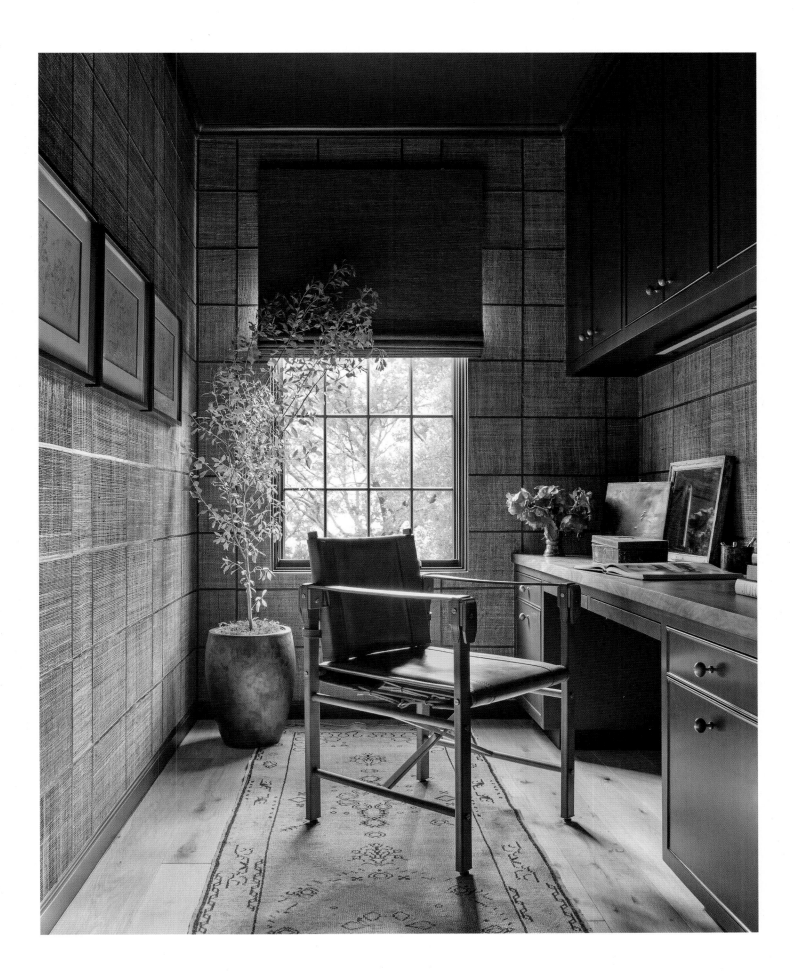

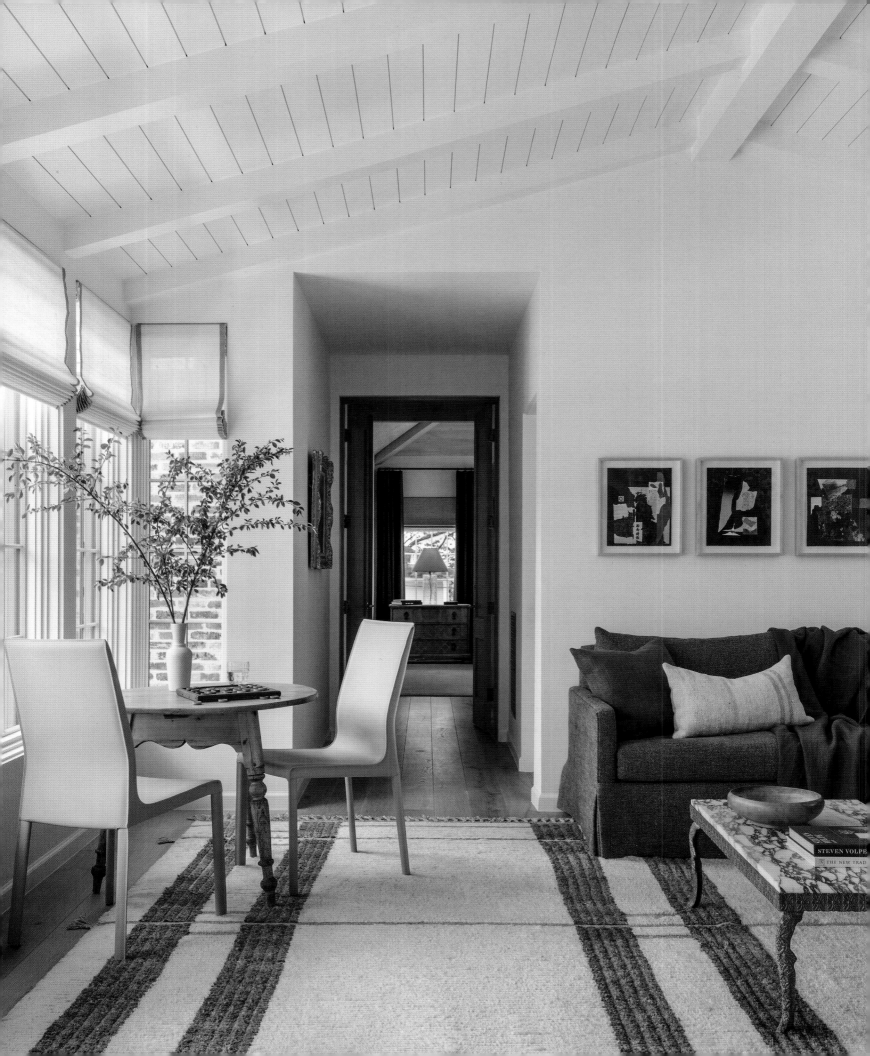

Travel

Thoughtfully designed hallways and staircases
provide moments of graceful progression that elevate
the experience of traveling through a home.

Circulation spaces like halls and stairs are often overlooked from a design point of view, yet they are essential to both the function and character of a home. They guide us through the daily rhythms of life and enhance the experience of navigating through the house with sophisticated transitions linking cozy rooms with more spacious ones. When adorned with artwork, furniture, decorative lighting, and finishes like paneling, wallpaper, or murals, they elevate the overall visual appeal of a home. We should never overlook their potential to frame focal points and axial views for a striking effect. In a residence in Houston, Texas, we graced a two-story, sunlit stair hall with a magnificent thirteen-foot-tall olive tree. As the tree revealed its beauty from multiple vantage points, the journey of ascent became a magical experience, lending a quality of enchantment to the entire space.

Often the first feature encountered in the home, stairs play the important role of introducing its character. Straight flights of stairs can impart a casual impression or an understated, minimalist one. For greater drama, I gravitate toward staircases that curve and float throughout the volume of the entrance hall like a monumental piece of sculpture. The design and materials of banisters, balusters, and newel posts play an important role. Painted wood balusters combined with stained handrails and newel posts are traditional embellishments, but you can also vary the materials. A mix of steel balusters with handrails of carved oak or brass is a favorite combination that can be contemporary or conservative, depending on their shape and detailing. Well-thought-out illumination accentuates the beauty of a staircase's silhouette and materials and influences the experience of entering the home. I love combining sconces, chandeliers, and step lights with a natural source of illumination like a tall window, skylight, or dome.

It's important to treat circulation spaces as integral to the home's overall aesthetic. Lining all the halls on one floor with matching linen or seagrass wallpaper promotes continuity in the experience of traveling through the house and avoids competition with adjoining rooms. Choosing flooring and light fixtures that are consistent with neighboring spaces also promotes unity. However, halls are also worthy of unique features that lend individual character. Colorful wallpaper in an overscale pattern or a mural can be a delightful discovery. Architectural treatments like wainscoting, paneling, and coffered or vaulted ceilings make a transitional area feel like a space in which to pause. Lush runners and area rugs of wool or silk provide luxury underfoot while dampening noise, protecting floors, and directing traffic.

I love arranging intimate seating areas in halls, bay windows, or stair landings to encourage breaks from household tasks and invite impromptu conversations. Furniture is often an afterthought, but intimate arrangements of chairs, benches, ottomans, and small tables beautify transitional spaces and broaden their mission. Well-placed consoles are among my favorite "tools" for introducing rhythm or symmetry. I often use them to flank the entrance to more voluminous spaces like living or dining rooms to emphasize it as a primary portal.

A well-furnished foyer makes an immediate impression, heightening the ceremony of arrival and issuing an invitation to travel more deeply into the house. I often center generously proportioned, circular tables in entries to make a statement that contrasts with or complements the surrounding architecture. For a traditional entrance hall with white walls trimmed with ornate woodwork, we chose a sleek art deco–style table of burled wood. In a house near the ocean, a classically styled table served as a foil to the entrance hall's contemporary design, as well as a place to showcase a stunning three-foot-tall piece of coral that became the artwork in the room. The design of circulation areas deserves to be considered as intentionally as any other space in the house. As the connective thread that guides us daily on our way, they have the potential to enhance that journey.

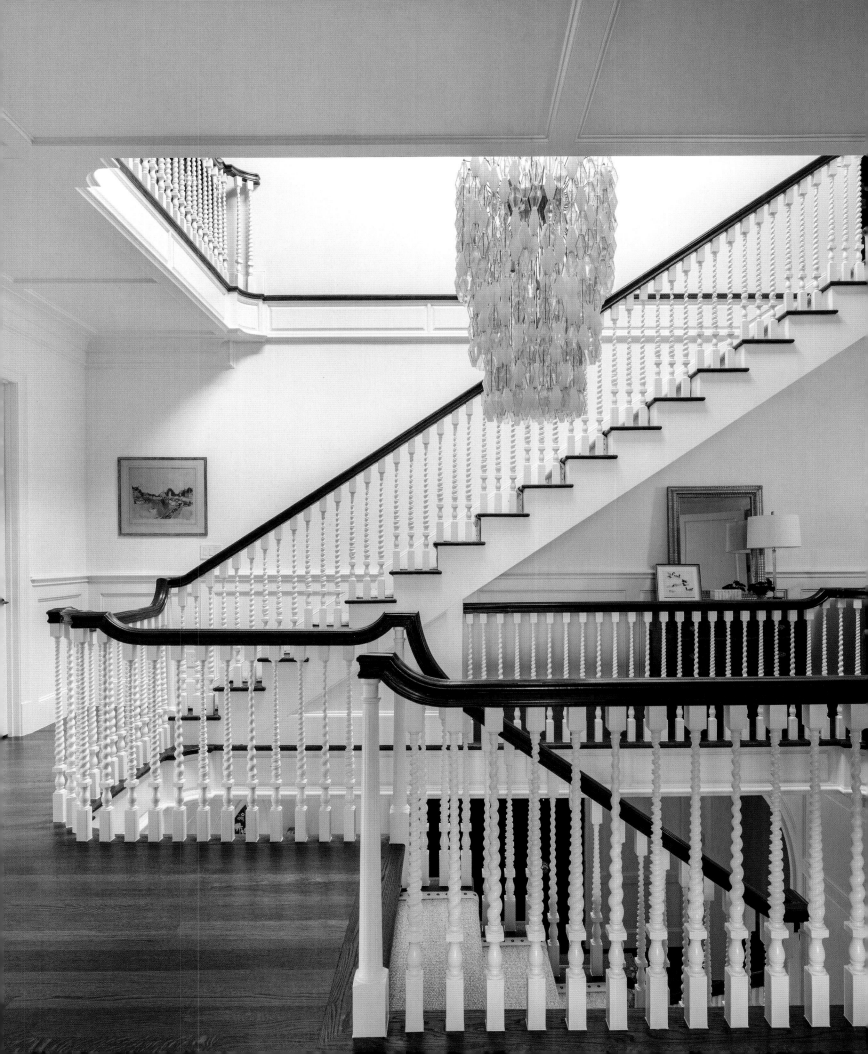

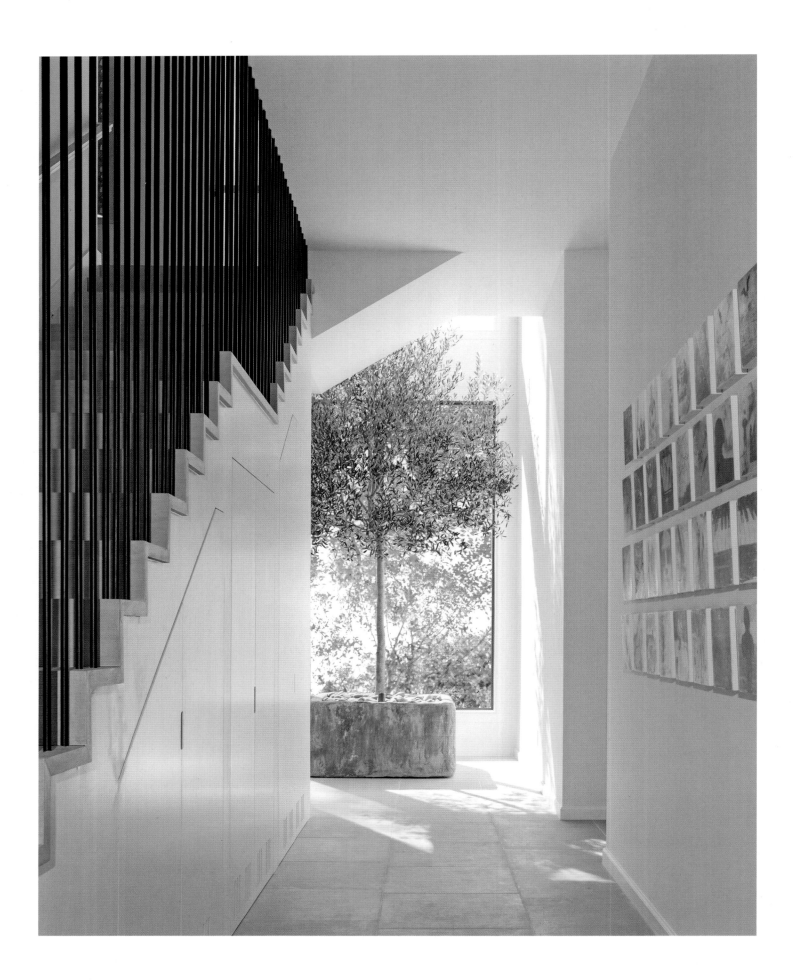

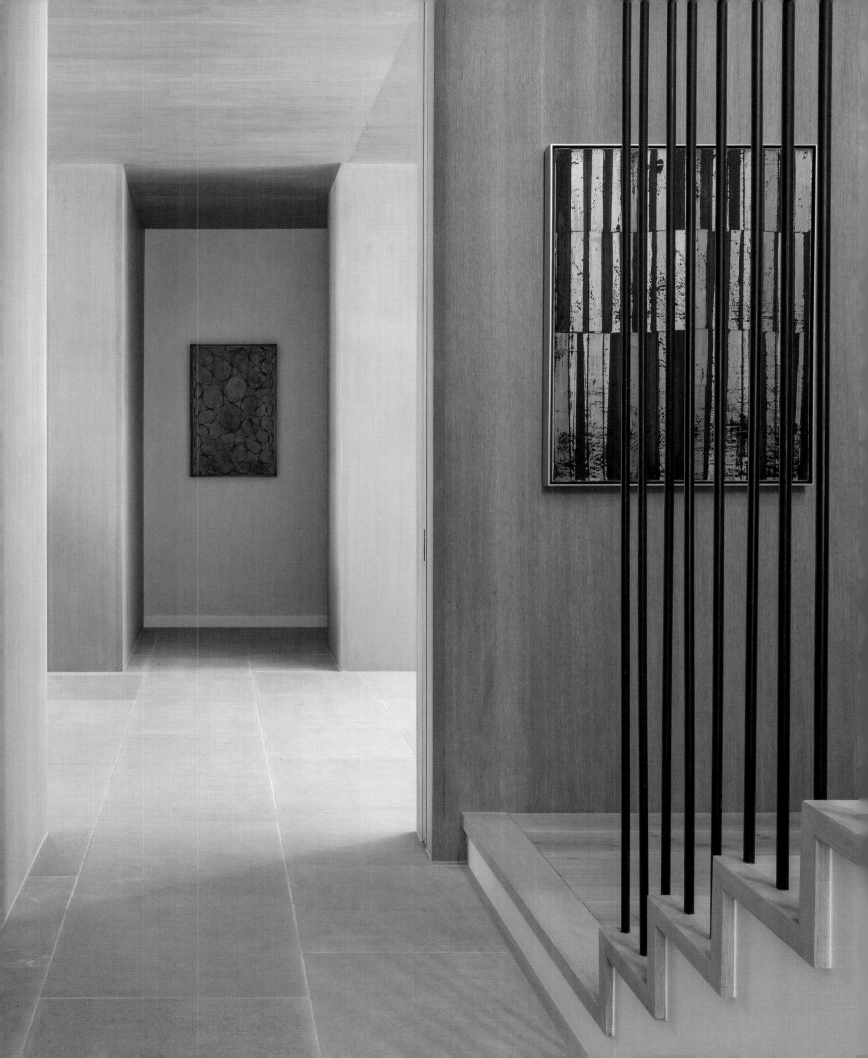

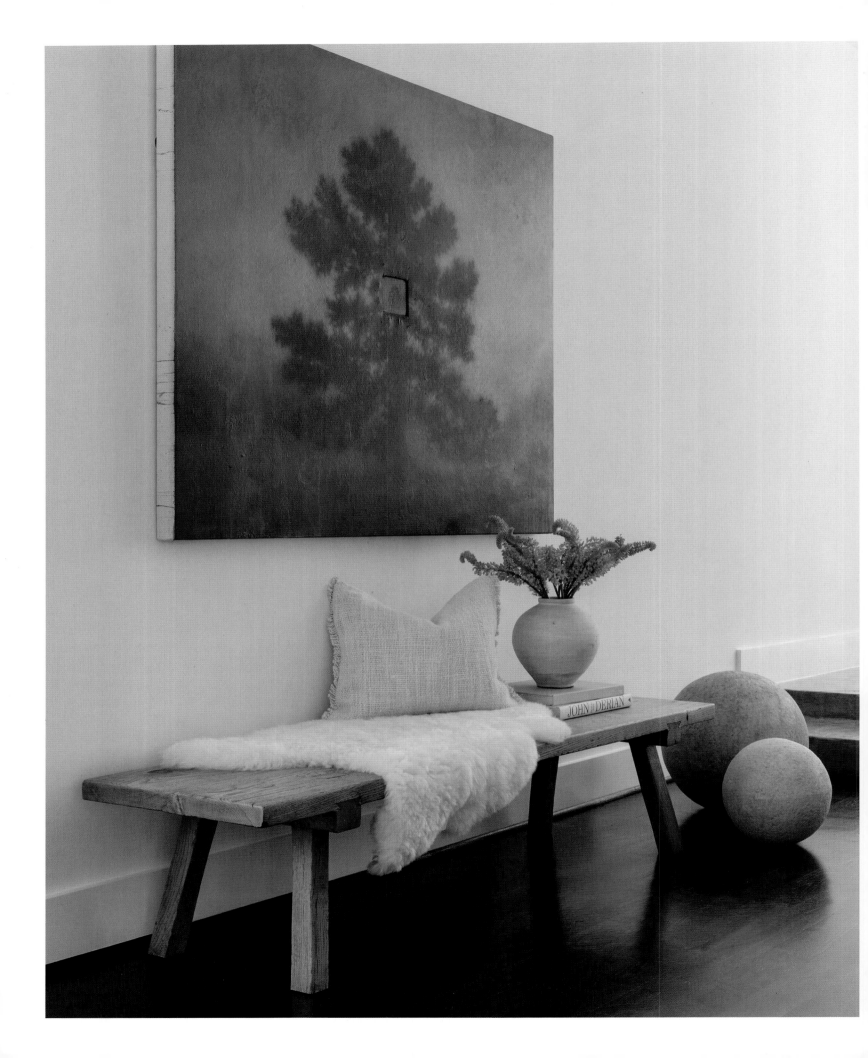

Light emanating from the end of a hallway beckons you forward

Understated passageways afford a moment of calm between highly decorated spaces.
Well-composed arrangements of collected objects invite you to slow down and enjoy the
journey as you travel from one room to the next.

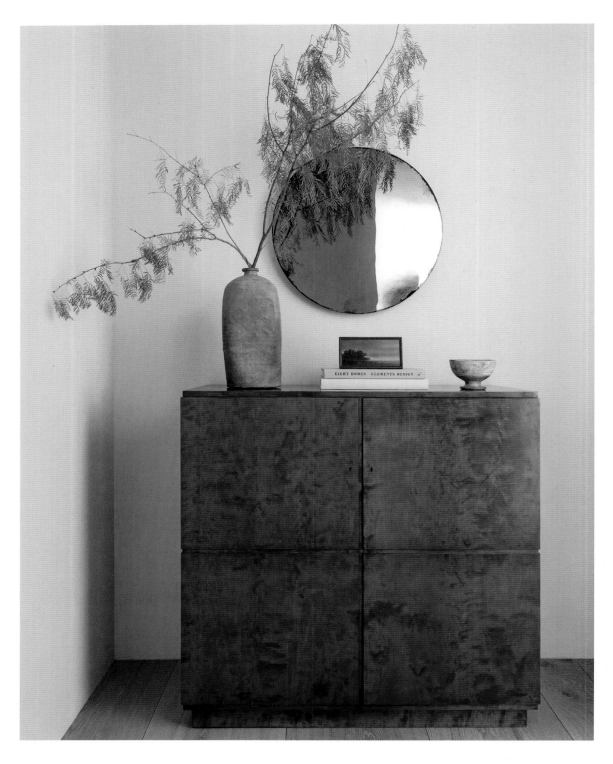

Turn your hall into a gallery

Halls can become personal museums for collections of artwork and antiques. A unique piece of furniture transforms a transitional space into a place to pause and appreciate the beauty of your surroundings. Collage walls make the most of limited wall space for hanging art. For harmonious arrangements, display similar works in contrasting frames or disparate pieces in matching styles.

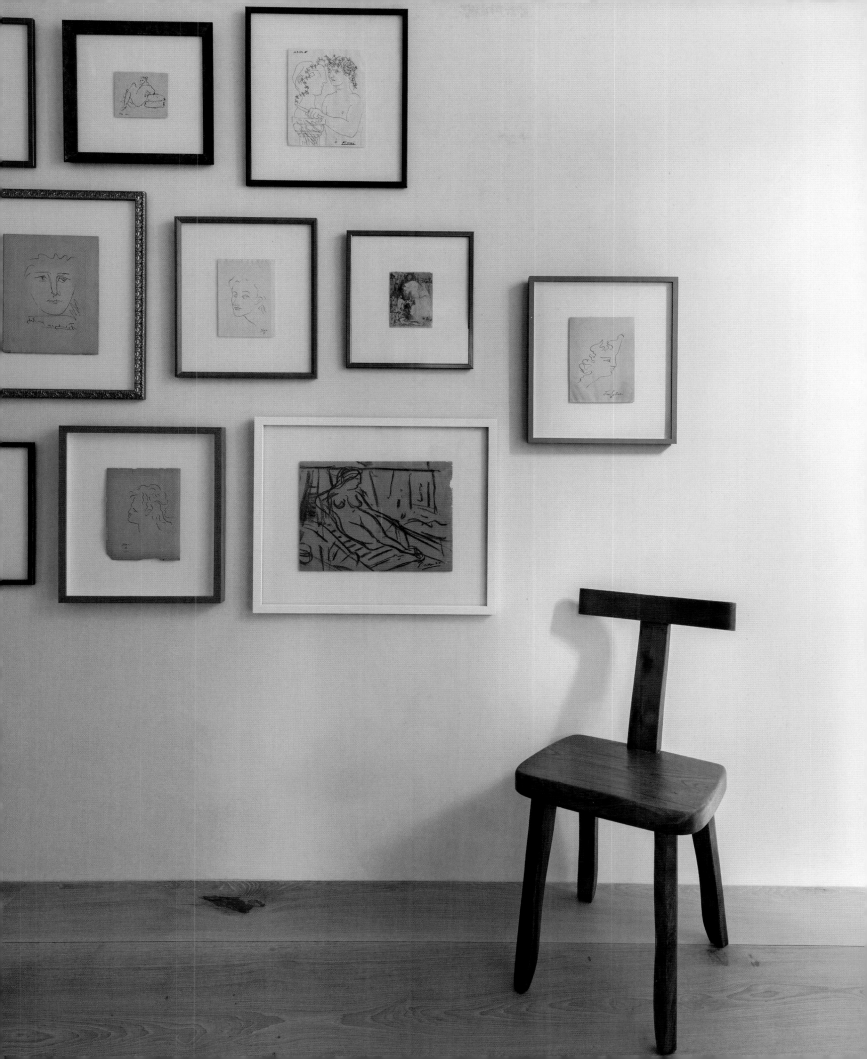

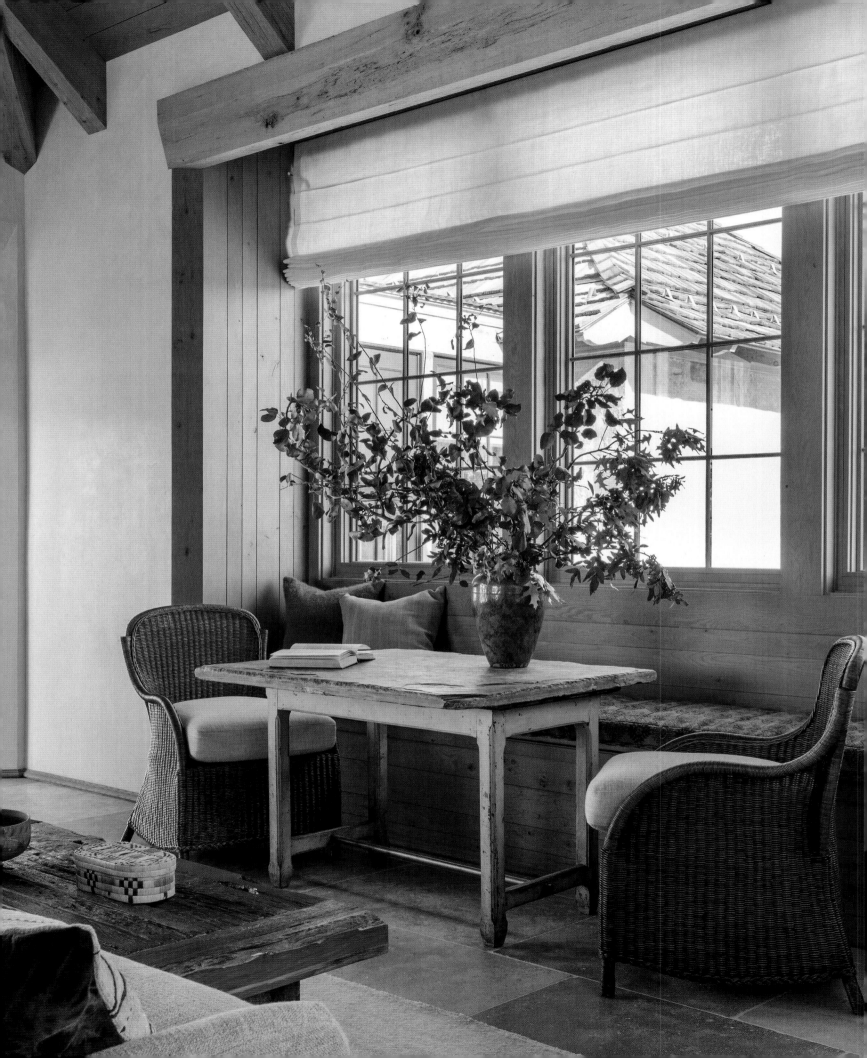

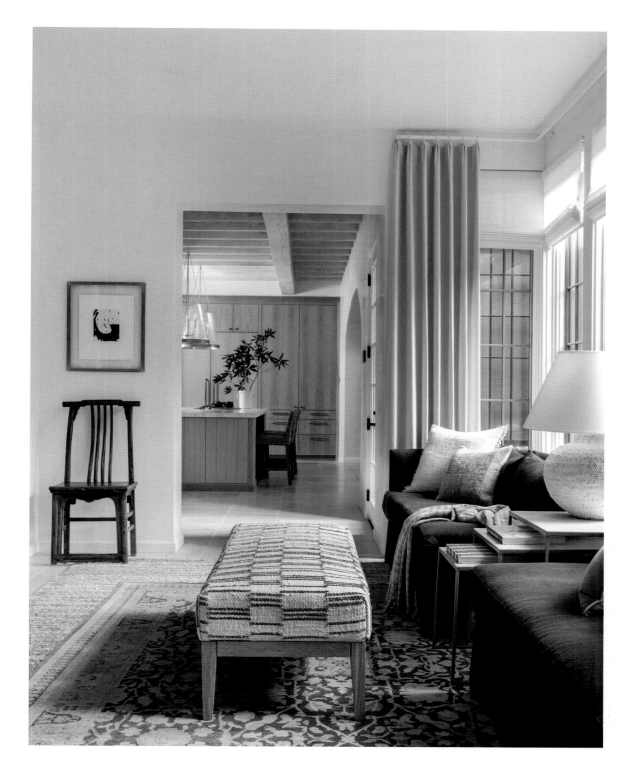

Make the most of windows

Tall windows and floor-to-ceiling drapery illuminate the volume of transitional spaces and enhance their impression. A bay window positioned along a frequently traveled path or a comfortable seating arrangement adds dimension and purpose to the space. Sectional sofas are ideal for long expanses of glass. For shorter ones, banquettes or window seats work well.

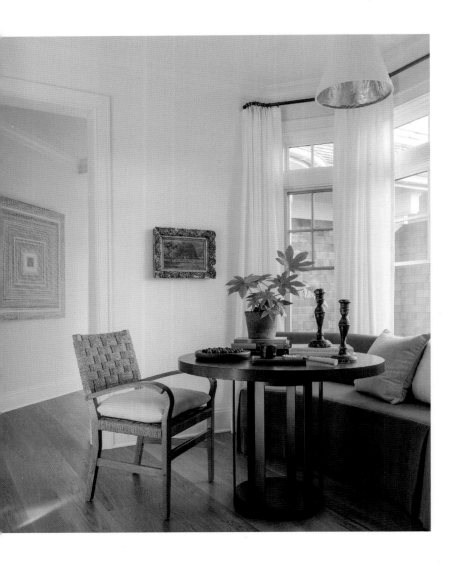

Find space to rest along the way

Halls and stair landings are typically compressed spaces with straight lines, sharp angles, and hard surfaces. Bringing in curves through furniture and lighting choices and introducing highly textured rugs and fabrics makes them more inviting places.

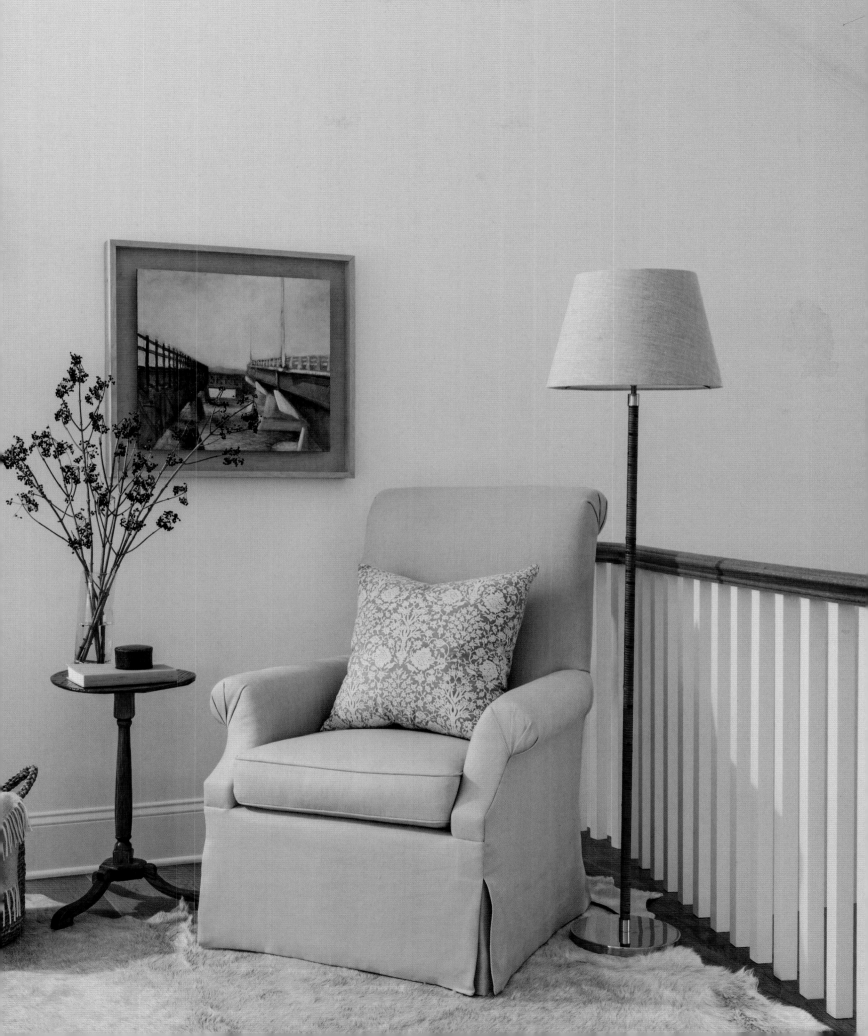

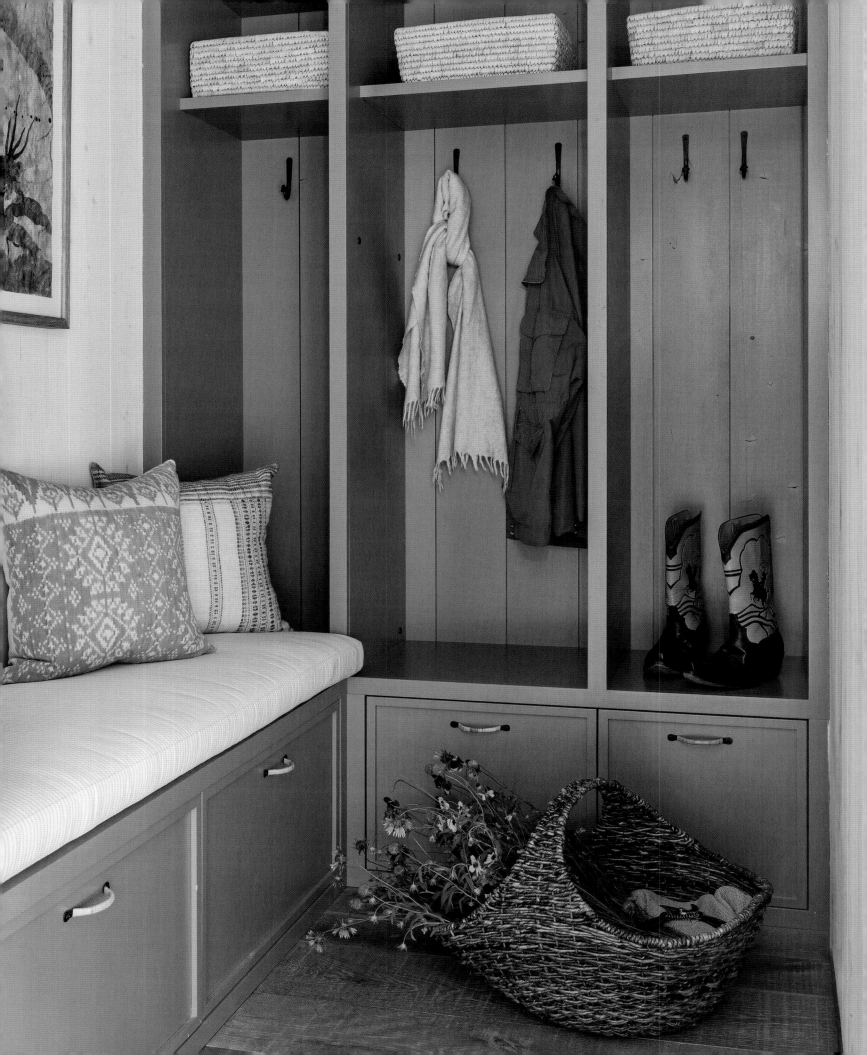

Task

Intentionally designed organizational spaces ensure
that the home feels neat and efficient, fostering
contentment as we go about our daily tasks.

Areas dedicated to utilitarian functions ease everyday activities and, when decorated with imagination, inspire us to make the most of mundane pursuits. When everything has its place in a room designed with both efficiency and aesthetics in mind, stress and frustration fade away and we experience satisfaction as we go about our household chores. Just because an area is functional in purpose doesn't mean that character and style should be sacrificed. There are many ways to introduce luxurious touches of warmth, color, and texture that give these frequently visited locations an identity of their own. Assigning zones dedicated to specific tasks corrals clutter in discrete, conveniently located areas.

In a long, rectangular utility area tucked away on the second floor of a house in Houston, we energized the room's narrow shape with playful green, white, and gray encaustic floor tile. Arranged in angled stripes, this unexpected burst of color and pattern breathed life, movement, and a spirit of fun into the space. In Jackson Hole, we added texture to the walls of a large laundry room with hand-glazed terra-cotta zellige tiles laid in a vertical pattern. An antique French farm table with the subtle patina of faded black paint illuminated by a charming pendant light composed of wicker and linen formed a central focal point. With the addition of a watercolor painting that contrasted colorfully with the neutral tones of the zellige, the room became a design destination, as well as a practical one.

When possible, I like to locate the laundry room on an upper floor near bedrooms and bathrooms. This streamlines washing and prevents dirty linens and clothes from making their way downstairs. If the primary bedroom is located on the ground floor, it's a worthwhile convenience to incorporate a small washer and dryer into a nearby closet. Well-designed storage solutions are a must in laundry rooms, which accommodate a host of moving pieces including sorting hampers, drying racks, ironing boards, and steamers. Each object needs its own place where it can be tucked away when not in use.

I always tailor cabinetry to maximize every inch of available space while looking for ways to soften the uniform impression of millwork. Introducing variety by alternating painted and stained finishes, selecting handsome countertop materials like soapstone, leathered granite, or even veined marble, and incorporating antique light fixtures adds distinction and charm. In one utility room, we meticulously fashioned a bespoke turned-leg walnut table to support a white porcelain apron sink. Strategically placed beneath a graceful glass pendant and an oil painting, this unique piece stood out as furniture and complemented the surrounding lush green cabinets.

Mudrooms are basic, everyday luxuries that allow family members to easily store belongings without disrupting the overall order of the house. I like to keep their decoration simple, but that doesn't mean they can't have style. Cabinetry can be accented with louvers, decorative openings, or finishes with a furniture-like appearance. Sometimes I'll bring in more depth with stained walnut or oak countertops. Windows can be softened with café curtains or roman shades and benches upholstered with textured fabric. It's best for surfaces to be durable and moisture-proof, especially flooring. Since mudrooms are transitional areas, I sometimes use the same paving material inside and outside the front door. Stone, herringbone brick, and tile are excellent options.

Compact, optimized storage options are a must. Cabinets with cubbies; drawers for light bulbs, batteries, and sunscreen; a countertop for keys and sunglasses; and hooks for sports bags, backpacks, purses, and jackets are all pieces of the organizational puzzle that keep routines running smoothly. I always suggest incorporating charging stations near the door to encourage family members to put down their electronic devices when they get home and engage more closely with each other. When we make the most of their functional and aesthetic potential, task-oriented spaces do so much more than bring order to the house. They enhance the quality of life, restore serenity, and bolster a spirit of gratitude and mindfulness as we go about our day.

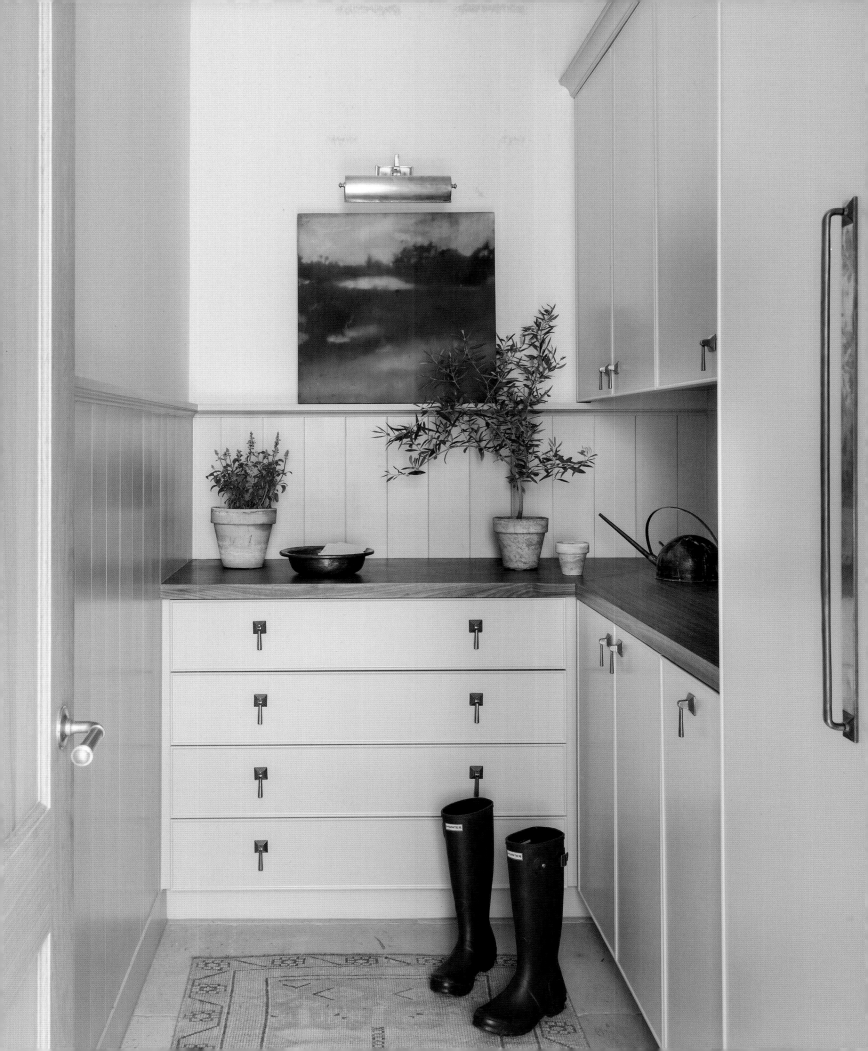

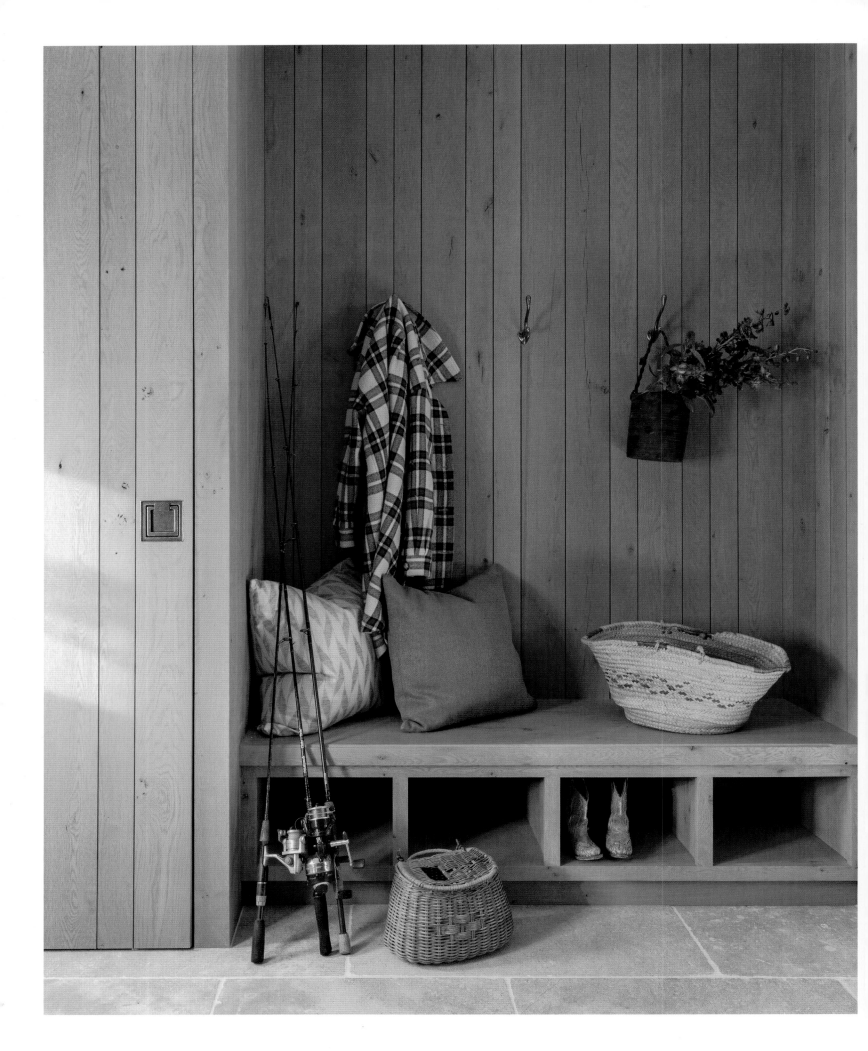

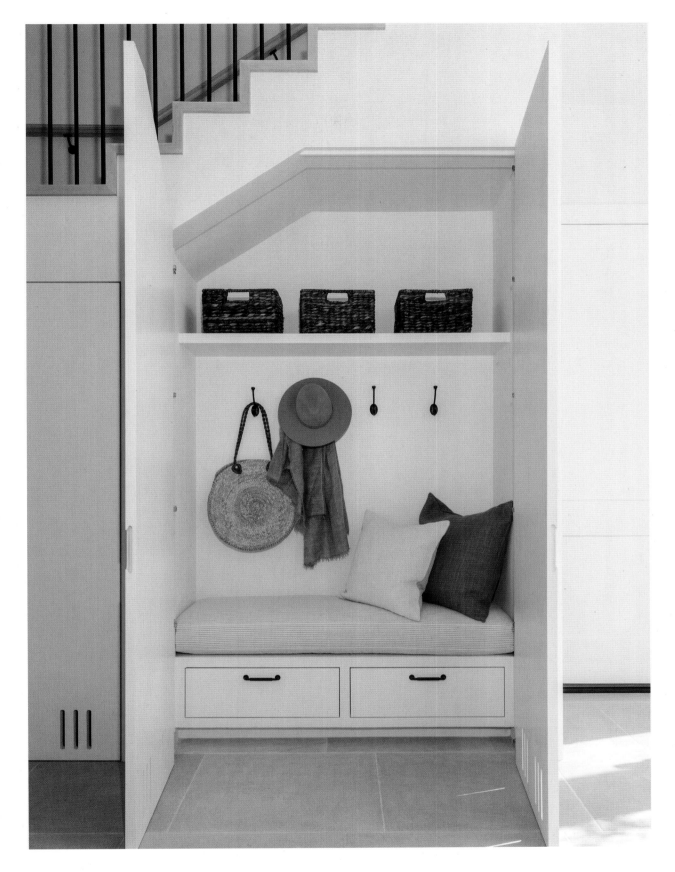

Tuck mudrooms into unexpected places

I once found space for a mudroom complete with storage cabinets and a padded bench for removing shoes underneath the stairs in an entrance hall—the perfect location for stashing possessions upon entering the house. When the doors are shut, everything remains hidden from sight.

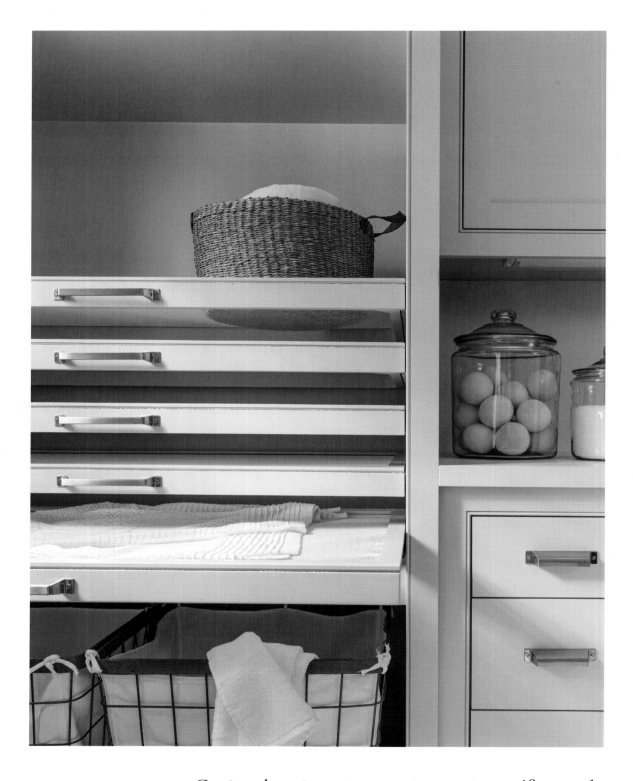

Customize storage areas to meet specific needs

This keeps everything in its place, easing household tasks and making tidying up less time consuming. A combination of open and closed storage conceals some contents while ensuring that others are readily found. Pull-out shelves, clear containers, cloth-lined bins, and baskets are great ways to accommodate various items, keeping them organized and accessible.

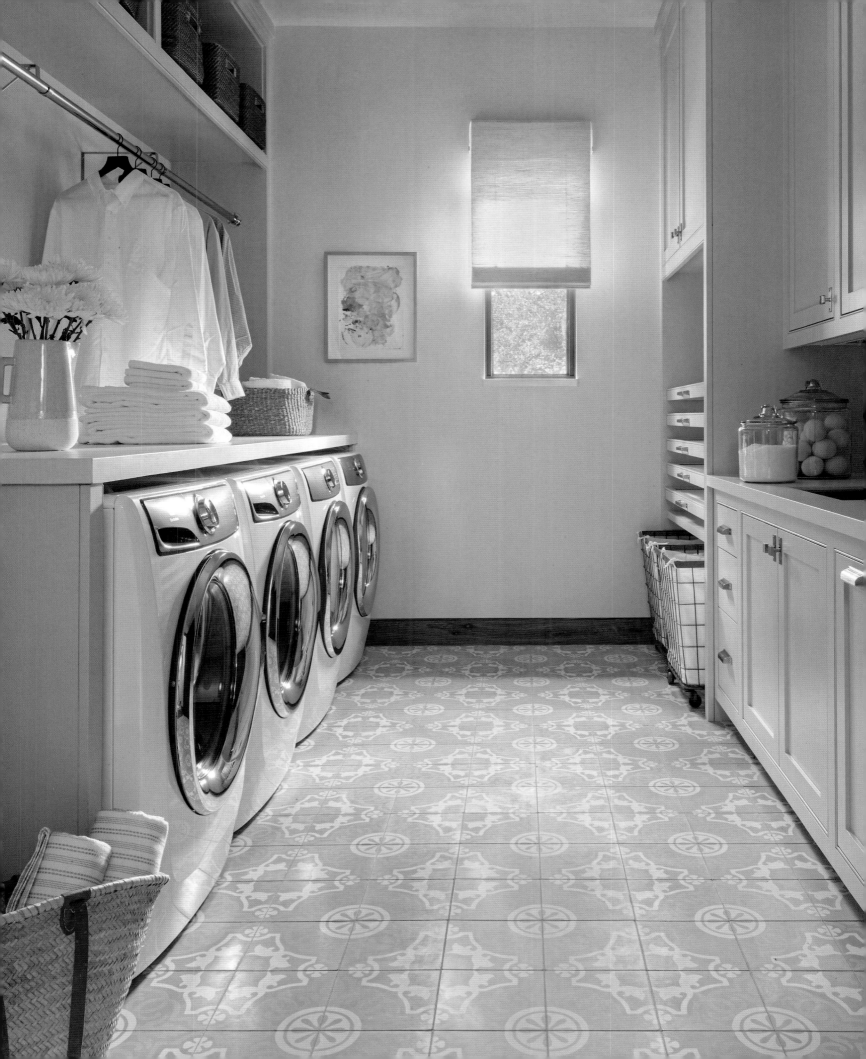

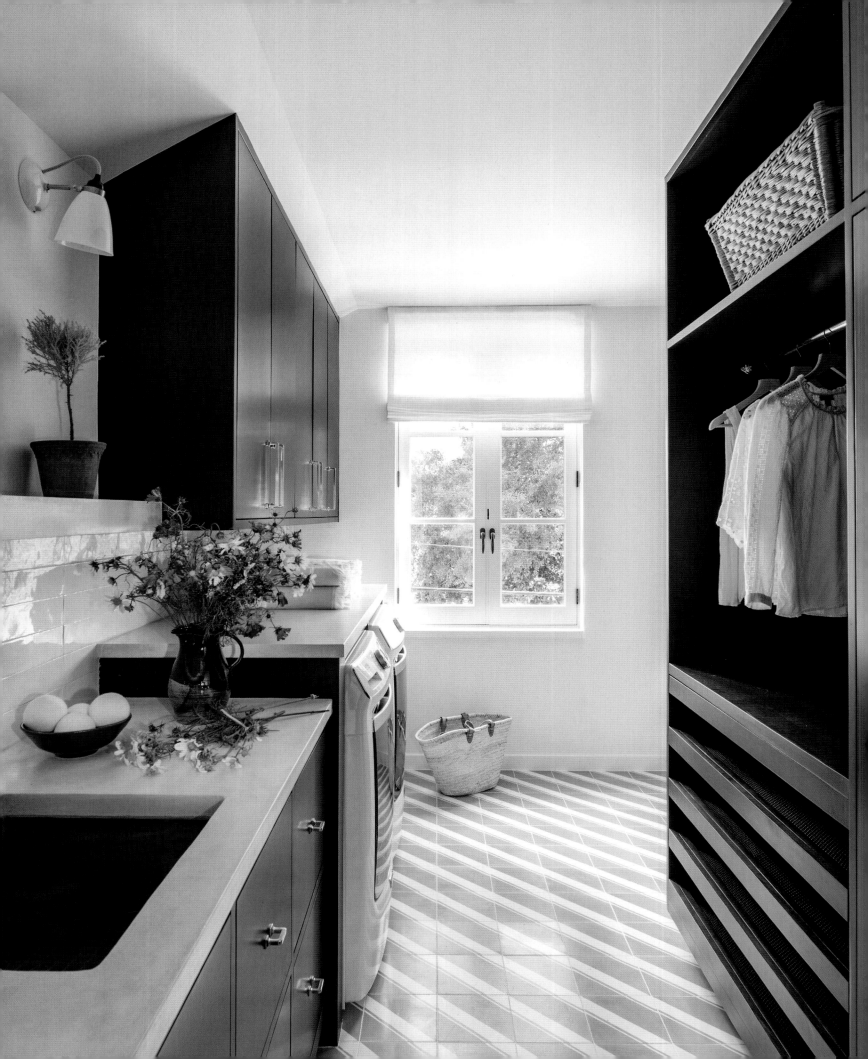

Patterned floors instantly uplift the energy of a small space

Encaustic tile is one of my favorite materials for laundry-room floors. Durable, water resistant, and easy to clean, it is ideal for daily use. Softer underfoot than ceramic tile, it comes in myriad colors, shapes, and patterns that pair beautifully with other materials such as concrete counters and glossy ceramic backsplashes.

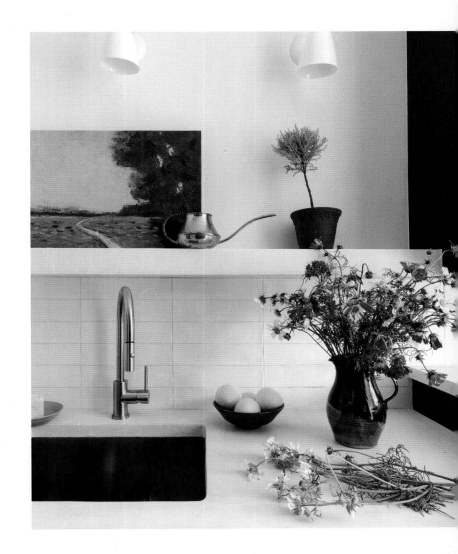

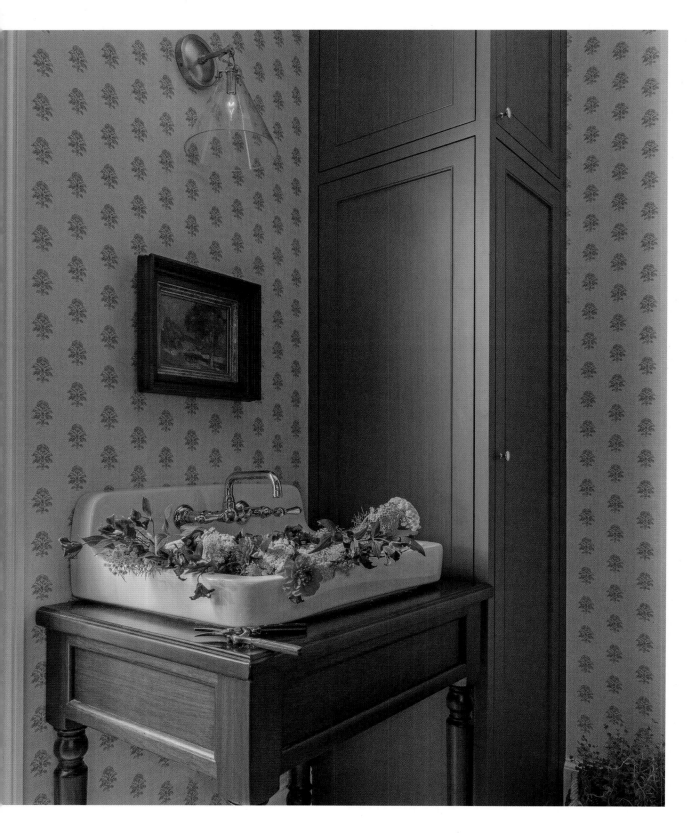

When task-oriented rooms have a furnished look, they are more pleasant to spend time in. I love repurposing antique washstands and worktables or designing custom pieces with furniture-like appeal to mix among the cabinetry. Stained wood countertops and handsomely detailed door and drawer fronts also add charm to utilitarian spaces.

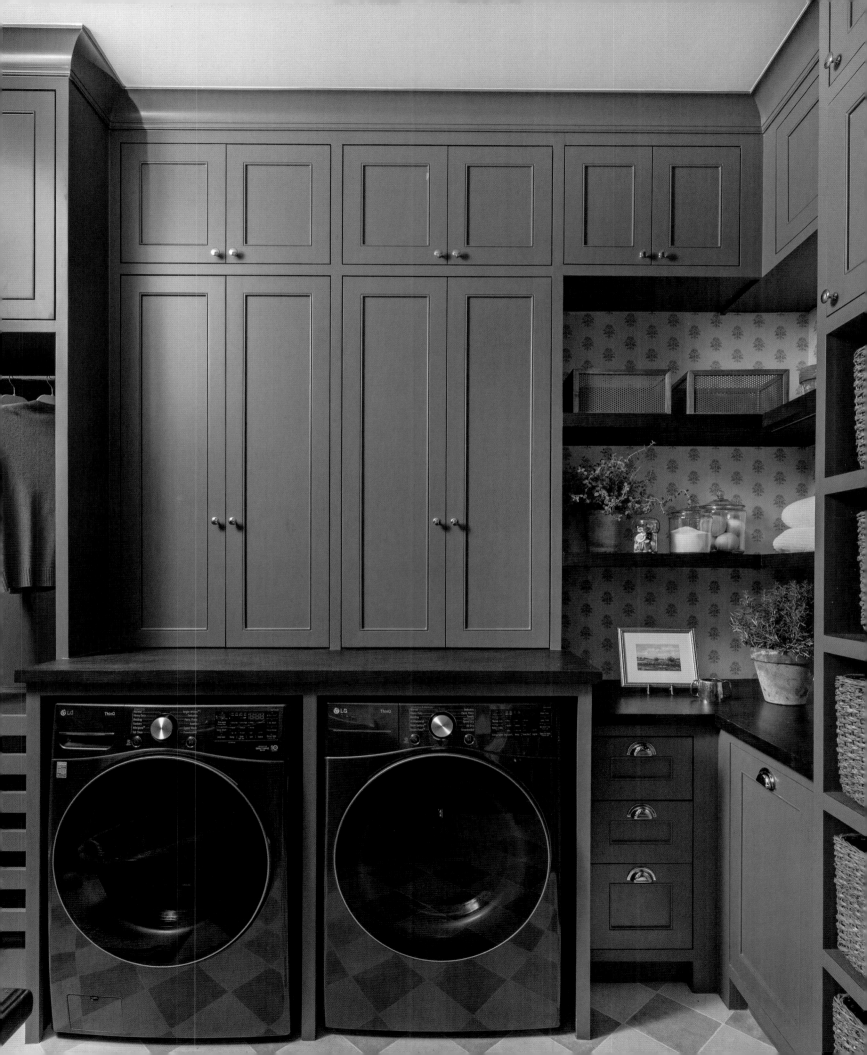

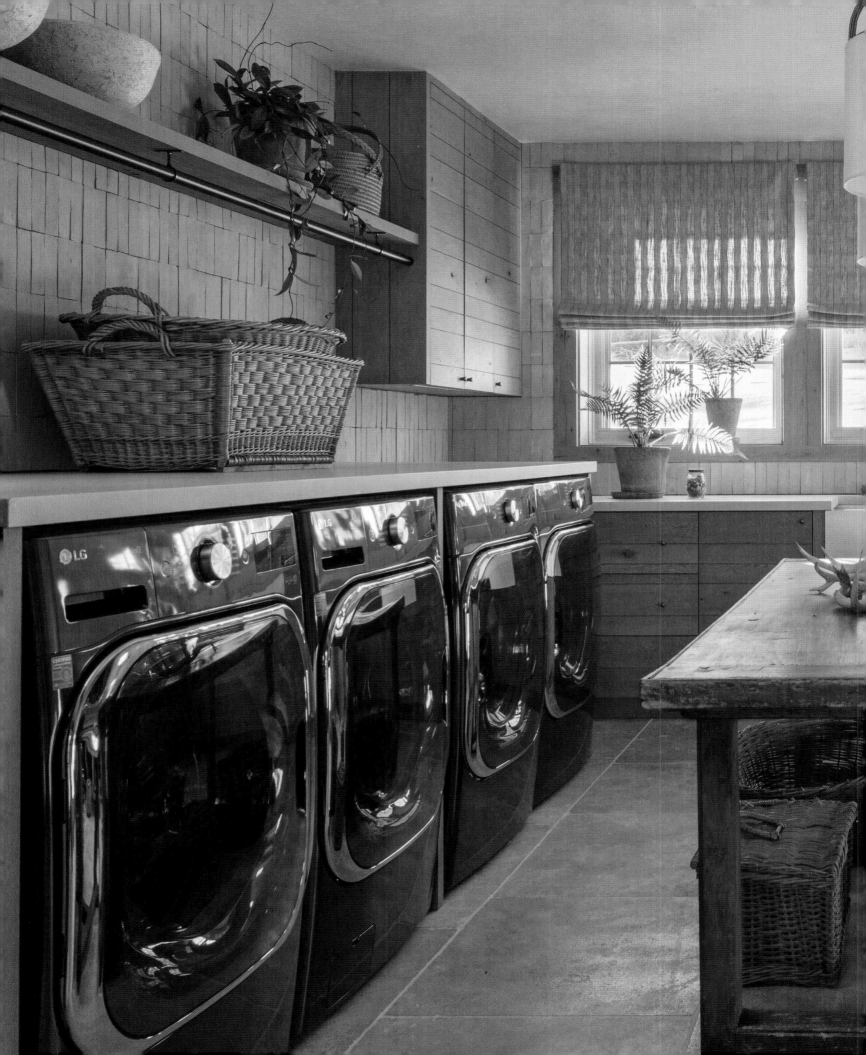

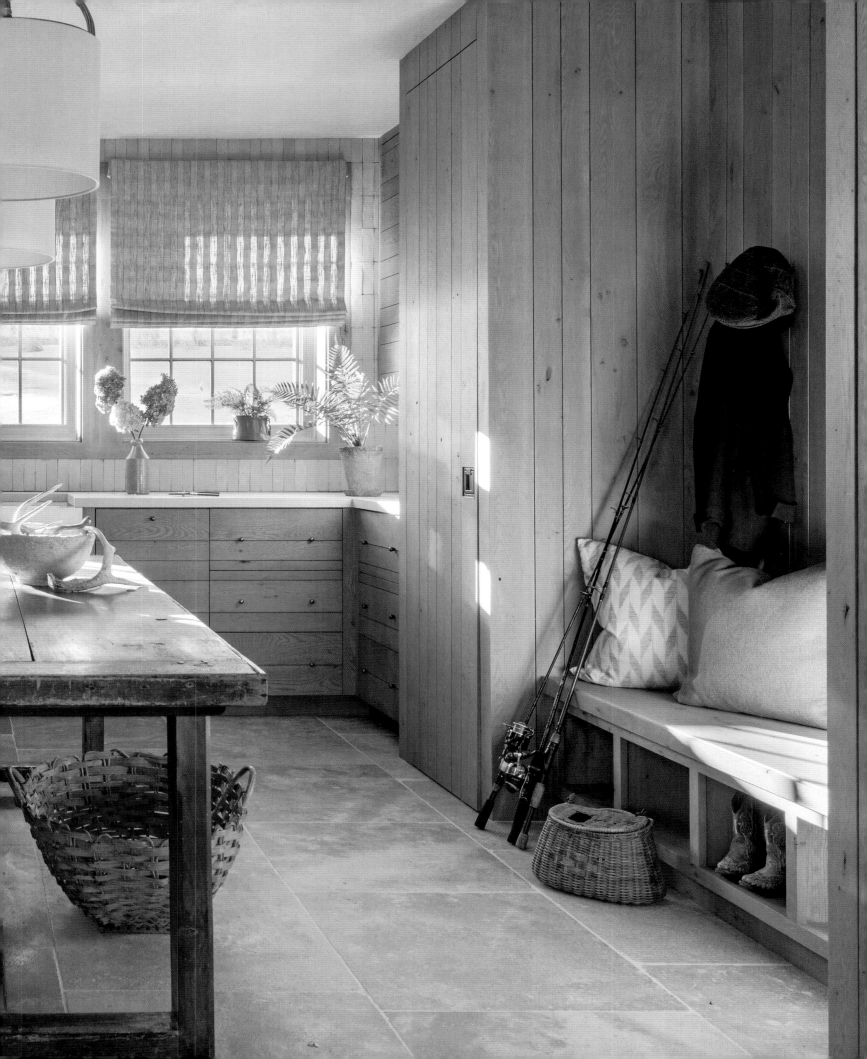

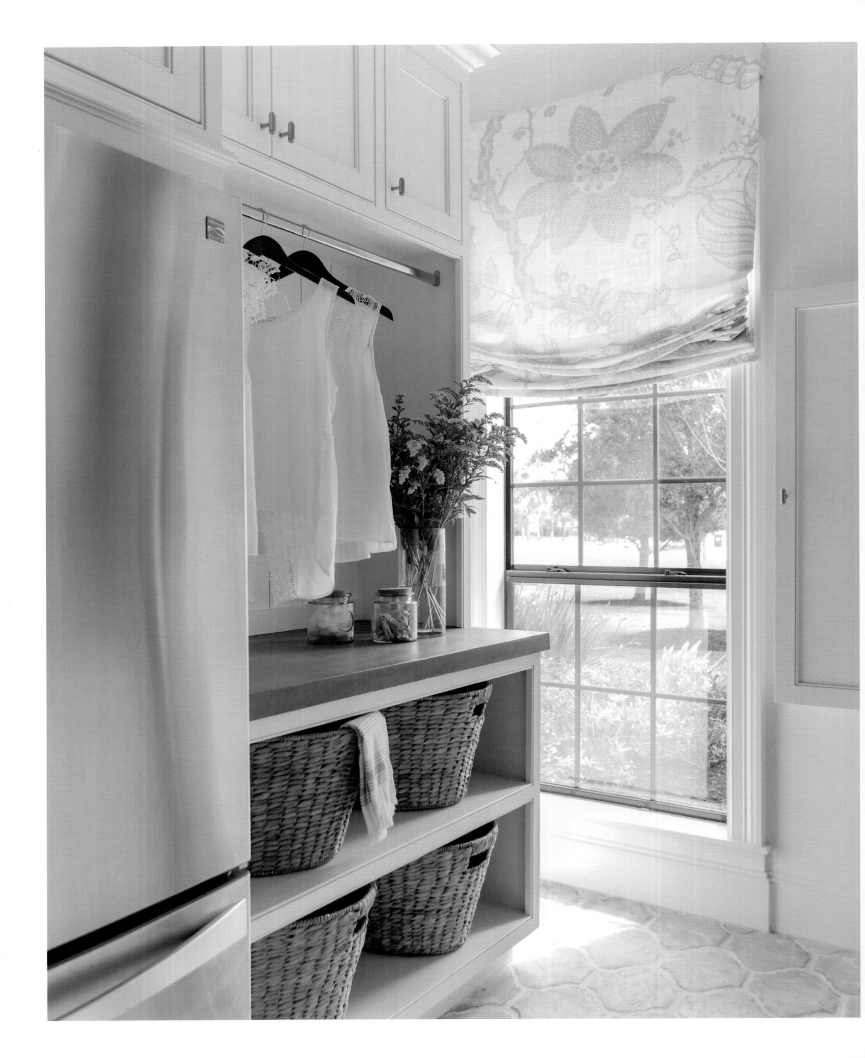

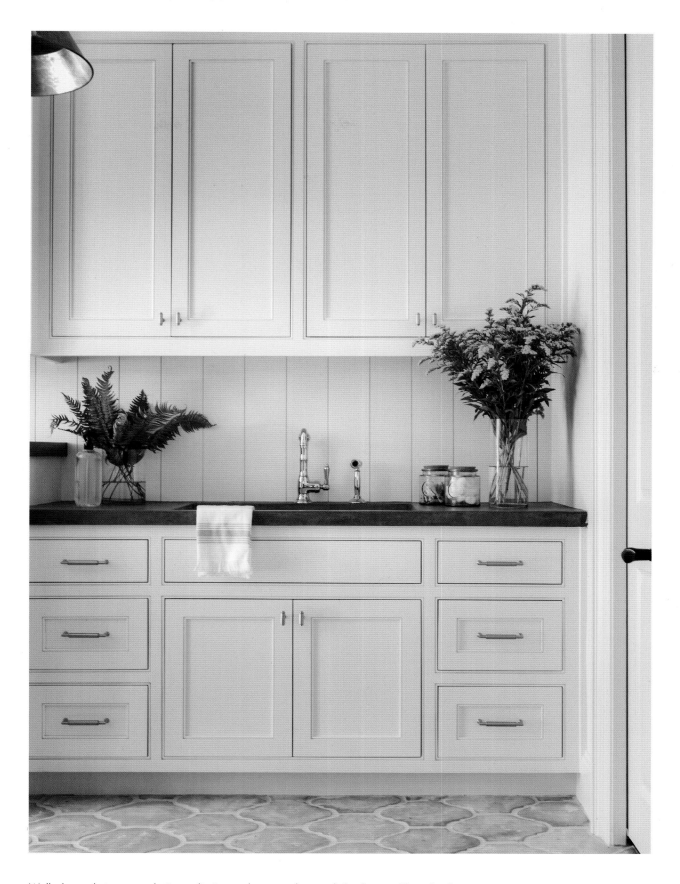

Well-planned storage solutions eliminate clutter and ease daily chores. Closed cabinets keep everything out of sight, while open shelving makes frequently used items easy to reach.

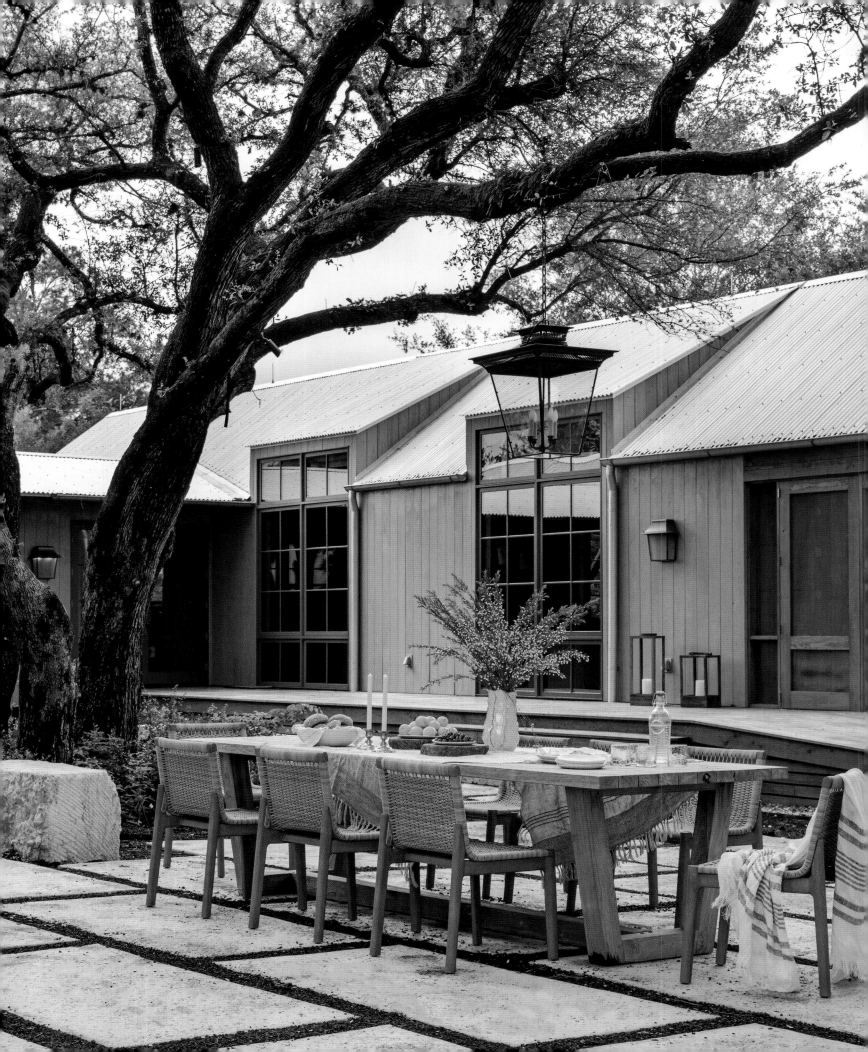

Breathe

Open-air spaces should beckon us outdoors for peaceful
moments of solitude or gatherings in nature's embrace.

Nature is a major inspiration for my work. The kaleidoscope of colors and textures, the sound of water, and the scent of flowers deliver a feast for the senses and the soul. Outdoor spaces intended for relaxation and rejuvenation such as porches, terraces, pavilions, or maybe just a shaded bench connect us with something greater than ourselves. When designed to look and feel like extensions of the house, they bring the healing power of nature into everyday life. I like to establish unity between the house and its open-air counterparts by repeating architectural motifs and materials. For instance, I might choose the same stone for the surround of an indoor fireplace and the outdoor dining area's retaining wall. For covered porches, I often employ paving materials, wall treatments, and ceiling details identical to those in adjoining interior rooms. The goal is a seamless experience that puts us at one with nature.

My approach to designing outdoor living areas resembles that of composing indoor ones, but my choices relate more directly to the surrounding environment. I begin by considering the floor plan and identifying focal points, then select a palette of colors and textures that reinforce the desired mood. In selecting furniture, I tend to limit my choices to two or three collections and repeat them throughout the property for a resort-like appearance. I treat textiles the same way, choosing a few foundation fabrics to unify areas, then enlivening them with accent patterns and textures. Each space deserves its own distinct personality, so it's important to layer in a few unique "found" items like rustic lanterns, an antique stone dining table, or decorative planters. Statuesque masonry fireplaces, mirrors with antiqued glass and weathered frames, and fountains composed of limestone or metal please the senses, heightening appreciation of the moment.

Plantings visually organize the landscape, establishing a sense of order, coherence, and purpose. They can provide privacy for intimate areas, establish borders around outdoor rooms, or frame vistas that are restful or impressive. If a beautiful view isn't available, a specimen tree or vines espaliered on a fence offers lush scenery on demand. It's also possible to savor nature's beauty and tranquility without even leaving the house. Doors and windows, whether a small, oval window silhouetting a well-composed view or an expanse of folding glass doors affording full exposure to the surrounding landscape, are potent tools for blurring the boundaries between interior and exterior spaces. I planted a screen of Japanese yew complemented by shrubs that attract butterflies and hummingbirds outside my kitchen window. This replaced a view of a neighboring house with a living manifestation of nature to be enjoyed every day.

When selecting plants, I lean toward those that blend with their location and appear native to their landscape. Naturalistic plantings around swimming pools make them seem as if they have always been part of the scenery. I also choose tile, coping, pavers, and plaster for the pool to reflect the surrounding environment. If there's a body of water nearby—a pond, a lake, the ocean—I select colors that echo it. I have a fondness for crafting distinct destinations across properties, encouraging exploration of overlooked areas or natural features. In a house surrounded by majestic, century-old oak trees, we positioned a sizable table beneath a particularly impressive one and adorned its limbs with a hanging lantern. In addition to presenting a captivating focal point when viewed from inside the house, the arrangement provided an enchanting outdoor dining space for family and friends.

Seizing opportunities to reach beyond our immediate environment to connect with nature deepens and enriches the contentment we find within our own walls. In a distracting world where people struggle to spend time outside, dedicated spaces that immerse us in nature improve our health and mood. Nothing is more spiritual and satisfying than communing with creation.

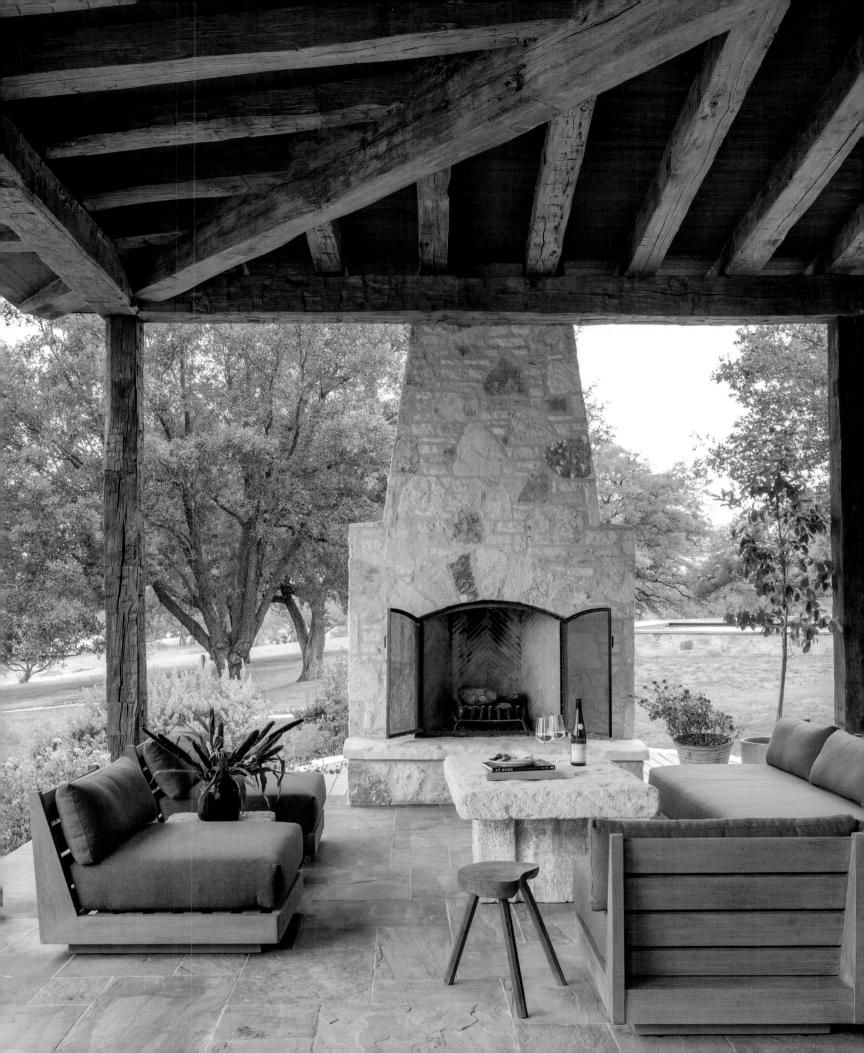

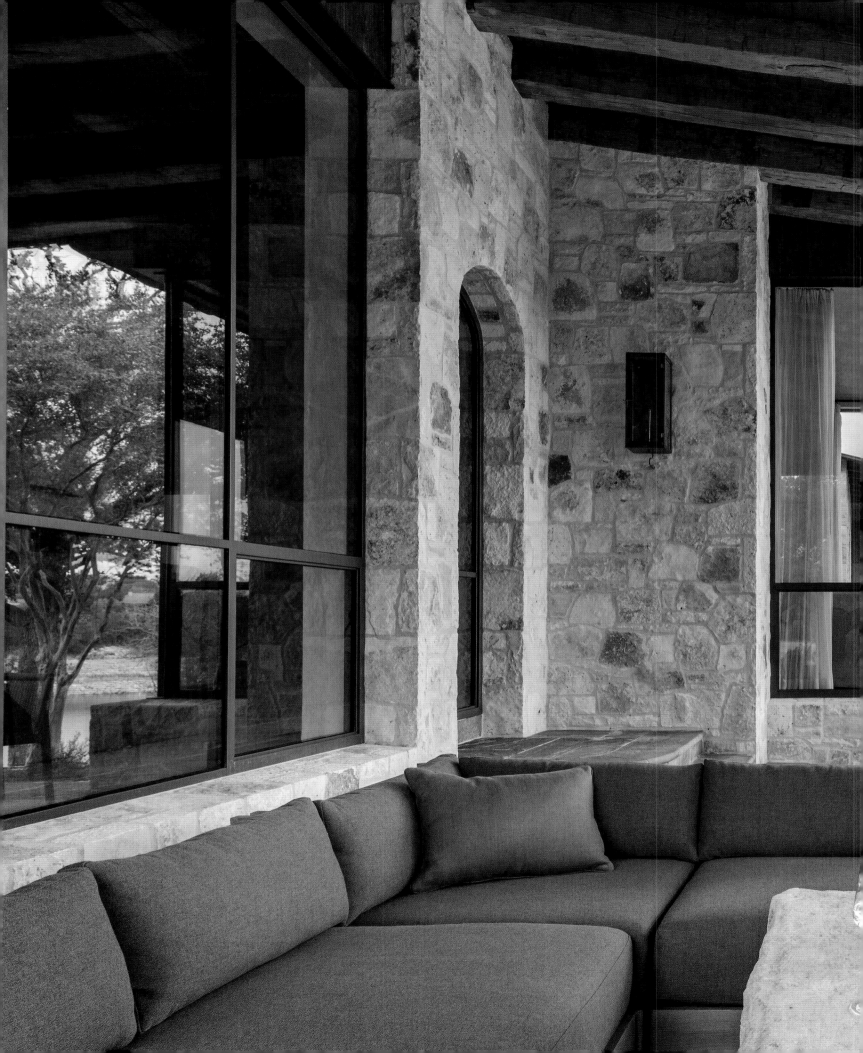

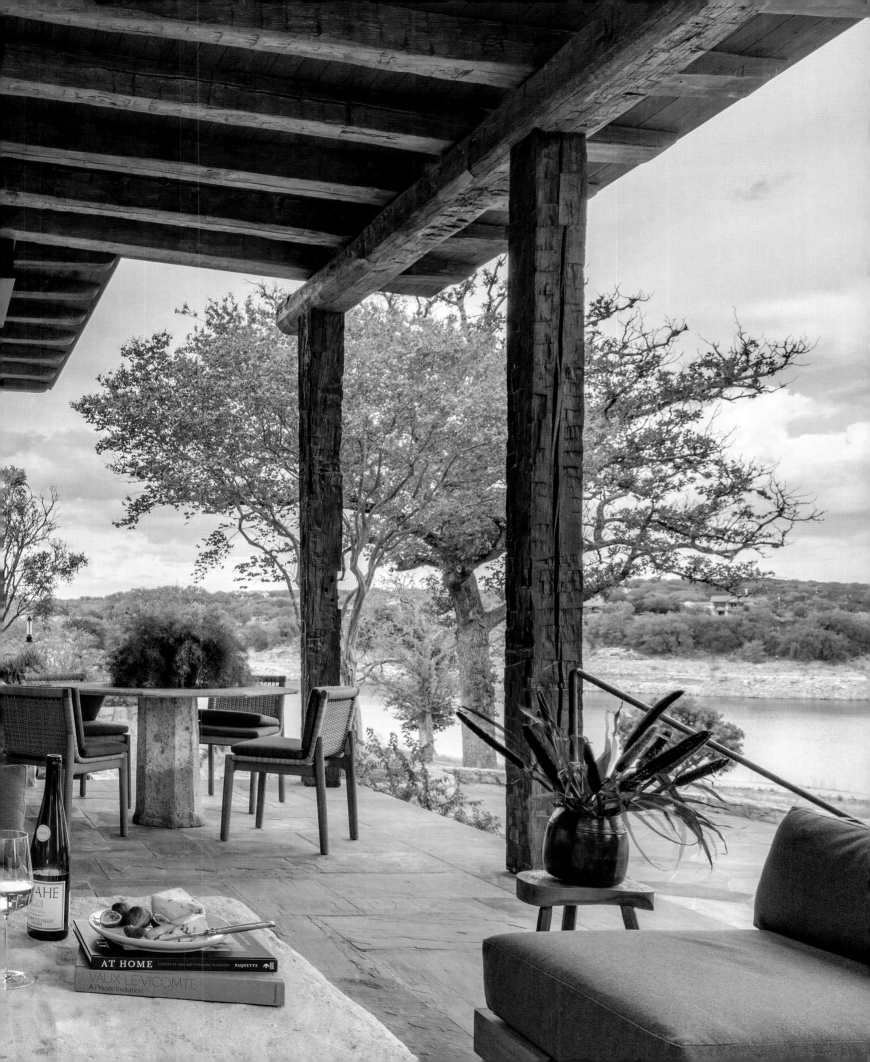

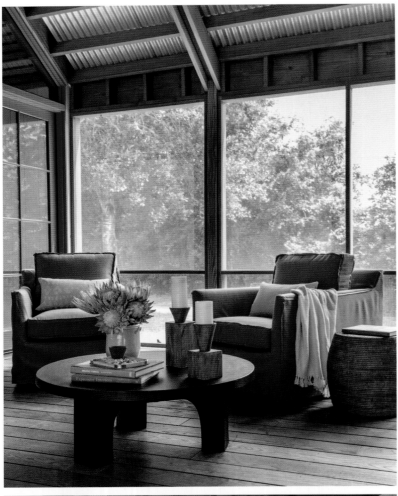

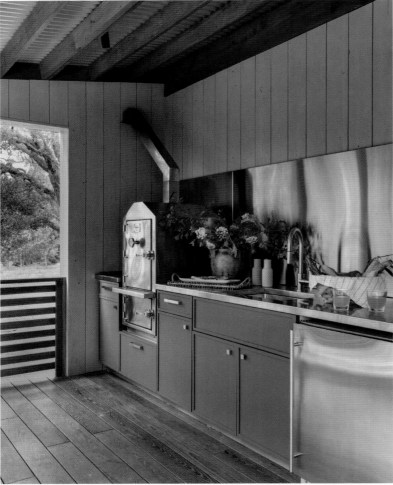

Porches can form a seamless connection between indoor and outdoor environments. These transitional spaces should establish unity between the house and its surroundings. While architectural materials typically reflect the home's exterior, I also seek ways to forge a connection with adjoining interior rooms through color and texture. Comfortable seating arrangements with a mixture of plush, sturdy cushions and weather-resistant tables and chairs are essential, as well as outdoor rugs, throws, and cushions that make seating groups feel inviting.

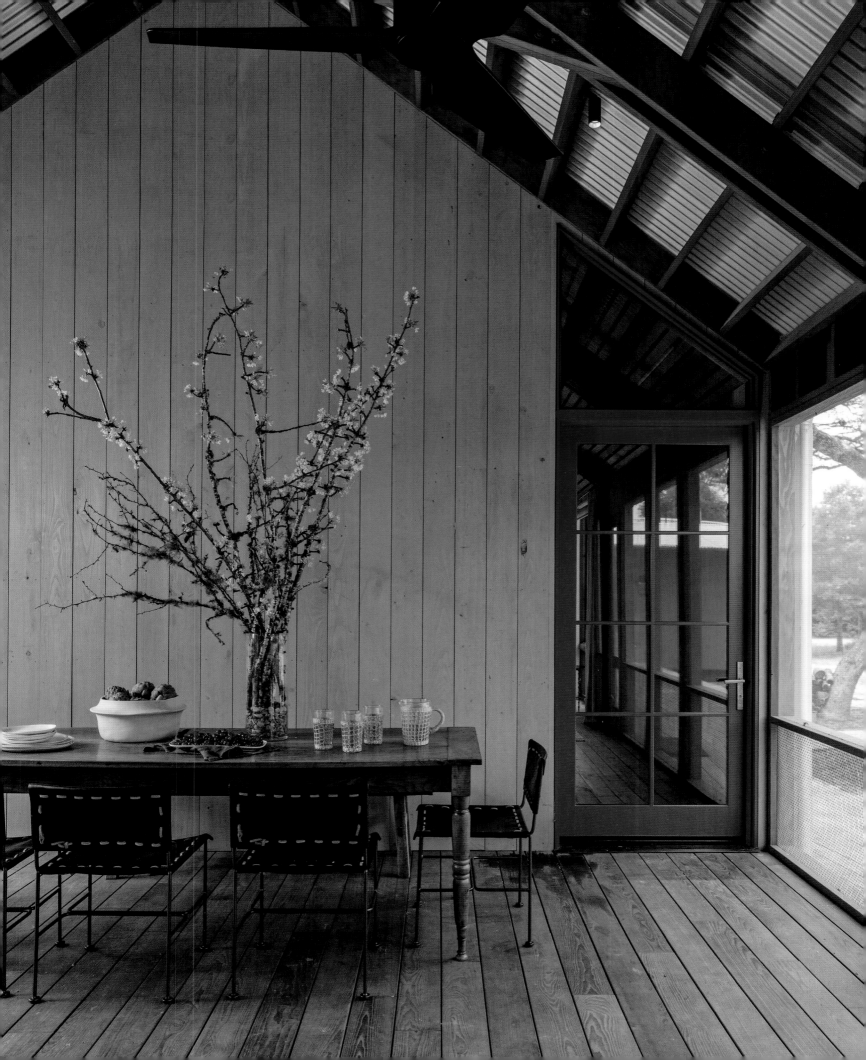

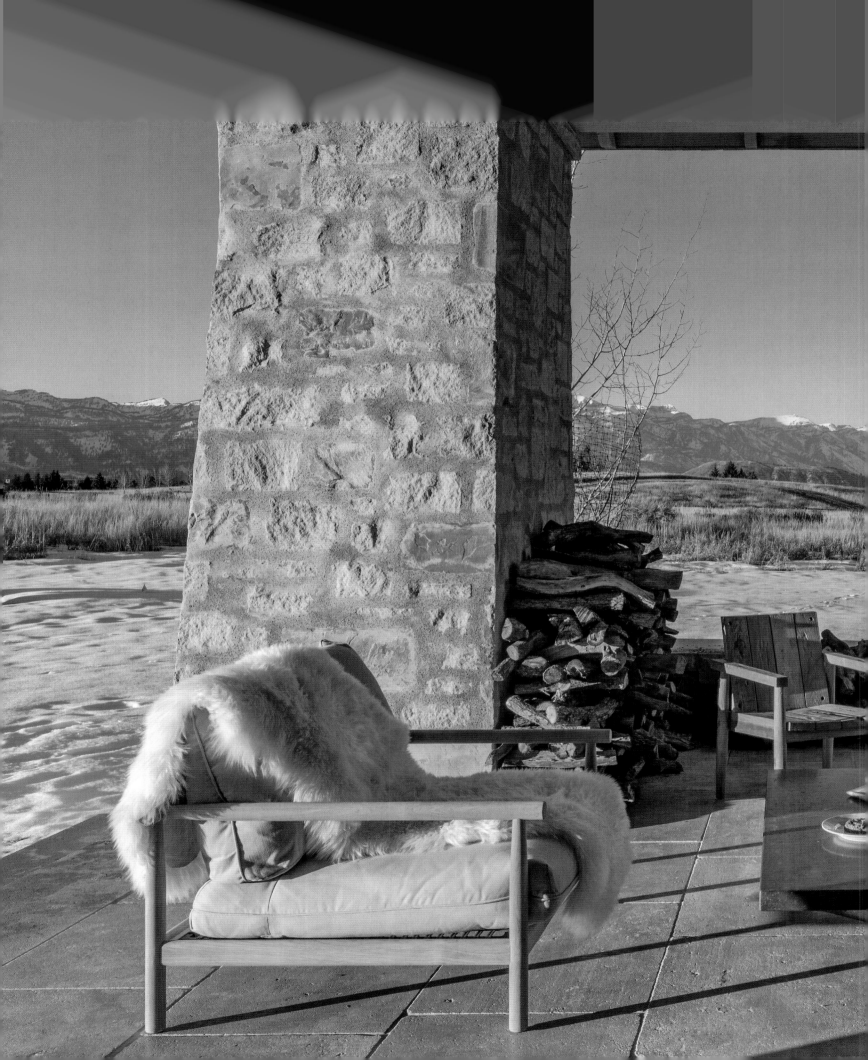

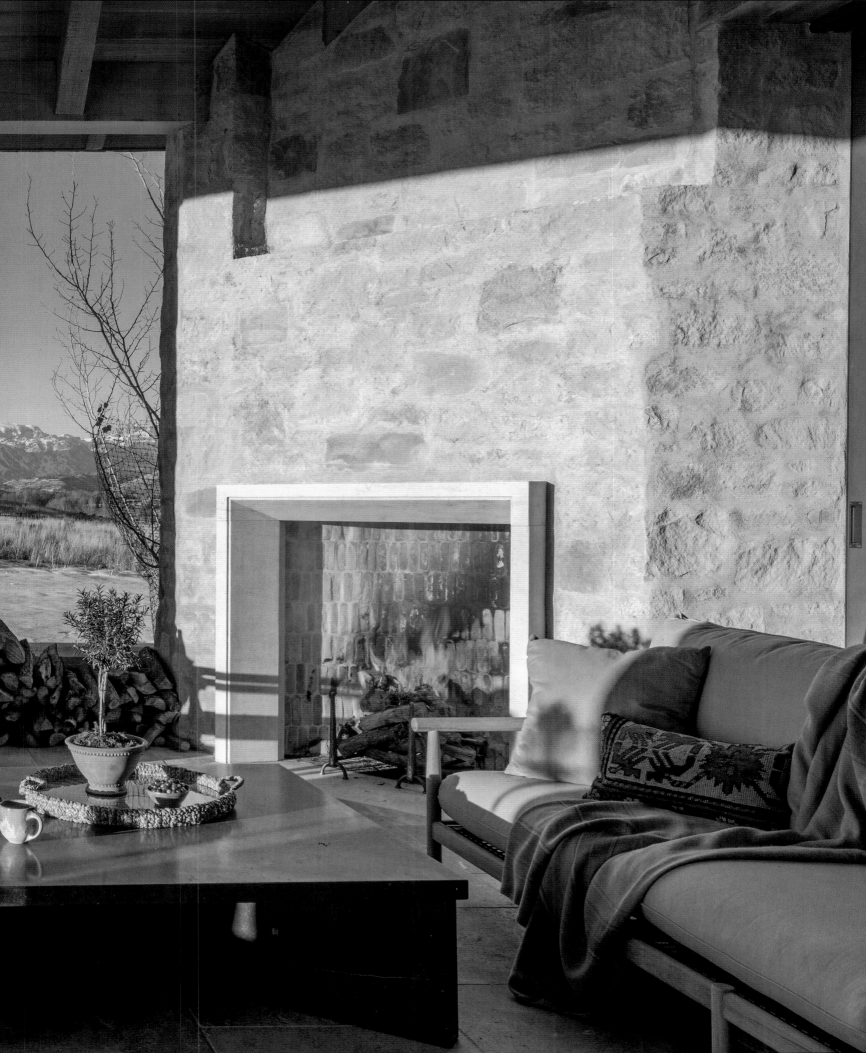

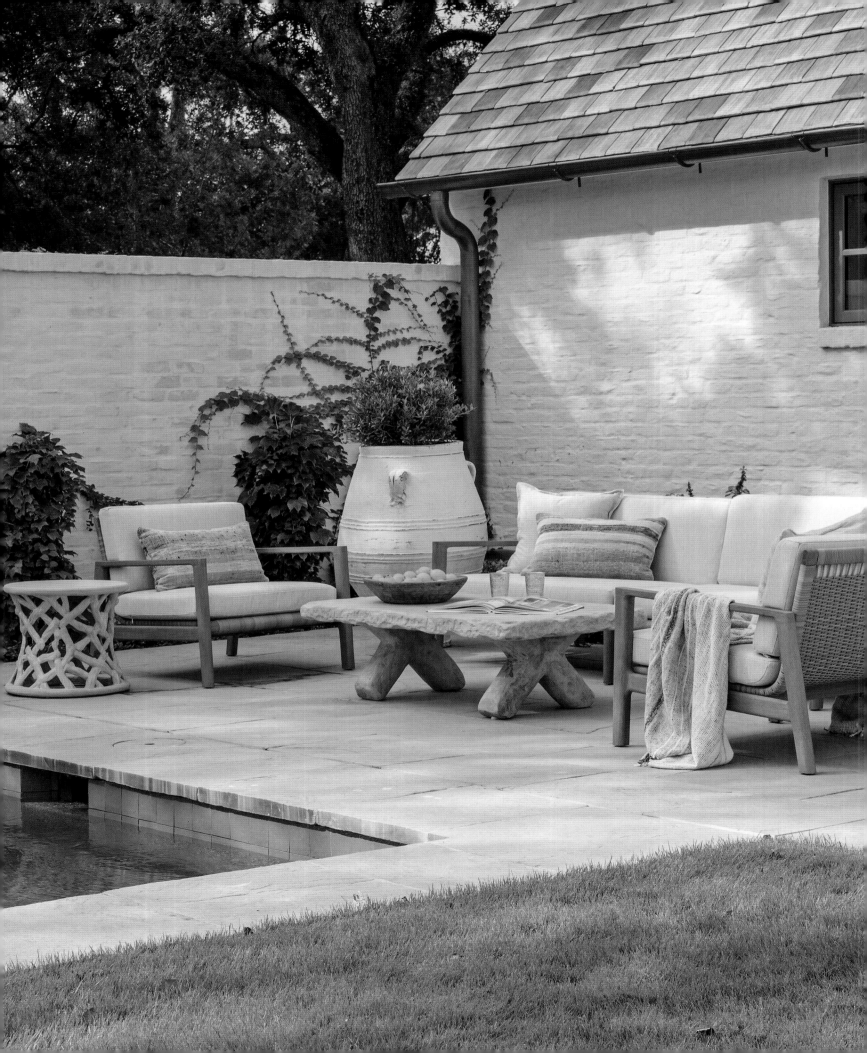

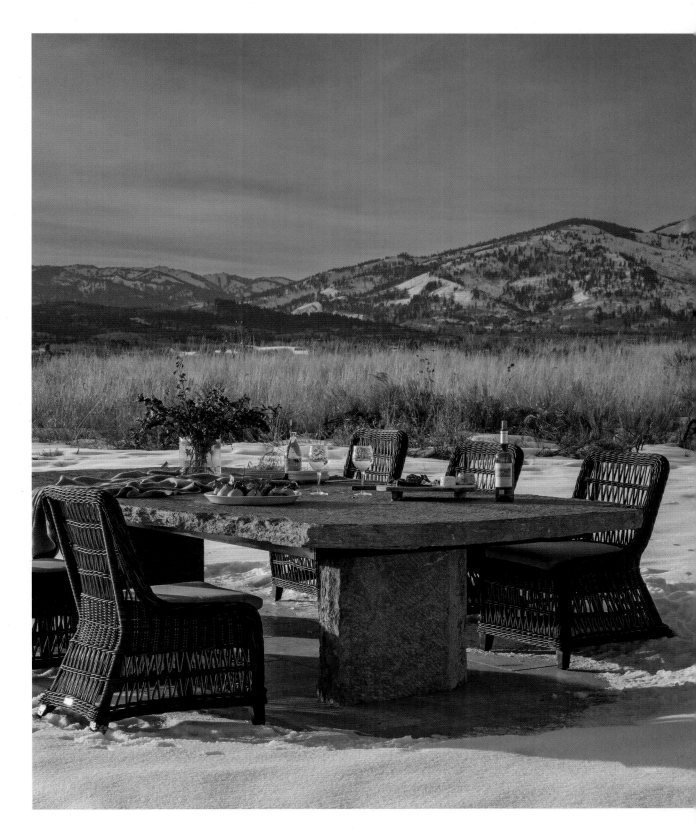

Whatever the season, a well-placed furniture vignette encourages spending time outdoors, engaging with nature and one another in meaningful ways. Grounding the composition with a stone table allows lighter furnishings to float around the area, accommodating different sizes and types of gatherings.

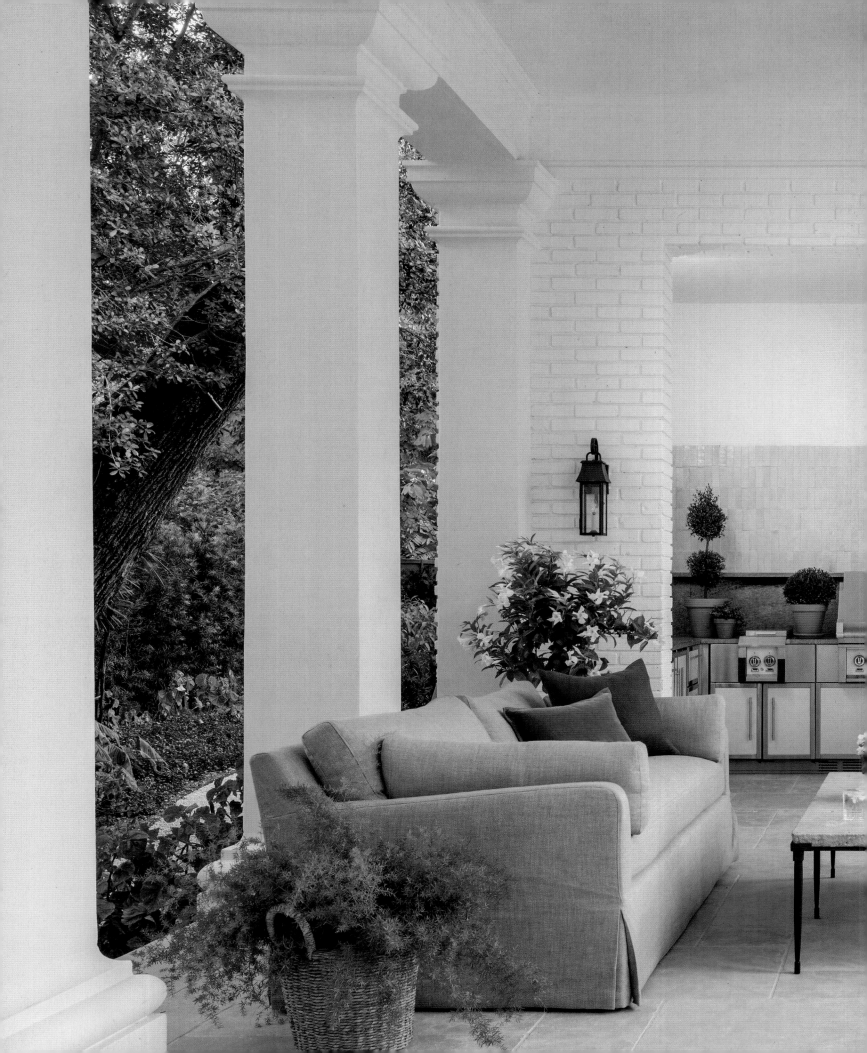

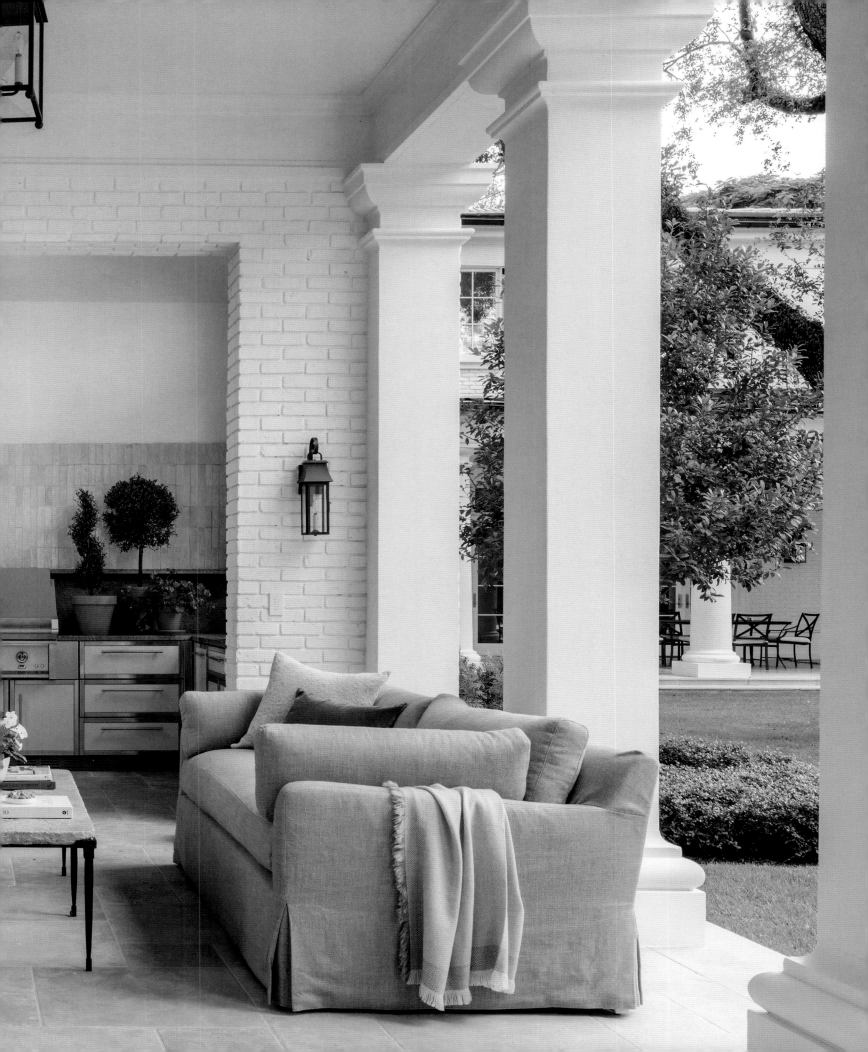

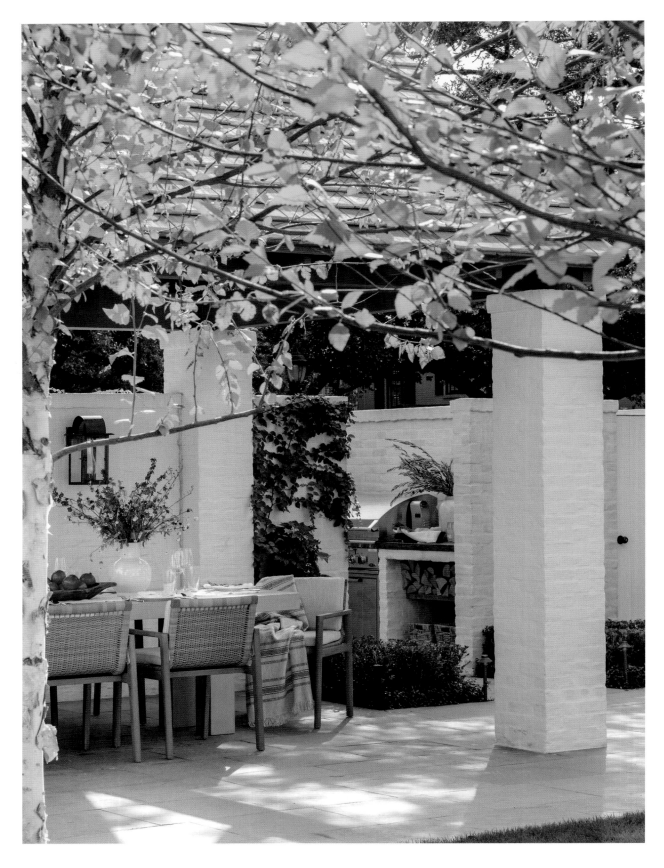

A harmonious selection of materials promotes a feeling of tranquility and focuses attention on the surroundings. When the color palette is limited, I use metal lanterns of oxidized copper and bronze and chairs of teak, mahogany, wicker, or rattan to introduce texture and patina. For tactile contrast, consider mixing wood with concrete, plaster, stone, or glass.

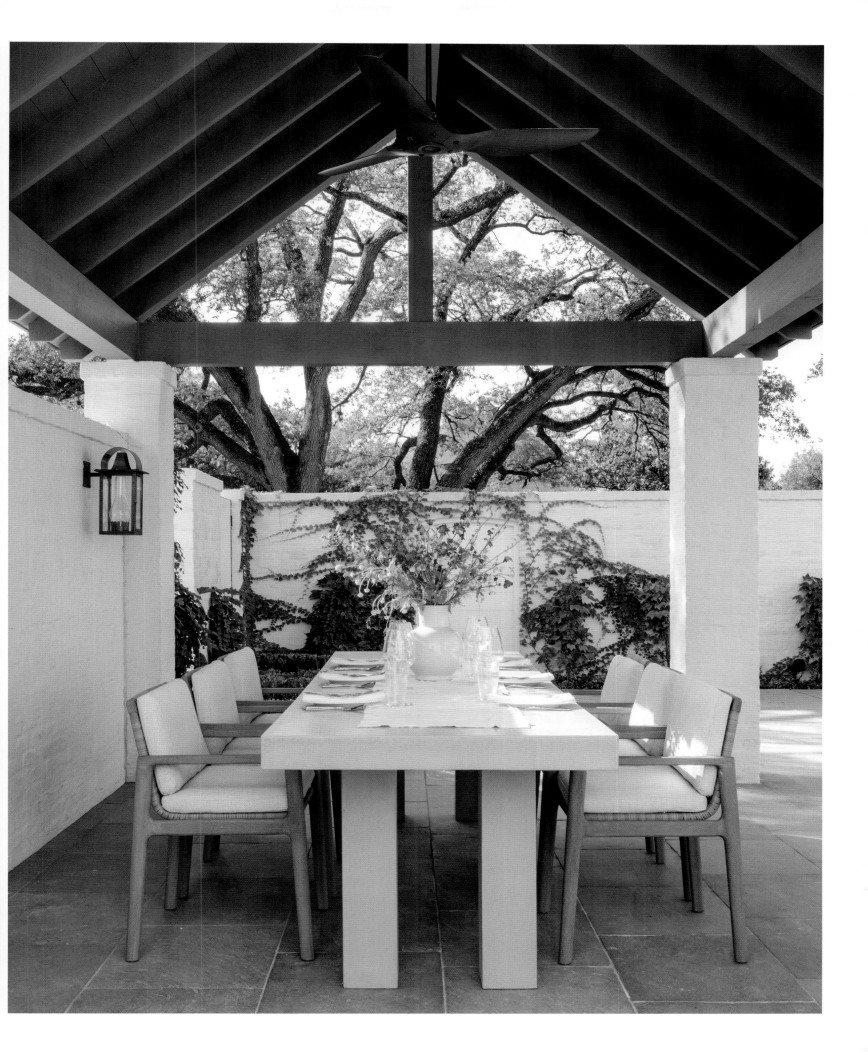

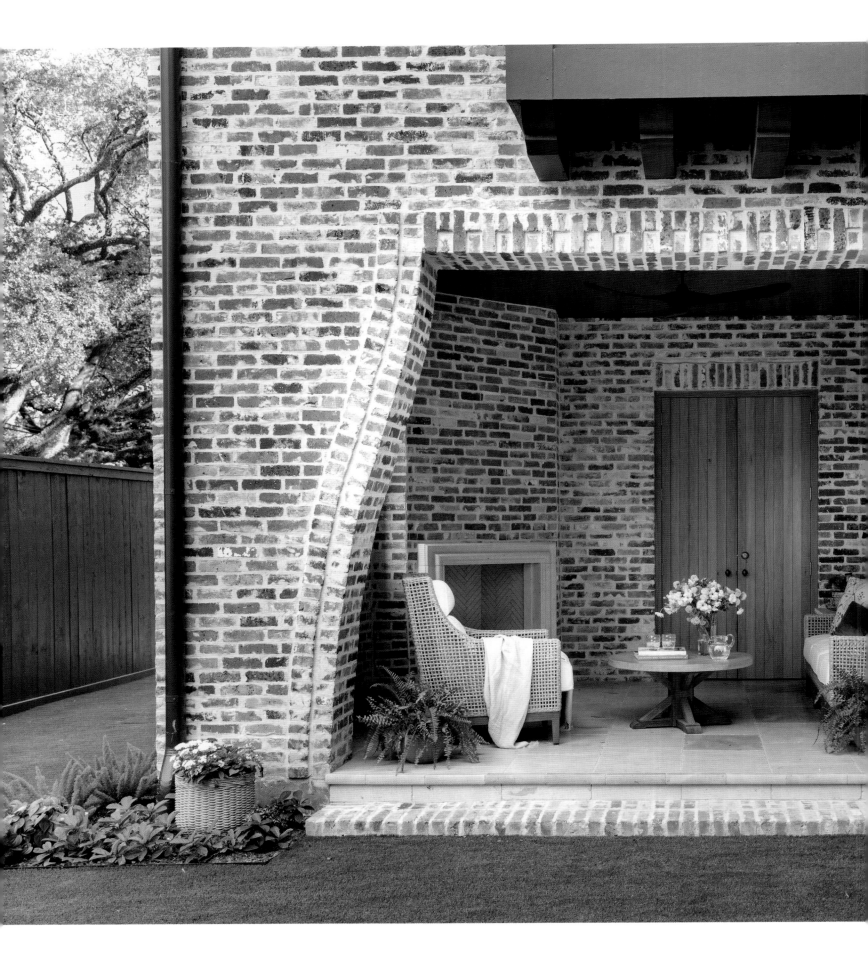

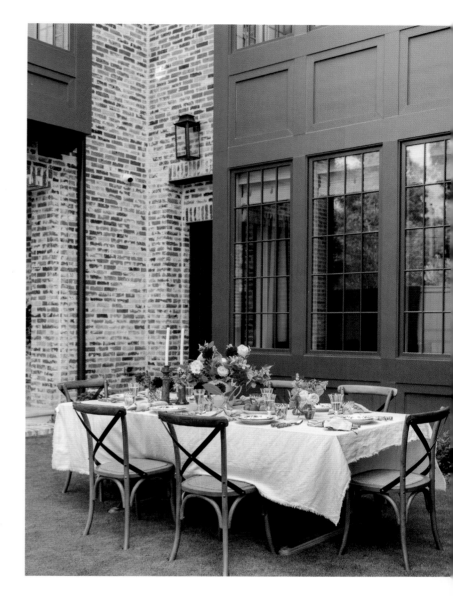

Intimate porches carved into the architecture of the house can become favorite outdoor destinations, as exemplified by a small, sheltered spot at my home where we relax while watching our children play. When space constraints preclude a dedicated outside dining area, versatile furnishings that can be easily stored ensure effortless adaptability for fresh-air entertaining.

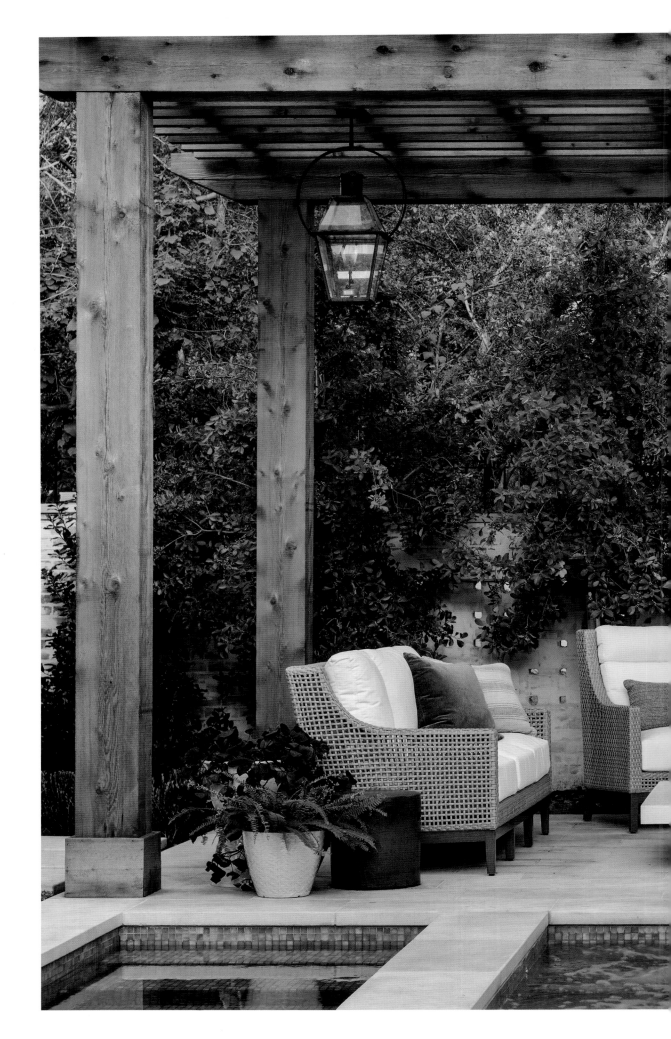

Create an outdoor destination with a rustic pavilion positioned at the end of a lawn. When illuminated by gas lanterns, it presents an invitation to romantic gatherings beneath the stars. I love to vary textures in hardscaping, contrasting matte materials like limestone pavers with glimmering ones such as glass mosaic tile.

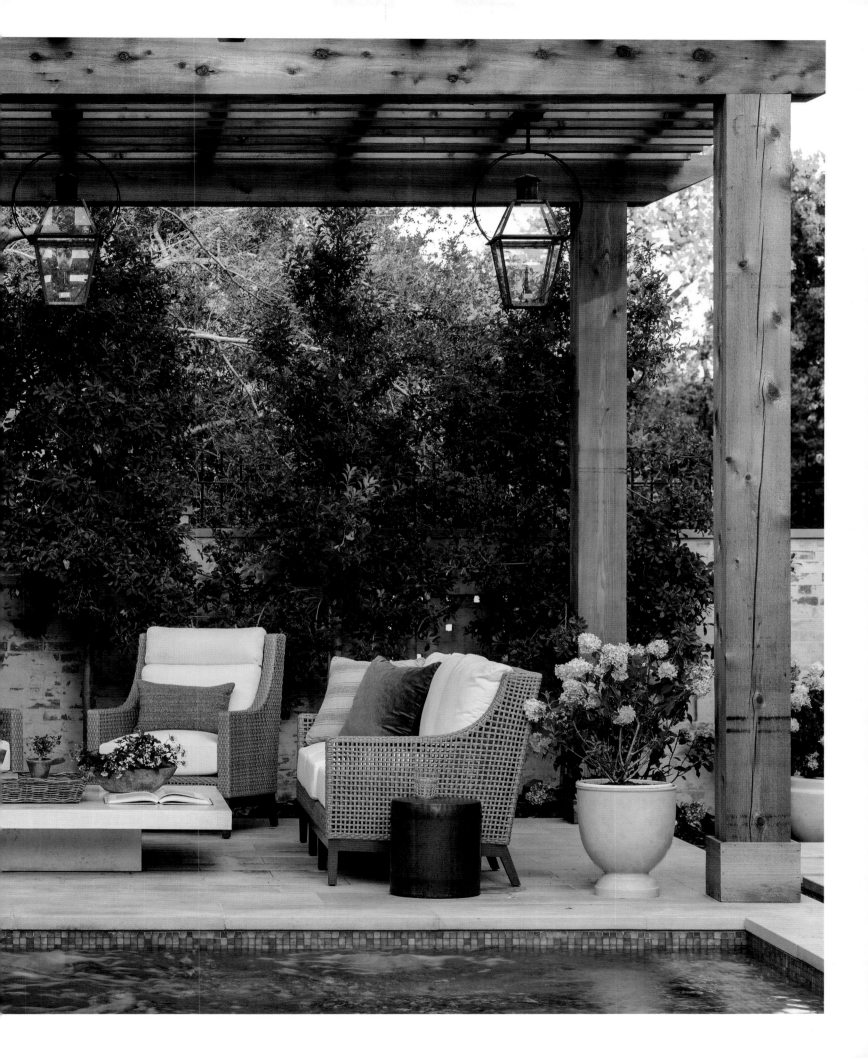

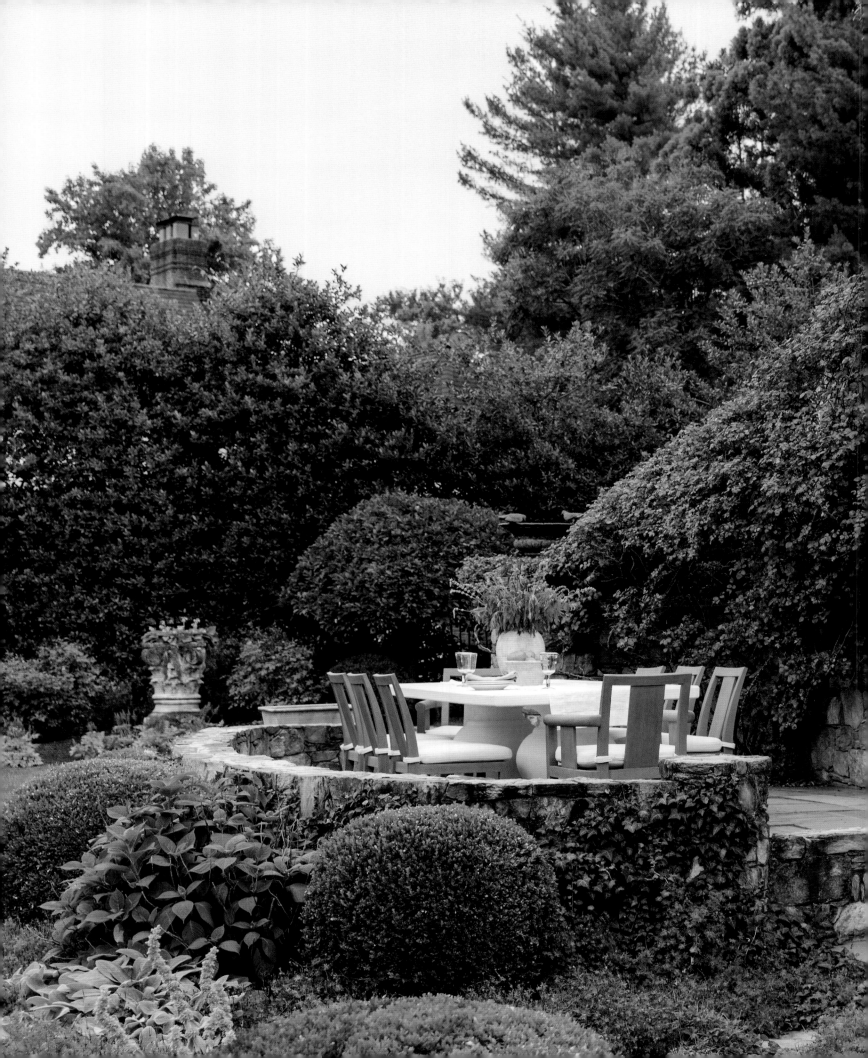

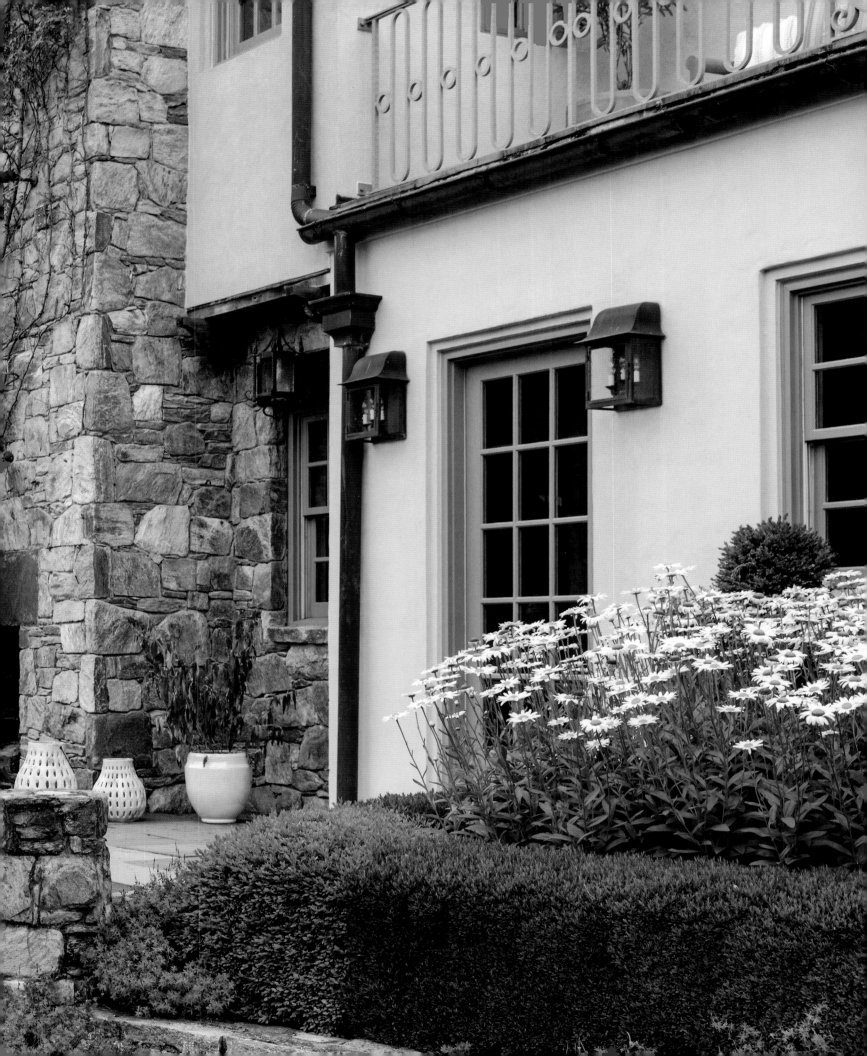

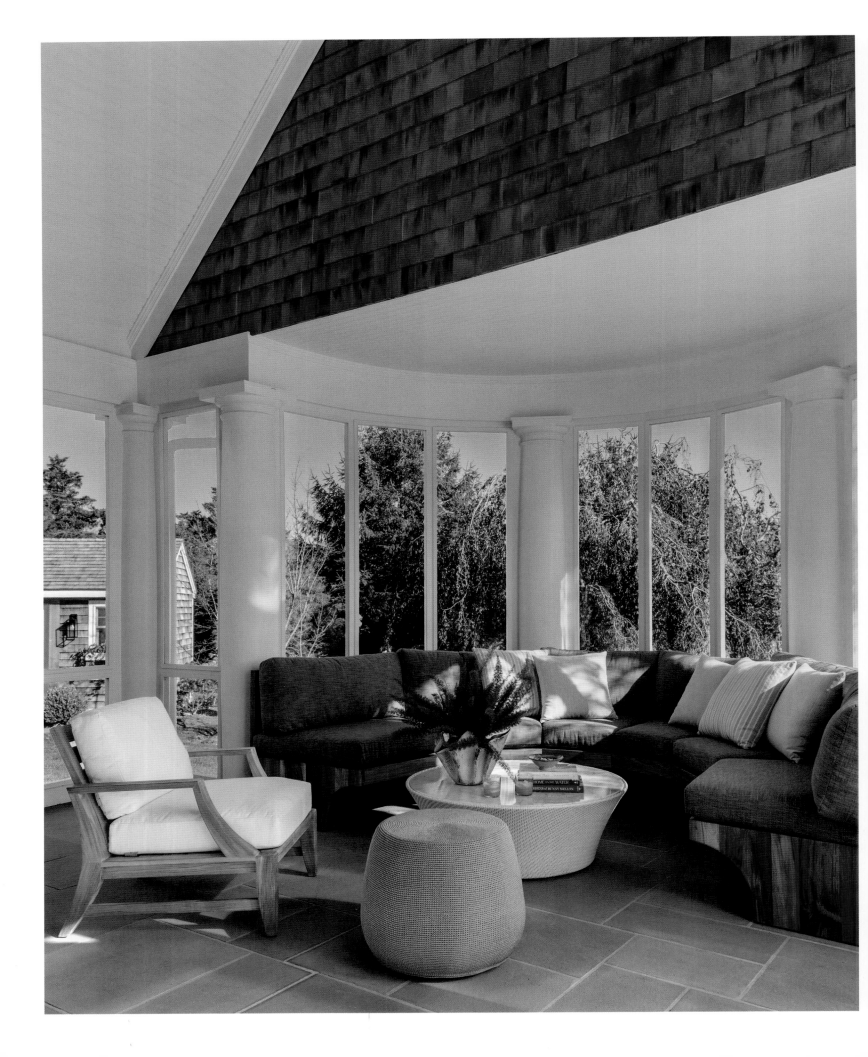

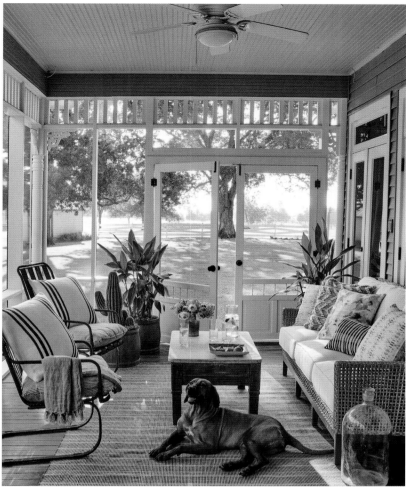

It's hard to resist the charm of natural materials on porches

Painted timber planks, cedar shakes, and stone are good choices for the walls of casual porches. I often choose ipe, limestone, or brick for floors and painted beadboard or stained mahogany on ceilings. Weather-resistant rugs, upholstery, and cushions bring color and soft texture into the mix. Blue-and-white cotton, linen, and solution-dyed acrylic are my go-to choices in coastal settings. Nothing looks cooler and more inviting or lasts longer outdoors.

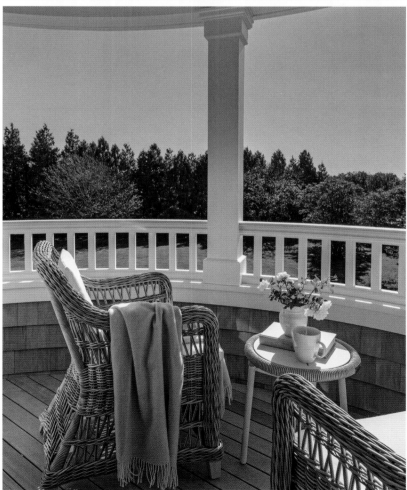

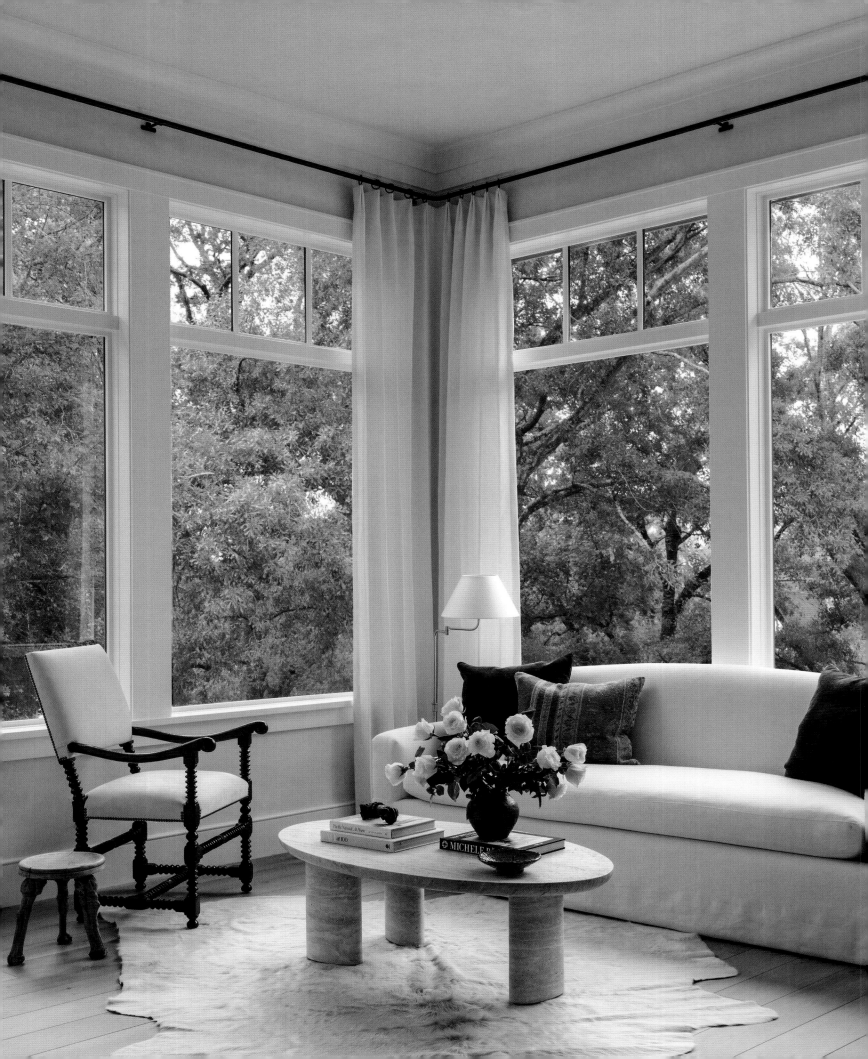

Acknowledgments

One of my favorite teamwork metaphors is that of steering a ship. Everyone involved must simultaneously row in the same direction at a well-coordinated pace to make progress. It is my pleasure to collaborate daily with our firm's exceptional design staff who work tirelessly to stretch the boundaries of this creative field while demonstrating the utmost professionalism. Sydney Manning, Melanie Hamel, Kristin Fitzgerald, Kelsey Grant, Ashlee Garner, Maddie Farmen, Helene Dellocono, Kandice Eiskant, Kristin Carter, Lillian Denton, and many other talented women have served our clients faithfully throughout the years. I offer special, heartfelt thanks to Kelsey Grant, who has been instrumental in managing this complex book project. We have worked together for more than a decade, and I greatly value the passion, dedication, and insight you brought to *The Perfect Room*. Of course, none of our design intent would come to fruition without the precise detail management of our logistics and operations colleagues Julie DiPaolo, Kristen Emerson, Jennifer Hammer, Laura Wheeler, Susan Wilt, Anne Calvo, and Lily Nasar. The fruits of our labor are shared with the world at large through the notable efforts of our in-house marketing and public relations teammates, Kathleen Landry and Jasmine Pachar.

The relationship between interior designer and client is in many ways a sacred one, and I have had the joy of forming lasting friendships with many homeowners during my career. To be entrusted with your dreams is a responsibility I do not take lightly. I cherish the opportunity to work alongside the best architects, builders, and landscape architects across the country. It is an honor to bear witness to their processes and to shape a meaningful future for our clients together. I would like to express particular gratitude to Jeffrey Dungan, whose work I have long admired, for contributing the foreword to this book.

Long-standing industry partnerships with the highest caliber vendors, craftspeople, artisans, and installers are the key to delivering beautiful and functional designs. Thank you for bringing the finest resources, furnishings, and finishing touches to execute our visions. Our portfolio is built on the imagery that photographers Julie Soefer and Claudia Casbarian capture so skillfully. I offer a special thanks to Julie for her beautiful contributions to this book, as well as to stylist Jessica Brinkert Holtam, who enhances every photo shoot with her styling and floral talent.

To Charles Miers, publisher of Rizzoli International Publications, thank you for giving me a distinguished platform and the necessary support to craft another volume. To the esteemed editor Sandy Gilbert Freidus, your expert advice and thorough shepherding of this process has been invaluable. Susan Sully, I cannot thank you enough for organizing and recording my thoughts in an authentic voice in this second book we have created together. Your commitment to polished language and your inexhaustible work ethic are indispensable. Jan Derevjanik, thank you for producing countless iterations of graphic layouts until we landed on the perfect design. It has been a joy to work with a team of such talented and dedicated people.

Finally, I would like to thank my parents, who always encouraged my love for the arts and taught me to chase my passions. And most importantly, my deepest gratitude is reserved for my family—Joe, John, William, and Eve. You are my greatest joy. All of this would mean nothing without you.

Project Credits

Del Monte
Design Lead: Melanie Hamel
Logistics Lead: Julie DiPaolo
Builder: The Southampton Group
Architect: Dillon Kyle Architects
Pages 30–31, 43

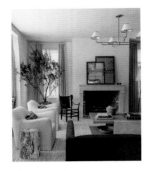

Flanigan Home
Builder: Cronin Builders with Joe Flanigan
Architect: Cusimano Architect
Landscape Architect: Moss Landscaping
Pages 2, 4, 34–35, 52, 53, 60, 69, 96 (top), 120, 121, 128, 130 (top), 136, 154–55, 166, 182, 197, 198, 209, 215, 244–45

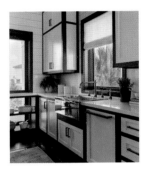

Galveston Bay
Design Lead: Melanie Hamel
Logistics Lead: Julie DiPaolo, Nycole McMahon
Builder: LeBoeuf Homes
Pages 12–13, 72, 73, 126

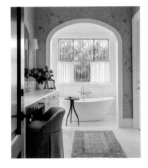

Highland Park
Design Lead: Sydney Manning, Maddie Farmen
Logistics Lead: Julie DiPaolo
Builder: Barringer Custom Homes
Architect: Jerry L. Coleman Design LLC
Pages 14, 27, 32–33, 40, 66, 80–81, 103, 117, 129 (bottom), 164–65, 192, 193, 194, 195, 201, 222, 223, 246–47

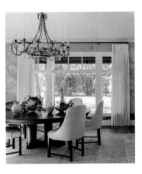

Hunters Creek
Design Lead: Ashlee Garner
Logistics Lead: Julie DiPaolo
Builder: Builders West
Pages 44–45, 49, 252

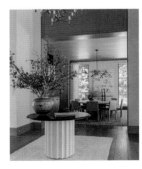

Inwood
Design Lead: Sydney Manning
Logistics Lead: Nycole McMahon
Builder: The Southampton Group
Architect: Dillon Kyle Architects
Landscape Architect: Moss Landscaping
Pages 23, 116, 185

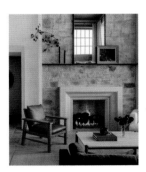

Jackson Hole
Design Lead: Melanie Hamel
Logistics Lead: Julie DiPaolo
Builder: On Site Management
Architect: Jeffrey Dungan Architects
Landscape Architect: Agrostis, Inc.
Pages 7, 8–9, 18, 19, 61, 62–63, 82, 83, 90, 91, 110–11, 124, 138, 152, 153, 178, 208, 216, 224–25, 236–37, 239

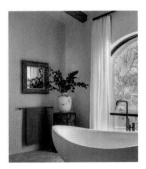

Lake Travis
Design Lead: Melanie Hamel
Logistics Lead: Julie DiPaolo, Nycole McMahon
Builder: Classic Constructors
Architect: Chas Architects
Landscape Architect: James Hyatt Studio
Pages 28–29, 46, 47, 64–65, 86, 87, 100, 104–05, 125, 148, 149, 156, 157, 205, 206, 207, 231, 232–33

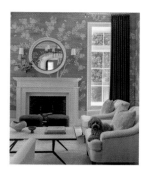

Miami

Design Lead: Kristin Fitzgerald, Kristin Carter
Logistics Lead: Laura Wheeler
Builder: Hidalgo Construction Group
Architect: Portuondo Perotti Architects
Landscape Architect: SMI Landscape Architecture
Pages 24, 84, 85, 127, 140, 160–61, 190, 191, 240–41

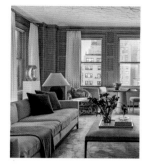

New York City

Design Lead: Sydney Manning, Kelsey Grant, Maddie Farmen
Logistics Lead: Nycole McMahon
Builder: Vectra Construction
Architect: Appel Architecture, DPC
Pages 38–39, 54–55, 58–59, 122, 123, 162–63, 172–73, 174, 175

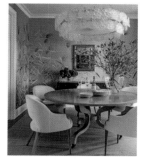

Quogue

Design Lead: Melanie Hamel, Helene Dellocono
Logistics Lead: Julie DiPaolo
Builder: JP Spano Building
Pages 48, 70–71, 188–189, 210, 211, 250, 251 (bottom)

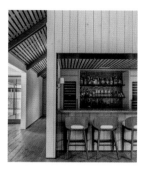

Round Top

Design Lead: Kristin Fitzgerald
Logistics Lead: Nycole McMahon
Builder: Fischer-Langham Custom Builders
Architect: Lake Flato
Landscape Architect: Rialto Studio
Pages 92, 93, 118, 119, 145, 186, 187, 212, 228, 234, 235

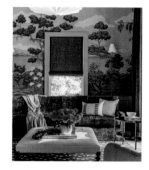

Royal Point

Design Lead: Ashlee Garner
Logistics Lead: Julie DiPaolo
Builder: The LaRocque Group
Wallpaper: Gracie's New World in Color
Pages cover, 17, 36, 37, 74–75, 88, 89, 98, 114–15, 132, 137, 142, 150–51

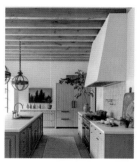

Sunset Boulevard

Design Lead: Kristin Fitzgerald
Logistics Lead: Julie DiPaolo
Builder: The Southampton Group
Architect: Murphy Mears Architects
Landscape Architect: Herbert Pickworth
Pages 56, 57, 76, 77, 96 (bottom), 106, 107, 220, 221, 238, 242, 243

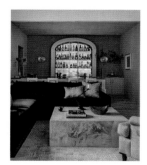

Tanglewood

Design Lead: Kristin Fitzgerald, Danica Bezewada
Logistics Lead: Laura Wheeler, Kristin Carter
Builder: Frankel Design Build
Architect: Frankel Design Build
Pages 22, 94, 95, 99, 108, 109, 131, 139, 146–47, 202, 203, 217

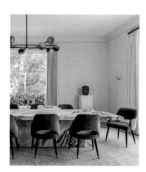

Terrace Boulevard

Design Lead: Ashlee Garner
Logistics Lead: Julie DiPaolo
Builder: Al Ross Custom Homes
Architect: Greg Roffino of Benjamin Johnson Design
Landscape Architect: Edgeland Group
Pages 20, 21 (bottom), 50–51, 97, 112, 113, 129 (top), 130 (bottom), 158–59, 179, 180–81, 196

Additional Projects Featured

Brenham, page 251 (top)

Briargrove Park, page 21 (top)

Little John, pages 78, 79

Longleaf, pages 169, 204

McLean, pages 248–49

Memorial Park, page 141

Pebble Brook, pages 135, 226, 227

Telluride, pages 176–77

Timber Lane, pages 170–71
Photographed by Rachel Manning

West Lane, pages 218, 219

All photography by Julie Soefer Photography, styled by Jessica Brinkert Holtam, with the exception of pages 170–71, photographed by Rachel Manning

First published in the United States of America in 2024 by Rizzoli International Publications, Inc.
300 Park Avenue South
New York, NY 10010
www.rizzoliusa.com

Publisher: Charles Miers
Editor: Sandra Gilbert Freidus
Editorial Assistance: Kelli Rae Patton and Sara Pozefsky
Design: Jan Derevjanik
Production Manager: Barbara Sadick
Managing Editor: Lynn Scrabis

Printed in China

2024 2025 2026 2027 / 10 9 8 7 6 5 4 3 2 1

ISBN: 978-0-8478-3753-3
Library of Congress Control Number: 2024934628

Visit us online:
Facebook.com/RizzoliNewYork
instagram.com/rizzolibooks
X.com/Rizzoli_Books
pinterest.com/rizzolibooks
youtube.com/user/RizzoliNY

Featured on the front cover and endpapers, Gracie's New World in Color and New Heights Forest Tapestry handpainted wallpapers, respectively, celebrate the lush colors and shapes of nature.

Backcover: Neutrals have timeless appeal and the ability to complement various styles of design. They are also adaptable and welcoming and create a sense of calm.

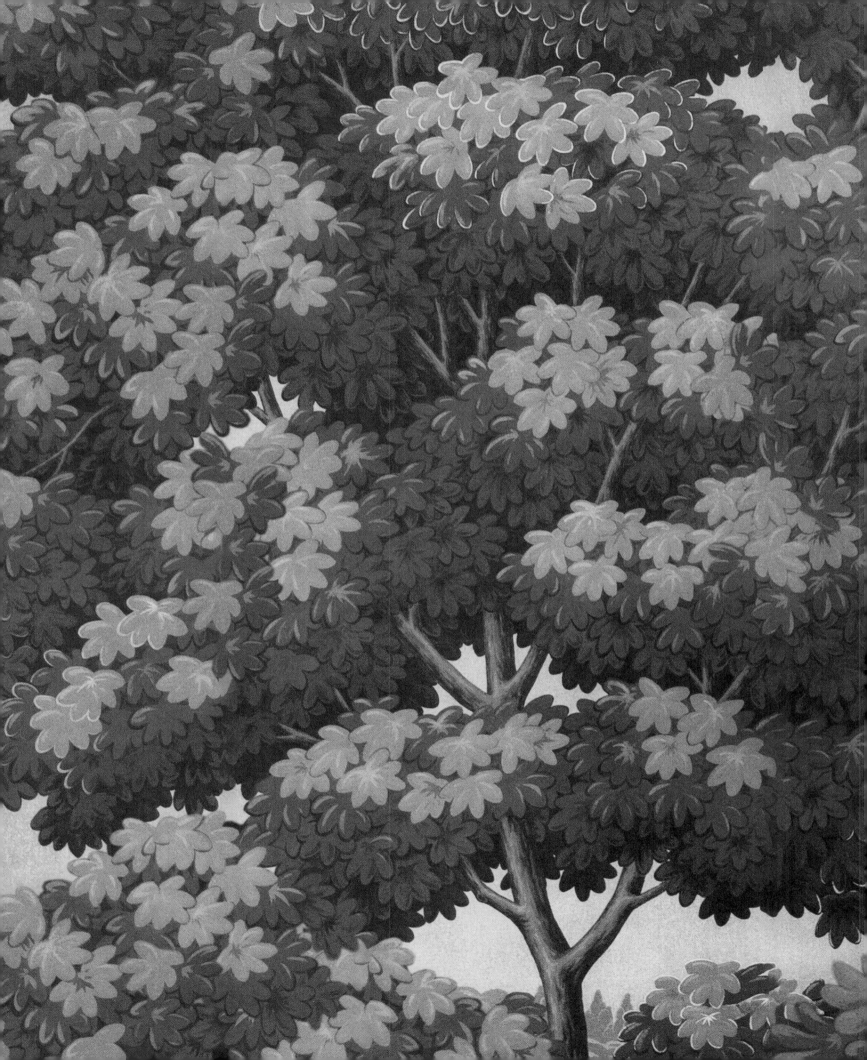